Eighth Edition

Pattern Making
by the
Flat-Pattern Method

Norma R. Hollen

Professor Emerita, Iowa State University

Carolyn J. Kundel

Iowa State University

Merrill,
an imprint of Prentice Hall

Upper Saddle River, New Jersey *Columbus, Ohio*

Library of Congress Cataloging-in-Publication Data
Hollen, Norma R.
 Pattern making by the flat-pattern method / Norma R. Hollen,
Carolyn J. Kundel. —8th ed.
 p. cm.
 Includes index.
 ISBN 0-13-938093-0 (pbk.)
 1. Dressmaking—Pattern design. I. Kundel, Carolyn J.
II. Title.
TT520.H64 1999 98-24667
646.4'072—dc21 CIP

Cover photo: © Gerber Technology, Inc.
Editor: Bradley J. Potthoff
Production Editor: Mary M. Irvin
Design Coordinator: Diane C. Lorenzo
Text Design and Production Coordination: The Clarinda Company
Cover Designer: Rod Harris
Production Manager: Pamela D. Bennett
Illustrations: Eunah Yoh
Director of Marketing: Kevin Flanagan
Marketing Manager: Suzanne Stanton
Advertising/Marketing Coordinator: Krista Groshong

This book was set in Goudy and Legacy Sans by The Clarinda Company and was printed and bound by Courier/Kendallville. The cover was printed by Courier/Kendallville.

© 1999, 1993 by Prentice-Hall, Inc.
Simon & Schuster/A Viacom Company
Upper Saddle River, New Jersey 07458

Earlier editions © 1961, 1965, 1972, 1975, 1981 by Burgess Publishing Company; © 1987 by Macmillan Publishing Company.

Printed in the United States of America

10 9 8 7 6 5 4 3 2

ISBN: 0-13-938093-0

Prentice-Hall International (UK) Limited, *London*
Prentice-Hall of Australia Pty. Limited, *Sydney*
Prentice-Hall of Canada, Inc., *Toronto*
Prentice-Hall Hispanoamericana, S. A., *Mexico*
Prentice-Hall of India Private Limited, *New Delhi*
Prentice-Hall of Japan, Inc., *Tokyo*
Simon & Schuster Asia Pte. Ltd., *Singapore*
Editora Prentice-Hall do Brasil, Ltda., *Rio de Janeiro*

Preface

Pattern Making by the Flat-Pattern Method, Eighth Edition, is designed as a text for students seeking a career as a designer or pattern maker in the apparel industry. It is also an excellent reference for persons interested in custom sewing, teaching, and homemaking. The previous seven editions of this text have helped thousands of students master the basic principles and procedures of making patterns for original clothing designs for both themselves and apparel firms.

GOALS AND COVERAGE

The major goals for this revision were to update the old chapters and to add new information to reflect changes in pattern making in the apparel industry. The first chapter on the role of the pattern maker in the apparel industry includes an overview of apparel industry activities, including designing apparel; making first patterns and sample garments; making production patterns; grading patterns; marker making; and cutting, assembling, finishing, and costing garments.

This chapter also explores the use of computers in the apparel industry. The most significant change in pattern making is the use of computers to speed up the process of making patterns. In the past all patterns were made by hand, but today expensive computer-aided design (CAD) systems are used to generate patterns with great speed and accuracy. When computer systems become less expensive, more universities will be able to give students hands-on experience in making patterns by computer. However, students still need to know the basics of pattern making by hand before they produce patterns by computer.

The new edition retains the "tried and true" information of the previous editions, organized with step-by-step instructions and over a thousand illustrations. Fundamentals of pattern making for all the standard clothing components used in designing apparel for women, men, and children are included, along with helpful sewing suggestions and practice problems.

The half-scale and quarter-scale patterns in Appendix A allow student to practice pattern making with less paper and fabric than is required for full-scale patterns. Students should be encouraged to save their patterns in a notebook as a reference for making additional patterns.

Unique chapters on men's and boy's patterns and girlswear provide a broader range of instruction than several other texts in the field, better preparing students for a wider choice of career opportunities. The chapters on jackets, coats, and capes cover more complex clothing garments; students often choose these garments for final class projects.

A chapter on making patterns for knit garments was expanded because of the increasing demand for knit garments. It addresses variations in stretch of knit fabrics and techniques for working with the basic garment components. A chapter on knockoff designs was expanded because entry-level pattern makers need to know how to create patterns that reproduce designs from competitive companies. Several different techniques for duplicating patterns are presented with explanatory photographs. This chapter includes information on making garments for accurate measurements or specifications.

NEW IN THE EIGHTH EDITION

Chapter 17 includes fashion illustrations and information on making patterns for evening gowns and wedding dresses. These garments are favorite choices of students when they design their final class projects.

Chapter 18 on decorative design illustrates a variety of ways to decorate and embellish items of clothing to make them more unique. Clothing designers need to constantly think of creative ways to use fabrics, trims, and design details. This chapter also includes information on selecting appropriate fabrics for patterns.

Acknowledgments

I wish to express my appreciation to the following:

Iowa State University for a Faculty Improvement Leave

Dr. Lu Ann Gaskill, Textiles and Clothing Department Executive Officer, for her words of encouragement

Norma Hollen for her wonderful wisdom and excellent advice

Eunah Yoh of Iowa State University for providing the artistic fashion illustrations for the chapter title pages and Chapters 17 and 18

Iowa State University Textiles and Clothing faculty members, especially Dr. Grace Kunz and Phyllis Brackelsberg, for their helpful comments

LouAnn Doyle for typing the new manuscript

Kundel family members for their words of encouragement

The Butterick Company for permission to reproduce its commercial fitting patterns and two charts

Gerber Technology, Inc. for photos showing computer pattern making in the apparel industry

Chuck Greiner for taking photos

Mary Irvin, Production Editor, for careful and thorough supervision of the book's production

Brad Potthoff, Senior Editor, and Mary Evangelista, Editorial Assistant, Merrill/Prentice Hall, for their helpful advice and comments

Gail Gavin, Production Editor at The Clarinda Company, for supervising the production of the text

Reviewers of this edition who offered excellent suggestions, including Diane K. Frey, Bowling Green State University; Peyton Hudson, North Carolina State University (retired); Jacqueline Keuler, Syracuse University; Debra S. McDowell, Southwest Missouri State University; and Jolene Smith, Ricks College

Apparel Design students at Iowa State University, who were a joy to teach as they experienced the excitement of learning how to make patterns

C. J. K.
Iowa State University
Ames, Iowa

Contents

17

Evening Wear 282

18

Decorative Design 292

The Apparel Manufacturing Process

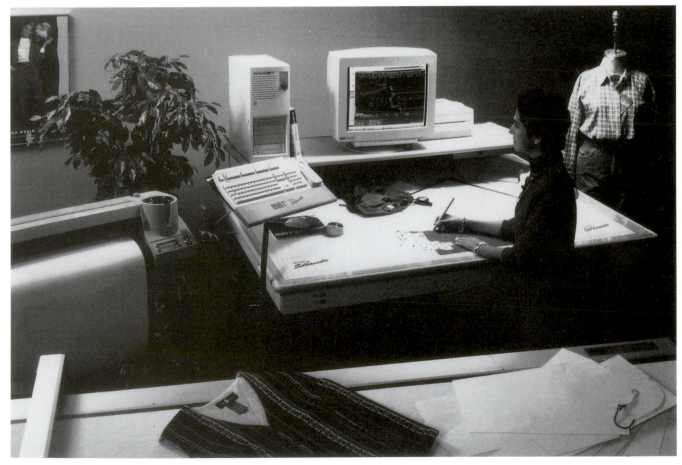

Source: Gerber Technology, Inc., CAD/CAM/CMS Division, 24 Industrial Park Rd. W., Tolland, Ct. 06084.

INTRODUCTION

This textbook is designed to help college students majoring in textiles and clothing learn how to make patterns of clothing for women, men, and children.

In the past, students were mainly interested in learning pattern making for these reasons:

1. As a hobby to make interesting clothing designs for themselves
2. To be able to teach pattern making to other persons
3. To be able to start a custom business of designing and constructing clothing for other persons

Although these three reasons still continue for some students today, the goal of a majority of students is to become a pattern maker with an apparel manufacturing company. Therefore, this chapter was added to give a brief overview of the apparel industry.

Students majoring in apparel design need to understand the apparel industry as they pursue their careers as designers and pattern makers for companies that manufacture clothing for men, women, and children. In some apparel firms, the designer is involved in every step of the production of a line of clothing, from the original ideas to the completed groups of garments. Computer-aided design (CAD) systems are an important technology that is revolutionizing the apparel industry. Universities are purchasing CAD systems to teach students how computers are used to improve the speed and accuracy of several apparel production processes. Students need to know the basics of pattern making, however, before they can become proficient with CAD systems.

The typical sequence involved in mass-producing apparel is designing the group of garments for a line, pre-costing the line, making first patterns, constructing the sample garments, making the production patterns, grading the patterns to various sizes, making the markers, cutting multiple garments, assembling the garments, pressing, finishing, and final costing each garment. This chapter will briefly examine each of these steps and explain how the computer can be used in performing several of them. In a large company the pattern maker may be involved only in making patterns, but in a smaller company the pattern maker may be responsible for many of the steps listed here.

DESIGNING THE LINE

A designer's primary job is to create a product that sells. No matter how large or small the apparel manufacturer, to stay in business the firm must make a profit.

A plan is developed for the new group of garments based on a theme, a color story, coordinating fabrics, design

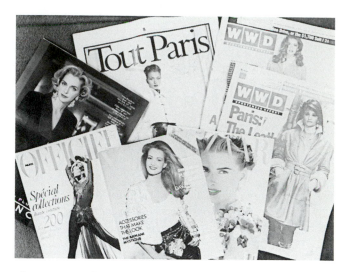

Figure 1.1 Ideas can be obtained from current publications that show clothing of famous designers.

details, and so on. An apparel manufacturer usually specializes in a particular styling category, price range, and size of clothing.

The designer sketches new styles and decides on changes to be made to existing styles that are selling well for the firm. Designers obtain ideas for creating new styles from many sources. *Women's Wear Daily* and other publications show photographs and sketches of clothing by famous designers from around the world as well as from the United States (See Figure 1.1).

New fabrics are another source of design inspiration. Designers visit fabric showrooms and international fabric fairs to see color and fabric trends for the season ahead. Sample cuts of fabrics, as shown in Figure 1.2, are obtained

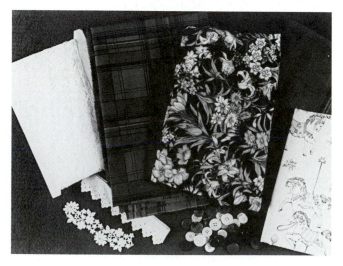

Figure 1.2 New fabrics and trims are a source of design inspiration.

from the showrooms and from traveling fabric sales associates. Fabric may suggest an idea to the designer, or the designer may sketch the garment first and then select suitable fabric. Choosing appropriate fabric for a particular style is a very important aspect of designing. Fabrics should be chosen on the basis of fashion trends, quality, performance, price, and suitability.

Each company has a target market, and designers must be familiar with their customers and also with apparel made by other companies who are competing for the same target market. To make a profit and increase market share, a company must accurately predict the styles and quantities that will sell. In addition to visiting stores to see the competing lines of clothing, pattern makers can copy or knock off successful designs of other companies. This technique is explained in Chapter 16.

Styles that are selling well for a company are usually kept in the line for the new season with updated details or new fabrics (Figure 1.3). As a general rule, clothing for children and classic designs such as those for men's suits may just need minor design changes. However, fashionable clothing for misses and juniors may need major changes to keep up with the changing styles for the new season.

The related designs making up the line or collection are usually composed of groups of mix-and-match garments made of coordinating fabrics, trims, design details, and so on. Figure 1.4 shows three garments in one collection made of coordinating fabrics. Most apparel firms have several lines a year that are presented to buyers. For fashionable goods, these typically include a fall line, a holiday line, a spring line, and a summer line. Manufacturers also fill in

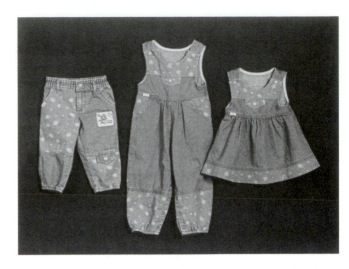

Figure 1.4 The same blue denim and pink print fabric were used in three of the garments for this fall line of children's clothing.

their lines with new items, shipping to stores on a monthly basis. The largest and most important lines for clothing manufacturers who produce basics are the fall and spring lines. Specialized companies, such as swimwear companies, have greatest sales in summer while a coat manufacturer's best season is the fall. Designers work on their new collections of garments nine to twelve months in advance of the retail season. The use of computers and different manufacturing techniques will allow the clothing industry to shorten this time frame and respond more quickly to market trends. This is known as Quick Response or QR.

CAD systems can maximize designer creativity and speed the design process in several ways. CAD can eliminate time-consuming hand sketching by allowing the designer to make changes without redrawing the basic design each time. On the computer, the designer can experiment with design details or with the size, shape, and color of the entire garment. The CAD system can color the design and change the hue instantly at a touch. It can also scan pictures of garments or fabric swatches into the computer's memory to be used for ideas later. By using the computer to generate garment designs, the number of sample garments actually made can be reduced significantly.

PRECOSTING THE LINE

Preliminary costing, or precosting, must be done before a design can be accepted into a line of clothing. This quick costing is used to determine whether the designer's sketches can be produced and marketed within the established price range for the line. Precosting is a rough estimate of the costs of fabric, trims, notions, and labor. Costs

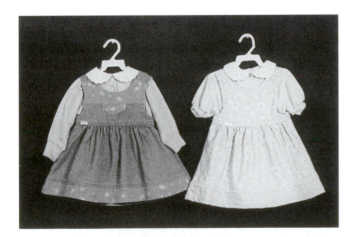

Figure 1.3 For fall, the child's jumper on the left was made of denim and a twill weave print and the blouse had long sleeves. For spring, the child's jumper is a lighter-weight fabric and color and the blouse has short sleeves. Similar patterns are used for both the fall and spring collections.

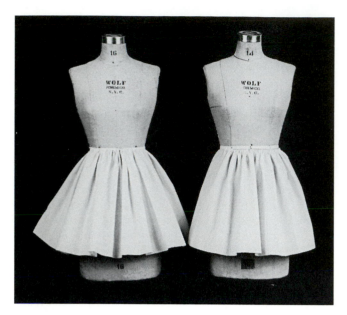

Figure 1.5 One way the designer can cut fabric costs is to reduce the fullness of a skirt. The skirt on the left has three times as much fullness as the basic pattern and the skirt on the right has two times the fullness of the basic skirt pattern.

Figure 1.6 Making patterns by drafting. Accurate measurements and good instructions are needed to draft basic patterns.

of previously produced similar styles can be used to predict what a new style will cost.

Because of cost, some styles are rejected, and others are sent back to the designer to have cost-reducing changes made. At this point, the designer may change the type of fabric or the trims used. Another way to cut costs is to use less fabric in a full skirt (Figure 1.5).

FIRST PATTERNS

A patternmaker typically makes a pattern from a flat sketch with measurements or a two-dimensional fashion (2-D) illustration. He or she must have a good eye for proportion and line and the ability to interpret the sketch correctly. First patterns of the sketch can be made by drafting, flat-pattern designing, draping, or a combination of these methods.

Drafting

Drafting uses measurements from sizing systems or accurate measurements taken on a person or dress or body form. Measurements for chest, waist, hip, and so on, plus ease allowances, are marked on paper, and lines are drawn to complete the pattern (Figure 1.6). Each company has a typical target customer in mind when the slopers and patterns

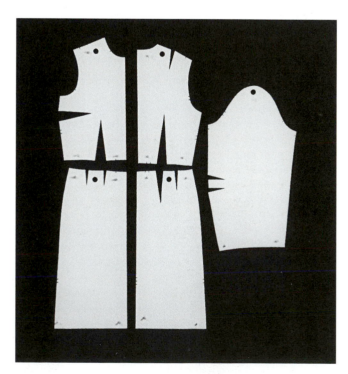

Figure 1.7 Making patterns by flat pattern. Basic patterns made of oak tag are used for flat-pattern designing.

are drafted. Drafting is used more often for basic ready-to-wear items and menswear than for women's fashion apparel.

Flat Pattern

In the flat-pattern design process, a fitted basic pattern with comfort ease is developed to fit a standard-size person, or body form. Five basic pattern pieces are used for women's clothing. They include a snug-fitting bodice front and bodice back with darts and a jewel neckline, a long fitted sleeve, and a fitted skirt front and skirt back with darts.

Copies of these five basic pattern pieces without seam allowances are made out of oak tag and are called slopers, blocks, or master patterns (Figure 1.7). Each apparel manufacturer develops its own basic blocks to represent the firm's size and fit, and to conform to the perceived needs of its customers. Although slopers with two darts in the bodice front and two darts in the skirt front and skirt back usually fit better, one-dart slopers can be used to simplify the pattern-making process and to lower the cost of assembling the garments. A variety of patterns are made from the basic blocks and kept on hangers for future use. Flat-pattern designing takes less time than other methods and is the most common method of making patterns for ready-to-wear apparel.

Draping

In draping, muslin or fashion fabric is fitted to the curves of a dress or body form to create the desired design. These body forms are made to duplicate the firm's sizing standards. Ease allowances for movement are added to make the garment comfortable to wear. One advantage of draping is that the designer can see the overall design effect of the finished garment on the body form before the garment pieces are cut and sewn. Draping requires more skill and is more expensive and time-consuming than flat-pattern designing. The draping technique works better than flat patterns when making very elaborate designs such as in Figure 1.8.

Designers often use more than one method of pattern design. The flat-pattern method may be used to design garments when speed is needed. Draping may be used on unusual fabrics or on garment segments to see how a bias-cut cowl neckline will drape or to check the roll of a collar, the fullness of a puffed sleeve, the amount of flare added to a skirt, or the angle of the neckline in relation to the bust darts (Figure 1.9).

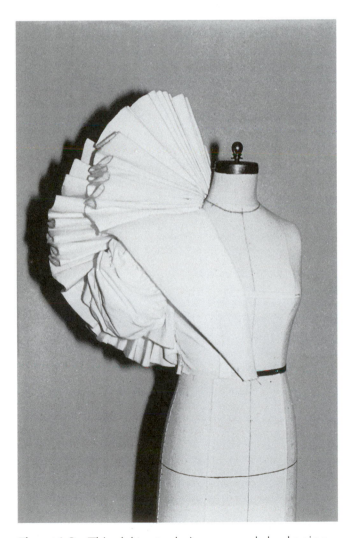

Figure 1.8 This elaborate design was made by draping muslin on a body form.

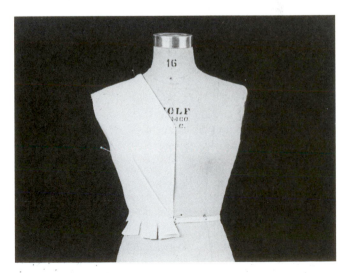

Figure 1.9 Fabric is pinned to a body form to make a draped garment. Draping was used to check the shape of the neckline in relation to the placement of the diagonal dart.

A computerized pattern design system can improve the speed and accuracy of pattern making. The sloper or block is entered into the computer's memory by scanning or digitizing. Changes in the pattern are made on screen instead of manually by computer operators that know how to make patterns (see Figure 1.10).

SAMPLE GARMENTS

Patterns are made in a sample size for each part of the garment. Typical sample sizes are size 10 for misses, size 34 for men's trousers, and size 38 for men's shirts. A sample maker cuts the pieces out of fashion fabric and constructs the sample garment. At this point, design details such as pockets or the length of a collar can be changed. The fit can be adjusted or a different sleeve or collar can be designed to improve the garment. The sample garment is then analyzed to determine if it can be sold at a profit. Minor changes in the design may still be suggested at this point. The best designs are chosen for the new line. Samples are made for sales representatives to show retail buyers, who view the line and place orders for styles they think will sell in their stores. Styles that are ordered in sufficient quantities to justify production are retained, and the remaining styles are dropped from the line. Fabric and trims necessary to make the multiple garments are ordered for mass production. The new technology of three-dimensional (3-D) computer illustrations of garments may result in making fewer sample garments in fashion fabric.

PRODUCTION PATTERNS

Styles chosen for production go to the production pattern maker, who can change the pattern slightly without destroying the appearance of the garment. A production pattern is accurate to within 1/32 of an inch. Production pattern makers keep in mind efficient fabric utilization and ease in assembling the garment. Constant communication and negotiation between the design and production departments is a way of life.

PATTERN GRADING

Pattern grading involves increasing the pattern to make larger sizes and decreasing the pattern to make smaller sizes. For example, the original garment may be made in sample size 10 and then graded upward to sizes 12, 14, and 16 and downward to sizes 6 and 8. Instead of adding or subtracting an equal margin around the pattern to increase or decrease it, the pattern grader adds or subtracts various amounts at specific places to reflect the way the body changes from size to size. This method ensures that the pattern will fit the body properly (see Figure 1.11 for a pattern of a bodice graded by computer).

In the apparel industry there are no standard sizes in women's apparel, and sizes can vary greatly from company to company. However, for commercial patterns for home sewing, which are standardized, a standard grade for misses sizes 6, 8, and 10 is a 1-in. (2.5-cm) difference in circum-

Figure 1.10 Computer-aided design systems can change the pattern-making process. Changes to the pattern can be made instantly without redrawing the pattern by hand. (Source: Gerber Technology, Inc., CAD/CAM/CMS Division, 24 Industrial Park Rd. W., Tolland, Ct. 06084.)

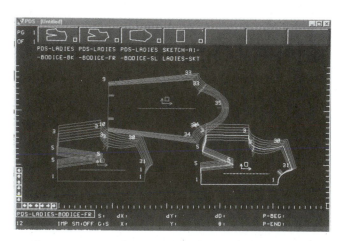

Figure 1.11 A pattern for a bodice front, bodice back, and sleeve graded by computer. (Source: Gerber Technology, Inc., CAD/CAM/CMS Division, 24 Industrial Park Rd. W., Tolland, Ct. 06084.)

ference at the bust, waist, and hip. There is a 1 1/2-in. (3.8-cm) difference among sizes 10, 12, 14, and 16 at the bust, waist, and hip measurements and a 2-in. (5.1-cm) difference among sizes 16, 18, and 20. In children's clothing, there is a 1-in. (2.5-cm) difference in the chest and hips among sizes 2, 3, 4, 5, and 6 and just a 1/2-in. (1.3-cm) difference between a size 6 and 6X.

Patterns can be graded by hand with a slash-and-spread technique to increase or a slash-and-overlap technique to decrease. A similar method that does not cut the pattern apart involves a slide-and-spread technique to increase and a slide-and-close technique to decrease.

A pattern-grading tool is helpful because it holds the pattern perfectly straight in a vertical position, without tilting, as it increases or decreases the pattern with specific vertical and horizontal measurements (Figure 1.12). Grading all the pattern pieces by hand is a time-consuming job and requires a skilled pattern grader. When students understand how patterns are graded by hand, they will appreciate the fast and accurate way they can be graded by the computer.

Today many apparel manufacturers grade patterns by computer. A library of grade rules can be developed and entered into the computer, which accurately grades the pattern to all the desired sizes automatically at the touch of a button. Some smaller apparel firms contract with larger firms that can do pattern grading by computer. The accuracy of the original pattern is crucial in any method of grading patterns because it affects the accuracy of all the other sizes.

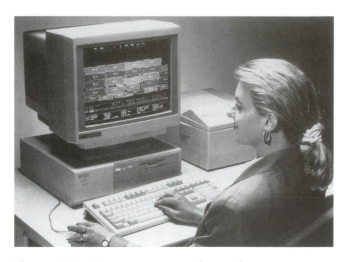

Figure 1.13 Computers are used to make accurate patterns and efficient markers.
(Source: Gerber Technology, Inc., CAD/CAM/CMS Division, 24 Industrial Park Rd. W., Tolland, Ct. 06084.)

MARKER MAKING

A marker is a cutting guide showing how all the pattern pieces of the various sizes of garments to be cut are arranged on the fabric in an efficient layout. Utilizing the fabric to the best advantage in cutting is important because saving as little as an inch of fabric over thousands of yards will affect the firm's profit. Computers can be used to make efficient markers (Figure 1.13) as well as to compute the percentage of fabric by each marker. When the marker is completed by the computer, it is plotted on paper the same width as the fabric and is used in the next stage of cutting.

CUTTING

In preparation for cutting, layers (plies) of fabric are placed on long cutting tables. The marker is placed on top of the multiple plies of fabric and used as the guideline for the cutter as the pattern pieces are cut out. Sometimes marker information is fed directly to a computer-controlled cutting machine. After being cut by machine, pieces are bundled and sent to the assembly line.

GARMENT ASSEMBLY

Technologically advanced computerized sewing machines assist sewing operators to rapidly and accurately assemble the garments (Figure 1.14). Many apparel manufacturers produce garments on an assembly line. The cut pieces are tied together in bundles and each sewing machine operator

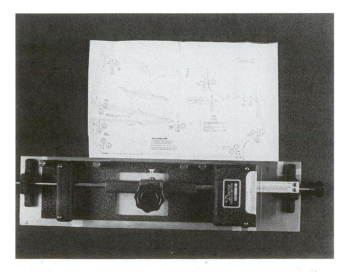

Figure 1.12 A pattern-grading tool is used to add length and width to a pattern to change it from one size to another size. Grading rules tell how much to add at each pattern point.

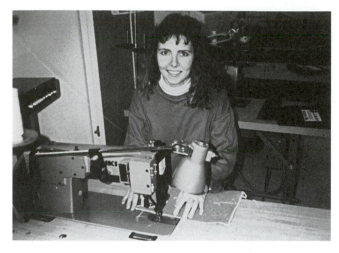

Figure 1.14 Computerized sewing machines, such as the Lock Stitch 301, are used to assemble garments.

completes the same task on a bundle of garments before passing it on to the next operator.

Some apparel manufacturers use unit production systems (UPS) or modular manufacturing. In UPS, garments are directed to operators who need work. These operators are cross-trained for several jobs and know how to operate more than one specialized sewing machine (Figure 1.15). They work where they are needed most. For example, if an operator sewing sleeves gets behind, the worker who was sewing collars starts setting sleeves.

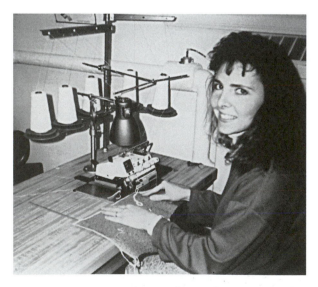

Figure 1.15 Some sewing machine operators are cross-trained and know how to operate more than one specialized sewing machine. The Safety Stitch 516 machine is shown here.

In modular manufacturing, groups of operators work as teams to produce one garment at a time. Operators are familiar with all the steps in producing the garment and can rotate to different machines. Using modular manufacturing or unit production systems, a simple T-shirt can be completed on two or three machines with a few minutes of sewing. A lined, tailored jacket is more complex: It takes about two hours of sewing to complete and requires several specialized sewing machines for the lining, hem, pockets and buttonholes.

PRESSING AND FINISHING

Garments are commonly pressed with steam, heat, and pressure. Complicated garments of high quality are pressed during garment assembly in addition to a final pressing. Simple, inexpensive garments may be pressed only after they have been assembled or not be pressed at all. Computerized control of temperature, time, and pressure of pressing equipment produces a garment of consistent quality. After pressing, garments are hung and bagged or folded and packaged and shipped to the retailer.

FINAL COSTING

Final costing is determining the cost of producing each garment. It includes the cost of the fabric, trim, notions, and labor as well as general expenses of operating the business.

After a garment is accepted as part of the line, the production costs are more accurately determined. Costs are calculated for every operation required to assemble the garment. The final cost is more accurate than the preliminary costing step because actual costs of fabric, findings, labor, and overhead are considered. Computerized costing systems using standard industry data can greatly speed this process. A sample cost sheet and a design inspiration sheet are in Appendix D.

Computers can keep accurate inventory records for both the manufacturer and the retailer. Good communication between retailers and manufacturers helps manufacturers keep abreast of which items are selling well for reorders this season so that they can make similar garments for another season. Apparel firms must make a profit and ideally this means having the right merchandise in the right quantity at the right time and right price for the consumers.

NEW TECHNOLOGY ON DISPLAY

One of the best places to see the new developments in equipment and technology for the apparel industry is the Bobbin Show in Atlanta, Georgia. This international show

is sponsored by the American Apparel Manufacturers Association (AAMA) and is usually held the last week of September each year. Major companies have huge exhibits and trained personnel to explain the advantages of their apparel industry products that relate to designing apparel and fabrics, making and grading patterns, fabric spreading, cutting, sewing, embroidery machines, and new fabrics.

Among new developments exhibited at a recent Bobbin Show were:

1. A 3-D body measurement system used for mass customization of garments.
2. Single-ply laser cutting for tubular knits, ultrasonic cutting upgrades, and automatic detection and correction of dull cutting blades for heavy-weight fabrics.
3. Identification of flaws in fabric and automatic matching of plaid fabrics.
4. Computer software to design knit and woven fabric with a variety of different colors, textures, and prints and to visualize fabrics on 2-D and 3-D fashion illustrations.
5. Digitally printed fabrics from computer-generated fabric designs.
6. Computer programs for line development, storyboarding, specification sheets, automatic sketching, catalog copy, and 3-D store layout plans.

A list of companies specializing in computer software and hardware for the apparel industry is found in Appendix D.

Serving as a designer or pattern maker for an apparel firm is a demanding career, but also an exciting one. A sense of satisfaction comes from seeing apparel by your firm in retail stores and from recognizing your clothing designs being worn and enjoyed by people around the country.

This chapter is an overview of the apparel design and manufacturing process. More detailed information on this topic can be found in the following texts:

Ready-to-Wear Apparel Analysis by Patty Brown and Janett Rice. Upper Saddle River, N.J.: Prentice Hall, Inc., 1998.

Apparel Manufacturing Sewn Product Analysis Second Edition by Ruth E. Glock and Grace I. Kunz. Upper Saddle River, N.J.: Prentice Hall Inc., 1995.

Guide to Apparel Manufacturing by Peyton B. Hudson. Columbia, S.C.: Bobbin-Blenheim Publications, 1988.

Fashion from Concept to Consumer Third Edition by Gini Stephens Frings. Upper Saddle River, N.J.: Prentice Hall Inc., 1991.

Inside Fashion Design Fourth Edition by Sharon Lee Tate. New York: Harper & Row, 1998.

Apparel Manufacturing Handbook Second Edition, *Analysis, Principles and Practice* by Jacob Solinger. Columbia, S.C.: Bobbin-Blenheim Publications, 1988.

The Business of Fashion, Designing, Manufacturing and Marketing by Leslie Burns and Nancy Bryant. New York: Fairchild Publications, 1997.

Patternmaking Tips, Tools, and Rules

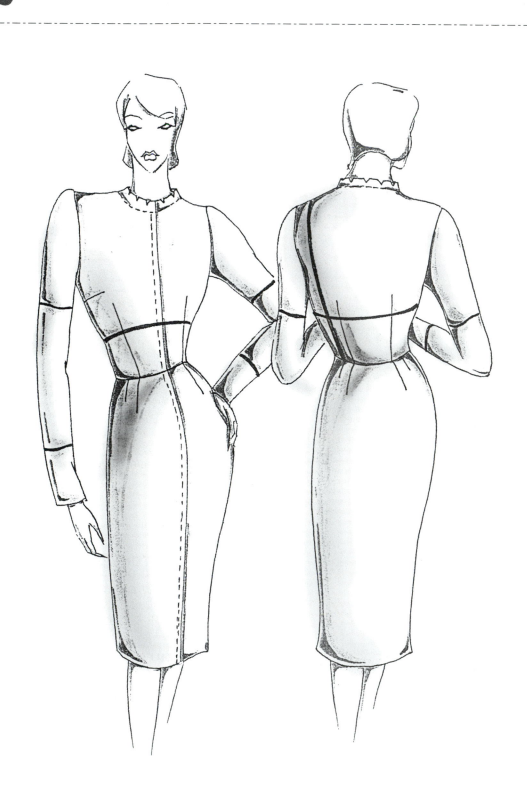

THE FLAT-PATTERN METHOD

Flat-pattern work usually starts with a basic pattern that fits a standard size dress form. This basic pattern can be a standard size or it can be altered to fit an individual. Directions for this type of alteration are found in most clothing construction books. Flat-pattern work consists of changing this basic pattern to create a pattern for a chosen design. The work is done in paper on a flat surface, hence the name.

Basic flat patterns have an established shape with the proper amount of comfort ease added. Making up the finished pattern in muslin or other inexpensive material is often helpful, however, so you can actually see the effect of the design being created and determine if the pattern is correct.

Two other methods of pattern making that are usually taught in more advanced courses are draping and drafting. **Draping** is an artistic approach in which muslin or fashion fabric is fitted to the curves of a dress form to make a cloth pattern. You can see how the garment will look as the pattern develops. **Drafting** is an engineering approach based on a set of body measurements. The accuracy of the pattern depends on the accuracy of the body measurements and the accuracy of the drafting instructions.

A thorough knowledge of flat-pattern methods is particularly important when designing for someone with an unusual figure. The designer may find it convenient to develop an entire set of basic patterns (i.e., basic yoke, basic princess bodice, basic six-gore skirt) before beginning the actual design work. These basic patterns will speed up the pattern-designing process.

APPLYING THE STUDY OF FLAT PATTERN

Knowledge of flat-pattern methods is essential to the designer or pattern maker hired by a clothing company and is also valuable to the home sewer or custom dressmaker. Designers who work in the commercial garment industry, for pattern companies, or as costume makers for theatre companies will use flat-pattern methods extensively. Such methods provide a fast, cost-effective way of making patterns.

Graduates have built successful careers in the clothing field by using their flat-pattern knowledge. Apparel design majors will find career opportunities as pattern makers for companies that produce clothing. (See Chapter 1 for more information on the apparel manufacturing process.) **Home businesses** provide good incomes for some graduates who work on an hourly basis consulting with persons who want remedial pattern help. Still others teach flat-pattern techniques to groups or individuals, or do patternwork and custom sewing for people who cannot buy ready-to-wear clothes. **Specialty shops** have been established by some graduates to custom-make clothes and patterns for a clientele interested in individually styled clothing.

When you know how to make your own patterns, sewing is a much more rewarding experience. One of the most satisfying benefits of flat-pattern work comes from the feeling of confidence that you have when you know you have used **correct procedures.** There are other benefits as well.

Creativity Clothes that you like but cannot afford to buy can be yours because flat pattern teaches you how to make the patterns. Creating original designs with flat patterns gives you a feeling of pride and artistry.

Economy You save money when you can restyle out-of-date commercial patterns or do the patternwork required to remodel out-of-date clothing. No longer will you have to buy two patterns to get all the design features that you want in a garment.

Related Benefits A knowledge of flat pattern increases your understanding of garment fitting, altering patterns, correcting errors that occur, working out new procedures, and organizing a project efficiently.

CREATING ORIGINAL CLOTHING

Sources of Inspiration

Designers gain inspiration from many sources including fashion magazines, newspapers, pattern books, and catalogues. They get ideas by observing the clothing styles displayed in stores and museums, or worn by persons in movies, on television, and at public events. Beautiful fabrics and trims are another source of creative inspiration.

Organizing Design Ideas

One of the most efficient ways to organize ideas is to keep a file of clippings of current clothing styles from fashion magazines, newspapers, pattern books, and catalogues. The clippings could be organized by type of garment (e.g., dresses, blouses, skirts) or by garment detail (e.g., sleeves, collars, belts). Sketch interesting clothing designs and details, and add these sketches to the file.

Know Figure Types

Basic patterns are made for body forms that have symmetrical features, perfect posture, and balanced proportions in terms of bust, waist, and hip measurements. When making

garments for individuals who are not of standard size, analyze the figure by looking at front and side views of the person wearing undergarments. Take a picture of the front and side views, so the figure can be analyzed objectively. Several universities take somatograph pictures that show front and side views in silhouette form (Figure 2.1). Analyze the body proportions and compare them with the standard dress forms or with pattern-measurement charts. As you make the comparison, ask these questions:

1. Is posture standard, over-erect, or slumped with rounded shoulders?
2. Is the person symmetrical, or is one shoulder or hip higher than the other?
3. Does the person have the same proportions as those listed on the pattern measurement chart, or is height, bust, waist, or hip measurement larger or smaller?

Altering the Basic Pattern

Good clothing construction books, such as *Unit Method of Clothing Construction*, *Reader's Digest Complete Guide to Sewing*, or the fitting books published by various pattern companies, give complete instructions on how to alter basic patterns. When you have made the alterations on the paper pattern, construct a trial garment out of muslin or checked gingham and make further refinements in the fit.

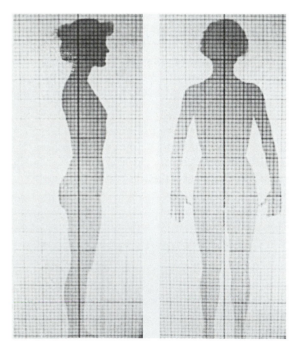

Figure 2.1 Somatograph pictures showing side and front views.

After doing this, mark carefully all changes made in the fabric garment on the original paper pattern before making the cardboard sloper. The sloper is then used for pattern making.

Achieving Good Fit

Appearance, comfort, design, and fabric are all related to good fit. A garment has good fit when the darts, seams, and grainlines are in their proper place and when the garment lies smoothly over the body with no pulls, wrinkles, or baggy areas. Vertical side seams must hang straight; the hemline should be even and parallel to the floor; darts should be tapered and stop before the fullest part of the area that they shape; waistline seams must follow the natural waistline and should not be binding; shoulder seams should rest on top of the shoulders; and the neckline must not be tight or binding.

Comfort and Design Ease

All garments must have comfort ease and may also have extra ease added for design effect. A garment should feel good to the wearer, or it will hang unworn in the closet. A person should be able to walk, bend, reach, and sit in a garment without feeling restricted and without straining seamlines. For a dress, typical comfort ease added for the bust is 2 to 3 in. (5.1 to 7.6 cm), for the waist is ½ to 1 in. (1.2 to 2.5 cm), and for the hip is 2 in. (5.1 cm). Other ease amounts are given in pattern-measurement charts.

Some garment designs are close fitting and some are loose fitting (Figure 2.2). Garments with a fitted waistline, bustline darts, or princess lines have close-fitting features. In contrast, garments with a blouson top, gathers under the yoke, pleated or flared skirt, cape, caftan, or tent dress design have loose-fitting areas. Fashions change over time, so the fashionable silhouette may be close-fitting one year and may then change gradually to a loose-fitting design a few years later. (Ease amounts for fitted, semifitted, and loose-fitting dresses, jackets, and coats are given in Table 11.1.)

Make a Trial Garment of the Patternwork

Before cutting into an expensive fabric, make a trial or test garment to see if design details and fit are correct. For the trial garment, choose an inexpensive fabric that has a weight and draping properties similar to the final fabric. Cut out the pieces and machine baste the garment together. Check in front of a mirror that the placement of design lines is attractive on the body form. Note details

Figure 2.2 Close-fitting and loose-fitting garments.

such as fabric, grainline, roll of the collar, flare of the skirt, placement of pockets and buttons, and drape of the cowl neckline. Good fit includes both design ease and comfort ease. Make any necessary corrections in fit or design lines to achieve a better appearance. This trial garment can be taken apart and used as the new pattern, or all changes made in the test garment can be transferred to the paper pattern. When the final garment consists of a fitted bodice, straight skirt, pants, jacket, coat, or other detailed design, you will find that making a trial garment is well worth the time and effort involved.

Choosing Fabric for the Design

Study the draping effect of different kinds of fabric. Hold the fabric lengthwise, crosswise, and on the bias. Place the fabric over a cylinder, such as a coffee can, and see if it drapes close to the edge or sticks out. This will help you decide if the fabric is appropriate for more tailored garments that have pleats, tucks, or straight lines, or for less tailored garments that have gathered or flared sections or cowl necklines. Broadcloth, chambray, gingham, and percale are called **topweights** and are suitable for blouses, shirts, and dresses. Heavier-weight fabrics, called **bottomweights,** are more suitable for pants and skirts. Some

examples of bottomweight fabrics are denim, poplin, twill, corduroy, gabardine, and double-knit jersey.

Woven fabrics can be soft or crisp, and can vary in the amount of "give" that they have. A garment made of a firmly woven polyester shantung will feel and fit differently from the same design made of a wool crepe. Knit fabrics stretch differently from woven fabrics and require special patterns that have less ease and fewer darts. Look at the design ideas in Figure 2.3. Which designs would require a firm fabric and which would take a drapable fabric? Suggest some fabrics that would be appropriate for each garment.

The garment design and the fabric should complement each other. The effect of an ornate print fabric can be ruined by an inappropriate design that has too many seams, while a very plain fabric can be enhanced by an interesting design. Large all-over prints usually look better when the design has a flared or gathered skirt rather than a straight silhouette. The design and the fabric should never compete for attention. Tiny checks and small floral prints can be handled almost like fabrics that have no pattern. Designs for a plaid should be in harmony with the geometric lines of the print. Straight lines and pleats go well with plaids. When plaids are used on the bias in skirt construction, the plaids will match at the side seams if both seams have the same angle of flare. Stripes are usually monotonous if the design allows them to run in one direction only, but if the stripes go in too many directions in the same garment, the result is also displeasing. Prints with a one-way design require that all pattern pieces be cut in the same direction. Velvet, velveteen, corduroy, and many knits should have all garment pieces cut in the same direction to ensure that the pieces do not reflect light differently. These fabrics also require additional yardage because the pattern layout is less efficient. If a fabric unravels easily, avoid unnecessary seams and details such as set-in pockets or bound buttonholes. Do not combine a washable fabric with a nonwashable trim. Look at the fashion illustrations in Figure 2.3 and on chapter opener pages of this book, as well as in newspapers, catalogues, and pattern books. Why did the designer select a stripe, plaid, print, or solid color for each specific design?

Determining Required Yardage

Most pattern companies now determine yardage requirements by computer. Before this technology was available, the companies had large tables marked off with different standard fabric widths.

To determine the yardage required for a pattern, use one of the following procedures:

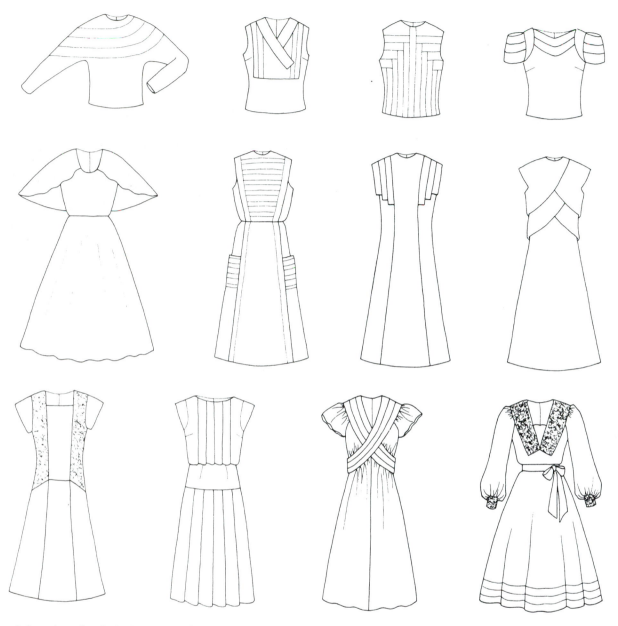

Figure 2.3 Ideas for designing original clothing. Name appropriate fabrics for each garment.

Directions

1. On a large table, such as a Ping-Pong table, mark off the various fabric widths with chalk or string before laying out the pattern pieces.

2. Keep on hand some 3-, 4-, or 5-yd pieces of inexpensive fabric, such as muslin or a double-knit, in the common 36-in., 45-in, 54-in., and 60-in. widths. (Brown wrapping paper can also be used instead of fabric.) Following the correct grainline placement, lay the pattern pieces on the fabric to determine number of yards needed for the design.

3. Estimate yardage by finding a similarly styled garment in a pattern book. Buy that yardage plus $\frac{1}{8}$ to $\frac{1}{4}$ yd more fabric. This method takes less time but is less accurate.

4. Take the paper pattern pieces to the store when selecting fabric. If the store is not busy, ask permission to lay the pattern pieces out on the fabric to determine how

many yards are needed before the bolt is cut. Be sure that seam allowances are added to the pattern, and remember to include patterns for all pieces, even facings, belts, and pockets.

Enjoying Your Patternmaking Skill

After learning the principles of making patterns by the flat-pattern method, you will be able to make a pattern for any garment that you see in a store, catalogue, or pattern book. You will also be able to design original clothes for pleasure or profit. You might even choose a career in pattern making with an apparel manufacturer or pattern company.

When designing and making garments for yourself, wear each creation with pride. When designing clothing for another person or for an apparel manufacturing or pattern company, be proud to attach your name or the company's name to each design. Enjoy your new pattern-making knowledge and skill. It will be with you for the rest of your life as you design and create works of beauty.

SUPPLIES AND EQUIPMENT

> Have your rules
> and your tools
> and you're free!
> —Julia Child

Patternmaking Tools

Some of the helpful tools to make patterns are shown in Figure 2.4. An aluminum L square and hip curve are at the top. Other tools from left to right include a hanger to hold patterns, a needlepoint tracing wheel, a pair of shears to cut oak tag patterns, a 10-in. shears to cut fabric, a pattern notcher, a tool to cut circles in oak tag patterns so they can be hung on hangers, and a metal weight to use when cutting out fabric.

Recommended Supplies and Tools

- Basic commercial pattern
- Roll of medium-weight paper
- L square
- Hip curve
- Flexible plastic ruler
- Tape measure
- Yardstick
- Soft lead pencil and colored pencils
- Rubber cement

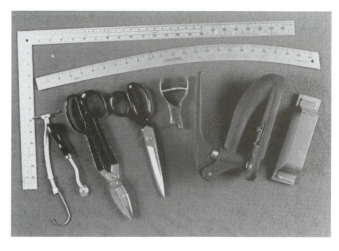

Figure 2.4 Patternmaking tools include an L square, a hip curve ruler, a pattern hanger, a needlepoint tracing wheel, a pair of shears to cut oak tag, a pair of shears to cut fabric, a pattern notcher, a pattern circle punch, and a metal weight.

- Removable transparent tape
- Compass
- Tracing wheel with sharp points
- Thumbtacks or pushpins
- Pins, needles, thread
- A pair of shears for cutting paper
- A pair of shears for cutting cloth
- Notcher for marking notches
- Muslin for trying out patterns
- Protractor
- Isosceles triangle
- Large corkboard
- French curve—provided in Appendix A
- Dressmaker's gauge discussed on page 44
- Sloper or block. (This is a cardboard or oak tag copy of a full-scale basic pattern.)
- Half-scale and some fourth-scale slopers provided in Appendix A

Using the Ruler

Figure 2.5 illustrates a way to make efficient use of the ruler.

Directions

1. Assume that the vertical line is the center front line of a bodice pattern.
2. Assume also that you wish to draw a grainline that can be used to cut the bodice *on the bias* of the cloth.

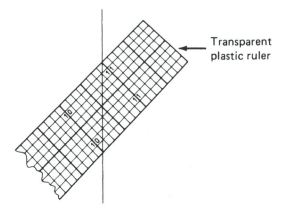

Figure 2.5 Use the plastic ruler to draw a line for bias position of the cloth.

3. Place a 1-in.-wide ruler in such a way that the diagonal of one of the inch squares falls on the center front line (10 and 11 in the drawing).
4. Now draw a grainline along the edge of the ruler. Either one of the long edges can be used. This line will be placed on the straight of the goods when the bodice is to be cut on the bias. (The bodice with a cowl neckline is an example of a garment cut on the bias.)

...

Figure 2.6 illustrates how to measure a curve with a flexible plastic ruler. You can also use the ruler to draw curved lines on patterns.

Using the French Curve

The French curve provided in Appendix A can be very useful for drawing smooth pattern curves. Note that it has

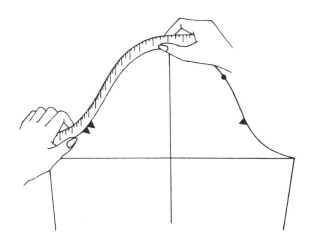

Figure 2.6 Measure sleeve cap by standing a plastic ruler on edge and fitting it to curves.

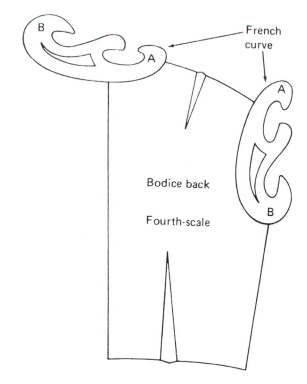

Figure 2.7 Positions of French curve for drawing bodice curves of back pattern.

different amounts of curve at the two ends labeled A and B, respectively.

Directions: Back Pattern

1. For the back pattern neckline, use the less rounded A side of the French curve and position it as shown in Figure 2.7.
2. For the back pattern armscye, the French curve will fit exactly (Figure 2.7), except in large-size patterns where the curve will not reach to the two ends of the pattern armscye. These can usually be extended as straight lines.

Directions: Front Pattern

1. Neckline: Use the rounder B end of the French curve as shown in Figure 2.8. The corner at center front is drawn as a right angle.
2. Armscye: Both ends of the French curve are used. The solid line shows the first position, and the dashed line shows the second position.
3. Sleeve cap: Turn to Figure 9.6 to see how the French curve is used to draw the curves of the sleeve cap.

...

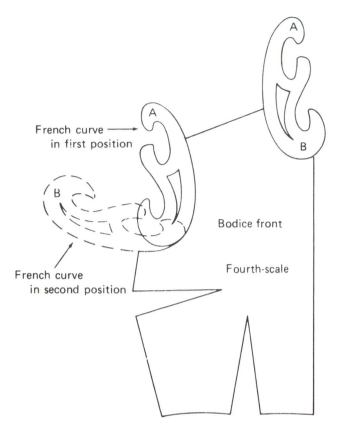

Figure 2.8 Positions of French curve for drawing curves of the bodice front pattern.

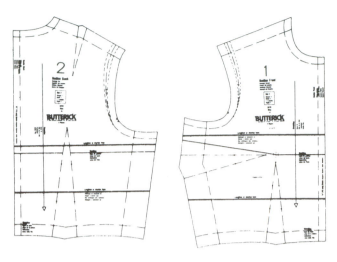

Figure 2.9 Basic bodice. (Courtesy of Butterick Company, Inc., 161 Avenue of the Americas, New York, NY 10013.)

The French curve can be used to draw any curves required in a pattern. Page 54 shows how to use the French curve to draw the princess-line curve.

Basic Pattern and Sloper

The **basic pattern** is the starting point for flat-pattern designing. It is a simple pattern that fits the body with just enough ease for movement and comfort. The basic pattern for women has five pieces: bodice front, bodice back, skirt front, skirt back, and sleeve. The five pieces of a commercial basic pattern are shown in Figures 2.9, 2.10, and 2.11.

A commercial basic pattern is the starting point for full-scale patternwork. If the basic pattern is not available, a simple dress pattern with similar pieces can be used. The basic pattern should be purchased on the proper size, altered to fit, made up as a muslin shell, and checked for fit.

The basic pattern is sometimes called a **master** or **foundation pattern.** The drafted pattern is referred to as a **block.**

A **sloper** is an oak tag copy of the basic pattern with dart areas and seam allowances cut away. It is used in the **pivot** and **slash** methods of flat-pattern designing.

The sloper for the personal pattern is a cardboard copy of a commercial basic pattern that has been altered to fit. Half-scale and fourth-scale slopers to be used for practice work are provided in Appendix A. These slopers are exact reductions of a size 14 commercial basic pattern. (*Remember that all measurements given in this book are for full size.*)

Slopers do not have seam allowances, and the darts are cut away (see Figure 2.12). Do *not* use the curved lines of the

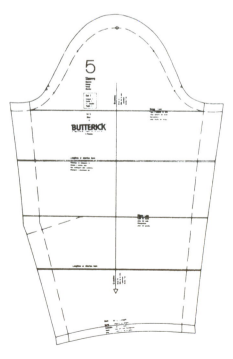

Figure 2.10 Basic sleeve.

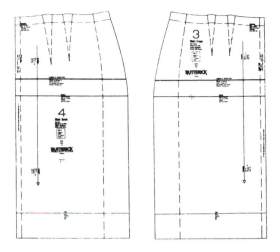

Figure 2.11 Basic skirt. (Courtesy of Butterick Company, Inc., 161 Avenue of the Americas, New York, NY 10013.)

waist-fitting dart. Instead, draw straight lines, as shown in Figure 2.13, because curved lines cannot be folded, and folding is a necessary part of the flat-pattern process. This applies to skirt darts also. The tracing wheel method for making a sloper follows.

Directions .

1. Use a commercial pattern that has been altered to fit.
2. Press out all the wrinkles in the tissue paper.

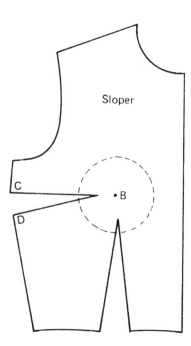

Figure 2.12 Bodice front sloper.

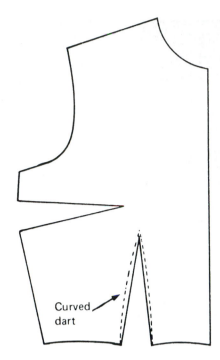

Figure 2.13 Straightening curved darts.

3. Thumbtack the commercial pattern (or fasten it with paper clips) to a piece of flexible cardboard, such as oak tag.
4. Trace all sewing lines and dart lines with a tracing wheel. Cut out the sloper by cutting along the tracing wheel marks. Cut away dart areas so you can trace dart lines when designing.

An alternate method of making a sloper is to place a piece of semitransparent paper over the commercial pattern. With a pencil, trace the seamlines and dart lines. Paste the tracing to oak tag, and cut out the sloper.

. .

DESIGN ANALYSIS

Design analysis consists of examining a picture or sketch to determine how the fitting darts have been used. Figures 2.14 and 2.15 show the **bust-fitting dart** and the **waist-fitting dart** of the bodice.

When a new design is created, the two fitting darts can be moved to other positions, combined in one dart, or converted to seams or gathers.

The job of the analyzer is to explain what has happened to these two fitting darts. Remember:

Both basic fitting darts must be accounted for. If the analysis is wrong, the pattern will be wrong.

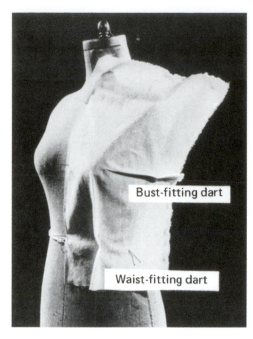

Figure 2.14 Bust-fitting and waist-fitting darts.

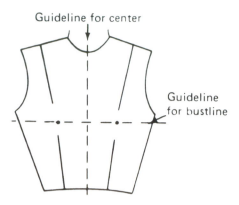

Figure 2.16 New design with guidelines shown.

- Is it still used as a dart, or has it been converted to a dart equivalent, such as gathers?
- Has it been released to create a loose or boxy look, as in some jackets?
- Does the amount of gathering seem to equal one dart or more than one?

USE OF THE MUSLIN SHELL IN DESIGNING

The **muslin shell** is an unfinished garment made from the commercial basic pattern. It can be an asset in flat-pattern work when you are trying to decide where to locate the design lines. These lines must be scaled to the size of the individual if the pattern is to be becoming.

Directions

1. Put the muslin shell on the person, and while standing in front of a mirror, place a row of pins to mark the proposed position of the design line. (Figures 2.17 and

Directions

1. Prepare the sketch by drawing guidelines to mark the center front and the bustline. In Figure 2.16, the bust-fitting dart has been moved to the shoulder. Guidelines have been drawn on the design to help you in the analysis. (Guidelines make it easy to compare the position and the spacing of lines in the new design with those of the basic design.)
2. Ask yourself these questions about the bust-fitting dart, and then ask the same questions about the waist-fitting dart.
 - Has it been moved?
 - If so, where is it now located?

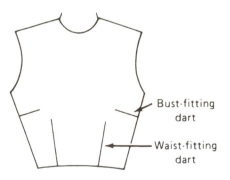

Figure 2.15 Sketch of basic bodice.

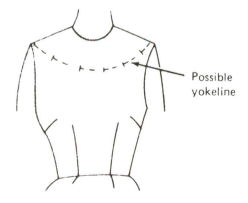

Figure 2.17 Pin line on muslin shell marks possible yokeline.

Figure 2.18 Try out yokeline with pins or cord.

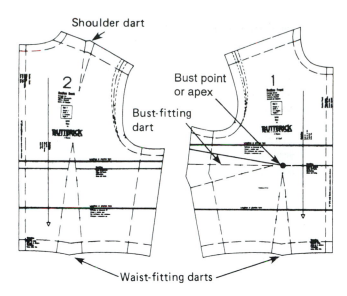

Figure 2.19 Bodice fitting darts. (Courtesy of Butterick Company, Inc., 161 Avenue of the Americas, New York, NY 10013.)

2.18 show pins marking possible yokelines.) Move the pins until a satisfactory line has been achieved.

2. Measure the distance from the row of pins to the various seamlines, then draw the line on the personal basic pattern.

3. If the design line is to be in the back, have someone assist you if you are working on a pattern for yourself. Asking the opinions of others on the becomingness of the line is often helpful.

..

UNDERSTANDING DARTS

Anyone who is involved in the use of patterns or in the making of patterns should have a thorough understanding of the function of darts and how darts are used to create designs.

A few darts are decorative only, but most are *fitting darts*. *Fitting darts* are triangular folds in the cloth that make the flat fabric fit the curves of the body. The fitting darts and bust point, or apex, of the bodice are shown in Figure 2.19. Fitting darts are decorative, as well as functional.

Dart Rules..

1. *Fitting darts point toward the bust point and, for certain design effects, may point into the bust circle.*
2. *Fitting darts must not point outside the bust circle.*
3. *Decorative darts point outside the bust circle and do no fitting. The dart angle must be very small so no bulge is created.*
4. *The length of a fitting dart is determined by the distance from the seam of origin to the bust circle or the bust point or apex.*
5. *Fitting darts end on or within the bust circle.*
6. *All fitting darts must extend to the bust circle. This is the minimum length.*

7. *A fitting dart may not extend beyond the bust point or apex. This is the maximum length.*
8. *Both sides (i.e., lines) of a dart must be the same length.*
9. *If one dart has a larger angle than another, the dart with the larger angle should extend farther into the bust area.*
10. *If both fitting darts are of almost equal size and originate in different seamlines, both darts will end at or slightly within the bust circle.*
11. *If all of the fitting is accomplished by two darts in the same seamline, both darts extend almost to the bust point or apex.*
12. *A combined bust-fitting dart and waist-fitting dart should extend almost to the bust point or apex, because the large bulge created by this dart fits better if it goes close to this point.*
13. *If two fitting darts in different seamlines are lengthened to the bust point or apex, the darts will take up some of the normal ease, and the garment will fit more snugly.*
14. *When two darts originate in the same seamline, both darts cannot point to the bust point or apex. The dart tips may be equidistant from the bust point or apex, or one tip may point to the bust point or apex and the other may point into the bust circle.*
15. *Vertical darts originate in horizontal seamlines. Make the first crease on the dart line nearest the center front or center back line. Vertical darts fold toward the center on the inside of the pattern or garment.*
16. *Horizontal darts originate in vertical seamlines. Make the first crease on the lower line. Horizontal darts fold down on the inside of the pattern.*

17. *Fitting darts may also be decorative and, for decorative purposes, can be folded as indicated by the design.*

18. *The shape of the wide end of a dart is determined as excess paper is cut from the pattern along the seamline once the dart is folded.*

19. *A waist-fitting dart can be released for added fullness. A bust-fitting dart coming out of the side seam should not be released for added fullness because the front side seam will be longer than the back side seam.*

20. *A horizontal line should meet a vertical line at right angles. Examples are center front neckline and center front waistline.*

...

DART SIZE, LENGTH, AND SHAPE

Determining Dart Size

The size of the dart is measured by the angle at the tip. The larger the body curve, the larger the fitting dart must be. As the angle becomes larger, the bulge made by the dart also becomes larger. Figure 2.20 shows two bodice front patterns. In each, the fitting darts are combined in one dart. Circles drawn around the tip of the dart mark off the same radius. The part of the dart within each circle is the same angle size, so we see that dart length is *not* a factor in angle size. (Dart A is almost twice as long as B, yet the angle size is the same.) In other words, short darts are not necessarily small darts!

Determining Dart Length

Darts must be long enough to reach to the bust circle, and they may be lengthened to reach to the bust point or apex

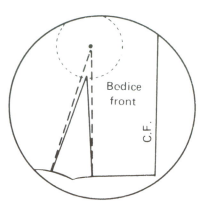

Figure 2.21 Lengthening the dart.

(Figure 2.21). If a dart is lengthened to the bust point, it takes up some of the ease that is normally allowed and makes the garment fit more snugly.

Rules ...

1. *All fitting darts of the bodice front must extend the minimum dart length from seamline to bust circle.*

2. *Fitting darts of the bodice front may not extend beyond the bust point or apex. This is the maximum dart length.*

...

Determining Dart Shape

Dart lines may be either straight or curved, depending on the shape of the body. Straight lines are easier to sew.

Straight-line darts are used for most flat-pattern work because paper cannot be folded around a curve. The folding of darts is an essential part of the pattern-making procedure.

Waist-fitting darts of the bodice front have an **outward** (convex) curve, which makes the garment fit more snugly under the bust (Figure 2.22).

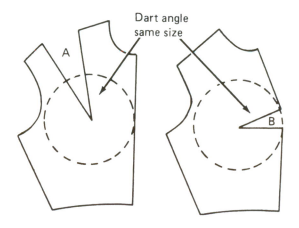

Figure 2.20 Dart size does not depend on length.

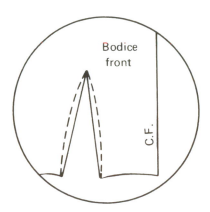

Figure 2.22 Dart with outward curves.

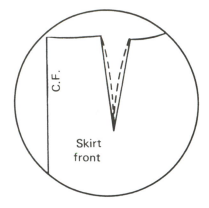

Figure 2.23 Dart with inward curves.

The waist-fitting darts of the skirt front have an **inward** (concave) curve, which gives more room for a rounded stomach (Figure 2.23).

Drawing the Dart End

Figures 2.24, 2.25, and 2.26 illustrate how to draw the wide end of the dart.

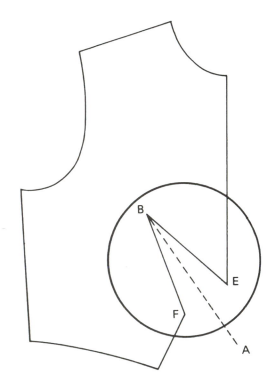

Figure 2.24 Marking the middle of the dart.

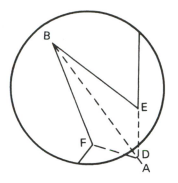

Figure 2.25 Drawing the dart to fold down.

Figure 2.26 Drawing the dart to fold up.

Directions ...

1. Draw a line marking the middle of the dart (line *BA* in Figure 2.24).
2. If the dart is to fold down (Figure 2.25), draw line *ED* to meet middle line *BA*, then draw line *FD*.
3. If the dart is to fold up (Figure 2.26), draw line *FD* to meet middle line *BA*, then draw line *DE*.

...

These directions can be applied to drawing darts in other locations as well.

Pressing Darts

Pressing can enhance (or ruin) a good dart. Figures 2.27 and 2.28 illustrate two ways to press a dart to preserve its bulge.

If you have a pressing pad, place the dart on the pad and allow the remainder of the garment to hang over the edge of the pad (Figure 2.27).

A pressing pad is not, however, necessary. Hold the bodice as shown in Figure 2.28, with the dart on the ironing board and the remainder of the bodice held up to pre-

Figure 2.27 Using a pressing pad or tailor's ham.

Figure 2.28 Pressing the dart without a pressing pad.

serve the dart bulge, or let the remainder of the bodice hang over the end of the ironing board.

PATTERN MAKING WITH DARTS

Darts are a designer's greatest asset. They can be used in the following ways to create many designs:

1. Darts can be moved from one seamline to another.

2. Smaller darts can be combined into one larger dart.

3. Darts can be divided into two or more smaller darts.

4. Darts can be converted into gathers or seamlines.

5. Darts can be converted to flare in skirts.

6. Waist-fitting darts can be released to make boxy jackets or tent dresses.

7. When working with woven fabrics, however, a *bust* dart *cannot* be eliminated.

FOLDING DARTS

The act of folding darts is repeated many times in flat-pattern work, so learn to do it quickly and efficiently.

Rules .

1. *Vertical darts fold toward the center front (or back).*
2. *Horizontal darts fold down.*
3. *Vertical darts originate in horizontal seamlines. Make the first crease on the line nearer the center front or center back.*
4. *Horizontal darts originate in vertical seamlines. Make the first crease on the lower line of the dart.*
5. *Fold decorative darts according to the design effect to be achieved.*

Directions .

1. Hold the pattern as shown in Figure 2.29 and crease each dart through its tip. (See Rule 3.)

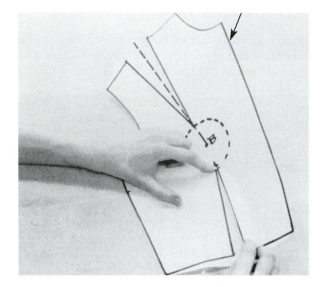

Figure 2.29 Folding the waistline dart.

2. Now lay the pattern flat on the table and place the forefinger of one hand in the tip of the dart (Figure 2.30). Pick up the creased line closest to the center front with the other hand and bring both dart lines together. Crease again.

3. The opposite side of the pattern will curl up off the table, so be sure that neither hand interferes with this shaping of the pattern. Reverse the position of the hands and fold the other dart.

4. True any curved lines by sketching a smooth curve, and true straight lines by drawing them with a ruler.

5. Cut off excess paper while the darts are folded. This determines the shape of the wide end of the dart.

Figure 2.30 Make the first crease on the line nearer the center and bring it to the second dart line.

6. Unfold the darts. The pattern must be *completely flat* when it is finished.

..

LABELING THE PATTERN

Label the following items on the pattern as shown in Figure 2.31.

- Bust point or apex (B)
- Center front (C.F.)
- Fold line (∴)
- Notches* (——▲—) or (——⊥—)
- Lengthwise grainline (↕ or ↱|) at center back (C.B.) or C.F. fold
- Name of pattern piece
- Name of person and date
- Gathers (•———•) or (X———X)
- Size
- Pleats |——→|
- Top stitching _ _ _ _ _ _
- (Do not use ∦∦∦∦∦)
- Cut 1 or Cut 2

...............

*Notches may be omitted in practice work unless there are two pattern pieces and notches are needed to show how to join them together.

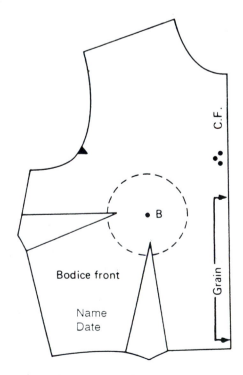

Figure 2.31 Labeling the pattern.

ADDING SEAM ALLOWANCES

All flat patterns are made without seam allowances. Seams are added after the patterns are made. Seam allowances on commercial patterns measure ⅝ in. (1.6 cm), but because much fitting is done at the side seamlines (and for the zipper in the center back) plan to leave a 1-in. (2.5-cm) allowance on these seams. Trim to ⅝ in. (1.6 cm) after fitting the garment. In the clothing industry, the seam allowance is ⅜ in. (1.0 cm.) to save fabric.

Students learning pattern making should use one or both of the following methods for making seam allowances.

Method I Add allowances to the paper pattern. To do this, glue the pattern to another piece of paper and draw on the seam allowances and stitching lines.

Method II Add allowances on the fabric after pinning the pattern in place ready for cutting. A pencil can be used because the marks are cut away as the garment is cut out. Figure 2.32 illustrates this method.

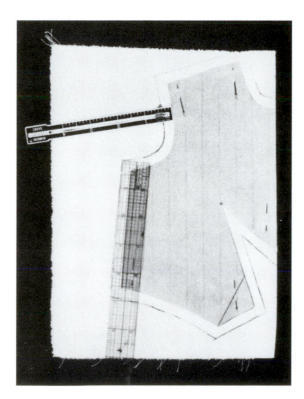

Figure 2.32 Seam allowances marked on fabric.

ACCURACY

Accuracy is very important in patternwork. Draw patterns accurately with a sharp pencil, and true the edges of each pattern. Check to see that pattern pieces that join each other are the same length. Darts, pleats, tucks, and gathers may need to be folded in before the two seamlines will match in length.

CHECK LIST FOR COMPLETING PATTERNS

When you complete each pattern, use this check list to ask yourself if you remembered to do the following things.

1. Name each pattern piece such as bodice front, bodice back, sleeve, skirt front, and so on.
2. Add all markings such as center front, center back, grainline, gathers, cut 1 or cut 2, pattern size, and notches on joining pieces.
3. Perfect or true the seamlines after folding in the darts.
4. Check to make sure joining seamlines are the same length. Never just omit horizontal bust darts because the front seam will be longer than the back seam. The bust dart can be moved to another seamline. Vertical waistline darts can be released for added fullness.
5. Almost all seams should join with right-angle corners. This prevents an inward or outward point at the seamline. Examples of right-angle seamlines are shoulder seams, underarm seams, waistline seams, crotch seams, hemlines, and so on.
6. Continue design lines onto joining pieces, for example, waist darts and seamlines in the skirt. Princess lines on the shoulder front bodice should match princess lines on the shoulder back bodice and so on.
7. For best results, keep the same amount of flare on the skirt side front and skirt side back.
8. Use correct proportions when making patterns from sketches.
9. Include a sketch with the pattern.
10. Make a pattern for each piece of the garment. Don't forget facings, collars, and cuffs.

Bodices

The two methods of moving darts are the pivot method and the slash method. Both methods are described in this chapter.

MOVING DARTS: PIVOT METHOD

Bodice Front

The bust point or apex is the focal point for dart manipulation in the bodice front. Fitting darts rotate around the bust and can be moved from one seamline to another to create different designs. To move darts by the pivot method, you will need:

- Cardboard sloper
- Sheet of paper larger than the sloper
- Pencil, thumbtack, and ruler
- Working surface to which sloper can be thumb- tacked

Locating the Bust Point or Apex

Using one of the following pivot methods, locate the bust point, or apex, and bust circle on the sloper.

Method I Draw lines through the middle of each dart, and extend these lines until they intersect. (See dashed lines in Figure 3.1.) The point of intersection is the bust point, or pivot point.

Method II Extend the line in the center of the waist- fitting dart. Extend the top line of the bust-fitting dart, or draw a line through the center of the bust-fitting dart. The point of intersection is the bust point or apex (Figure 3.2).

Drawing the Bust Circle

The bust circle encloses the area of the pattern that covers the bust. *With a compass, draw the circle around the bust*

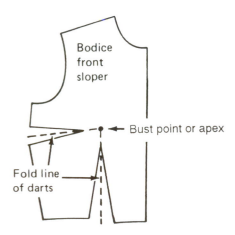

Figure 3.1 Method I: Locating the bust point or apex.

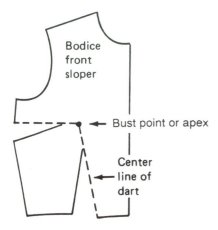

Figure 3.2 Method II: Locating the bust point or apex.

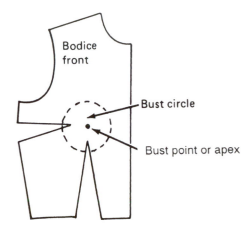

Figure 3.3 Drawing the bust circle. Use 1½ in. radius for size 8, 10, and 12. Use 2 in. radius for size 14, 16, and 18.

point. Use a radius of 1½ in. (3.8 cm) for sizes 8, 10, 12; use 2+ in. (5+ cm) for sizes 14, 16, 18 (Figure 3.3).

Moving the Bust-Fitting Dart

All of the design sketches in this unit are front views because these are easier to analyze than stylized sketches. Compare the dart locations in the basic bodice (Figure 3.4) with the dart locations in the design to be made (Figure 3.5).

To analyze the design, review the discussion on pages 18 and 19, then draw guidelines on the design (Figure 3.5) to assist in your analysis. Note that there is no underarm dart. It has been moved to the middle of the shoulder seamline.

To make the new pattern by the pivot method, read each step of the directions carefully, twice if necessary. Take one step at a time: read one step, then do that step. Enjoy a feeling of success because your pattern came out right the first time!

Figure 3.4 Basic bodice.

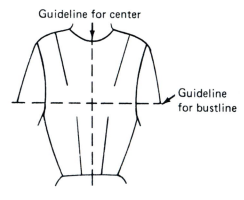

Figure 3.5 Design to be made.

Directions .

1. Thumbtack the sloper, at the bust point or apex, to a piece of paper placed on a suitable board or table.
2. Mark the location of the new dart, A in Figure 3.6, on the sloper, and label the lines of the bust-fitting dart as C and D. Label the bust point or apex B.

Figure 3.6 Trace the sloper clockwise.

Figure 3.7 Waist-fitting dart remains unchanged from original pattern.

3. Now trace from the new dart location A, *clockwise* around the sloper *toward the front* to D, which is the dart to be moved. (The arrows in Figure 3.6 indicate the tracing.) If the sloper is lifted off at this time, the portion that has been traced will resemble Figure 3.7. Note that the waist-fitting dart remains in the same place. (The final pattern would be the same if the sloper were traced toward the side, but a wider piece of paper would be needed.)
4. Next, pivot the sloper as shown in Figure 3.8 so C moves down to coincide with D, thus closing the dart to be moved. The dart must be closed accurately, or there will be an error in the length of the underarm seamline and in the size of the new dart.

Figure 3.8 The dart to be moved is closed, and the pattern is traced clockwise to starting point A.

5. After pivoting, trace the rest of the sloper from C to starting point A, as indicated by the arrows in Figure 3.8. Remove the sloper. Remember that *no* part of the pattern is ever traced twice.

6. Label the pivot point as B. (This is the thumbtack hole.) Draw the bust circle as a guide for determining the length of the new dart. (See the rules section that follows.)

 The bust circle can be drawn *before* the sloper is removed if a hole the size of a lead pencil has been punched in the bust circle of the sloper. Insert a pencil lead in the hole and rotate the sloper, thus drawing the circle on the pattern as the sloper turns.

7. The space between A and A′ in the shoulder seamline is the opening at the wide end (or point of origin) for the new dart (see Figure 3.9).

8. Draw a guideline, dashed line GB in Figure 3.9, through the middle of the dart opening and extending down to the bust point or apex.

9. Mark the tip of the new dart on the guideline at a point slightly within (point E) the bust circle. The new dart is the same distance from pivot point to tip as the dart was before it was moved. (There will be no change in the way the new design fits.)

10. Draw the new dart lines AEA′ (Figure 3.10).

11. Fold the dart before cutting off any of the excess paper. True the seamline on the shoulder where the dart is folded. The wide end of the dart is shaped by cutting off the excess paper while the dart is still folded.

12. Complete the pattern with adequate labels. (See page 24.) Label the center front, fold line, and grainline of the pattern piece. Name the pattern piece, and deter-

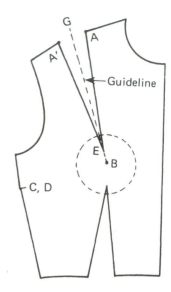

Figure 3.10 Draw dart lines.

mine the number of pieces to cut. Write this information on the pattern piece.

...

Rules ...

1. *A single bust-fitting dart ends on or slightly within the bust circle. This is the* minimum *length.*
2. *A fitting dart may not extend beyond the bust point or apex. This is the* maximum *length of the dart.*
3. *All fitting darts point toward the tip of the bust. Some exceptions occur in which a fitting dart may point away from the bust point or apex, but it may not point outside the bust circle.*

...

Bodice Back

The darts of the bodice back (Figure 3.11) have limited use in pattern designing.

 Note that the bodice back darts should *not* be combined. Each dart of the bodice back has its own pivot point because no well-defined location exists for a common **pivot point**. The pivot point is about 1½ in. (3.8 cm) away from the tip of the dart and is in line with the middle of the dart. (See Figure 3.12.)

Shoulder Dart

The shoulder dart should be kept in the upper part of the bodice back. In this area, it may be moved or converted to seamlines, such as the yokeline or princess line, or to the neckline.

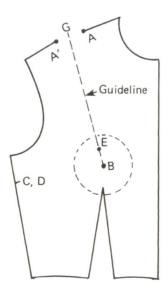

Figure 3.9 Draw guideline.

Figure 3.11 Basic bodice back.

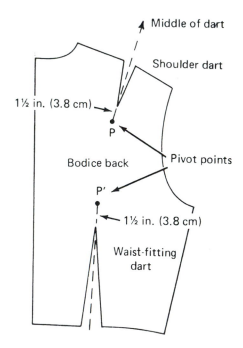

Figure 3.12 Bodice back pivot points.

The shoulder dart is usually about 3 to 3½ in. (7.6 to 8.9 cm) long.

In other patterns, no indication of a dart is given, but the shoulder seamline of the bodice back will be longer than that of the front. The directions for this pattern will say: "Ease the back shoulder seamline to the front."

Waist-Fitting Dart

The waist-fitting dart of the bodice back is usually retained at the waistline. It may be divided into two or more darts, converted to gathers, or converted to seamlines.

In length, the waist-fitting dart extends up, almost to the underarm level, but never beyond the underarm level.

Moving Bodice Back Darts

The shoulder dart of the bodice back is sometimes moved to the neckline.* This location works well for the person with a rounded back or hump. Place the neckline dart where it will not crowd the zipper or add unnecessary bulk.

Directions

1. Establish a pivot point for the shoulder dart 1½ in. (3.8 cm) below the dart tip.
2. Mark the location of the new dart on the sloper, A in Figure 3.13.
3. Begin at A and trace counterclockwise around the sloper to C, as shown by the arrows in Figure 3.13. Pivot the pattern and close the dart by bringing dart line D over to coincide with dart line C. Continue tracing from D to A (Figure 3.14). Now remove the sloper.

*The garment may be more comfortable if some of the shoulder dart is left in the shoulder and used as ease.

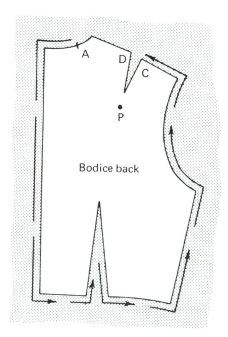

Figure 3.13 Trace sloper from A to C.

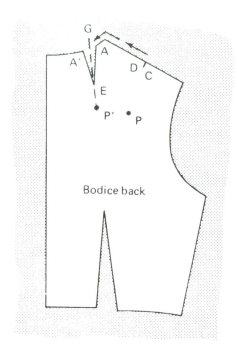

Figure 3.14 Pivot pattern, trace from D to A, draw dart.

4. Draw a guideline through the middle of the dart opening. Make it parallel to center back, or slant it slightly away from center back. The dart should be 3 to 3½ in. (7.6 to 8.9 cm) long.
5. The pivot point for the new dart will be 1½ in. (3.8 cm) below the tip. Draw dart lines AEA' (Figure 3.14), fold the dart, cut off excess paper, and complete the pattern with labels.

..

Be sure that the shape and length of the new neckline are the same as the original neckline.

COMBINING DARTS: PIVOT METHOD

The fitting darts of the bodice front can be moved to any seamline and combined there to make one large dart. This dart will be referred to as a **combined dart.**

Analyze the design in Figure 3.15. Both fitting darts have been moved to the shoulder and combined to make one large shoulder dart. Note that a combined dart such as this extends almost to the bust point or apex.

Directions ...

1. Mark the location of the new dart A on the edge of the sloper (Figure 3.16).
2. Thumbtack the sloper to a piece of paper on a suitable surface.

Figure 3.15 Design with darts combined at shoulder.

3. Trace toward the front (Figure 3.16), from point A to waist-fitting dart E. (This part of the pattern is unchanged from the original sloper.) Next, pivot the sloper to close the waist-fitting dart.
4. With the dart closed, trace to the bust-fitting dart at D (Figure 3.17).
5. Pivot the sloper again to close the bust-fitting dart, then trace to point A (Figure 3.18). Remove the sloper.
6. There is now a large opening in the shoulder for the combined dart. This is a large dart; in the full-scale pattern it should extend to within about ½ in. (1.3 cm) of the bust point or apex. Draw guideline GB from the middle of the dart opening to the bust point B (Figure 3.19).
7. Draw dart line AEA'. Fold the dart according to the rules on page 23.
8. Shape the wide end of the dart by cutting off excess paper while the dart is folded.

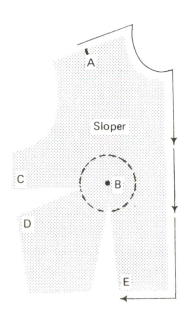

Figure 3.16 Trace around sloper toward front.

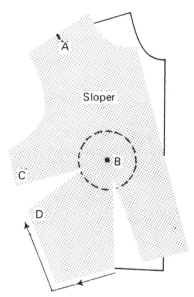

Figure 3.17 First pivot closes waist-fitting dart.

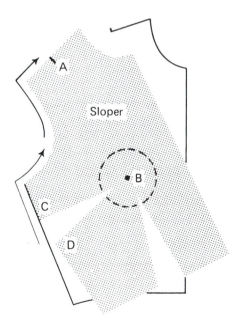

Figure 3.18 Second pivot closes bust-fitting dart.

9. Complete the pattern with adequate labels. (See page 24.)

. .

Two special types of combined dart, the French dart and the English dart, are discussed next.

The French Dart

The **French dart** is a combined dart that originates low in the underarm seamline. It is a flattering design for many

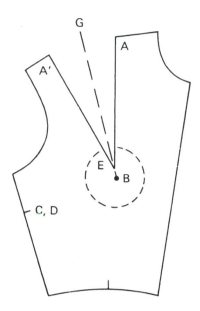

Figure 3.19 The combined dart.

and is especially suited to the figure with a low bust (Figure 3.20).

Directions .

1. Starting at the bust-fitting dart, first trace around the sloper to the armhole and then around to the waist-fitting dart. Pivot the sloper to close the waist-fitting dart, and trace from there to point A (Figure 3.21).
2. Return the sloper to its starting position. Close the bust-fitting dart, and trace from there down to point A'.

. .

The French dart is basically a horizontal dart because it originates in a vertical seamline. When folding the dart, therefore, crease it first on the lower line. For design pur-

Figure 3.20 The French dart.

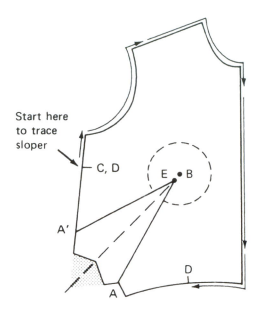

Figure 3.21 Folded as a basic dart.

poses, however, the dart may be folded the other way. It may also be converted to a seamline.

Rules

1. *When a dart originates diagonally from a seamline, the wide end of the dart will have a long, sharp point. (See shaded area, Figure 3.21.)*
2. *If a dart folds across an adjacent seamline, some of the excess dart point will be cut away.*
3. *The shape of the wide end of a dart is determined by the angle it makes with the seamline from which it originates, that is, right angle or diagonal.*

The English Dart

The **English dart** is a combined dart and partial yoke design (Figure 3.22). In this design, line *BE* represents the fitting dart because it points toward the bust point or apex. Extend line *BE* down to the waistline with a dashed line and arrow as shown. Point A on the waistline is the point of origin of the dart.

Line *DE* is the partial yokeline, which accomplishes no fitting because it is *not* directed toward the bust point or apex.

Directions

1. Use the sloper and start at the waist-fitting dart, which does not need to be moved.
2. Trace to the front edge, up the front, and around to the bust-fitting dart. Close this dart, then trace to the

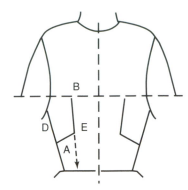

Figure 3.22 The English dart—dashed line and arrow show dart origin.

waist-fitting dart. Both darts are now combined at the waistline.
3. Fold the dart on the side line as shown in Figure 3.23. Sketch the partial yokeline *DE*. Do *not* unfold the dart.
4. Slash from *D* to *E*. This will cut through the fold of the dart, and the upper end can then be opened as in Figure 3.24.
5. Tape the lower part of the dart shut. (It will no longer be used.) The dashed lines in Figure 3.24 show where seam allowances should be added in the yoke area.
6. After closing the waistline dart, blend the waistline seam into a smooth curve to avoid a point at the waistline dart.

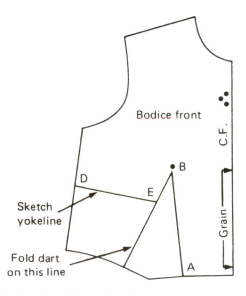

Figure 3.23 Combining the darts.

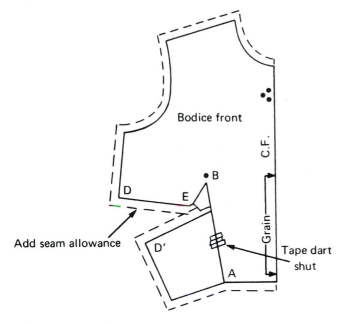

Figure 3.24 The pattern after cutting along line *DE*.

Sewing Suggestion

Sew dart point *EB* first, then sew line *ED*.

..

DIVIDING DARTS: PIVOT METHOD

One or both fitting darts of the bodice can be moved to another seamline and divided into two or more darts there.

Divided Darts that Are Parallel

Directions are given here for creating shoulder darts that are parallel to each other.

Directions

1. Study the design in Figure 3.25. The bust-fitting dart has been moved to the shoulder and divided into two darts there.
2. Mark points A and A' on sloper as the location of the two new darts (Figure 3.26).
3. Thumbtack the sloper to a large piece of paper on a suitable surface. The bust-fitting dart is the dart to be moved, so make a mark *F* at the middle of the bust-fitting dart as a guide for closing half of the dart at a time.

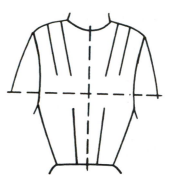

Figure 3.25 Parallel shoulder darts.

4. Now trace from A toward the front and around to D (Figure 3.26). Next, pivot the sloper to bring C down to *F,* thus closing one-half of the dart.
5. While the dart is closed halfway, trace between A and A'. There will now be an opening in the shoulder seam for the first of the two darts (Figure 3.27).
6. Pivot the sloper again to close the remainder of the bust-fitting dart, and trace from CD to A. This makes an opening in the shoulder seamline for the second dart (Figure 3.28).
7. Remove the sloper. You are now ready to design the two new shoulder darts. Draw guideline GB from the middle of line AA' to the bust point or apex (Figure 3.29).
8. Locate the new darts as follows (Figure 3.30):

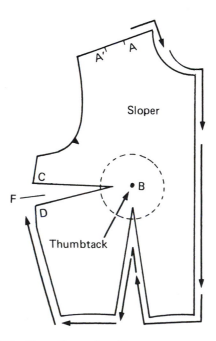

Figure 3.26 Trace from *A* to *D*.

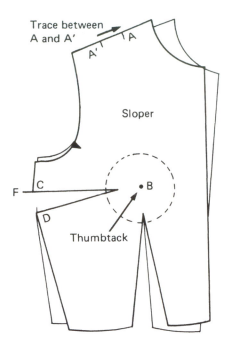

Figure 3.27 Pivot the sloper, and close half of the bust-fitting dart.

Place points E and E' on or slightly within the bust circle.*

.

*Two (or more) darts that represent *only one* of the basic fitting darts will end on or within the bust circle.

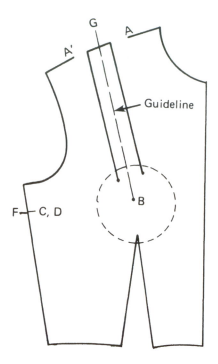

Figure 3.29 Draw guidelines, and draw adjacent dart lines parallel.

Space points E and E' so the two inner lines (AE and A'E') will be *parallel* to the guideline and to each other.

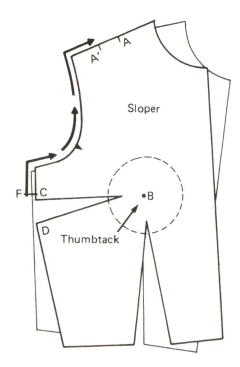

Figure 3.28 Finish tracing the sloper.

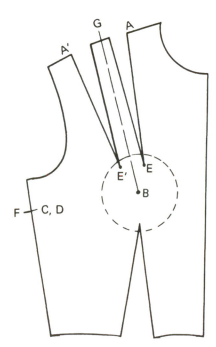

Figure 3.30 Complete the darts.

9. Draw the new dart lines, and complete the pattern.
10. If you want to change the darts to shorter tucks, measure approximately 3 in. (7.6 cm) from the shoulder seam on both darts, and end your stitching lines at that point.

DARTS THAT FAN OUT

Divided Darts That Fan Out

Study the design in Figure 3.31. The bust-fitting dart has been divided to make two darts at the neckline. Be careful about the spacing! Remember that the pattern is for half the bodice front, so the distance on the neckline from A to the center front edge is only one-half the space between the two center darts.

Directions

1. Use directions 1 through 7 from page 34, but apply them to the neckline dart design.
2. Locate points E and E' on the bust circle, because the two neckline darts represent only *one* of the basic darts. The space between point E and the center edge should be about one-half of the space between E and E'.
3. Complete the darts and the pattern.

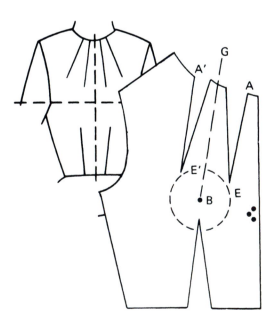

Figure 3.31 Bust-fitting dart moved to neckline and divided.

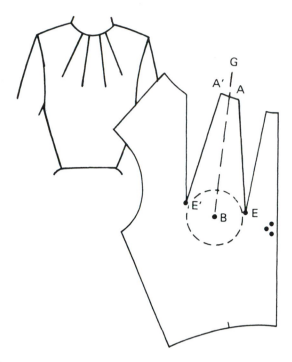

Figure 3.32 Both bust-fitting and waist-fitting darts moved to neckline.

Combined Darts That Fan Out

Directions

1. Both waist-fitting and bust-fitting darts can be moved to the neckline (Figure 3.32). Remember that the space between the center dart and the center edge of the pattern (at both the wide end and tip of the dart) will be one-half as much as the space between the two darts.
2. The length of the darts will be the same as the length of a single combined dart.

 When all of the fitting is done by darts that originate in the same seamline, these darts will be comparable in length to a combined dart.

3. Draw the darts, and complete the pattern.

MOVING DARTS: SLASH METHOD

Use a paper pattern without seam allowances and with the darts retained. It can be a copy of the personal pattern or of a sloper. (The slash method is very efficient for making design changes directly on commercial patterns.) The

slash method is the main method used in the apparel industry.

Bodice Front

Locate the pivot point and the bust circle.

> **All slashes will go to, but not through, the bust point or apex.**

Directions .

1. Study the designs in Figure 3.33, and decide which dart (or darts) of the basic pattern must be moved to make the shoulder dart shown in Figure 3.33b.
2. Decide on the exact location of the new dart. Is it to be in the middle of the shoulder seamline? Is it closer to the armhole, or is it closer to the neckline? Mark its position by drawing a line *AB* to represent its entire length.
3. Slash along line *AB* of the new dart and along line *DB* of the dart to be moved (Figure 3.34). Slash along the **lower line** of horizontal darts and along the line that is **nearer center front** for vertical darts. This corresponds with the rules for folding darts.
4. Close the dart by lapping *D* over the dart space to meet *C*. Be sure that the dart closes exactly at the seamline, and do not worry about the rest of the dart line.
5. There is an opening for the new dart at *ABA'* (Figure 3.35). To fill the opening, tape the pattern to a piece of paper (Figure 3.36).
6. Draw guideline *GB* through the middle of the opening. Review rules for dart location on pages 20 and 21. Now locate the tip of the new dart, point *E*, on line *GB* at (or slightly within) the bust circle.

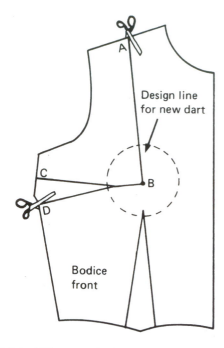

Figure 3.34 Where to slash.

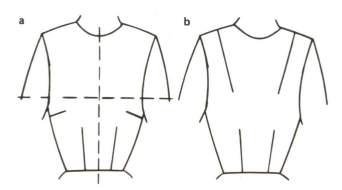

Figure 3.33 (a) Basic bodice and (b) shoulder dart design.

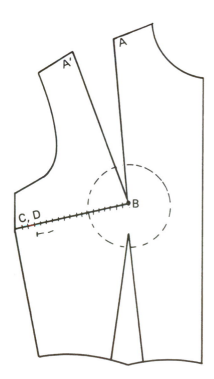

Figure 3.35 Close the bust-fitting dart.

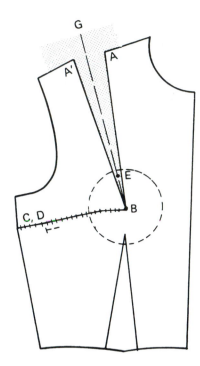

Figure 3.36 Add paper to fill dart opening, and draw guideline.

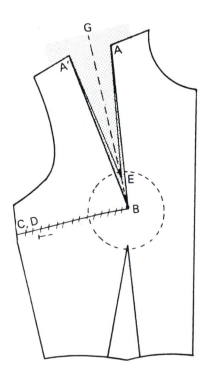

Figure 3.37 Draw new dart.

7. Draw the lines of the new dart *AEA'* (Figure 3.37).
8. Fold the new dart. True the seamline by cutting the shoulder seamline across the new dart. Label:
 - Center front
 - Fold line
 - Grainline
 - Name of pattern piece
 - Number of each pattern piece to cut

Bodice Back

The shoulder dart is the dart most often used when creating new designs for the bodice back. The waist-fitting dart may be divided in two or converted to gathers or seamlines, but it usually is *not* moved to another seamline.

Directions

Move the back shoulder dart to the neckline by the slash method as follows:

1. Use a paper pattern. Locate the pivot point 1½ in. (3.8 cm) away from the tip of the dart and in line with the middle of the dart.
2. Draw a line indicating the entire length *AE* of the new dart. The new dart is the same length as the old dart, about 3 to 3½ in. (7.6 to 8.9 cm) long. The middle of the dart is parallel to center back, or it can slant away from center back. Continue this line to the pivot point as shown by the dashed line *EP* in Figure 3.38.

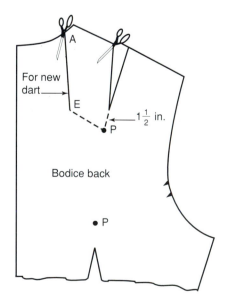

Figure 3.38 Design line for new neckline dart. The pivot point is 1½ in. (3.8 cm) below the tip of the dart.

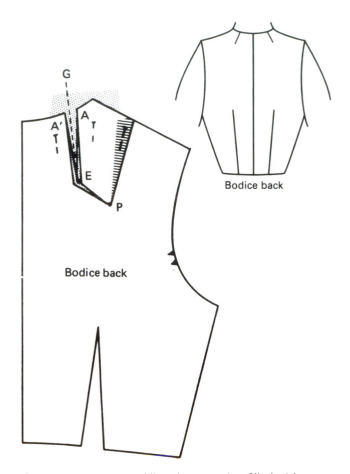

Figure 3.39 New neckline dart opening filled with paper.

3. Slash along the shoulder dart to the pivot point and also along the new dart to the pivot point.
4. Close the shoulder dart, and pin or tape the pattern to a piece of paper to fill in the new dart opening (Figure 3.39).
5. Draw a dashed line G to mark the middle of the new dart. Make the dashed line parallel to center back, or slant it away from center back for a pleasing effect.
6. Draw the lines for the new dart AEA′, making the dart about the same length as the original shoulder dart.
7. Fold the dart, true the neckline seam in a smooth curve, cut off excess paper, and label the pattern.

COMBINING DARTS: SLASH METHOD

Both darts of the bodice front may be moved to the same location and combined to make a single large dart. (See page 30 for pivot method.)

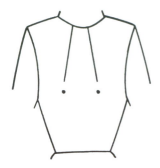

Figure 3.40 Combined dart at neckline.

All slashes go to, but not through, the bust point (or pivot point).

Directions .

1. Study Figure 3.40, then design a line for the new combined dart. Slash along this line (AE in Figure 3.41), and slash also along one side of the two fitting darts.
2. Close the two fitting darts, and tape them shut. This creates an opening for the new dart at the neckline (Figure 3.42).
3. Fill the dart opening with paper, and complete the dart as directed in items 6, 7, and 8 on pages 37 and 38. (See Figure 3.43.)
. .

Remember that a combined dart must extend almost to the bust point or apex because of the large amount of

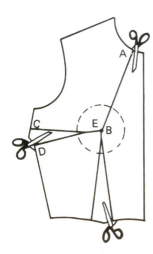

Figure 3.41 Slash to prepare for moving both fitting darts.

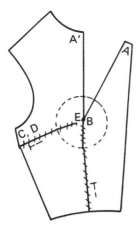

Figure 3.42 Close both fitting darts to make new dart opening at neckline.

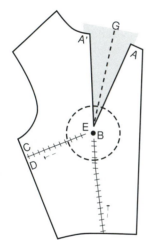

Figure 3.43 Add paper and draw dart.

fabric being controlled between the seam and dart point locations.

DIVIDING DARTS: SLASH METHOD

Study the design in Figure 3.44. Observe that the bust-fitting dart has been moved to the shoulder and made into two darts there.

Rules

1. *Darts should be designed to look well in the space they occupy.*
2. *On the bodice front, all slashes go to, but not through, the bust point or apex.*

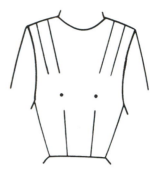

Figure 3.44 Design to be made.

3. *When a dart is closed accurately, the seamline retains its correct length, and the size of the new dart equals the original dart size.*
4. *A combined dart must extend almost to the bust point.*

Directions

1. Draw lines to indicate the location of the two new darts. For shoulder darts, make the lines parallel and centered over the bust point or apex.
2. Slash along the lower line of the bust-fitting dart and along both new dart lines (Figure 3.45).

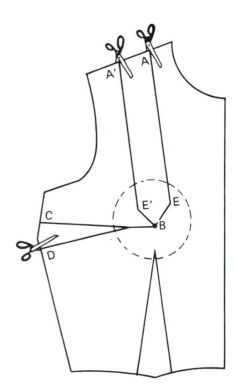

Figure 3.45 Move bust-fitting dart to shoulder, and divide it into two darts.

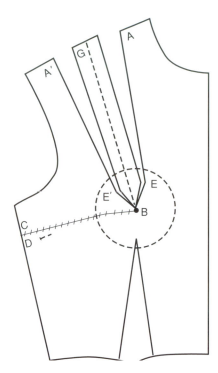

Figure 3.46 Close bust-fitting dart to create new shoulder darts.

3. Close the bust-fitting dart by lapping the lower line of the dart over the dart space (Figure 3.46).
4. Make the new darts equal in size by adjusting the part of the pattern between the two darts.
5. Fill the new dart openings with paper, and draw the new darts. Fold and cut off excess paper to true the seamline (Figure 3.47).

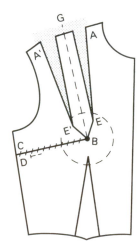

Figure 3.47 Add paper and complete new shoulder darts.

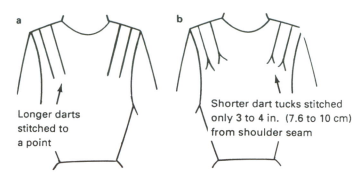

Figure 3.48 All fitting darts are moved to shoulder and divided into two darts there: (a) darts sewn to a point and (b) dart tucks sewn only part of the way from the shoulder seam.

6. Complete the pattern with proper labeling.

. .

Combined-Divided Darts: Slash Method

Both darts can be moved to the same seamline and divided into two darts there (Figure 3.48). These two designs show fully stitched and partially stitched darts, respectively.

Figures 3.49, 3.50, and 3.51 illustrate the steps in making the pattern for the combined-divided dart.

Refer to pages 45 and 46 for directions on preparing the pattern for partially stitched darts, if that design is to be made.

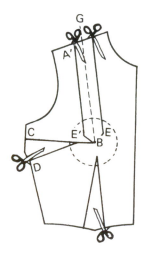

Figure 3.49 Where to slash.

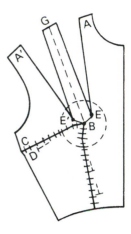

Figure 3.50 Close-fitting darts.

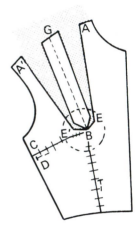

Figure 3.51 Add paper and draw new darts.

DECORATIVE DARTS: SLASH METHOD

A decorative dart, unlike a fitting dart, does *no fitting*. It does not point toward the bust. Its purpose is usually to complete a series of design lines when one or more of the lines must be directed away from the bust. Darts *D* and *D'* in Figure 3.52 are examples of decorative darts.

The **decorative dart** is always an extremely small dart because it does no bust fitting. It should never create a bulge in the garment. It is made by slashing and spreading the pattern (Figures 3.53 and 3.54) to add the tiny triangular space.

Note that the rules for fitting darts do not apply to decorative darts.

To achieve the sunburst effect of the darts in Figure 3.52, where the darts seem to be almost equidistant from one another, the center front line of the pattern must be

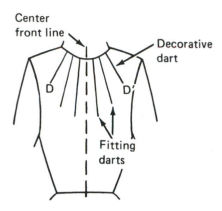

Figure 3.52 Bodice with decorative darts.

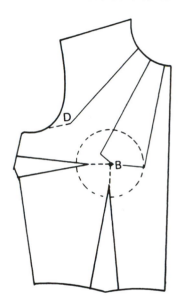

Figure 3.53 Design slash lines.

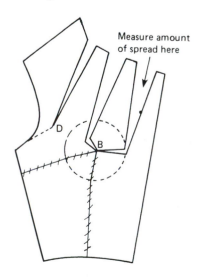

Figure 3.54 Spread pattern slightly at decorative dart, and move fitting darts to neckline.

half as far from the first dart as the darts are from each other.

Restore neckline edge if necessary.

OTHER METHODS OF MOVING DARTS

The Tracing Method

Study Figures 3.55 and 3.56, and observe that the bust-fitting dart in Figure 3.56 has been moved to a lower position in the side seam.

When a dart is to be moved to another position in the same seamline, use the sloper and trace the dart in its new position. The following method is useful for lowering the bustline in a commercial basic pattern.

Directions .

1. Thumbtack the sloper to the paper pattern at the bust point or apex (Figure 3.57). Pivot the sloper until the bust-fitting dart of the sloper is moved down to the place where the new dart should be (see arrow). Trace the dart, and remove the sloper.

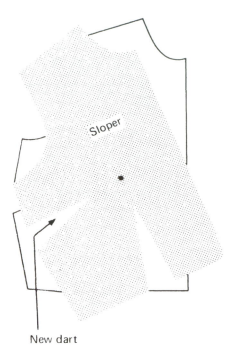

Figure 3.57 Sloper thumbtacked to basic pattern at bust point or apex.

2. Add some paper (Figure 3.58), and extend the new dart lines to the underarm seamline. Cross out the original dart. Fold the new dart on the lower line, and true the underarm seamline.

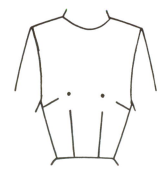

Figure 3.55 Basic underarm dart position.

Figure 3.56 Underarm dart lowered.

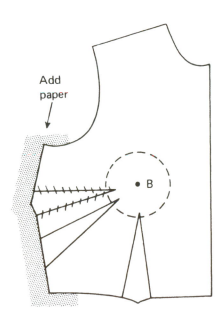

Figure 3.58 Add paper and extend new dart lines to underarm seamline.

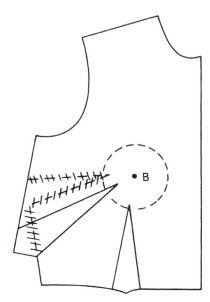

Figure 3.59 Fold in new dart, and draw new side seam.

3. Cut off excess paper to shape the dart (Figure 3.59). Note that the new dart looks larger, but that is only because it is longer. The new dart is actually the same size as the original dart. The hatched lines show the original pattern lines.

..

The Measurement Method

The measurement method is used to divide a dart when the new darts are to remain in the same seamline. This method gives you an opportunity to learn how to use a dressmaker's gauge.

Directions ...

1. The illustrations are for creating two darts at the waistline. Trace around the sloper, but *do not trace the waistline dart*. (If a commercial pattern is used, cross out the lines of the original dart. New darts should be drawn in a different color.)
2. Remove the sloper, and locate the bust point or apex and bust circle on the pattern.
3. Make a dressmaker's gauge. This is an individualized measuring device that consists of a strip of paper folded to give a firm, straight edge. Figure 3.60 shows the dressmaker's gauge.
4. Place the folded edge of the dressmaker's gauge on the dart space of the pattern as shown in Figure 3.61, and mark the total dart width on it (one mark at each side).

Figure 3.60 Dressmaker's gauge.

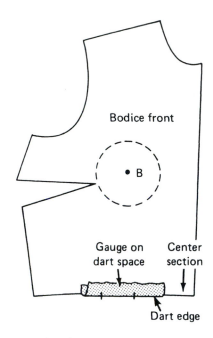

Figure 3.61 Using the gauge.

5. Fold the dressmaker's gauge to divide the dart space in half, and mark this point. One half will be used for each dart (Figure 3.62).
6. Mark openings for two new darts on the waistline. Keep the center section of the waistline unchanged so it will still match the skirt. The space between the darts should be about 1 in. (2.54 cm). Darts will not be parallel. A small side dart may end below the bust circle and is thus an exception to the rule that a dart must end on or within the bust circle.
7. Draw guidelines* for the darts, then draw the dart lines (Figure 3.63).
8. Complete the darts by standard flat-pattern methods.

..

*The side dart need not reach the bust circle (exception to the rule).

Figure 3.62 Mark fold at center of original dart space.

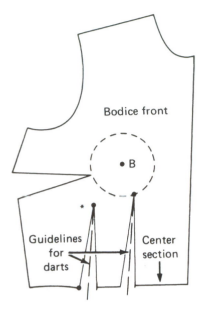

Figure 3.63 Two darts at waistline.

RELEASED DARTS

Dart designs that are open-ended, unstitched, or fully released are easy to make. The patternwork for open-ended and unstitched darts is the same.

Directions .

1. Move the dart to the desired position first.
2. Fold the dart.
3. Mark the end of the stitching line.
4. Cross off the rest of the dart.
5. Unfold the dart. Label for stitching.

. .

These darts are sometimes incorrectly called "tucks" or "pleats." If the open-ended dart is placed beside the arm-hole seam, it is called a **Gibson pleat.** It need not point toward the bust because it is shortened and has no dart tip to create a bulge (Figures 3.64 and 3.65).

The Gibson pleat is a good design for the person with a large bust if width is added to the pattern at the bustline by slashing and spreading the pattern as shown in Figure 3.66.

Sewing Suggestion .
Unstitched darts should be closed by a basting thread as the garment is being constructed. After the seamline from which the dart originates has been stay-stitched to hold the end of the dart or has been permanently stitched, the bast-ing can be removed.

. .

Figure 3.64 The Gibson pleat.

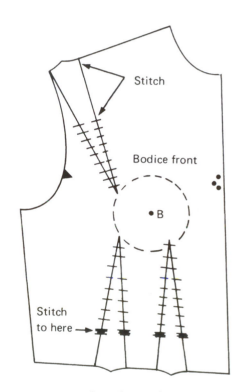

Figure 3.65 Pattern for Gibson pleat.

Trouser pleats are examples of unstitched darts. The waist-fitting darts in Figure 3.64 are another example.

Fully Released Waistline Darts

A fully released dart can be recognized by the straightness of the silhouette at the waistline. No lines or other evi-dence of a dart are present.

The fully released dart is part of the design of jackets, overblouses, and sheath-style dresses.

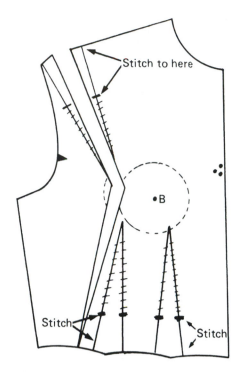

Figure 3.66 Adding width for large bust.

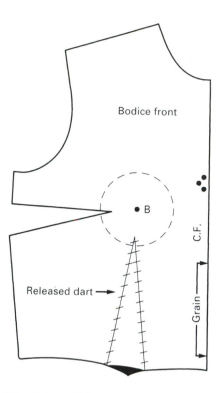

Figure 3.67 Released dart.

To show a released dart in the pattern, cross off the lines of the dart, as pictured in Figure 3.67, to indicate that the dart will no longer be used.

Note that the bust-fitting dart in Figure 3.67 remains unchanged, but the waist-fitting dart is released for added fullness.

The bust-fitting dart could be moved to the shoulder or moved to the armhole. Figure 3.68 shows three designs with a released waist dart. *Do not release the front bust dart coming out of the side seam or the front seamline will be longer than the back seamline at the side seam.*

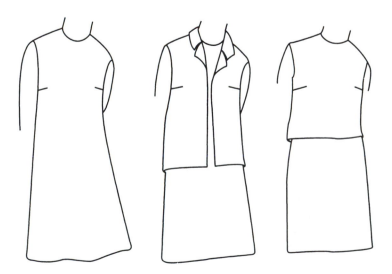

Figure 3.68 In these released dart designs, bust dart remains, but waist dart is released for added fullness.

GATHERS

A garment will have a softer, less tailored look if the darts are converted to gathers. These gathers are called dart-equivalent gathers.

Dart-equivalent gathers conform to the rules for dart location. The lines or folds of cloth point toward the bust point (or apex) or bust circle.

Not all gathers are dart equivalents. Some are made by slashing and spreading the pattern. Gathers achieved in this way are called **added-fullness gathers.** When a dart does not furnish enough gathers to achieve the desired effect, added-fullness gathers may be included with the dart-equivalent gathers. You must decide when you make an analysis if the gathers are:

- Dart-equivalent gathers only
- Added-fullness gathers only
- Dart-equivalent plus added-fullness gathers

In a photograph, gathers may be recognized as soft folds of cloth originating in a seamline (Figure 3.69). In a drawing, gathers are represented by a group of uneven lines that originate from a seamline (Figure 3.70).*

.

*Gathers in the shoulder seamline require special treatment (see page 51).

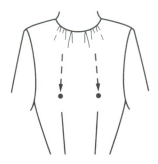

Figure 3.70 Gathers are represented by a group of uneven lines with arrows indicating the way gathers point.

Analyzing Gathers

1. Draw an arrow on the design to extend one of the center lines of the gathers to determine which way the gathers point.
2. If this arrow points toward the bust point (or apex) or bust circle, then the gathers are dart equivalents. (In Figure 3.70, the arrow points toward the bust, so these gathers are dart equivalents. The amount of gathers is so small that these cannot be added-fullness gathers.)
3. If the arrows extending from the gathered edge do *not* point toward the bust circle, the gathers are added-fullness gathers only (Figure 3.71).

Amount of Gathers Observe the quantity of gathers in the designs in Figure 3.72. Figure 3.72a shows the amount of gathers represented by one dart. Figure 3.72b represents a combined dart, and Figure 3.72c has both fitting darts and added fullness converted to gathers. In Figure 3.72c, the large amount of fullness has increased the size of the garment across the bust.

Added Fullness Only

Observe that none of the gathers in Figures 3.73 and 3.74 point toward the bust, so these gathers are *not* dart

Figure 3.69 Dart converted to gathers.

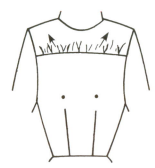

Figure 3.71 Added-fullness gathers point away from bust.

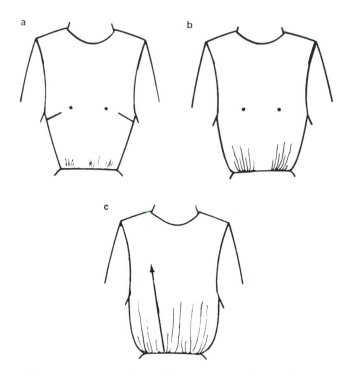

Figure 3.72 Examples of darts converted to gathers:
(a) one dart only, (b) combined darts, and (c) dart
equivalents and added fullness.

equivalents. Both fitting darts have been combined as one
large dart at the waistline.

Directions

1. To make the added-fullness gathers, slash along the
side line of the combined dart, then fold the dart under
the front section (Figure 3.73).

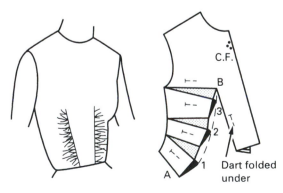

Figure 3.73 Gathers on one side of dart line; grain at
center front.

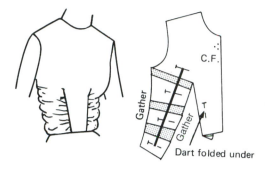

Figure 3.74 Gathers on one side of dart and on side
seam; grain at center front.

2. Slash and spread the pattern as shown, pin or tape to
paper, and complete the seamline A to B with a grad-
ual curve as shown by the dotted line. Label the pat-
tern.

3. In Figure 3.73 there will be a gradual curve from A to
B. In Figure 3.74 line A to B and the side seam will be
straighter lines because gathers are added to both sides.

Less experienced pattern makers have difficulty esti-
mating the amount of fullness to be added to gathers. The
type of fabric must be considered, for stiff fabric requires
less fullness than does soft fabric for a comparable amount
of gathers.

Table 3.1 gives the ratio of the length of the edge to be
gathered to the length of the edge to which it will be sewn.

Converting Darts to Gathers (Without Added Fullness)

Using the information given in the two preceding sections,
analyze the design in Figure 3.75, then make a pattern as
directed here.

Use this two-step procedure! When you become more
expert in pattern making, you can take shortcuts or com-
bine steps.

Table 3.1 **Amount of Fullness to Gathers (full-scale)***

Amount of Fullness	Gathered Edge	to	Ungathered Edge
Moderate	1½	to	1
Moderately full	2	to	1
Full	3	to	1

*Fullness varies depending on the weight of the fabric.

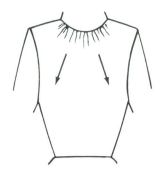

Figure 3.75 Design with neckline gathers.

Directions .

Step I

1. Move both darts to the neckline by the pivot method. Remember that a combined dart extends almost to the bust point or apex.
2. Complete this preliminary pattern.

Step II Using the pattern that you have just made (Figure 3.76), convert the neckline dart to gathers as follows:

1. Cross out the dart lines that will no longer be used. Do not erase them because they may be needed for checking pattern procedures.

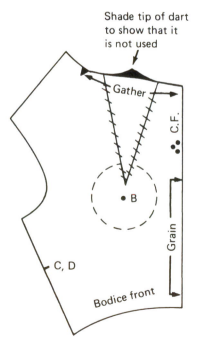

Figure 3.76 Pattern for neckline gathers.

2. Draw a smooth line that curves outward above the unused dart. Shade the tip of the dart to show that it is not used. (*Never* discard any of the original pattern. You may need it later!)
3. Mark the end of the gathers with a notch. Only one notch is needed because the gathers are distributed across the entire front of the bodice, rather than just the dart opening, to give a better appearance.
4. Complete the pattern with adequate labels.

. .

Dart Equivalents Plus Added Fullness

Fullness Added Above Bustline

The design shown in Figure 3.77 has many more gathers than the design in Figure 3.75. If the pattern for Figure 3.75 were slashed and spread to provide added fullness above the bustline, it would become the pattern in Figure 3.78.

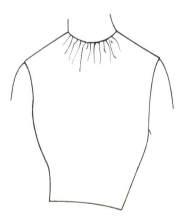

Figure 3.77 Fullness added above bustline.

Figure 3.78 Pattern with fullness added above bustline.

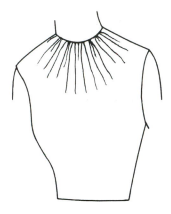

Figure 3.79 Fullness added at bustline.

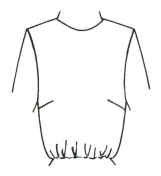

Figure 3.81 The blouson design.

The Blouson Design with Added Fullness

To create a blouson design, the bust-fitting dart may be combined with the waist-fitting dart, or it may be retained in its basic position (Figure 3.81). If the darts are combined, added fullness may be omitted.

Directions

1. Cross out the waist dart, and slash the pattern as shown in Figure 3.82. This does not increase bustline width. The underarm seamline should fall on or near straight grain.
2. Add ¼ in. (0.6 cm) (±) of length at the center front and back. True the waistline. The bodice may be lengthened at the side seam.

Some blouson designs have 1 to 3 in. (2.5 to 7.6 cm) of extra length added, depending on the desired effect. For extra fullness at the waistline, more width can be added to each side seam.

Sewing Suggestions

This bodice needs a lining to hold up the blousiness and to keep the waistline in place, or a piece of elastic may be used to hold the blousiness in place. The lining is the length of the original bodice pattern.

The blouson design looks best with a *slim* skirt. To enhance the blousiness, turn the waistline seam of the garment *up*.

The Dropped Shoulder

Unlike the other bodice darts, the shoulder dart cannot be converted to gathers at the normal shoulder seamline unless the gathers are controlled in some way to prevent

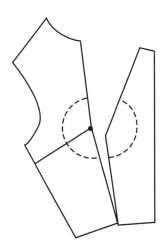

Figure 3.80 Pattern with fullness added at bustline.

Note that the armhole has become more circular in shape.

Fullness Added at Bustline

The design in Figure 3.79 shows fullness added at the bust-line. When the pattern is slashed to the waistline and spread to increase fullness at the bustline, the result is the pattern in Figure 3.80. More than one slash can be used.

Rules

1. *Slashes to add fullness must end at a seamline.*
2. *Whenever seam allowances are present, the slash must stop at the seamline, and the seam allowance must be clipped to meet the end of the slash.*

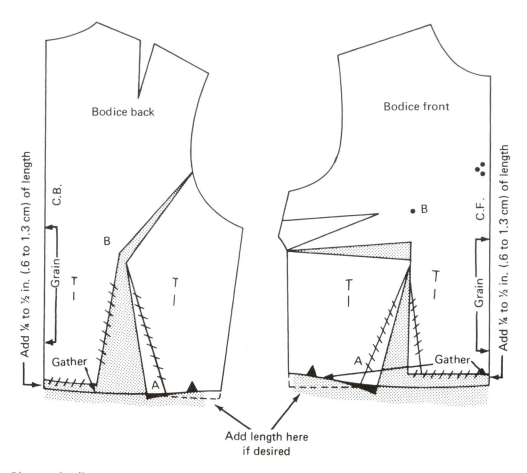

Figure 3.82 Blouson bodice pattern.

the armhole of the garment from swinging out over the arm and spoiling the drape of the sleeve.

Gathers can be controlled by shirring or by the dropped shoulder design shown in Figure 3.83.

Directions

1. Move the bust-fitting dart to the shoulder. Fold and pin. Move the back shoulder dart to the neckline.

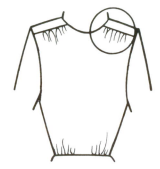

Figure 3.83 Dropped shoulder design.

2. Tape together the back and front patterns at the shoulder seamline.
3. True a new seamline AC across the folded dart to drop the shoulder seam 1½ in. (3.8 cm) (+) at the armhole and 2½ in. (6.4 cm) (+) at the neckline. Tape the fold closed above the new seamline (Figure 3.84).
4. Mark notches on the new seamline, and cut along this line to separate the back and front pattern pieces. Complete the pattern as shown in Figure 3.85. More fullness may be added if desired.

Note that the front neckline is now more shallow than the back neckline, so be careful not to confuse the back with the front!

SEAMLINES MADE FROM DARTS

Any line in a garment is a part of the total design. Lines may indicate either darts or seamlines or both.

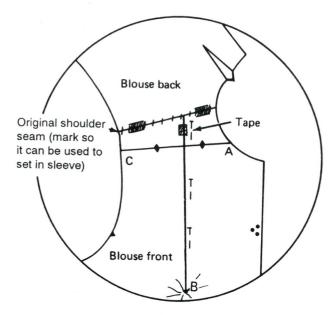

Figure 3.84 New shoulder line *CA*.

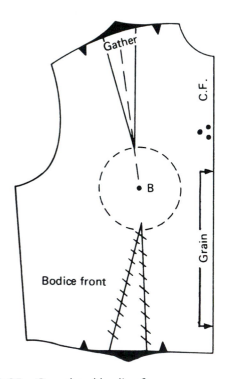

Figure 3.85 Completed bodice front pattern.

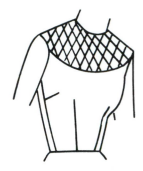

Figure 3.86 Yoke cut on bias.

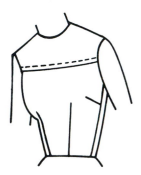

Figure 3.87 Topstitched yokeline.

Although all seamlines are design lines, some seamlines do *no fitting*. They are used for design purposes or to allow you to utilize fabric to better advantage. Figure 3.86 shows a yokeline that does no fitting but permits the yoke area to be cut on the bias for interesting texture or pattern effects. Figure 3.87 shows a topstitched yokeline.

A garment often can be cut from smaller amounts of material if certain design lines are introduced into the pattern.

Seamlines as Fitting Lines

If a seamline replaces a dart, it is a fitting line and is referred to as a **dart equivalent**.

Darts can be converted to seams by cutting away all the dart space *except* the seam allowances. This will reduce bulk in heavy fabrics or in designs in which a large dart folds down across a seamline. Figure 3.88 shows a French dart that has been converted to a seamline. The seam allowance for full-scale commercial patterns is $\frac{5}{8}$ in. (1.6 cm) and for half-scale patterns is $\frac{1}{4}$ in. (0.6 cm). The apparel industry uses $\frac{3}{8}$ in. (1 cm) seams to save fabric.

Note in Figure 3.88 that the seam allowances merge at the tip of the dart to form a fold of cloth in the garment. If the seam allowances are pressed open in the garment, the fold at the tip of the dart should be pressed open, too.

The Basic Princess Line: Bodice Front

The princess line is a vertical design line that crosses the tip of the bust.* It is a dart equivalent because it replaces

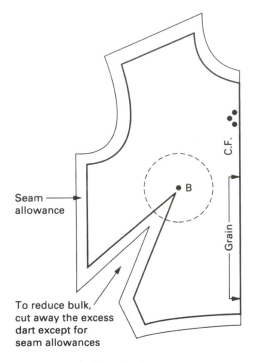

Seam allowance

To reduce bulk, cut away the excess dart except for seam allowances

C.F.

Grain

B

Figure 3.88 French dart that has been converted to a seamline with seam allowances added.

both of the fitting darts and is, therefore, a fitting line as well as a style or design line. Figure 3.89 shows the basic princess bodice in which line AB replaces the bust-fitting dart, and line BE replaces the waist-fitting dart.

Dart-equivalent seamlines can be recognized because they comply with the rules for dart location.

Rules

Dart-equivalent fitting lines must point toward the bust, extend to the bust, or cross over the bust.

* * * * * * * * * * * * * *

*The princess line is sometimes called a French dart line.

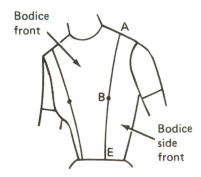

Bodice front

A

B

E

Bodice side front

Figure 3.89 The basic princess bodice is characterized by a vertical fitting design line.

B A

Figure 3.90 Curved line is *not* a fitting line; all of dart is in line AB.

Exception Not all vertical seamlines are fitting lines. The design in Figure 3.90 is an example. The vertical design line does not cross the tip of the bust. This line is actually a yokeline (or gore line) because it performs the function of a yoke (see pages 58 to 60). All of the fitting in this design is done by a combined dart at AB.

The princess seamline separates the bodice pattern into two pieces, the bodice front and the bodice side front (Figure 3.89).

Directions

1. Analyze the basic princess design in Figure 3.89. Thumbtack the sloper to a piece of paper. Trace around the sloper—moving the bust-fitting dart to the shoulder seamline. Do *not* draw in any of the dart lines. (The princess line usually has a more attractive slope if point A is located at the center of the shoulder or is out, toward the armhole.)
2. Locate the bust point or apex and draw the bust circle.
3. Draw a grainline in the side front section (Figure 3.91) parallel to the center front line.
4. *Bodice Front Pattern Piece:* Draw the *front* lines of both darts (the lines nearer the center front), and lengthen them to bust point B, or the apex. (See arrows in Figure 3.91.) This line ABE should be a smooth, well-shaped line because it is the line that determines the shape and appearance of the princess line of the finished garment.
5. *Bodice Side Front Pattern Piece:* Draw guidelines BG and BG' from the middle of the dart openings to the bust point or apex.

 Now draw dart lines A' and E' until they meet the guideline at the bust circle. (See arrows, Figure 3.92.)
6. Sketch a smooth curve across the bust point, or apex, or draw it with a French curve. (For French curve, see Appendix A.) An outward curve prevents removing necessary ease in this area.

 Use the less-rounded end of the French curve, and draw the curve across the bust point in two steps, with

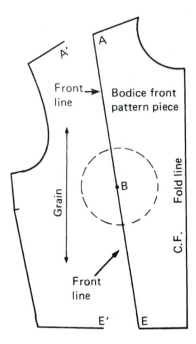

Figure 3.91 The front line.

the French curve positioned as shown in Figures 3.93 and 3.94.

7. The princess seamline of a garment is a bias line and is easily stretched, so mark three sets of notches as shown in Figure 3.95.

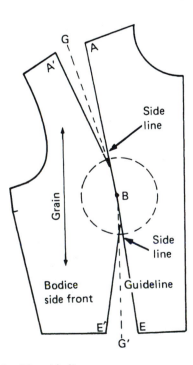

Figure 3.92 The side line.

Figure 3.93 French curve in first position.

Figure 3.94 French curve in second position.

8. Separate the pattern into two pieces by cutting along line A'BE' (Fold the dart spaces under the front pattern section. You may need them if an error occurs.)

9. Cut off the excess paper, and label the pattern pieces. Remember to add seam allowances.

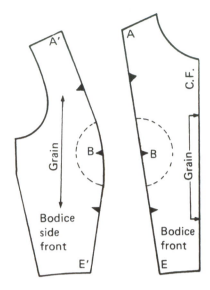

Figure 3.95 Basic princess pattern.

10. For additional ease at the bustline on the bodice front, slash from the bust point to the side seam and spread ½ in. (1.3 cm.) at the bust point. Now line A'E' is longer than line AE due to the extra ease added over the bustline on the side front pattern.

...

Practice problems are provided at the end of this chapter.

The Curved Princess Line: Bodice Front

To make this pattern, use the slash method, for paper cannot be folded around a curve and folding is an essential part of the pivot method.

Directions ...

1. Analyze the design. Observe that the bust-fitting dart has been moved to the armhole. The waist-fitting dart has not been moved (Figure 3.96).
2. Use a paper pattern. Move the bust-fitting dart to the armhole as follows:
 • Sketch the new dart line AB as a smooth curve.
 • Cut along line AB and also along the lower side of the bust-fitting dart to, but not through, the bust point or apex (Figure 3.97).
 • Close the bust-fitting dart accurately, and tape it shut.
3. Draw the waist-fitting dart line from E to B. Draw the other side of the dart as a straight line to the bust circle and then curve smoothly to the bust point.

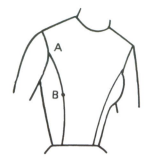

Figure 3.96 Curved princess-line design.

4. Draw a grainline for the side bodice. Make it parallel to center front. Mark matching notches.
5. Separate the pattern into two pieces by cutting from E' to B (Figure 3.98). Fold the dart space under the bodice front piece.
6. Complete the pattern with labels.

...

Designing with the Basic Princess Pattern

The basic princess pattern can be modified to make other princess-line designs. One example is shown here.

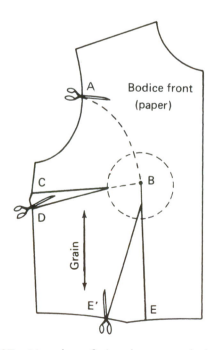

Figure 3.97 Move bust-fitting dart to armhole.

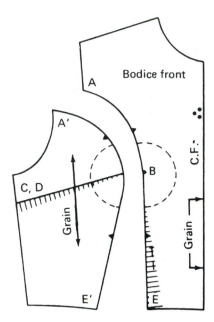

Figure 3.98 Separate two pattern pieces.

Directions .

1. Study the design in Figure 3.99. Note that the princess line follows a neckline dart position.
2. Tape the two parts of the basic princess pattern together from bust to shoulder as shown in Figure 3.100.
3. Design a new line AB from neckline to bust, mark notches, and cut along this line (Figure 3.101).
4. True a smooth line on the bodice side front if it dips inward at the bust point or apex.

. .

The Basic Princess Line: Bodice Back

The darts of the basic bodice back are usually located in a position suitable for a princess-line design. If they are not, redraw them, moving only the tip, so a smooth line can be

Figure 3.99 Design to be made.

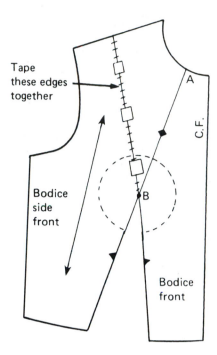

Figure 3.100 Tape pattern together at shoulder dart line.

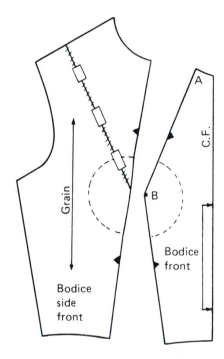

Figure 3.101 Cut pattern apart on design line.

sketched. The following directions are for the princess seamline pattern. When princess lines originate in the shoulder seamline, the princess line on the bodice back should match the location of the princess line on the bodice front.

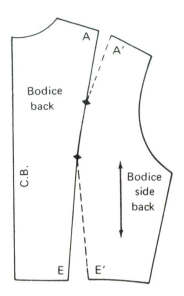

Figure 3.102 Princess seamline in bodice back.

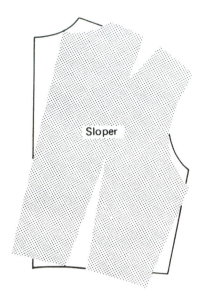

Figure 3.104 Sloper used to reposition shoulder dart.

Directions ..

Method I

1. Make a tracing of the sloper, or use a paper pattern. Connect dart lines A and E as a smooth gentle curve (Figure 3.102). Line AE forms the seamline for the center back pattern piece and determines the appearance of the princess seamline.

 Be sure line A'E' is a smooth curve also.
2. Draw the grainline for the side back pattern piece parallel to the center back line. Mark notches.

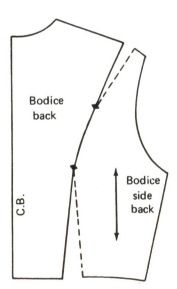

Figure 3.103 Princess seamline moved toward end of shoulder.

3. Separate the pattern pieces by cutting along line A'E'. Fold the dart spaces under the center bodice back section. (The dart spaces could be discarded, but we recommend keeping them as a safety measure.)
4. Cut off excess paper, and label the pattern.

Figure 3.103 shows a princess design with the dart moved closer to the end of the shoulder.

Method II

1. An easy way to move the dart is shown in Figure 3.104. Trace all of the sloper *except* the shoulder dart.
2. Now reposition the shoulder dart of the sloper in the new position. Trace the shoulder dart, and remove the sloper.
3. Fold the dart, and true the shoulder seamline.
4. Make the princess-line seam as you did in Method I.
..

The Curved Princess Line: Bodice Back

When the princess line of the bodice back is a curve, as shown in Figure 3.105, use the slash method and a paper pattern. (See page 55 for designing the curved princess line of the bodice front.)

Directions ..

1. Sketch a line for the new dart from point A in the armhole down to the tip of the waist-fitting dart. (You may have to move the tip of the dart to give an

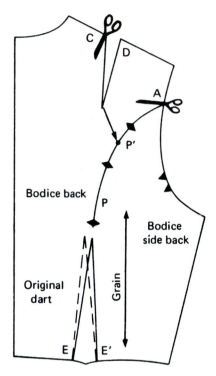

Figure 3.105 Pivot points on design line.

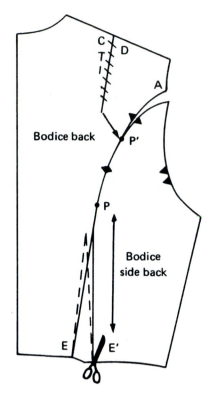

Figure 3.106 New dart space in armhole.

attractive line.) The dashed line in Figure 3.105 shows the original dart.

2. Locate a pivot point *P'* on the design line as shown in Figure 3.105. Mark matching notches.
3. Draw a grainline in the side pattern area. Make it parallel to the center back line.
4. Move the shoulder dart to the armhole by slashing from point C to *P'*. Close the shoulder dart, and the new dart space will open up in the armhole (Figure 3.106).
5. Separate the remainder of the pattern into two pieces by cutting along line *P'E'*.
6. Fold the waist-fitting dart under the bodice back pattern piece, and cut off any excess paper.
7. Complete the pattern with labels.

. .

YOKES

Bodice Front Yokes

A **yoke** may be defined as that part of a garment fitted closely to the shoulders, hips, or other body areas as support for other parts of the bodice or skirt.

By using a yoke, you can shorten a dart so it appears to originate from a style line. Making a yoke pattern requires two basic steps.

Directions .
Step I

1. Analyze the design (Figure 3.107). Note that the bust-fitting dart has been moved to point A in the shoulder seam.
2. Make a pattern with a shoulder dart. Complete the pattern.

Step II

1. Fold and pin or tape the shoulder dart (Figure 3.108).
2. Design the yokeline *across the folded dart*.

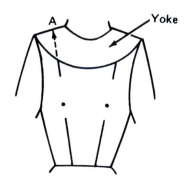

Figure 3.107 Yoke design.

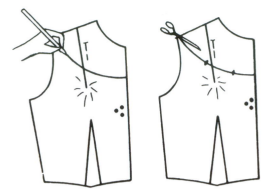

Figure 3.108 Design line across folded dart.

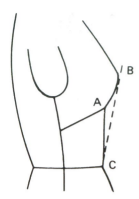

Figure 3.110 Midriff yoke fits snugly under bust.

A horizontal line should meet a vertical line at a right angle at center front and at the shoulder seamline.

3. Mark matching notches on the yokeline.
4. Separate the pattern into two pieces by cutting along the yokeline *while the dart is still folded.*
5. The dart in the yoke will remain closed, so tape it shut. Open the dart in the lower bodice (Figure 3.109). This dart can be changed to gathers. More fullness can also be added, if desired.
6. True seamline and add labels to complete the pattern.

..

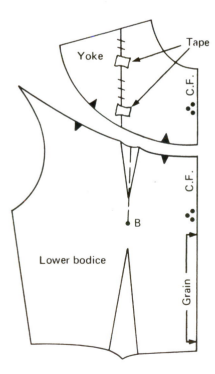

Figure 3.109 Completed pattern.

Always retain *all* of the original basic pattern. It serves as an illustration of the method used.

Midriff Yokes

The pattern-making method for the midriff yoke (Figure 3.110) differs from the method used for the shoulder or hipline yoke for two reasons:

First, the midriff yoke fits more snugly under the slope of the bust (A in Figure 3.110) than does the basic bodice, which is represented by dashed line BC.

Second, the upper bodice of the midriff yoke needs to be lengthened because distance BAC is greater than distance BC.

Directions ...

1. Make a pattern with the fitting darts combined at the waistline. Omit or cross out the dart lines.
2. Draw new dart lines AC and A'C' to widen the dart 1/4 in. (0.6 cm) at each side (Figure 3.111). Use a muslin shell to check the amount for each individual.
3. Fold line AC over to meet line A'C'. Do *not* attempt to fold or pin beyond these lines.
4. Design the yokeline *across the folded dart.*
5. Mark notches on the yokeline so the gathers can be spread over a distance equal to the width of the bust circle.
6. Cut the pattern apart, and tape shut the dart in the yoke.

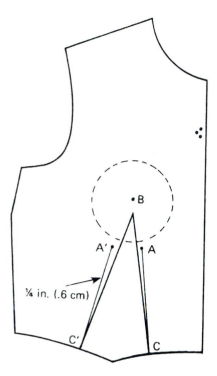

Figure 3.111 Widen dart at points *A* and *A'* to tighten bodice in yoke area; do *not* tighten at waistline *C'C*.

7. Yokelines can be curved or straight, or they can slant to a point at center front.

..

The Midriff Yoke with Gathers

Add paper to the lower edge of the upper bodice (Figure 3.112). Lengthen the bodice ¼ in. (0.6 cm) at center front, and curve the line smoothly across to the side seam. (Do *not* add any length at the side seam.) Label for gathers.

The distance between notches should be comparable to the distance across the bust circle.

The Midriff Yoke with "Inverted" Dart

Add paper at lower edge of upper bodice (Figure 3.113). Redraw dart to take up as much width as was taken up by the dart in the yoke pattern. Draw a guideline through the middle of the dart. Fold both dart lines in, to meet at the guideline. Cut off excess paper.

The Partial Yoke

The partial yoke (Figure 3.114) is another way to shorten the shoulder dart while the lower part of the dart is released as gathers.

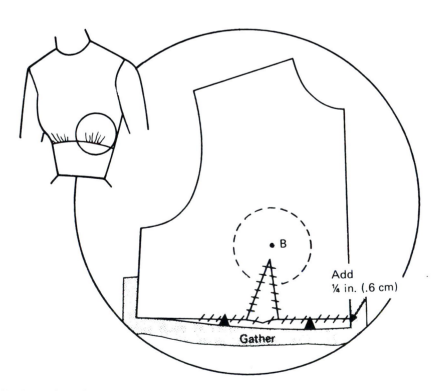

Figure 3.112 Midriff yoke with gathers.

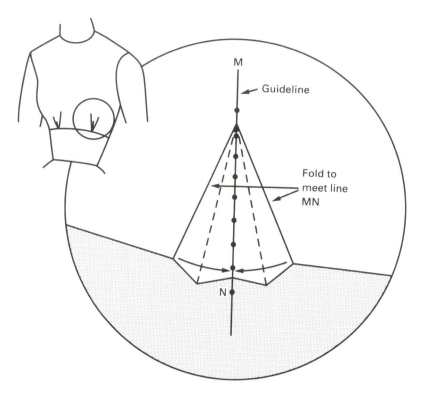

Figure 3.113 Midriff yoke with inverted, unstitched dart.

Directions .

1. Make a completed pattern with a shoulder dart. Draw the partial yokeline *across the folded dart* (Figure 3.115).
2. Mark a notch 1½ in. (3.8 cm) from the armhole, and cut along line *CD*. Line *CD* is perpendicular to center front. Next, cut from *D* to *E* at the waistline, and spread the pattern as shown in Figure 3.116.
3. Fill in with paper, and cross off the lines of both darts. Draw a smooth line from *C′* to *D*, shade or fold the pointed dart end under, and label for gathers. This pattern will have small seams on line *CD* and line *C′D*.

. .

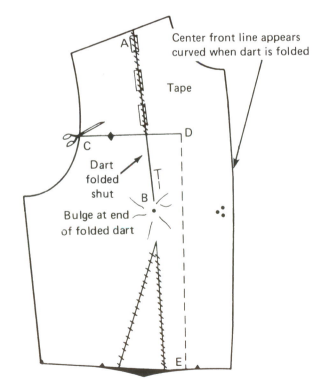

Figure 3.115 Partial yokeline sketched across folded shoulder dart.

Figure 3.114 The partial yoke.

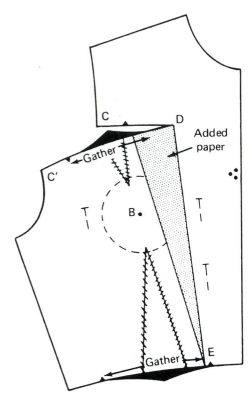

Figure 3.116 Completed partial yoke pattern.

Faced Yoke: Three-Layer Method

Design lines are often more interesting when they are finished with a facing to form a free edge. (Note finger under free edge in Figure 3.117.)

Directions

1. Use a paper pattern of the basic bodice.
2. Design the yokeline *MN* and the top-stitching line *OP* (Figure 3.118). Space the lines ⅜ to ¾ in. (1.0 to 1.9 cm) apart. Proportion the space to the size of the individual.

Figure 3.117 Design with faced edge.

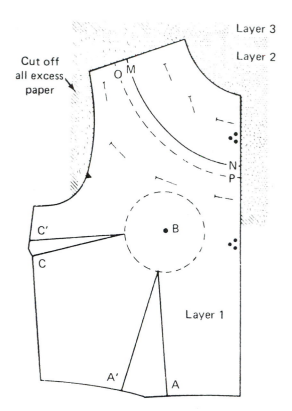

Figure 3.118 Pin to two layers of paper.

3. Put two layers of paper under the yoke area. Pin all layers together, placing the pins away from the design lines. Cut off excess paper outside pattern edges.
4. Use a tracing wheel to mark the position of the dashed line on layers 2 and 3 below.
5. Without unpinning, cut layers 1 and 2 on the solid line. Turn the pattern over, and cut layers 2 and 3 on the dashed line (tracing wheel line).
6. Separate the layers without removing pins. (This is possible if the pins are properly positioned.) Layer 3 will stay with the yoke. Tape it in place as shown in Figure 3.119.
7. Layer 2 is the facing for the lower bodice. Now remove pins, and discard excess paper from layers 2 and 3. Retain the original yoke area taped in place as shown in Figure 3.119.

NOTE: This is an easy pattern to make if you *follow directions exactly*.

Bodice Back Yokes

When a yokeline in the bodice back crosses the shoulders *at the tip* of the shoulder dart, the dart may be moved to the

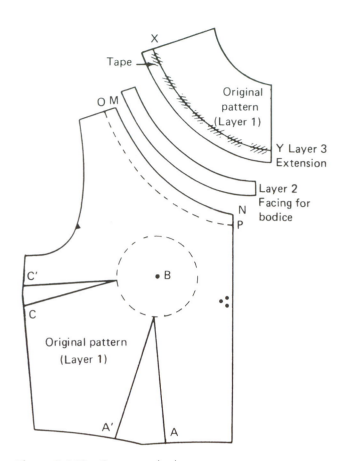

Figure 3.119 Separate the layers.

Figure 3.121 Yokeline is straight with fullness added to bodice back.

Figures 3.122 and 3.123, respectively. The yoke can be placed on the line of plaids and checks in gingham or other fabrics, or on the crosswise grain of a striped fabric to make use of the stripes in designing.

To move the dart to the straight yoke seamline as in Figure 3.120, complete the following steps:

Directions .

1. Fold and pin the shoulder dart. Lengthen it to the pivot point if necessary for the depth of the yoke.
2. Design the yokeline at right angles to center back and continue across to A at the armhole (Figure 3.124).

armhole and converted there to the yoke seamline (Figure 3.120).

If the yokeline crosses *above the tip* of the dart, the part of the dart that remains in the lower bodice back will be converted to gathers (or ease) since it will be very narrow in width at the yokeline. Figure 3.121 shows gathers with some added style fullness. Fullness may be added to the bodice back in Figure 3.120 also.

The lower edge of the yoke pattern may be straight, as shown in Figure 3.120, or curved or shaped, as shown in

Figure 3.122 Yokeline curves with added fullness.

Figure 3.120 Yokeline is straight.

Figure 3.123 Yokeline curves.

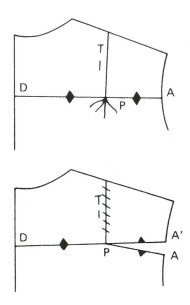

Figure 3.125 Zipper opening would be in back.

Figure 3.124 Yokeline crosses at pivot point, and dart is converted to seamline.

3. Mark notches on the yokeline. Separate the pattern into two pieces by cutting it apart on the yokeline.
4. Use the same procedure when the yokeline crosses the dart. (See preceding discussion for treatment of the part of the dart that remains in the lower bodice.)

Sewing Suggestion

The seam allowance of a gathered bodice sewn to a yoke should be pressed upward, toward the yoke. Yoke seams are often topstitched with matching or contrasting colored thread. A double yoke with two thicknesses of fabric is also commonly used.

OTHER BODICE PATTERNS

Bodice Pleats That Fold to the Inside of the Garment

Figure 3.125 is an example of bodice pleats (added style fullness).

Directions

1. Draw bustline and pleat lines on the basic pattern (Figure 3.126).
2. Divide the waist dart into thirds, and place one third along each of the side pleats.
3. Number the pieces, and cut apart on the pleat lines.

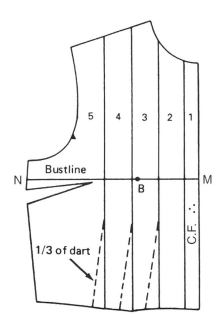

Figure 3.126 Bustline and pleat lines drawn on basic pattern.

4. Draw horizontal line *MN* on a large piece of paper, and match the bustline of the bodice pieces to this line. Put pieces in correct order. Spread to desired pleat size—1 in., on full scale, is a good width. Fold the pleats from the shoulder to the dart tip. Pleats usually fold *toward center*. (See arrows in Figure 3.127.)
5. Fold the lower part of the pleats to *include the one-third dart.* The three center panels are parallel since they have no dart included (Figure 3.125).
6. Complete the pattern.

Surplice Front Design

The surplice front bodice (Figure 3.128) is an asymmetrical design. Both sides of the pattern can be the same (i.e., both

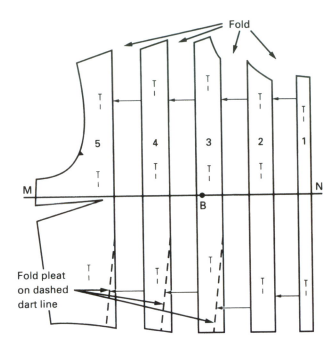

Figure 3.127 Pattern spread for desired pleat size.

sides of the garment can be cut from one pattern piece) if the design line is also an opening (Figure 3.129). If the design line is a seam only, a pattern piece for each side of the front will be needed (Figure 3.130).

Directions .

1. Start with a basic paper pattern for the *entire front*. Indicate center front by a dashed line.
2. Design the surplice line and the line for the corresponding opposite portion of the neckline of the bodice front.
3. Cut the pattern apart on line *ADB*, and fold under the part of the neckline that will not be used.

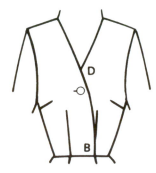

Figure 3.128 The surplice front.

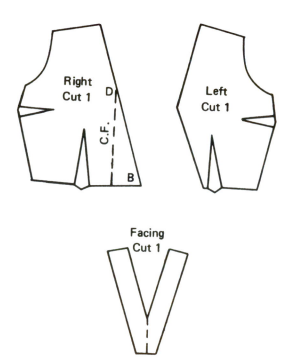

Figure 3.129 Line *DB* is a front opening.

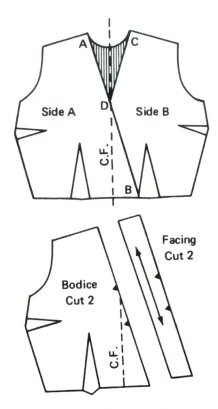

Figure 3.130 Line *DB* is a seamline, so bodice opening would be in back if neckline is not cut low enough to allow the head to pass through the garment opening.

4. Make facing patterns by duplicating the area to be faced.

..

DART END SHAPES

The shape of the wide end of a dart is determined by the angle formed by the dart and the seamline from which it originates.

In Figure 3.131 are three bodice designs. Use the half-scale pattern provided in Appendix A to make a *completed* pattern for each design. Use the pivot method.

Observe the shape of the wide end of the darts, and then match each design with one of the darts shown in Figure 3.131. Record your results and observations by filling in the blanks and checking the correct item in the exercise that follows.

Fill in the blanks.

1. Design A matches dart _____.
2. Design B matches dart _____.
3. Design C matches dart _____.
4. When a dart is located at a right angle to the seamline from which it originates, the dart end will have a: (check one)
 a. _____ long point
 b. _____ blunt point
5. When a dart is located diagonally to the seamline from which it originates, the dart end will have a: (check one)
 a. _____ long point
 b. _____ blunt point
6. The shape of the end of dart number 3 is the result of: (check one)
 a. _____ folding the dart the wrong way
 b. _____ shaping the dart end as excess paper is cut off

Answers

1. Design A is dart 3
2. Design B is dart 1
3. Design C is dart 2
4. b
5. a
6. b

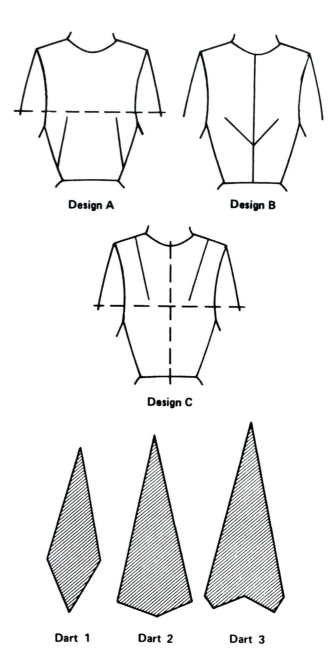

Figure 3.131 Examples of bodice designs and darts.

PROBLEMS ...

These problems include some thought questions to help you practice the kind of thinking necessary for good analysis. Make patterns for these designs, and try them out in muslin.

1. How does line *CD* differ from the basic princess line? Where does dart *BA* originate?

2. Why is line *CD* not a dart equivalent? Which seam should be stitched first in garment construction: *BE* or *CD*?

3. Is line *CED* a dart equivalent? To what seam were the darts moved in making this pattern?

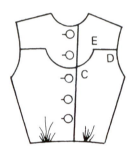

4. Is line *AB* necessary for the neckline opening? For the center front darts? Are the center front darts combined darts?

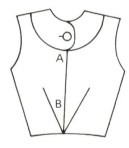

5. Draw dashed lines to show where darts originate. Is line *CD* a dart equivalent?

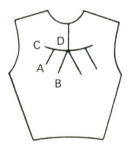

6. Is line *AB* a dart equivalent? Is line *BD* a dart equivalent?

Answers
1. *CD* is a side yokeline. *BA* originates in the side seamline.
2. *CD* does not go to the bust point or apex. Sew line *CD* first, then sew line *BE*.
3. *CED* is a yokeline. Bust and waist darts were moved to the waistline.
4. No. No. Yes, darts are combined bust and waist darts.
5. Line *AD* originates at center front neckline point. *CD* is not a bust dart.
6. Yes. Yes. *BD* could also be a large French dart, and *AB* would then be a design line.

Analyze each design and tell how it was made. Make paper patterns for several designs in each group.

Moving Bodice Darts

Only front views are shown because they are easier for beginners to analyze.

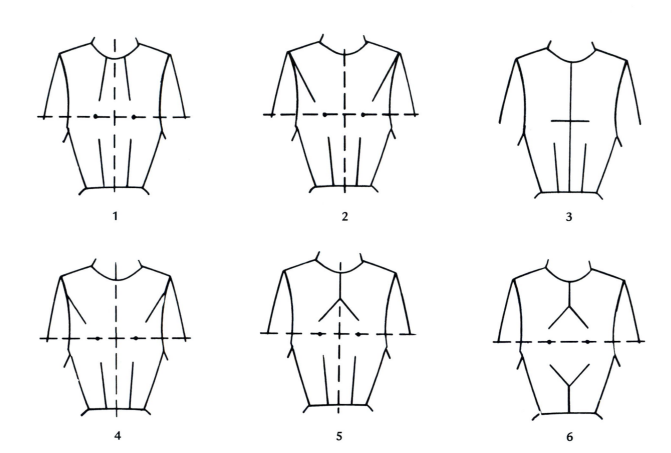

1 2 3

4 5 6

Combining Bodice Darts and Dividing Bodice Darts

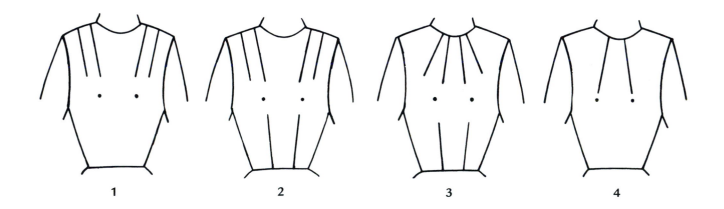

1 2 3 4

Combined or Divided Darts

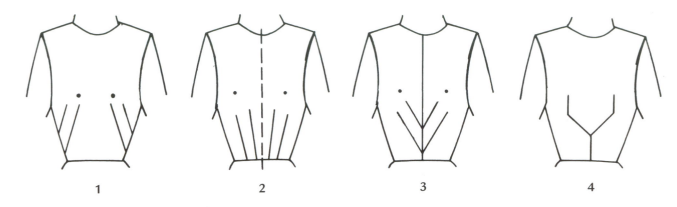

1 2 3 4

Darts and Gathers

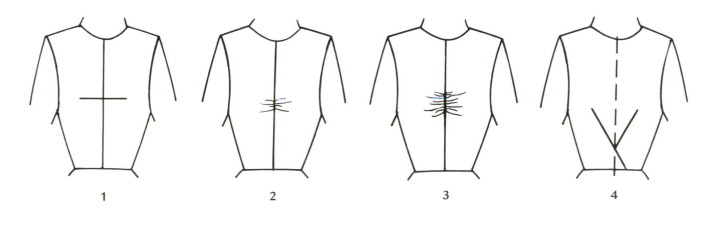

1 2 3 4

Yokes and Gathers

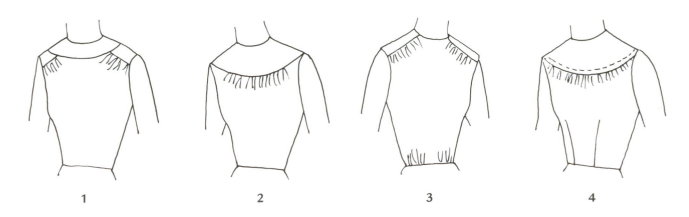

1 2 3 4

Princess Seamline Variations

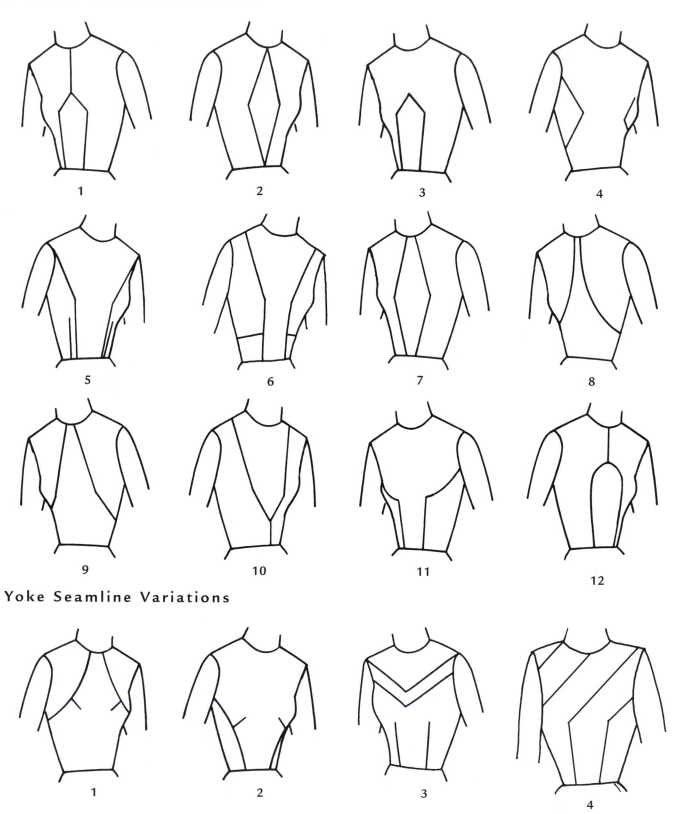

You may not like all of these designs, but they are good practice!

Yoke Seamline Variations

Necklines and Facings

LOWERED NECKLINE

Many variations in design are possible by lowering the neckline at the front only, at the back only, or by lowering it all the way around. The shape of the neckline—round, square, and so forth—can be changed to suit the individual or to reproduce a chosen design. Figures 4.1 and 4.2 show a round neckline that has been lowered about 1½ in. (3.8 cm) from the basic neckline.

When the new neckline is to be lowered a moderate amount and does *not* cross any dart, the patternwork is quite simple.

Directions ...

1. Sketch a line on the bodice pattern. Cut along this line and label (Figure 4.3).

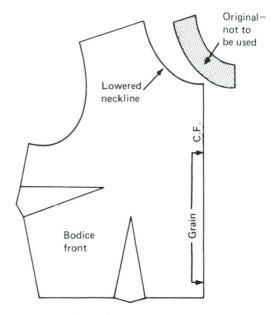

Figure 4.3 Making the pattern.

2. The piece of neckline that is cut off need not be discarded but can be taped to the bodice pattern and restored later to its original position so the pattern can be used for a different design.
...

Neckline Crossing Bodice Front Dart

When the lowered neckline of the bodice front crosses a dart, the dart should be pinned shut while the neckline is drawn on the pattern (Figure 4.4).

Do not unpin the dart until after the pattern is cut apart at the new neckline.

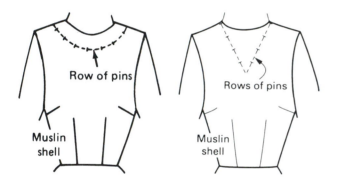

Figure 4.1 To determine becomingness of new neckline, put muslin shell on the individual and place a row of pins or dark-colored string to mark new neckline positions; try a variety of necklines, such as a curved neckline or a V-shaped neckline.

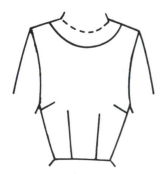

Figure 4.2 To locate a new neckline, sketch on the design the *basic* neckline position as a dashed line.

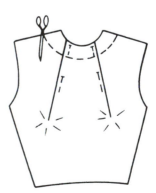

Figure 4.4 Pin darts shut to draw new neckline on pattern.

Neckline Crossing Bodice Back Dart

The fitting dart of the bodice back can be moved or lengthened whenever such a change makes patternwork easier or improves the design (Figures 4.5, 4.6, and 4.7).

Tightening Neckline to Improve Fit

If the neckline is lowered to the center of the shoulder, it will need to be shortened to fit the concave curve of the body at this location.

 This can be done by removing ¼ in. (0.6 cm) (±) from the neckline edge of the front and back pattern. The shoulder seamline now becomes a curved line and thus fits the ball of the shoulder better (Figure 4.8).

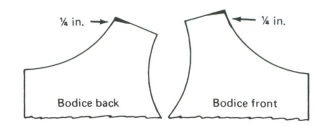

Figure 4.8 Removing gap at shoulder seam.

Boat style necklines do not require this change.

 Lowering the neckline to the chest area in the front (or back) necessitates removing some of the normal ease allowed in the basic pattern for freedom of arm movement.

 Estimate the amount to be removed by putting the muslin shell on the individual and pinning small folds of equal size as shown in Figure 4.9. *Do not overfit!* Measure the size of the pinned folds.

Directions .

1. Mark off, on the new neckline at A, the amount of looseness for one side only.

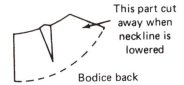

Figure 4.5 If neckline is lowered far enough at center back, move dart to neckline, cut away dart with that portion of the pattern, and tighten shoulder seam.

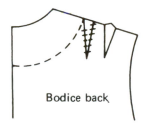

Figure 4.6 Move dart farther out in shoulder seamline when it is too close to lowered neckline and would create bulk or an unpleasing design line.

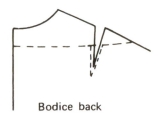

Figure 4.7 When lowered neckline crosses dart, lengthen shortened dart to its pivot point and widen if necessary to remove neckline gap.

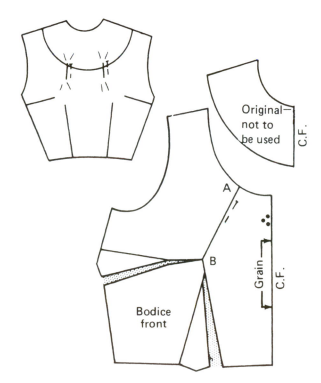

Figure 4.9 Pattern for lowered neckline. Neckline is made smaller at A.

2. Slash from A on the neckline to the bust point B. Slash along both darts to the bust point or apex.
3. Overlap cut edges at the neckline to remove looseness, which is then transferred to each of the two darts.
4. True the neckline, and complete the patterns.

..

BOAT NECKLINE

The boat (bateau) neckline is a high, wide, horizontal line. Because it extends toward the armhole, the crosswise tension at the neckline offsets any tendency of the garment to slip off the shoulders, as is the case when the neckline is lowered considerably at *both* the shoulder and center front.

Directions

1. Lower the neckline along the shoulder seamline as shown in Figure 4.10. The shaded area is the portion of the original bodice that would be removed. (More may be removed at the shoulder if desired.)
2. Raise the neckline at center front ½ in. (1.3 cm) or so. How much the neckline is raised depends on the height of the basic neckline. Some are higher than others.
3. Complete the pattern.

..

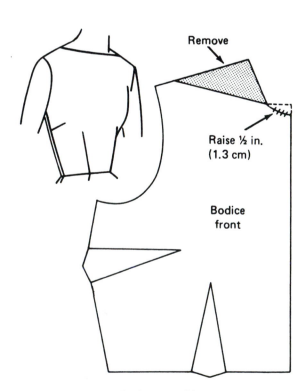

Figure 4.10 Pattern for boat neckline.

BUILT-UP NECKLINE

The built-up neckline pattern must provide an alternative way to do the fitting that was accomplished by the neckline seam, which has been eliminated. The keyhole in Figure 4.11, the dart in Figure 4.12, and the seam in Figure 4.13 can all serve as substitutes.

Individuals vary greatly in shape and size of the base of the neck. Make the pattern in muslin, and pin-fit it to the person. Use the muslin shell as a guide to true pattern lines.

To make the pattern for the design shown in Figure 4.12, follow these steps:

Figure 4.11 Keyhole neckline.

Figure 4.12 Built-up neckline with neckline dart.

Figure 4.13 Built-up neckline with seams.

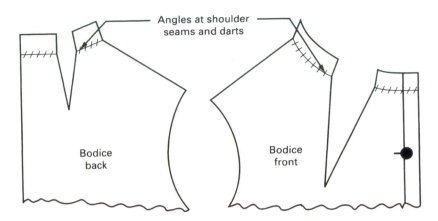

Figure 4.14 Pattern for built-up neckline design in Figure 4.12.

Directions ...

1. Move the bust-fitting dart to the front neckline.
2. Move the back shoulder dart to the back neckline.
3. Extend the neckline 1 to $1\frac{1}{2}$ in. (2.5 to 3.8 cm) so the extension forms an angle with the shoulder seam.
4. Extend the dart lines as shown in Figure 4.14.
5. Complete the pattern.
...

COWL NECKLINE

The cowl neckline can be developed from the boat neckline by adding width to the neckline and length to the center front to provide one or more softly draped folds.

Drape can be controlled and enhanced by attaching weights to the neck edge or to each underfold of drape. The weights should be encased in a cloth cover and fastened so they dangle on the inside of the garment.

The most satisfactory drape is achieved when crepe or some other soft fabric is used and when the garment is *cut on the bias*.

Patterns to be cut on the bias must be made for the entire front (or back) and cut from a single thickness of cloth.

High Draped Cowl

A small amount of width and length will produce a high draped cowl (see Figure 4.15).

Directions ...

1. Use the bodice sloper to make a paper pattern that has one or both of the fitting darts moved to the neckline. (The dart lines need not be drawn in.)

Figure 4.15 High draped cowl.

2. Sketch the boat style neckline on this paper pattern. Raise the neckline about $\frac{1}{2}$ in. (1.3 cm) at the center front.
3. Measure the new neckline with a tape measure, then *drape the tape measure on the person* to see how low the neckline will hang. If it does not hang low enough, make *vertical* slashes, as shown on page 77.
4. The folds are created by adding length to the pattern. The horizontal lines in Figure 4.16 show where to slash the pattern to add length. Slash along the dashed lines to, but not through, the shoulder seamline.
5. Figure 4.17 shows how the pattern is spread and how a pattern for the entire front is made. To make the entire front pattern, fold a piece of paper of suitable size, match the pattern to the fold, and spread at the slashes. Glue the pattern in place, cut out the pattern, and unfold the paper.
6. Draw lengthwise grain* as the diagonal of a square built around center front.
...

..............
*Or use the method for determining grainline given on page 16.

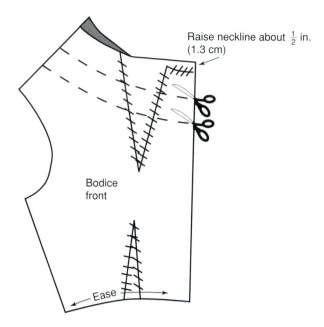

Figure 4.16 Bodice may be more comfortable if some of waist dart is used as waistline ease.

Pleats at Shoulder

To make pleats at the shoulder, slash *through* the shoulder seamline (Figure 4.18). Mark the exact pleat line, then fold each pleat to true it.

Facing

The facing can be a separate piece, or it can be an extension of the front (Figure 4.17). The second alternative is preferable because the fabric drapes better if there is no seam.

Attach weights to the facing edge as well as to the underfolds of the drape.

Low Draped Cowl

As the neckline width is increased, the drape of the neckline becomes lower.

To increase the width, slash the pattern from neckline to waistline, and spread the pattern the estimated amount (Figure 4.19).

For a facing, extend the neck edge, as shown by the dashed line.

Cut the pattern *on the bias* to achieve the most satisfactory draped appearance.

Alternate Method of Making the Cowl Neckline

If one or both fitting darts are moved to center front, the darts add length rather than width to the pattern. Straighten the center front line as shown in Figure 4.20 to add width at the neckline. If more length or width is desired, slash the pattern.

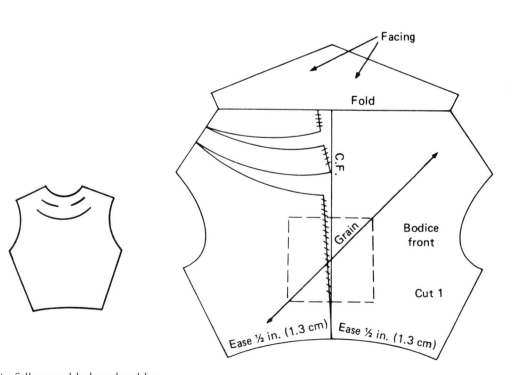

Figure 4.17 No fullness added at shoulder.

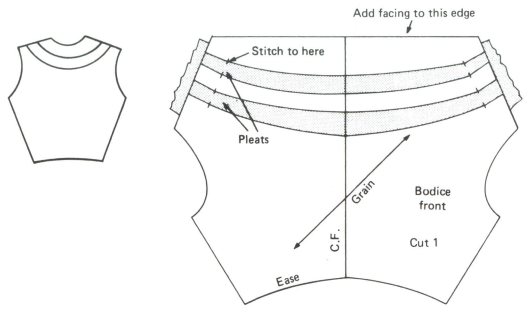

Figure 4.18 Creating pleats at shoulder.

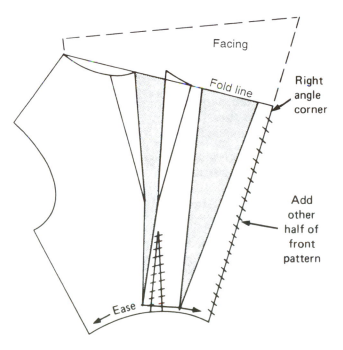

Figure 4.19 Low draped cowl.

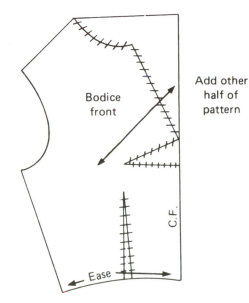

Figure 4.20 Alternate method.

Yokes with Cowl Neckline

The advantage of the cowl neckline yoke is that it permits the lower part of the bodice to be cut on the straight grain and the cowl yoke to be cut on the bias. Two examples of cowl neckline yokes are shown in Figure 4.21.

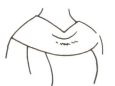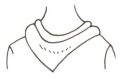

Figure 4.21 Yokes with cowl neckline.

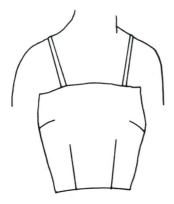

Figure 4.22 The sundress.

SUNDRESS

The sundress or camisole top (Figure 4.22) has a very fitted bodice.

Use the muslin shell as directed in Figure 4.23 to determine how much to tighten the bodice. Much of the normal ease can be removed at the side seamline. Looseness above the bust can be pinned in as a dart and then transferred by the slash method to the two fitting darts.

Directions .

1. Pin to remove ease as shown in Figure 4.23.
2. Determine the placement of the line for the upper edge in both front and back. The line should be about 4 in. (10.2 cm) below the neck in front and 8 to 9 in. (20.3 to 22.9 cm) below in back.
3. Sketch a line indicating the upper edge of the sundress on both the front and the back patterns. Cut along this line, and remove the upper part of the pattern (Figure 4.24).

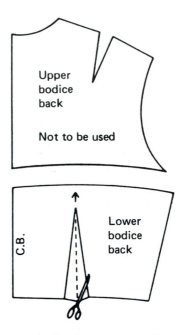

Figure 4.24 For the back pattern, use lower bodice only.

4. Slash the lower bodice of both patterns as directed in Figure 4.25.
5. Remove ease as indicated in the drawings in Figure 4.26.

. .

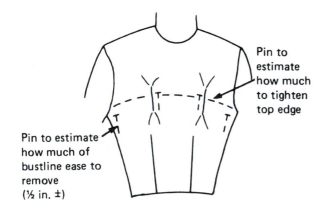

Figure 4.23 Measuring amount to be taken out of pattern.

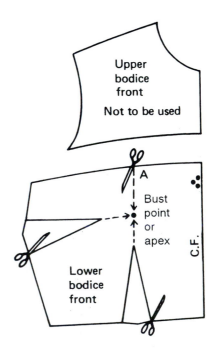

Figure 4.25 For front pattern, use lower bodice only.

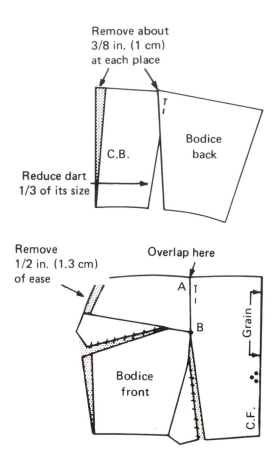

Figure 4.26 Removal of ease from patterns.

LINGERIE

Slips

If the basic sheath pattern is used, sundress pattern techniques can be combined with the midriff yoke techniques (and others) to make patterns for slips such as those shown in Figure 4.27. Figure 4.27c is an example of a slip that combines techniques from the sheath dress, the midriff yoke, the center front bust dart, and the six-gore skirt. (Before these patterns can be made, you should study Chapter 6 and 8 on skirts and sheath dresses.)

ABOUT FACINGS

Facings are one kind of construction finish for the free or "raw" edges of a garment. Other finishes are hems and bindings.

Garment edges that may be faced include:

- Necklines
- Sleeveless armholes
- Buttonhole closures

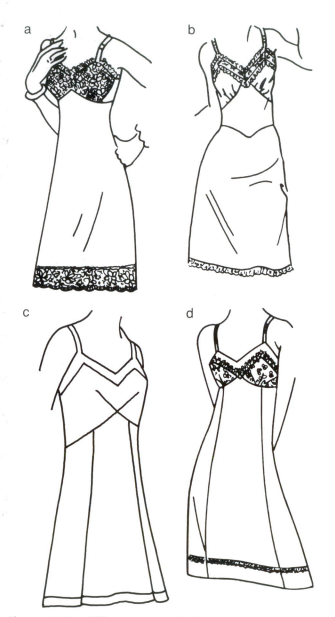

Figure 4.27 Different styles of slips.

- End of sleeves
- Skirts that have been let down and are too short to hem
- Collars (facing is called the undercollar)
- Pockets and pocket flaps

Facings usually are placed on the inside of the garment so they are not visible from the outside. They may be on the outside, however, if they serve as a decorative feature as well as an edge finish.

When the garment is made of a heavy or rough fabric, the facing should be made of a smooth, thin fabric, such as a lining fabric, to reduce bulk and to improve feel.

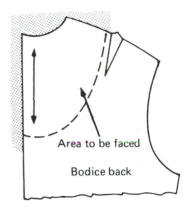

Figure 4.28 Deep facing for protection against skin oil and perspiration.

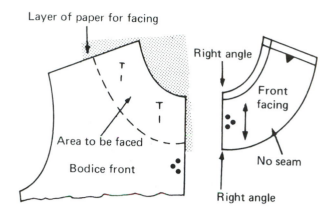

Figure 4.29 Front neckline facing.

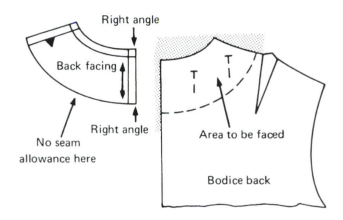

Figure 4.30 Back neckline facing.

When the garment is made of thin fabric, the facing can be made of a firmer fabric, such as taffeta, to give body. (This would not, however, replace the interfacing.)

Facings are often cut on the bias to make them more drapable or adjustable as the under (or inner) layer.

Wide facings are used for certain specific purposes. (See Figure 4.28.) For example, pajamas often have a very deep facing in the back to protect the pajama top from perspiration. In outer garments that are made of polyester, a deep facing protects the garment from skin oils. Some polyester fabrics that do not have a stain-resistant finish have an affinity for skin oils, and a prespotting treatment is needed to remove any oil.

A facing can duplicate an entire garment section. For example, in bell sleeves, the entire sleeve is faced. (The facing can be made of a bright color.) Cascade ruffles are also faced in this way. Common types of facings are:

- Fitted facings
- Shaped facings
- Bias facings

FITTED NECKLINE FACING

Necklines are usually faced with fitted facings. The fitted facing has the same shape, same grain, same number of pieces, and same number of seams as the area it faces.

Because the fitted facing is an *exact duplicate* of the area it faces, it will shrink, stretch, drape, and otherwise perform in the same manner as the outer fabric (unless the facing is made of a different fabric). The general procedure for making all facings follows:

Directions

1. Place a piece of paper under the area of the pattern where the garment is to be faced. The paper should be large enough to make a facing 2½ in. (6.4 cm) wide. (See Figures 4.29 and 4.30.)
2. Trim off any paper extending beyond the pattern edge.
3. Remove the facing layer of paper, and mark the width of the facing on it.
4. Trim off the rest of the excess paper, and label the facing pattern on the side *opposite to* the side labeled for the front.

Note that beginners often confuse the shoulder seam with the center edge. Study the pattern until you can recognize center front or center back edges by:

1. Right angle corners at center front or center back
2. Straight grain when cut on correct grain of the cloth

Sewing Suggestion

After a curved fitting facing is sewn to the neckline, remember to clip to, but not through, the seam allowance

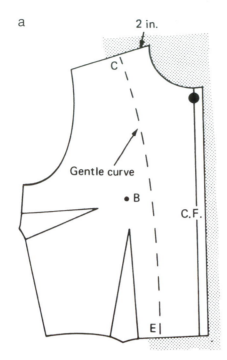

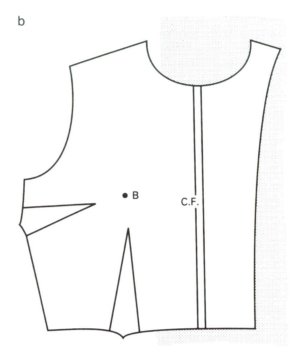

Figure 4.31 Neckline—center front facing.

every ½ in. (1.3 cm). Understitch the facing to the seam allowance to help hold the facing in place. It is easier for the apparel industry to use a narrower seam instead of clipping seams.

NECKLINE–CENTER FRONT FACING

The drawings in Figure 4.31 illustrate the procedure for making a facing for a garment that has a center front (or back) opening.

Figure 4.31a shows a facing of the standard width. Since the extension is a straight line, the facing is often placed on the fold rather than sewn with a seam as shown in Figure 4.31b.

Figure 4.31c shows the facing used in an unlined knit suit or jacket. The facing extends out to the armhole. This facing can be used to advantage in many garments because it is sewn in with the sleeve or armhole facing and is thus held firmly in place. It also adds desirable body to the garment.

When there is a dart in the neckline, fold the dart first (Figure 4.32). Allow the pattern to hump up at the tip of the dart so the neckline area lies *flat* on the table.

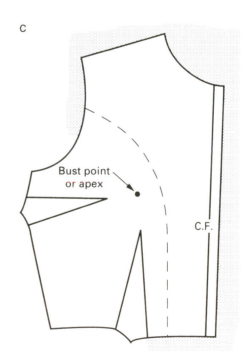

Figure 4.31 *(Continued)*

Figure 4.32 Facing the neckline that has a dart.

Pin the pattern to a piece of paper, and proceed as directed for the fitted neckline facing.

BIAS FACING

A bias facing is often used at the neckline of blouses or dresses that have flat or partial-roll collars.

The bias facing is a parallel strip of fabric cut on the true bias, as shown in Figure 4.33.

Figure 4.33 Bias-cut facing strips are cut 1 in. (2.5 cm) wide and folded under ¼ in. (0.6 cm) on each end to be ½ in. (1.3 cm) finished width.

When the bias facing is applied to a garment, it is eased on the neck edge while being stretched on the outer edge to give it the shape of the edge it faces. A bias facing is difficult to manipulate, so it should be kept narrow, about ½ in. (1.3 cm) finished width.

BUTTON AND BUTTONHOLE CLOSURE

Buttonholes are usually made on the straight grain. If the bodice is cut on the bias, the buttonholes can be made diagonal to center front.

Understanding the proper placement of buttons and buttonholes often poses a problem for beginners. *Center front lines must meet* when a garment is buttoned, or the garment size changes.

The patternwork required for a button and buttonhole closure is relatively simple. It is based on a series of rules.

Rules ...

1. *For women's clothing,* make the buttonholes on the right side of the bodice front (left side of the bodice back).*
2. *The width of the overlap should equal the radius of the button plus ¼ in. (0.6 cm).*
3. *The distance from the neckline to the top buttonhole equals the radius of the button plus ¼ in. (0.6 cm) (full scale).*
4. *One buttonhole should be located at or near the point of greatest strain, the bustline.*
5. *The space between the waistline and the bottom button should be similar to the space between the rest of the buttons. A belt buckle is treated as another button in the space plan.*
6. *For horizontal buttonholes, the buttonholes should begin ⅛ in. (0.3 cm) from center front, in the overlap, and extend back, into the bodice proper.*
7. *When a vertical band of fabric is sewn onto a blouse, shirt, or dress, vertical buttonholes are placed in the middle of the band, which is the center front line.*

 Although horizontal buttons and buttonholes stay closed better, the clothing industry often uses vertical buttonholes on garments with or without bands, because vertical buttonholes are sewn with greater speed on special industrial sewing machines.
8. *The buttonhole length is equal to the width of the button plus the thickness of the button.*

Directions ...

1. Use a paper pattern, or trace one from the sloper (Figure 4.34).

..............

*Buttonholes are on the *left* side of men's clothing.

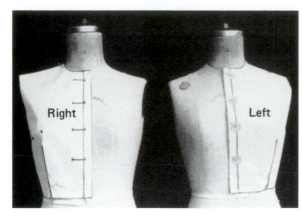

Figure 4.34 Paper patterns on these dress forms show correct location of buttons and buttonholes.

2. Add the overlap (underlap), as shown in Figure 4.35. An extension must be added to the center front to provide an overlap for the right side and an underlap for the left side, according to the size of the button. (See Figures 4.35, 4.36 and 4.37.)

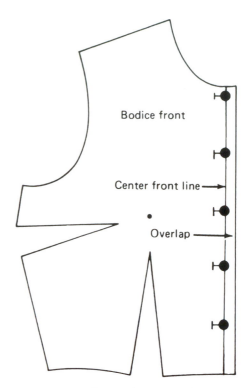

Figure 4.36 Pattern for overlap (underlap) showing button placement.

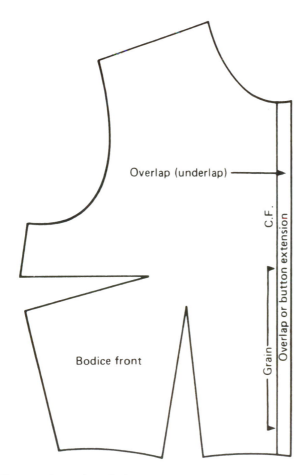

Figure 4.35 The overlap.

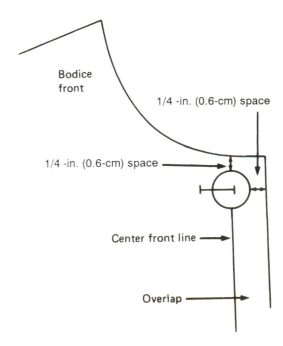

Figure 4.37 Position of first button in relation to neckline, garment edge, and center front line; in this example, the button, buttonhole, and extension beyond center front are all ½ in.

The width of the overlap should equal the radius of the button plus ¼ in. (0.6 cm). When large buttons and buttonholes are used, the overlap is equal to the diameter of the button. This is appropriate for suits and coats.

3. Decide on the size and location of the buttons.

Cut circles of paper to represent the buttons. Try two or three sizes. Place the pattern in position *on the individual*, in front of a mirror, and arrange the buttons on the center front line. Pin them in place.

Measure the distance between buttonholes, middle of button to middle of button.

4. To locate the buttonholes, remember that the distance from the neckline to the top buttonhole equals the radius of the button plus ¼ in. (0.6 cm) (full scale).

One buttonhole should always be located at or near the point of greatest strain, the bustline. In a dress, the hipline and waistline may also be areas of strain. A hook and eye is used at the waistline under a belt.

The space between the waistline and the bottom button should be similar to the space between the rest of the buttons. A belt buckle is considered as another button in the space plan.

5. To draw the buttonholes, begin ⅛ in. (0.3 cm) out in the overlap and extend back into the bodice proper.

The buttonhole length should be equal to the width of the button plus the thickness of the button. Buttons with a rough surface require a slightly larger buttonhole than slick buttons.

..

Vertical Buttonholes

Buttonholes may be placed vertically along the center front or center back line. This position is more satisfactory with small buttons than with large ones. The garment design must also be loose to avoid stress that would spread the buttonhole. Vertical buttonholes start ⅛ in. (0.3 cm) above the center of button placement.

ARMHOLE FACING FOR SLEEVELESS GARMENTS

The armhole facing is used on garments such as sleeveless dresses or jumpers. Remember that a basic bodice has 3 in. (7.6 cm) of bustline ease to allow for arm movement when the garment has a sleeve. Without a sleeve, some of this ease can be removed. The armhole also can be made smaller by raising the underarm section of the armhole. (Remember to always mark out a seamline that is no longer to be used.)

See the directions and illustrations in Figures 4.38 and 4.39. To make the armhole facing, follow these steps:

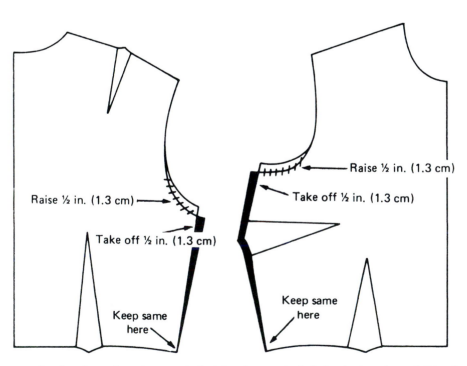

Figure 4.38 To prepare bodice for a sleeveless armhole (1) raise armhole ½ in. (1.3 cm), and (2) take ½ in. (1.3 cm) off side seam—tapering to nothing at waistline.

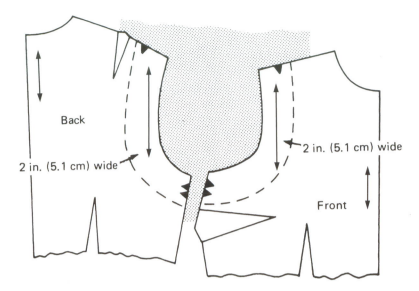

Figure 4.39 Making armhole facing pattern.

Directions .

1. Place a layer of paper for the facing pattern under the armhole area, as shown in Figure 4.39. The facing should be about 2 in. (5.1 cm) wide.
2. Use the general directions given on page 80.
3. Because these are fitted facings, the grain will be the same as that of the bodice.
4. The labels will be on the side opposite to those of the bodice.

. .

SHAPED FACING: ARMHOLE

Directions .

1. Join the bodice front and back at the shoulder seam-line (Figure 4.40).
2. Make the facing 2 to 2½ in. (5.1 to 6.4 cm) wide.
3. Label the facing so it is opposite to the bodice.
4. Use the grainline of the bodice front for the facing grain.

. .

NECKLINE–ARMHOLE FACING: LOWERED NECKLINE

Lower the neckline, and make a single facing for the neck-line-armhole area (Figure 4.41). Note that the bodice is cut a little larger than the facing so the facing will not show on the outside edge when it is sewn.

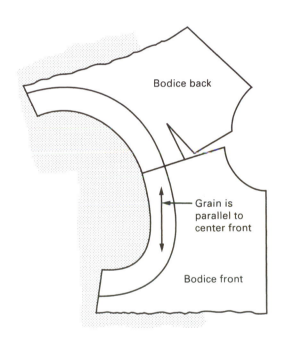

Figure 4.40 Shaped armhole facing.

Sewing Suggestion .

1. Place the front facing on the front and the back facing on the back with right sides together. Ease the bodice so it seems a little full. Stitch the armhole and neck-line edges to within 1½ in. (3.8 cm) of the shoulder.
2. Grade and clip the seams.
3. Turn *front* right side out and slip into back. Right sides of bodice back and front are now together. Stitch shoulders, stitch facings, and press open. Pull the fac-ing out farther, and complete the original stitching.

. .

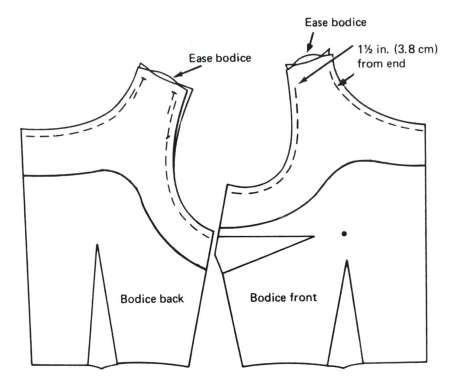

Figure 4.41 Neckline-armhole facing.

PROBLEMS ...

Describe how facings are made for each of these blouses.
Make patterns for several of these designs. End the design
at the waistline indicated by the dotted line. Omit the cap
sleeves.

1

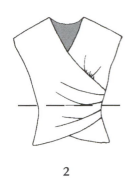

2

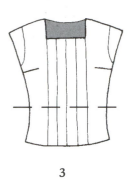

3

4

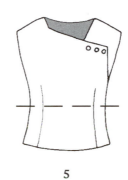

5

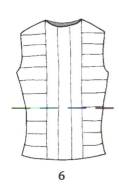

6

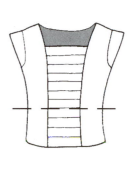

7

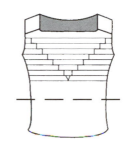

8

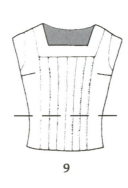

9

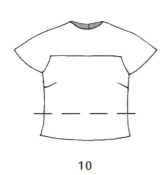

10

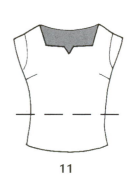

11

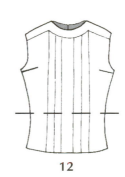

12

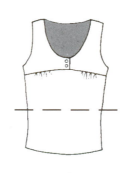

13

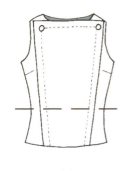

14

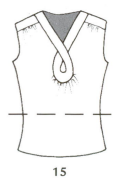

15

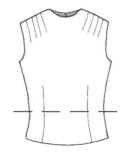

16

5

Collars

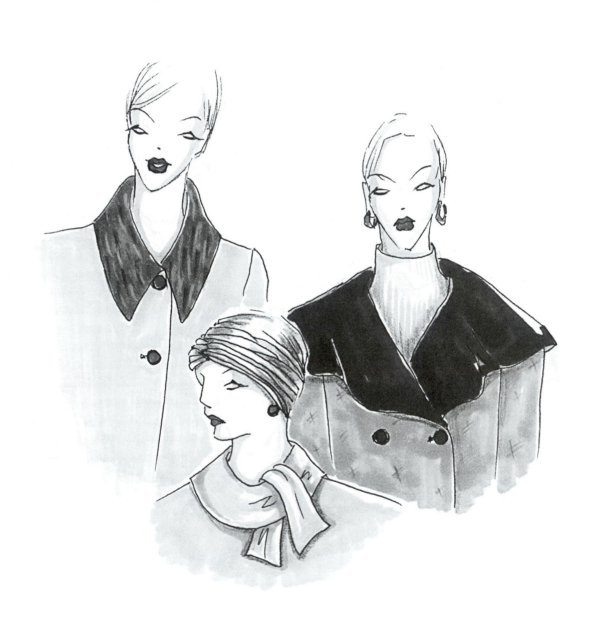

COLLAR TYPES

The three basic collar types are the flat, full-roll, and partial-roll collar (Figure 5.1).

Type refers to collar classification by the *shape* of the **neckline edge.** The shape of the neckline edge determines the amount of roll (or flatness) of the collar.

The amount of roll required must be judged at the back of the neck because collars tend to flatten out at an opening.

If the three basic collars are superimposed on one another so they coincide at the center back line, it is possible to compare the shape of the neckline edges. Figure 5.2 shows this arrangement. Note that the partial-roll collar is closer to the straight-line shape of the full-roll collar than it is to the curved shape of the flat collar.

Rules ..

1. *The straighter the neckline of the collar pattern, the greater will be the amount of roll at the back of the neck on the finished collar (see full-roll collar).*
2. *The more curved the collar pattern, the flatter the collar will lie on the body (see partial-roll and flat collar).*
3. *The more the collar conforms to the garment neckline, the flatter the collar will be (see flat collar).*

..

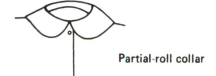

Full-roll collar

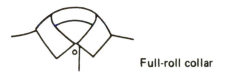

Partial-roll collar

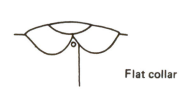

Flat collar

Figure 5.1 Three basic collar types.

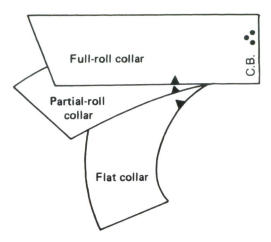

Figure 5.2 Comparing the shape of the neckline edge of the three basic collar patterns.

COLLAR STYLES

Collar *style* is related to the *shape* of the collar's **outer edge** or to the grain position.

Examples of some collar styles made from the basic flat collar are shown in Figures 5.3, 5.4, and 5.5. The dashed lines indicate the original flat collar.

Note that the neckline edge of the pattern remains the same; only the shape of the outer edge is changed.

A greater variety of styles is possible when the neckline of the garment is lowered and the collar is designed for the lowered neckline.

The sailor or middy collar in Figure 5.5 is designed as a flat-collar style that forms a V-shape at a lowered neckline. This collar is illustrated in Chapter 14 on clothing for girls.

All the collar variations in Figure 5.6 are made for the normal neckline of the basic bodice, so the necklines are all the *same length.* Study these collars in relation to the following statements:

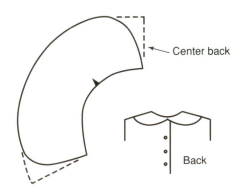

Figure 5.3 Divided Peter Pan collar.

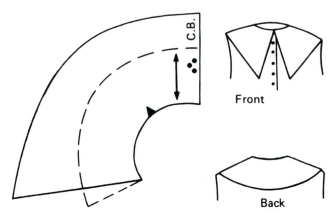

Figure 5.4 Puritan or bertha collar.

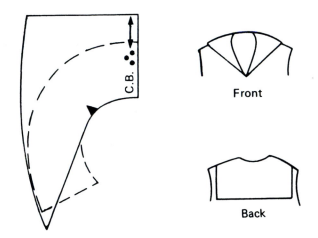

Figure 5.5 Sailor or middy collar on lowered neckline.

Rules ···

1. *The neckline curve goes from concave in the flat collar to convex in the convertible collar.*
2. *The outer edge of the collar becomes shorter as the neckline curve approaches a straight line.*
3. *The collar rolls higher against the neck as the outer edge becomes shorter.*
4. *The width of the full-roll collar is limited by the hairline and by the length of the neck.*
5. *A collar can be widened as it becomes flatter.*
6. *The front neckline area of a collar has a deeper curve than the back neckline area.*
7. *The distance from center back to the shoulder notch is shorter than the distance from the notch to center front.*
8. *Part of the successful attachment of a collar is knowing which edge is the neckline!*
9. *The corners at the center back of a collar are right angles.*

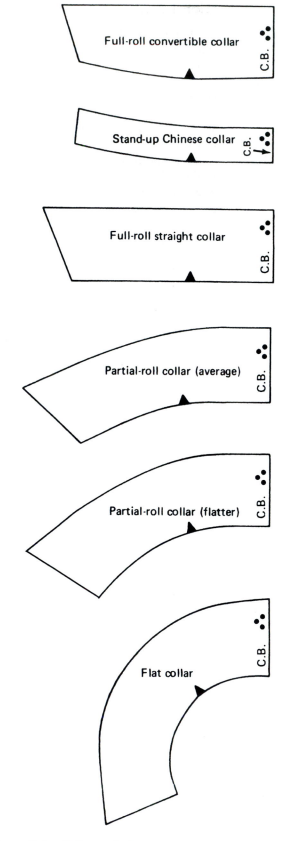

Figure 5.6 Collar variations.

Sewing Suggestion

The factors that should influence the choice of method for applying the collar to the garment neckline are (1) amount of stand, (2) position of seam allowances, and (3) fabric thickness.

The **flat collar** has no stand, so the seam allowance must be turned down inside the bodice (Figure 5.7) and covered by a fitted facing or by a very narrow bias facing. The fall of the collar will cover the place where the bias is hemmed to the bodice. The seam allowance cannot be turned up between the collar layers because it would add unnecessary bulk and would interfere with the collar drape.

The **partial-roll collar** with a low stand should also have the same allowance turned down inside the bodice back (Figure 5.8). When the roll or stand is high enough, the seam allowance can be turned up between the collar layers, and no facing is needed (Figure 5.9).

The **full-roll collar** has a stand that is high enough to permit the seam allowance to be turned up between the collar layers (Figure 5.10). This application is recommended for washable dresses and blouses and for sheer fabrics that a facing would show through. The seam allowance can be turned down inside the bodice back if a facing is used (Figure 5.11).

A bias facing should not be used for the full-roll collar neckline finish because the fall of the collar will not cover the place where the bias is hemmed to the bodice back.

In suits, coats, and heavy dress fabrics, the seam allowance is usually pressed open (Figure 5.12) to reduce bulk in the seam. A facing is then used to cover the part of the seam allowance that is pressed down into the garment.

FLAT COLLARS

The flat collar lies flat on the bodice. It has little or no roll or stand* (Figure 5.13). The bertha collar and sailor collar are variations of this collar and are explained in Chapter 14.

The flat collar is a duplicate of the neckline area of the bodice except for one slight change, which is an overlap at the shoulder seamline.

Directions

1. Start with the basic bodice front. Lower the front *shoulder* seamline ¾ in. (1.9 cm) at the armhole (none at the neck edge), and mark out the original line as shown in Figure 5.14. (The reason for this change is given in the Sewing Suggestion that follows.)

*Terms are explained on page 93, Figure 5.19.

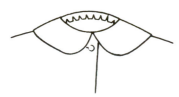

Figure 5.7 Seam allowance of flat collar is turned down under facing.

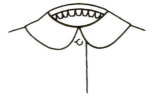

Figure 5.8 Seam allowance of partial-roll collar is turned down, and a facing is added.

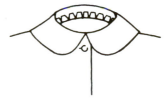

Figure 5.9 When roll is high enough, seam allowance may be turned up.

Figure 5.10 Seam allowance of full-roll collar is turned up between collar layers.

Figure 5.11 If facing is used, seam allowance is turned down under facing.

Figure 5.12 Seam allowance is pressed open on heavy fabrics.

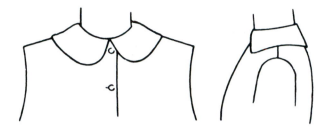

Figure 5.13 Front and side view of the basic flat collar (also called a Peter Pan collar).

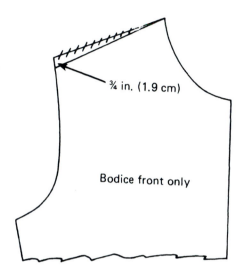

¾ in. (1.9 cm)

Bodice front only

Figure 5.14 Draw new shoulder seamline.

2. Fold and pin the shoulder dart of the bodice back pattern. (Figure 5.15).
3. Pin the bodice back to the bodice front so the back shoulder line matches the *new* shoulder seam of the bodice front.
4. Use a piece of paper large enough to make a collar 3 in. (7.6 cm) wide, and on it trace the center back, neckline, and center front of the bodice patterns.
 Mark the location of the shoulder seamline.
 Be sure that the bodice pattern remains flat while you do the tracing. Allow the back pattern to hump up at the end of the dart.
5. Remove the tracing and complete the outer edge of the collar. For the basic flat collar, measure 3 in. (7.6 cm) from the neck edge and draw a nice curve. (Figure 5.16.)
6. Label the collar. Center back will be a fold line on the straight grain.
7. Cut off excess paper and make two additional copies as you cut out the pattern. One will be used to make a partial-roll collar and one to make a ruffled collar.

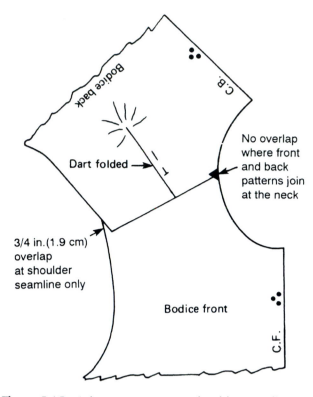

Bodice back

Dart folded

C.B.

No overlap where front and back patterns join at the neck

3/4 in. (1.9 cm) overlap at shoulder seamline only

Bodice front

C.F.

Figure 5.15 Join patterns at new shoulder seamline.

Sewing Suggestion

Do not make this error!

If the shoulder seamlines are matched without overlap, the outer edge of the collar will have a ripple. Note the rip-

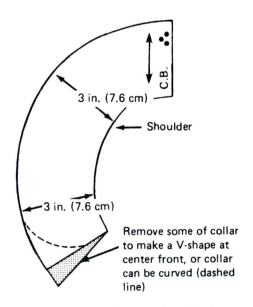

C.B.

3 in. (7.6 cm)

Shoulder

3 in. (7.6 cm)

Remove some of collar to make a V-shape at center front, or collar can be curved (dashed line)

Figure 5.16 Draw curved outer edge of collar.

Figure 5.17 Ripple in collar edge occurs when shoulder seamlines do not overlap enough on the collar pattern.

ple in the edge of the collar in Figure 5.17. The flat-collar fit is directly related to the amount of overlap of the shoulder seamlines in the pattern. This overlapping shortens the outer edge of the collar enough to cause the very small amount of roll needed for the turn at the neckline.

. .

FULL-ROLL COLLARS

Full-Roll Straight Collar

The straight collar is a full-roll collar because it stands up against the neck in the back, folds over, and falls down to cover the neckline seam. No part of the collar hangs down over the bodice at center back (Figures 5.18 and 5.19).

Directions .

1. The full-roll collar is drafted from neckline measurements. To get an accurate measurement of the bodice neckline, stand a bendable plastic ruler on edge and fit it to the bodice neckline. Read the total measurement for the front and back measurements.

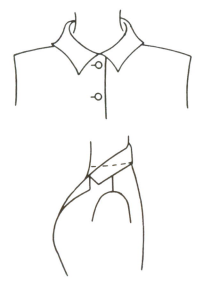

Figure 5.18 Front and side view of basic full-roll collar.

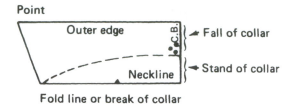

Figure 5.19 Collar fall should be equal to or slightly greater than the stand.

2. Draw a rectangle 3 in. (7.6 cm) wide and as long as the total neckline measurement, *ADEC* in Figure 5.20.
3. Measure and mark the shoulder notch *B*. *AB* is the back neckline, and *BC* is the front neckline. Corners at *A*, *C*, *D*, and *E* are right-angle corners.

 A typical back neckline is approximately 3 in. (7.6 cm), and a typical front neckline is approximately 4 in. (10.2 cm) on the basic sloper. Measure the front and back slopers at the neck edge to find the exact measurement for the size pattern you are working with.
4. Add the collar point *CFE*. The length of *FE* can vary, but it is usually about 1 in. (2.5 cm). This depends in part on the current fashion.
5. Label the collar. Center back is the fold line and usually the straight grain, but for some design effects it can be crosswise grain.

. .

Make five additional copies of this pattern to be used for the convertible collar, stand-up collar, partial-roll collar, shawl collar, and shirt collar. Make an oak tag pattern of this collar as it will be used to make other collars.

Full-Roll Convertible Collar

The convertible collar is made from the full-roll straight collar by changing the straight neck edge to a convex curve. This convex edge is often mistaken for the outer collar edge, so label it properly.

In the actual garment or in a photograph, straight and convertible full-roll collars look much alike unless the

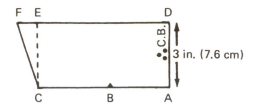

Figure 5.20 Straight full-roll collar pattern.

Closed convertible collar

Open convertible collar

Straight collar

Figure 5.21 Comparison of how the straight and convertible collars fit against the neck. The convertible collar is shown both closed and open.

fabric grain at the neck edge is visible (Figure 5.21). Note that the convertible collar fits more snugly against the neck. For this reason, it is frequently used in designing tailored suits.

Straight and convertible full-roll collars are not used for divided collar designs.

They may be worn either open or closed at the front neckline as shown in Figure 5.21.

Directions ..

1. Start with a copy of the straight full-roll collar. Remove a wedge, CMB, from the neckline edge (Figure 5.22). The wedge should measure at least ¾ in. (1.9 cm) at center front and taper to a point at the shoulder notch.
2. Check the length of the neckline, MB, and if it has changed, remove some of the collar at center front (Figure 5.23). Because the new line MB is a diagonal, it is usually longer than the original neckline. Make line BM equal to line BC in length.

..

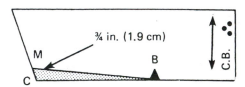

Figure 5.22 Remove wedge from neck edge of convertible collar.

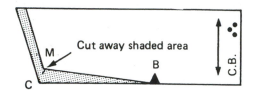

Figure 5.23 Measure neckline *MB* for correct length; note that line *BC* equals line *BM*.

Stand-up or Band Collar

These collars are called stand-up collars because the fall has been removed and only the stand remains.

The basic stand-up collar is also called a Chinese, Mandarin, Nehru, or military collar (Figures 5.24 and 5.25).

Two variations of the stand-up collar are shown in Figures 5.26 and 5.27. When the collar laps over and buttons

Figure 5.24 The true Chinese collar is made on the bias and should be interfaced.

Figure 5.25 Allow 1 to 1½ in. (2.5 to 3.8 cm) for open space at center front of military collar.

Figure 5.26 The stand-up collar overlaps and buttons at center front.

Figure 5.27 Ends of collar are extended and space is allowed at center front for the knot of a bow tie stand-up collar.

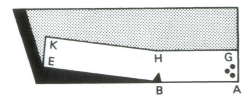

Figure 5.28 Black area shows part removed from full-roll collar to make convertible collar; shaded area shows part of convertible collar removed to make stand-up collar.

or is made as a bow tie, the change is achieved by extending the collar the proper amount at center front. When constructing a garment with a bow tie stand-up collar, leave about ¾ in. (1.9 cm) of space on either side of the bodice center front to allow space for the knot.

Directions

1. Start with a copy of the straight full-roll collar. Make this full-roll collar into a convertible collar as the first step.
2. Sketch line GHK for the upper edge of the collar. Make it 1 to 1½ in. (2.5 to 3.8 cm) above the neckline.
3. Draw line EK at right angles to the neckline. If the design requires a space between the collar edges at center front, take off ½ to ¾ in. (1.3 to 1.9 cm) here.
4. Cut away the fall of the original collar. (See the shaded area in Figure 5.28.)
5. *Round off any angular places* in the neckline.
6. Label the pattern and be sure to indicate which edge is the neckline. Beginners often confuse the two edges, and the result in the finished garment is a collar with ripple instead of a collar that fits snugly against the neck.

Stand-up Collar on a Lowered Neckline

This collar is sometimes referred to as a stovepipe collar. (Figure 5.29.)

Figure 5.29 The stand-up and stand-away collar.

Figure 5.30 Fitting the collar on muslin shell.

Directions

Method I
1. Lower the neckline a small amount and measure. Make a Chinese-type collar for this lowered neckline. If the collar is to be a stand-away as well as stand-up, slash and spread the upper edge 1 in. (2.5 cm)(±).
2. Make a muslin pattern of the collar and attach it to the neckline. Pin in small folds of material, as shown in Figure 5.30, to adjust the size of the neck opening as desired.

Method II
Method II is more effective for a neckline that is lowered a larger amount (Figure 5.31).
1. Join the bodice front and back at the shoulder.
2. Sketch a line for the lowered neckline, cut off this part of the bodice, and slash and spread as shown in Figure 5.32. Extend the upper collar edge 1 in. (2.5 cm)(±).
3. Test the collar in muslin.

The Shirt Collar

The shirt collar, which is made from the full-roll collar, consists of two separate pieces. The stand (or band) of the collar is joined to the fall by a seam (Figure 5.33).

Directions

1. Start with the straight full-roll collar and divide it into two pieces as shown in Figure 5.34. Use 1¼ in. (3.2 cm) at the neck edge for the band of the shirt collar and the remaining 1¾ in. (4.4 cm) for the fall.
2. Put two matching notches on the line where the collar is to be cut apart (Figure 5.34).

Figure 5.31 Stand-up collar on lowered neckline.

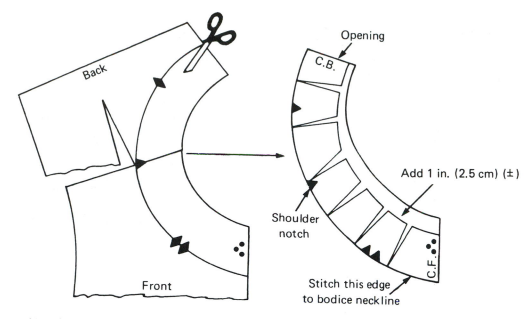

Figure 5.32 Making the stand-up collar from the bodice pattern.

Figure 5.33 The shirt collar.

Figure 5.34 Separate the collar into two pieces of widths indicated.

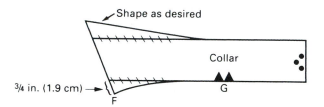

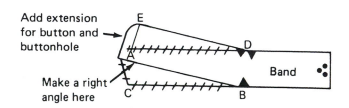

Figure 5.35 Shirt collar pattern.

3. Add to the "collar" section as shown in Figure 5.35. This converts the pattern to a partial-roll type of collar. (Directions for the partial-roll collar are given on page 96.)
4. Convert the band section to a stand-up collar as shown in Figure 5.35. The neck edge will form a convex curve that rises ¾ in. (1.9 cm) above the straight-line neck edge of the full-roll straight collar. (Note that $AB = CB$, and $ED = FG$.)
5. Be sure to *label each edge* so it can be identified easily!

PARTIAL-ROLL COLLARS

Any collar with less roll than the full-roll collar and more roll than the flat collar is called a **partial-roll collar.**

If the collar has rounded points, as in Figure 5.36, it is called a **Peter Pan collar.**

The average partial-roll collar has ⅓ stand and ⅔ fall. (Terms are explained on page 93.) Figure 5.37 compares the neckline of a partial-roll collar with the neckline shape of the other basic collars.

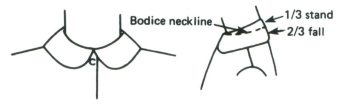

Figure 5.36 Front and side view of the partial-roll collar.

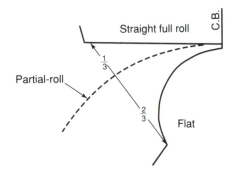

Figure 5.37 Neckline curve that gives ⅓ stand and ⅔ fall to the partial-roll collar.

The partial-roll collar can be made from the full-roll collar or from the flat collar, as explained in the following directions.

These collars are all the same width because they are made from the flat collar. Some width can be added to the partial-roll collar.

Directions

Method I: From the Full-Roll Collar

1. Slash from the outer edge to, but not through, the neckline (Figure 5.38). Spread the pattern and pin to a piece of paper.

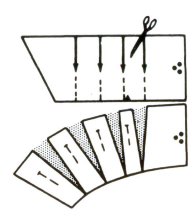

Figure 5.38 Making a partial-roll collar from the full-roll collar pattern.

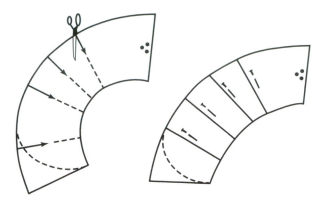

Figure 5.39 Overlap slashed edge of flat collar to make partial-roll collar.

2. Try to make the neckline curve the same as the curve of the partial-roll collar made by Method II. Perfect and label the pattern.

Method II: From the Flat Collar

1. Overlap the cut edges until the neckline curve has been straightened enough to resemble the partial-roll neckline shown in Figure 5.37, about 2½ in. (6.4 cm) for a 1 in. (2.5 cm) stand (Figure 5.39).
2. Pin edges in place and perfect the edges so they are smooth curves. Label the pattern. The outer edge of the collar at center front can be curved or pointed.

Note that Figures 5.38 and 5.39 show four slashes in the pattern. Many slashes will result in a smoother curve, but fewer slashes are easier to manage. Slashes are more effective when they occur at the deepest part of the curve. Make sure that the outer and inner curves are smooth on the finished pattern.

BIAS COLLARS

The Full-Roll Bias Collar

The full-roll bias collar made for the basic bodice neckline is called a **turtleneck collar** (Figure 5.40).

Because the collar opening is in the back, the collar drapes better and fits snugly against the neck when it is cut on the bias of a soft, drapable fabric.

Directions

1. Raise the bodice front neckline about ½ in. (1.3 cm) at the center front edge to keep the collar from standing away from the neck (Figure 5.41).

Figure 5.40 Turtleneck collar.

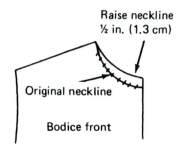

Raise neckline
½ in. (1.3 cm)

Original neckline

Bodice front

Figure 5.41 Raise neckline at bodice front.

2. Make a pattern for the entire collar with these dimensions:

Width = 6 in. (15.2 cm)
(Collar width × 2)
Length = Total neckline
(Pattern neckline × 2)

3. To establish the grainline, fold edge X to meet edge Y (Figure 5.42). This fold will be the diagonal of a square and can be used for lengthwise grain.

. .

The full-roll bias collar may also be designed for the lowered neckline. If the neckline curve is deep at the center front or back, the collar will tend to stand out at right angles to the body. The bias collar on a boat-style neckline will drape like the turtleneck collar. (See Figures 5.43, 5.44, and 5.45, respectively.)

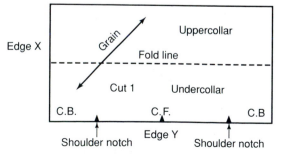

Figure 5.42 Full-roll bias collar.

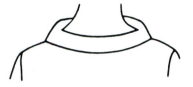

Figure 5.43 Boat-type lowered neckline with bias full-roll collar.

Figure 5.44 Bias cowl collar with neckline lowered in front.

Figure 5.45 Bias roll collar with neckline lowered in back.

The Partial-Roll Bias Collar

When the partial-roll collar is made with the opening in the back, it is usually cut on the bias of the cloth and the pattern for the entire collar is made in one piece.

In a picture or diagram, the bias partial-roll collar resembles the bias full-roll collar. One must observe them closely to differentiate between the two. The partial-roll collar flattens out somewhat at the shoulder. (See arrow in Figures 5.46 and 5.47.)

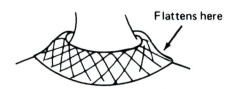

Flattens here

Figure 5.46 Partial-roll bias collar on basic neckline.

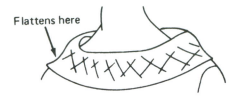

Figure 5.47 Partial-roll bias collar on lowered neckline.

Figure 5.49 Bias tie collar on normal neckline.

Directions

1. Start with the basic bodice neckline as prepared for the flat collar. Retain the center front edge and place it on the fold of a piece of paper, thus doubling the pattern to make the entire collar when it is unfolded.
2. Trace around the bodice neckline to the center back. (The collar opening at the back may be closed by buttons or hooks to hold the two ends of the collar together, or it may be designed with pointed corners and allowed to flatten out in the back.)
3. Design the outer edge of the collar. Remember that the width will be related to the amount of roll. Now slash and overlap the collar at the outer edge until the neckline curve yields the amount of roll desired.
4. Unfold the collar, draw a square around the fold line, and establish grainline as the diagonal of this square (Figure 5.48).

Figure 5.50 Bias tie collar on lowered neckline.

The Tie Collar

The tie collar may be made either on the straight grain or on the bias. Bias-cut tie collars (Figures 5.49 and 5.50) tie better in most fabrics than straight-grain tie collars.

The straight-grain collar is made by extending the center front ends of the stand-up collar by about 16 in. (40.6 cm).

The bias tie collar is made by cutting a strip of cloth on the true bias and making it two times the finished width plus enough for two seam allowances. If it is to be a full-roll type tie collar, cut it about 6 in. (15.2 cm) wide.

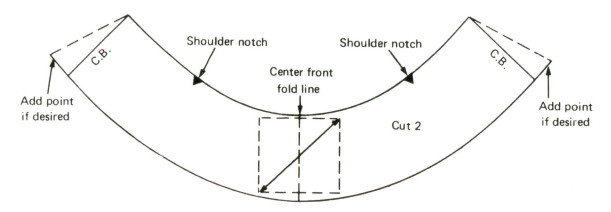

Figure 5.48 Make the partial-roll bias collar in a single layer of muslin and baste it to garment neckline to see how it will roll.

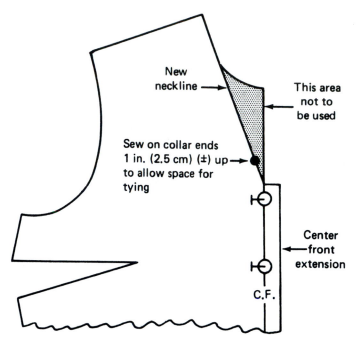

New neckline →

This area not to be used ←

Sew on collar ends 1 in. (2.5 cm) (±) up → to allow space for tying

Center → front extension

C.F.

Figure 5.51 Bodice prepared for full-roll bias tie collar with lowered neckline.

A regular or lowered neckline can be used for the tie collar. Figure 5.51 shows how to lower the neckline for the tie collar pictured in Figure 5.50.

When the collar is long, cutting the cloth with a seam at the center back is more economical. The angle at center back in Figure 5.52 makes it possible to put the seam on the straight grain and gives some shaping to the roll at the back of the collar. The narrowed area is optional, but it does reduce the bulk where the collar ties. The end of the tie can be an angle or a straight line.

Ruffle Collars

The ruffle collar is used on blouses or dresses made of soft fabric. It is constructed according to the directions given here or to geometric techniques.

Ruffle cuffs and cascade ruffles for the garment front can also be made by applying the following method:

Directions ...

1. Use a copy of the flat or full-roll collar. The flat collar is used in Figure 5.53.
2. Slash the collar from the outer edge to the neckline, pin to a piece of paper, and spread until the neckline edge of the pattern becomes a half-circle at the center front. Leave space for a seam allowance in the cloth, as shown in Figure 5.53. Cut from two layers of fabric with center back on a fold.

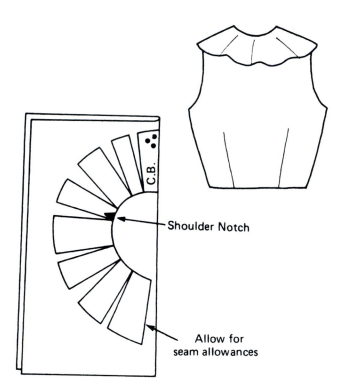

C.B.

Shoulder Notch ←

Allow for seam allowances ←

Figure 5.53 Half-circle collar cut from two layers of cloth on a fold.

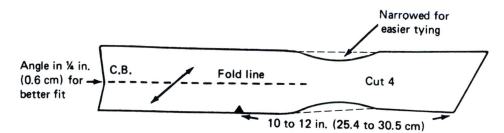

Narrowed for easier tying

Angle in ¼ in. (0.6 cm) for → better fit

C.B.

Fold line

Cut 4

10 to 12 in. (25.4 to 30.5 cm)

Figure 5.52 Full-roll bias tie collar.

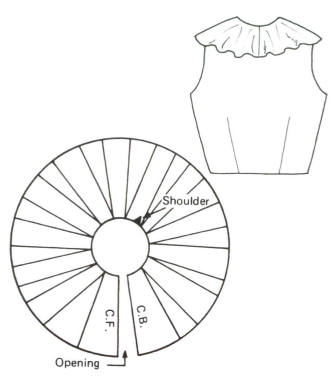

Figure 5.54 This full-circle pattern cut from two layers of cloth has twice as much fullness on the outer edge as the pattern in Figure 5.53.

3. Figure 5.54 shows how to spread the collar to a full circle to provide many ruffles. Cut from two layers of fabric, and seam at center back.

. .

SHAWL OR CUT-IN-ONE COLLARS

The shawl collar is made by joining the collar to the neckline of the bodice front, thus eliminating the seamline there. The back neckline of the collar will still have a seamline (Figure 5.55). (Collars that resemble a shawl but

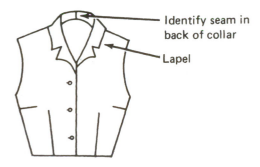

Identify seam in back of collar

Lapel

Figure 5.55 Full-roll shawl collar with notched lapel.

are attached to the neckline by a seam are also called shawl collars.)

A shawl collar can be identified by a seamline at the center back of the collar.

Shawl collars may be made as either full-roll or partial-roll collars.

Variety in the design of shawl collars is achieved by changing the shape of the lapel or by cutting away the fall of the collar.

The Full-Roll Shawl Collar

Directions ·

1. Trace the bodice front on a large sheet of paper. Allow about 6 in. (15.2 cm) above the bodice as space for the collar.
2. Extend the shoulder line as shown by dashed line AG in Figure 5.56. Measure out 3 in. (7.6 cm) along line AG; then measure up ½ to ¾ in. (1.3 to 1.9 cm), and mark point D. Draw solid line AD (Figure 5.57). Lengthen both lines about 1 in. (2.5 cm) so you can see them as the collar is being attached.
3. Use a copy of the straight full-roll collar. Draw a line across the collar width at right angles to the shoulder notch (Figure 5.58).
4. Join the full-roll collar to the bodice so the shoulder notch of the collar meets point A at the shoulder seamline and the line on the collar coincides with line AD. (See Figure 5.59.) Glue or tape the collar in place. Mark out the original necklines.

Figure 5.56 Extend shoulder line.

Figure 5.57 Establish line for joining collar.

Figure 5.58 Prepare the collar.

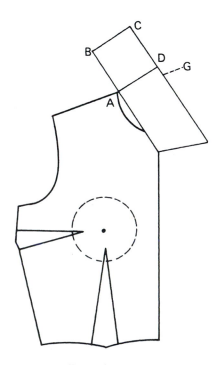

Figure 5.59 Join collar to bodice at neckline.

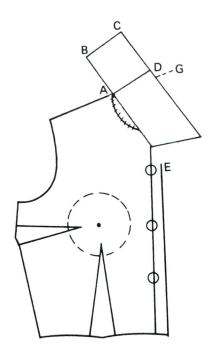

Figure 5.60 Design button and buttonhole closure.

5. Add a center front extension for a button and buttonhole closure. (Review pages 82 to 84.) One button should be near the bustline. The top button will be at the lower end of the lapel (Figure 5.60).

6. Design the lapel shape and complete the pattern. Grainline will be the same as it was in the basic bodice. (Figure 5.61 shows a notched collar lapel and other possible lapel shapes.)

..

Different styles of shawl collars are created by changing the shape of the lapel or by cutting away some of the fall to make a stand-up type collar as illustrated by line *c-c-c* in Figure 5.61.

To visualize how one of these styles will look in the finished garment, fold the collar along the fold line at center back and drape it around your hand with the lapel turned back on the bodice, or drape it on the body in front of a mirror.

The lapel line of the shawl collar should meet the bodice front edge about ¾ in. (1.9 cm) above the top button and buttonhole. See pages 82 to 84 for placement of the buttons and buttonholes.

The Two-Ended Dart

Note that when the collar is joined to the bodice to make the shawl collar, a space appears between the straight edge

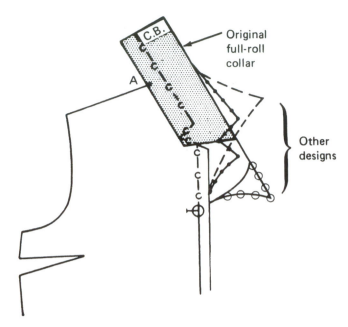

Figure 5.61 Different shawl collar styles are achieved by changing the lapel shape.

of the collar and the curved line of the bodice. This space will result in wrinkles unless it is taken up by a two-ended dart (Figure 5.62). The shawl collar of the finished garment will drape better around the neck when this space has a two-ended dart.

Directions

1. Draw a guideline first from the neckline corner to the center front line where the lapel joins the bodice front.
2. Make the dart ½ in. (1.3 cm) wide at the middle, and taper smoothly to each point (Figure 5.62).
3. The first button should be placed at the lower end of the lapel.

The Partial-Roll Shawl Collar

The method for making the partial-roll shawl collar is essentially the same as that for the full-roll collar with the exception of the back of the collar.

Directions

1. Start with a full-roll collar and draw the line across the collar at right angles to the shoulder notch. Slash the collar from the outer edge to the neckline in the back portion of the collar only (Figure 5.63).
2. Match the right-angle line with line *AD*; then spread the collar not more than a total of 2 in. (5.1 cm) at the

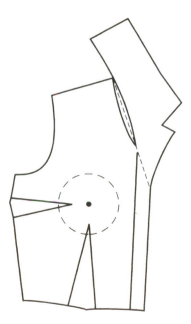

Figure 5.62 The two-ended dart begins at the neck point and follows the roll line.

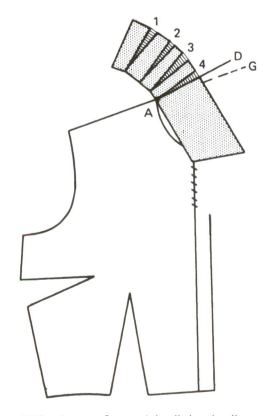

Figure 5.63 Pattern for partial-roll shawl collar.

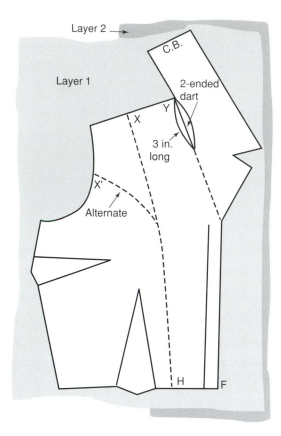

Figure 5.64 Facing pattern for shawl collar.

slashes (1, 2, 3, 4). Fasten in place and continue as for the full-roll collar.

3. As the outer edge of the collar becomes longer and the collar becomes flatter, the top button can be placed closer to the neckline.

Shawl Collar Facings

Directions

1. Place a second piece of paper under the area of the shawl collar to be faced.
2. The width of the facing at *XY* on the shoulder should be about 2 in. (5.1 cm). (See Figure 5.64.)

 The width of the facing at the waistline, *HF*, should be 3 in. (7.6 cm).
3. Sketch dashed line *XH* (or *X'H* for knit suits) as a gentle curve, and transfer it to layer 2 by means of a tracing wheel.
4. Cut off all excess paper and perfect the facing pattern.

Figure 5.65 Shawl collar on lowered neckline.

Shawl Collar on a Lowered Neckline

Study the collar in Figure 5.65 and observe that it *stands away* from the neck. This indicates that the neckline has been lowered. A collar of this kind is more comfortable in summer weather than the shawl collar with a normal neckline.

To lower the neckline for a shawl collar, follow these steps:

Directions

1. For the full-roll shawl collar, limit the amount the neckline is lowered to ¾ in. (1.9 cm) at the shoulder and ¼ in. (0.6 cm) at the center back. The neckline for the partial-roll collar can be lowered more than this.
2. Join the bodice front and back at the shoulder seamlines (Figure 5.66), and sketch a new neckline on both. This will remove the same amount from both shoulder seams to ensure that the two seamlines remain the same length.
3. Measure the new back neckline. It will be longer than it was before, so the collar will need to be made longer.
4. Turn now to the directions for the full-roll shawl collar and make the lowered neckline shawl collar shown in Figure 5.67. Remember that the lapel area *DE* can be varied in design.

The only differences in shawl collar methods for the normal neckline and the lowered neckline are the length of the line *AB* and the place where the collar rectangle is joined to the shoulder seam at *A*.

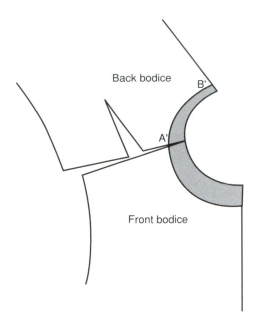

Figure 5.66 Sketch new lowered neckline on joined front and back bodice.

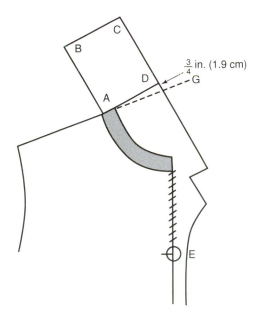

Figure 5.67 Collar *ABCD* is attached to lowered neckline; lapel line *DE* can vary.

COLLAR VARIATIONS

When you understand the basics of making flat, partial-roll, and full-roll collars, you will be able to look at illustrations or photos of different collars and make the patterns for them. Practice problems are at the end of this chapter. Clip interesting collars that you find in magazines or catalogs and sketch your own creative ideas.

Two common collar variations are a full- or partial-roll collar on a lowered neckline and a flat collar on a double-breasted front. Directions for these two collars are given in this section. See Chapter 11 on jackets, Chapter 12 on coats, and Chapter 14 on girls' clothing for other collar variations.

FULL-ROLL OR PARTIAL-ROLL COLLAR ON A LOWERED FRONT NECKLINE

Directions

1. Lower the front neckline the desired amount. Remove the part not used (Figure 5.68).
2. Add the extension for the buttons and buttonholes.
3. Measure the distance from center back to shoulder on the bodice back and the distance from shoulder to the new center front on the bodice front.
4. Draw a rectangle 3 inches (7.6 cm.) wide at center back and as long as the distance from center back to shoulder and shoulder to new center front.
 Add markings for shoulder point, grainline, and center back on fold.
 Add a point to the other edge of the front collar.
 This full-roll collar will have approximately equal rise and fall at the back of the collar.
5. Make a copy of this full-roll collar pattern. To make the collar into a partial-roll collar, slash from the outer edge to the neck edge in four places in the collar back. Spread ½ in. (1.3 cm.) at each of the four slash marks. This completes the partial roll collar that has approximately ⅓ rise and ⅔ fall at the center back. The center back of this collar can be placed on the fold with the grainline parallel to center back. If the grainline is placed perpendicular to the front neck edge it will be necessary to have a seam at center back.

FLAT COLLAR ON DOUBLE-BREASTED FRONT

1. For the double-breasted front, trace both the right and left front patterns (Figure 5.69). Draw the lowered neckline and the extension for the double breast. Cut away the rest of the right front and discard.
2. Trace the upper half of the bodice back pattern. Close the neck dart by slashing from the lower edge to the dart point.
3. On the front pattern, mark off ¾ in. (1.9 cm.) at the shoulder edge. Draw a line from this point tapering back to the neck point.

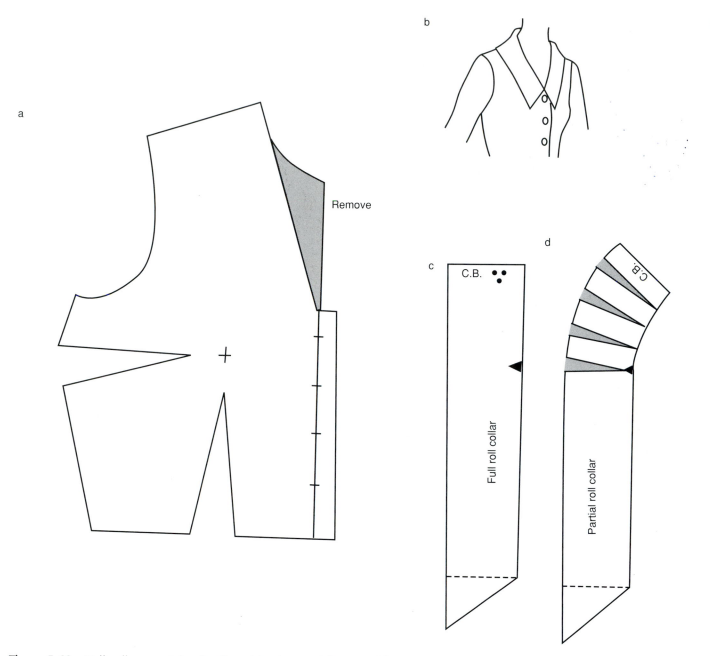

Figure 5.68 Full-roll or partial-roll collar with a lowered front neckline.

4. Place the back collar on the new shoulder line.
5. Draw the back and front collar as follows. The back of the collar should be a straight line with right-angle corners. Design the front collar with a straight bottom edge and right-angle corner near the armhole. Curve the point where the front and back collars join at the outer shoulder seam.

6. This collar can be cut all in one with a fold at center back resulting in a bias front collar. If straight grain is desired in the front collar, add either a center back or shoulder seam to the collar.
7. Mark the placement for the buttons and buttonholes. Make a double-breasted facing for the front and a neckline facing for the back.

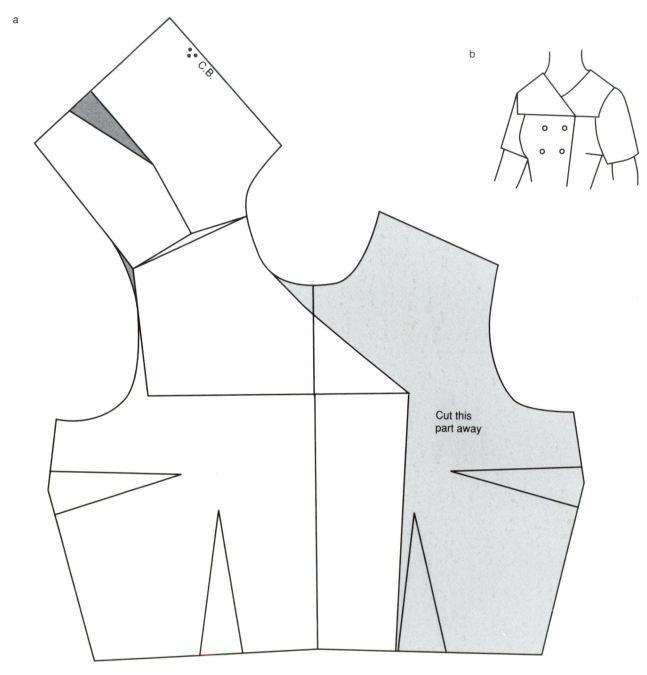

a

C.B.

b

Cut this
part away

Figure 5.69 Flat collar on double-breasted front.

PROBLEMS ...

Make the patterns for several of these collars.

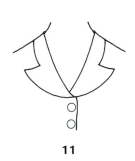

1

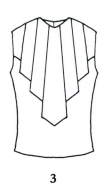

2

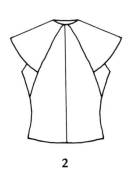

3

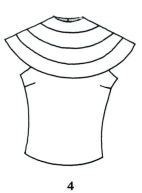

4

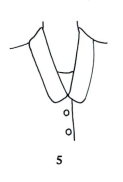

5

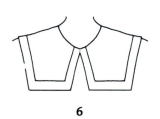

6

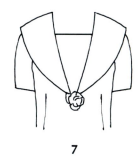

7

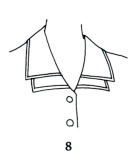

8

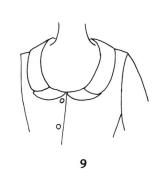

9

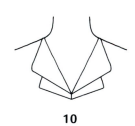

10

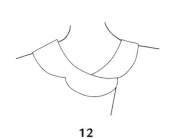

11

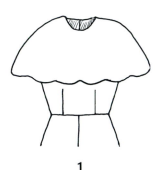

12

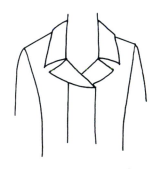

13

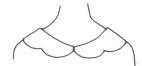

1. Notch collar

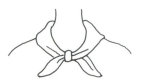

2. Petal collar

3. Collar ends go through loop

4. Collar made from straight strip of fabric pleated to size of neckline

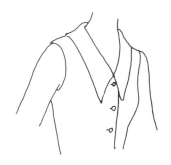

5. Chelsea collar

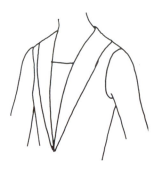

6. V-shaped collar with inset

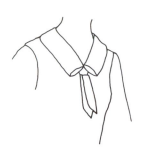

7. Open-end collar on lowered neckline

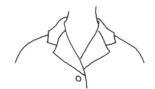

8. Asymmetric design

9. Flip tie collar

10. Scarf collar

11. Collar with open ends

12. Portrait collar

13. Large flat collar

14. Cape collar

15. Ruffle collar

16. Horseshoe collar

6

Skirts

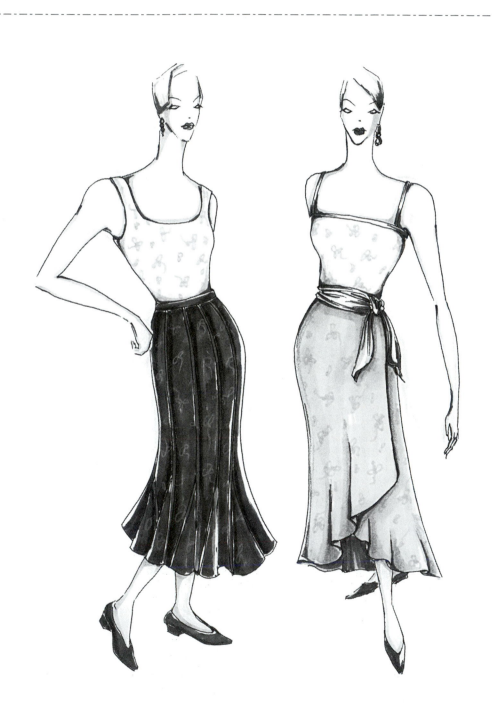

In this text, we classify skirts as basic, fitted, flared, or pleated. Table 6.1, a chart prepared by the Butterick Company, gives typical widths at the lower edge of various skirt, dress, pant, and culotte styles. Refer to this chart as you make patterns for skirts, dresses, and pants.

THE BASIC SKIRT

The basic skirt is a straight* fitted skirt in which the excess fabric above the hipline (or thighline) is controlled by one or two fitting darts in both back and front patterns, and also by a fitting curve at the side seamline. (See Figure 6.1.)

The area below the hipline (or thighline) is a rectangle. The side seams should therefore be drawn with a yardstick so they will be *straight lines*.

.

*The basic skirt may also have up to 2½ in. (6.4 cm) of flare at the side seamline.

Table 6.1 **Typical Skirt and Pant Widths at Hem***

Description	Dresses and Skirts (width at lower edge)	Pants and Culottes (width of each leg)
Tapered	34¼–26¼ in.	13–17⅞ in.
Straight	36½–44 in.	18–22 in.
A-line	44⅛–65 in.	Not applicable
Slightly flared	65⅛–85 in.	22⅛–26⅞ in.
Flared	over 85 in.	over 27 in.

Source: Butterick Company, Inc., 161 Avenue of the Americas, New York, NY 10013.

*A basic skirt is straight from hipline to hemline but can have some flare at hemline.

Figure 6.1 Commercial basic skirt pattern.

Figure 6.2 Hipline of the body.

The curved line from waist to hip (or thigh) is the fitting line, and the shape of the curve is related to the shape of the body.

Fitting darts or their equivalents are a necessary part of the skirt. They cannot be eliminated.

Two darts in each skirt pattern piece usually give a smoother fit than a single dart. This is especially true in firm, crisp fabrics. Inexpensive ready-made skirts are often constructed with one dart only because this takes less time to sew.

Half-scale and fourth-scale slopers are provided in Appendix A.

The hipline of the commercial pattern is 7 or 8 in. (17.8 to 20.3 cm) below the waistline. Body shape varies, however, so this distance may range from 5 to 10 in. (12.7 to 25.4 cm) on a personal pattern.

To determine the location of the hipline on the body, measure from the waist to the roundest part of the hipline *in the back* as shown in Figure 6.2.

To locate the hipline on the personal pattern, follow these steps:

Directions .

1. Start with the pattern back. Measure down the center back line and mark the hipline location. Draw the hipline at right angles to center back.
2. On the front, start at the side seam. Make the distance from waist to hip the same on both pattern pieces; then *square* a line from center front through this side seam hipline mark (Figure 6.3).

. .

If you measure the basic commercial skirt pattern, you will find that the side seamline of the skirt is usually ½ in. (1.3 cm) longer than the center back line and the center front is usually ¼ in. (0.6 cm) longer than center back.

If the buttocks protrude in the back (Figure 6.4), the center back line will be longer than the other vertical lines of the skirt. If the abdomen protrudes and the buttocks are

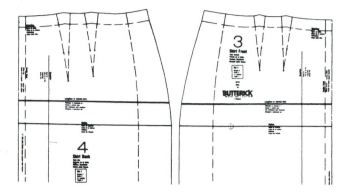

Figure 6.3 The hipline is a squared line that matches at the side seamline.

Figure 6.4 If buttocks protrude, center back line should be longer than other vertical lines of skirt.

somewhat flat and shapeless, the center front seamline will be longer than the center back seamline.

SKIRT DARTS

Number of Darts

Many skirts have four darts in front and four darts in back. Other skirts have just two front darts and two back darts. The one-dart sloper resulting in two darts is commonly used to make ready-to-wear skirts because it takes less time to sew. However, the two-dart sloper resulting in four darts will usually give better fit, especially to the skirt back, where the body is more rounded.

Dart Length

Skirt front darts are typically 2½ to 3½ in. (6.4 to 8.9 cm) long.

Skirt back darts extend down to within 2 in. (5.1 cm) of the hipline (Figure 6.5).

Pivot Points

The curves of the body in the hip area are flattened, so no well-defined location exists for the pivot point of the skirt pattern.

Locate the pivot point for each dart halfway between the tip of the dart and the hipline. Place it directly in line with the middle of the dart.

If more than one dart is present, locate a pivot point for each dart.

Figure 6.5 Dart length.

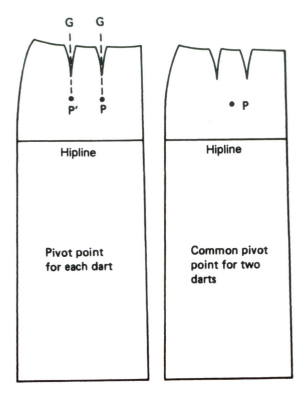

Figure 6.7 Dart with inward curves

Figure 6.6 Pivot points for skirt front pattern are located halfway between the tip of the dart and the hipline.

Sewing Suggestion.................................

Note in Figure 6.7 that the dart is actually shortened when the lines are curved inward. If you want the dart to appear longer in the finished garment, stitch for a distance along the fold of cloth (Figure 6.8).
..

Darts in Relation to Waistline Size

A dart gets wider as it gets longer. (Remember, however, that the angle at the point does *not* get larger.)

As a waist dart gets wider, it decreases the waistline size at the cut edge of the fabric.

Note the decrease in waistline size at the cut edge in Figure 6.9 as the dart goes from the sewing line ← B →

If the two darts are to be moved by pivoting or slashing, a common pivot point should be established midway between the two (Figure 6.6).

Darts are usually lengthened to the pivot point when they are to be converted to flare or to seamlines.

Dart Shape

Dart shape has an important effect on garment fit. The lines of the dart can be *shaped* to conform to the shape of the body. For the person whose hips are rounded just below the waistline, use a dart with concave lines (inward curves). (See dashed lines in Figure 6.7.) The curved dart takes up less fabric and provides more room for the rounded figure. You can calculate the increase in circumference that results from a curved dart. If ⅛ in. (0.3 cm) is gained on each side of the dart, the dart would give ¼ in. (0.6 cm) more room. If four darts are curved, an additional 1 in. (2.5 cm) of space would be provided.

Figure 6.8 Stitching a curved dart to make it longer.

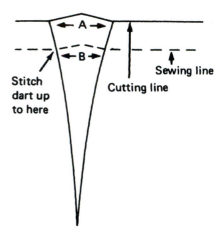

Figure 6.9 Dart stitching vis-à-vis waist size.

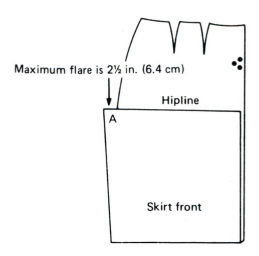

Figure 6.10 Determining amount of flare in a fitted skirt.

to the cutting line ← A →. To maintain correct waist size, do *not* stitch the dart from ← A → to ← B →. The seam allowance should be free to spread open during fitting.

Sewing Suggestion

If a skirt or bodice seems tight at the waistline during fitting, check to see how far the darts have been stitched in the seamline.
...

FLARE AT THE SIDE SEAM

The basic skirt may be a straight skirt (i.e., a rectangle from the hipline down), or it may have up to 2½ in. (6.4 cm) of flare added at each side of the seamline (Figure 6.10). When flare or fullness is added *below the hipline only*, a skirt is still a **fitted** skirt. When a skirt has fullness added *above the hipline*, it is no longer a fitted skirt. It becomes a **flared** skirt.

Flare should not be confused with garment ease, which is the difference between body and garment size that allows for comfort.

To add flare to the basic pattern, use the following method:

Directions ...

Slash the pattern from hemline to hipline at the side seam as shown in Figure 6.11. Spread from ½ to 2½ in. (1.3 to 6.4 cm). Fill in with paper and complete the pattern.
...

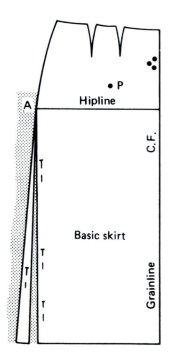

Figure 6.11 Slash and spread for flare.

DART DESIGNS: FLARE

Skirt darts originate in the waistline seam of the basic pattern. Like the darts of the bodice, skirt darts can be used to create many designs. They can be

- Converted to seamlines or flare
- Moved within the area above the hipline
- Converted to gathers or pleats in the same area

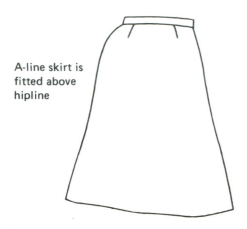

A-line skirt is fitted above hipline

Figure 6.12 One dart only is converted to flare.

CONVERTING DARTS TO FLARE

Either the slash method or the pivot method can be used to convert darts to flare to make the A-line skirt pattern.

Directions for Slash Method

1. If only one dart is to be converted to flare, retain the center dart because it matches the bodice dart (Figure 6.12).
2. Use a paper pattern and lengthen the side dart to its pivot point. Draw a slash line from the hemline up to the pivot point. Slash to, but not through, the pivot point, as indicated in Figure 6.13. Slash along the side dart to the pivot point.
3. Close and pin the dart, and the skirt will spread apart in the hemline to provide an equivalent amount of flare. Complete the pattern.

...

Directions for Pivot Method

1. Use the pivot method as shown in Figure 6.14. Thumbtack the sloper to the pivot point P' below the dart that is closest to the side seam.
2. Start at point A and trace around the part that remains unchanged.
3. Close side dart CD and finish drawing the waistline, side seam, and hem.

...

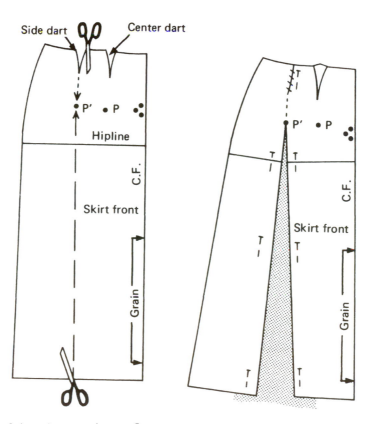

Figure 6.13 Slash method of changing one dart to flare.

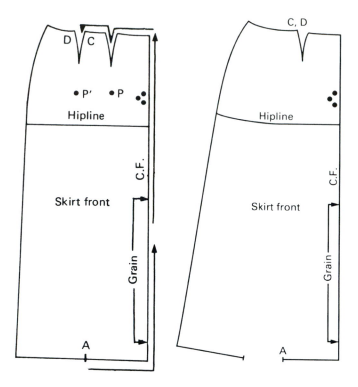

Figure 6.14 Pivot method of changing one dart to flare. As flare is added, waistline, hipline, and hemline become curved lines.

OPEN-END DARTS

Open-end darts give a V-like effect in the design (Figure 6.15).

Directions .

1. Combine the darts, and fold the new dart.
2. Mark crosswise on the folded dart at the place where the stitching is to end.
3. Cross off the rest of the dart.
. .

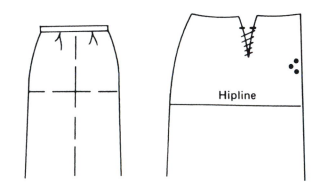

Figure 6.15 Open-end dart.

TROUSER PLEATS

Directions .

1. Slash through the middle of the darts and extend to, but not through, the hemline.
2. Spread ½ to 1 in. (1.3 to 2.5 cm) at the hipline (Figure 6.16).
3. Fold *on the original dart lines*.
4. Perfect the waistline.
. .

Sewing Suggestion .

When constructing the garment, baste the dart shut on the original dart lines. After fitting the garment and stitching the waistline, remove the basting. This is important if the pleats are to drape properly and not spread open more than intended by the design.
. .

MOVING AND COMBINING SKIRT BACK DARTS: SLASH METHOD

Do *not* attempt to do skirt dart designing until you have learned how to design with bodice darts. The directions

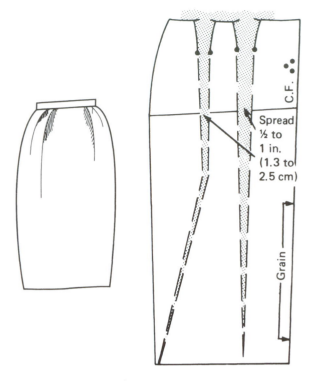

Figure 6.16 Trouser pleats.

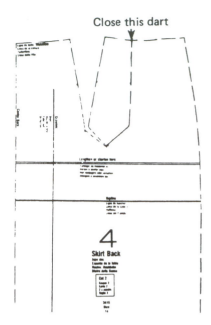

Figure 6.17 Side dart in skirt back is closed.

given here are abbreviated on the assumption that you have acquired a background knowledge of darts from the bodice patternwork.

The slash method of moving skirt back darts is presented because it is used more often in skirt patternwork than the pivot method.

Directions for Combined Darts

1. Establish a common pivot point.
2. Slash along one side of each dart to, but not through, the pivot point. Close the side dart (Figure 6.17).
3. Figure 6.18 shows the new combined dart (see dashed lines). The new dart can be made slightly longer.
4. Back darts can also be converted to gathers.
...

MOVING AND COMBINING DARTS: PIVOT METHOD

Review the procedures for moving bodice darts by the pivot method, and study the design in Figure 6.19.

Establish a common pivot point on the skirt sloper and thumbtack to a suitable surface. Follow the steps given in the following directions. (Be sure the dart is long enough for smooth fit.)

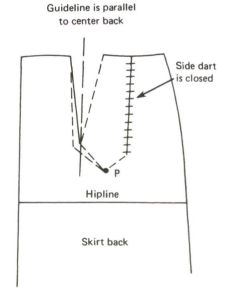

Figure 6.18 Drawing the combined dart.

Directions ...

1. Mark the location of the new dart A′ on the sloper (Figure 6.20). Trace from A′ clockwise around to the side dart, and pivot the pattern to close the side dart.

Figure 6.19 Design for moving darts.

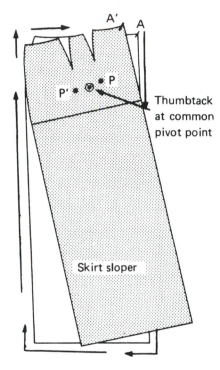

Figure 6.20 Mark location of new dart *A* on sloper.

2. Trace between the darts. Pivot again to close the center dart (Figure 6.21). Finish tracing the sloper, and then remove the sloper.
3. Mark a pivot point *P* (use thumbtack hole) and draw the guideline *GP* (Figure 6.22). Draw the pivot circle with a radius of 1 to 1½ in. (2.5 to 3.8 cm). Draw the new dart to, or slightly within, the circle.
4. Complete the pattern by flat-pattern methods.

MOVING AND DIVIDING FRONT DARTS: SLASH METHOD

Study the drawings in Figures 6.23, 6.24, and 6.25 as you apply the following directions.

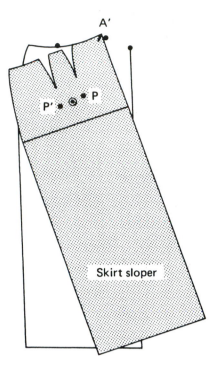

Figure 6.21 Pivot again to close center dart.

Directions

1. Start with a paper pattern and draw lines to indicate the position of the new dart.
2. Slash along new and old dart lines. Slash to the pivot point.

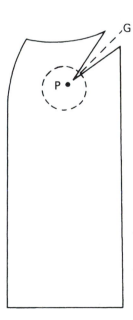

Figure 6.22 Draw guideline *GP* at middle of new dart.

Figure 6.23 Design for moving darts.

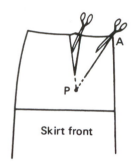

Figure 6.24 Design line for new dart.

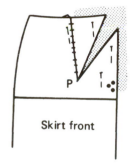

Figure 6.25 Slash and then close dart to be moved.

3. Close and pin (or tape) the old dart.
4. Pin (or tape) the pattern to a piece of paper and draw the new dart or dart lines.
5. Complete the pattern by standard flat-pattern procedures and add appropriate labels.

..

CONVERTING DARTS TO GATHERS

The three designs in Figure 6.26, 6.27, and 6.28 have different amounts of gathers. Gathers can be used in the skirt front only, the skirt back only, or both skirt front and back.

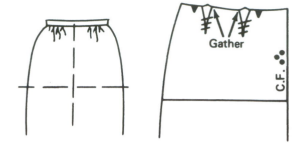

Figure 6.26 Convert darts to gathers.

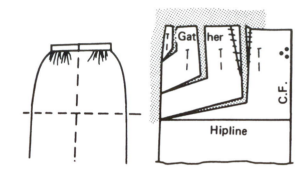

Figure 6.27 Added fullness.

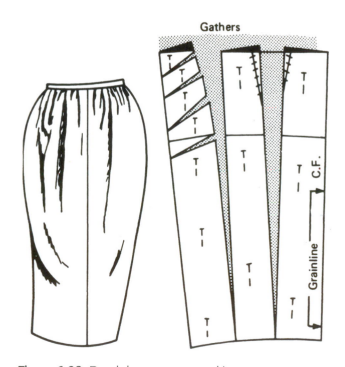

Figure 6.28 Dutch boy or peg top skirt pattern.

Directions ..

1. In Figure 6.26, all the gathers are made from the skirt darts, so the gathers are dart equivalents. Cross out the dart lines, label for gathers, and complete the pattern.
2. In Figure 6.27, the gathers are made from the darts and from fullness added above the hipline. Cross out the dart lines. Slash and spread above the hipline as shown on the pattern. Pin the slashed pattern to paper, perfect the waistline, and label for gathers.
3. In Figure 6.28, the gathers are made from the darts and from fullness added from waist to hemline. Cross out the dart lines. Slash the pattern from waist to hemline, and spread 2 to 4 in. (5.1 to 10.2 cm) at the hipline.

 Use horizontal slashes to straighten the fitting curve of the hip into a straight line.

 Perfect the waistline and label for gathers.

 The hemline becomes a curve and must be faced.
...

YOKES

Rule ..

A fitting dart cannot be eliminated!
...

In the analysis of any design, you must be able to show where and how the darts have been used.

The dashed line in Figure 6.29a shows the original position of the dart. In Figure 6.29b, the dart was converted to the horizontal yokeline and is now located in the section labeled *AP*.

The yokelines in Figure 6.30 are not dart equivalents. In Figure 6.30b, the darts have been shortened and then converted to gathers.

The darts in Figure 6.31a are still there as the original darts.

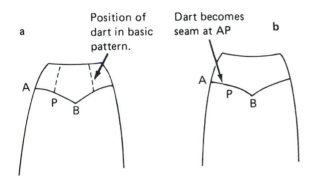

Figure 6.29 Darts converted to seamline of yoke.

Figure 6.30 Darts shortened by yoke.

Figure 6.31 (a) Darts retained and (b) one dart retained and one converted to vertical seamline of yoke.

Note that a dart cannot be lengthened *beyond* its pivot point. The yokeline here is below the pivot point of the darts.

One dart in Figure 6.31b has been converted to seamline and is now located in the vertical seamline portion of the yoke.

POCKETS

There are three layers of fabric in the area of the skirt pocket, so the three-layer method of pattern making is used.

Directions ..

1. Place two layers of paper under the pocket area of the skirt and pin as shown in Figure 6.32. Cut off any excess paper.
2. Design solid line *AB* and dashed line *CD*. Determine the approximate pocket length by using your hand as a guide. The pocket length is the distance from the wrist to the fingertips. The width is the hand width with fingers slightly spread apart. Trace these lines with a tracing wheel. Draw a grainline in the pocket area and parallel to the center of the skirt.

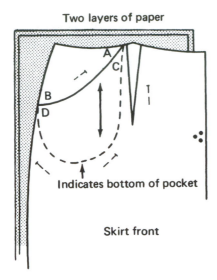

Figure 6.32 Pin two layers of paper under pocket area of skirt.

3. Cut layers 1 and 2 on the solid line, and cut layers 2 and 3 on the dashed line. This will cut away the remaining excess paper under the skirt pattern.

4. Tape the original skirt pattern piece to the yoke pocket pattern as shown in Figure 6.33.

5. If the pocket is to stand out somewhat, slash the pocket facing and slash the skirt as shown in Figures 6.33 and 6.34. Spread and pin to a piece of paper. Check to be sure that lines AB and A′B′ are the same length. Perfect the seamlines. If the pocket is to fit flat against the skirt, omit this step.

6. Complete the pattern. Check to see that the two pocket pieces are the same length at the lower edge. Pockets can also be cut straight across the bottom edge.

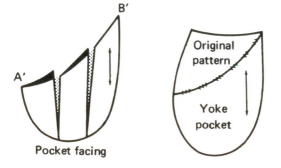

Figure 6.33 Tape original skirt pattern to yoke pocket pattern.

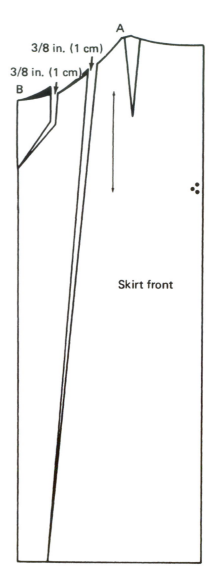

Figure 6.34 Slash skirt and pocket facing (see Figure 6.33) to make pocket stand out.

GORED SKIRTS

The dictionary defines a **gore** as any tapering piece of cloth used to give varying width to a garment. Each gore adds width to a garment. Each gore adds extra seamlines. Indeed, seamlines are a design feature of the skirt and give an impression of height to a short figure.

Gored skirts are named according to the number of gores. The two-gore skirt has two gores and two seams (Figure 6.35). The four-gore skirt has four gores and four seams (Figure 6.36). The six-gore skirt has six gores and six seams (Figure 6.37), and so on.

Figure 6.35 Basic two-gore skirt.

Figure 6.37 Basic six-gore skirt.

Figure 6.36 Basic four-gore skirt.

Combinations are possible, but each part retains its identity. For example, the front four-gore pattern may be used with the back six-gore pattern. This does not, however, make a five-gore skirt.

The designs shown here illustrate the fact that gored skirts can be as slim and as straight in silhouette as the basic two-gore. The fitted skirt of each gore style is the basic skirt for that style and serves as the starting pattern for flat-pattern designing. Many variations are possible.

Each seamline of the skirt provides a place to add some flare that will give more sitting room or more room for large thighs.

If only 1 or 2 in. (2.5 to 5.1 cm) of flare is added to each seamline, the skirt is still basic in design.

If flare is added below the pivot point only, the skirt is still considered **fitted**.

Grain

The vertical direction of the skirt pattern is usually placed on the lengthwise grain of the fabric, since most fabrics are stronger, less stretchy, and drape more softly in this direction. Crosswise or bias positions are used to achieve certain design effects as with stripes, border designs, or stiffer drape.

Three lengthwise grain positions for the flared skirt are shown in Figure 6.38.

Pattern 1 has the center front placed on a lengthwise fold. This part of the skirt will hang straight, and the fullness or flare will hang at the sides of the body as shown in Figure 6.39. The result is a wider silhouette that is less flattering to the stocky figure. Advantages of this skirt design would be fewer seams to construct and more economic use of fabric in this pattern layout than is possible with pattern 2. The bias fabric at the side seams may stretch, however, resulting in an uneven hemline after washing or dry cleaning.

Pattern 2 has the straight lengthwise grain in the center of the gore. The fullness thus hangs evenly around the skirt, so the hemline is less likely to be uneven (Figure 6.40).

Pattern 3 has the straight grain at the side seam, so the fullness hangs at the center of the skirt. The center seam, being on the bias, will tend to stretch more than the straight-grain seam at the sides (Figure 6.41).

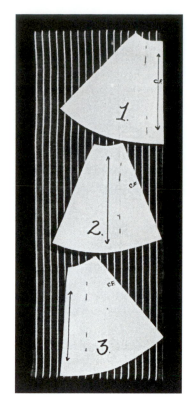

Figure 6.38 Three lengthwise grain positions.

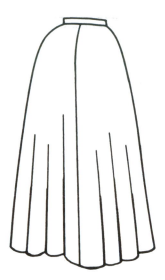

Figure 6.40 Straight grain in center of panel as in pattern 2.

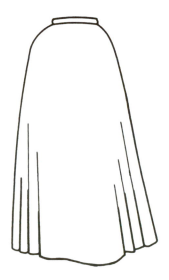

Figure 6.39 Straight grain at center front as in pattern 1.

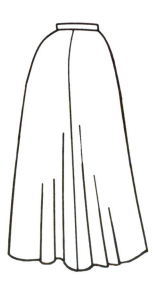

Figure 6.41 Straight grain at side seam as in pattern 3.

The Basic Four-Gore Skirt

Although the basic skirt can be made into a skirt with four gores by changing the center fold line to a seam, this design is not a true four-gore skirt unless some of the fitting dart is converted to seamline.

Figure 6.42 shows a pattern for a basic four-gore skirt. In this pattern, one dart has been moved to center front and converted to seamline there. The second dart has been moved to a position that maintains the center panel width. The remaining dart thus matches the dart in the bodice.

The skirt has been slashed and spread to add a basic amount of flare—up to 2½ in. (6.4 cm).

Grainline should be the same as it was in the basic skirt. Draw it parallel to center front *before* adding any flare.

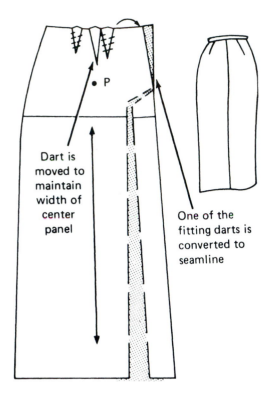

Figure 6.42 Basic four-gore pattern.

Dart is moved to maintain width of center panel

One of the fitting darts is converted to seamline

• P

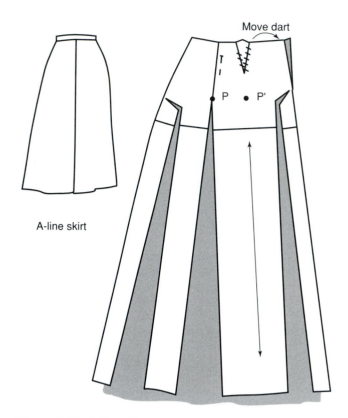

A-line skirt

Move dart

P P'

Figure 6.43 A-line skirt pattern.

The A-Line Four-Gore Skirt

The A-line four-gore skirt has more flare than the basic four-gore but is still *fitted above the pivot point* (Figure 6.43).

All of the dart can be converted to flare if desired.

When flare is added at the side seam, be sure to maintain good side seam shape.

The Flared Four-Gore Skirt

When flare is added *above* the pivot point, the skirt is no longer fitted, so it is referred to as a **flared skirt**.

In the flared four-gore skirt in Figure 6.44, the flare extends to the waistline. Study the flareline of the design (1, 2, 3 in Figure 6.44) to see how high the flare goes.

As the skirt becomes less fitted, the fitting curve at the hipline becomes less important. The horizontal slashes shown in Figure 6.45 are one way to straighten the side seam.

Note that this skirt has the grainline in the center of the gore because equal amounts of flare have been added at each side of the grainline.

Estimating the amount of flare to add to a skirt can be rather difficult. Table 6.2 will serve as a starting point.

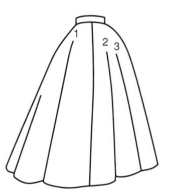

Figure 6.44 Flared four-gore skirt.

Table 6.2 Amount of Flare to Add

Type of Skirt	Inches at Hemline
Basic	35 to 50 (0.9 to 1.3 m)
Moderate flare	50 to 100 (1.3 to 2.5 m)
Full flare	100 to 180 (2.5 to 4.6 m)
Circular	±240 (6 m)*

*Depends on length of skirt.

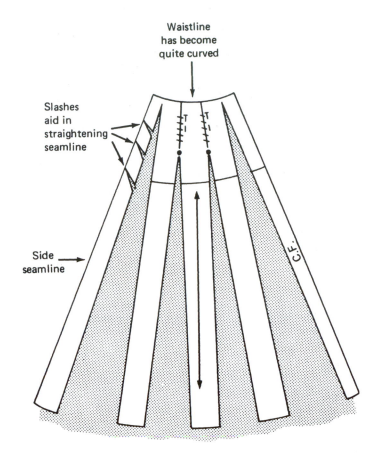

Figure 6.45 Pattern for flared four-gore skirt.

The Basic Six-Gore Skirt

The seams of the six-gore skirt are flattering to the short person because they give an impression of height. The addition of as little as ½ in. (1.3 cm) of flare at each seam will provide enough sitting room to reduce the possibility of bagginess in the back of the skirt. Note that ½ in. (1.3 cm) added on each side of six seams equals 6 in. (15.2 cm) at the hemline. Skirt flare is good for the person with large thighs.

Perspective

To make the gore lines look parallel as they do in Figure 6.46, the center panel of the skirt must be *wider at the hem* than it is at the hip. If the pattern for the center panel is of parallel width from hip to hem, the panel will appear to be wider at the hip, and this is not flattering to most figures.

Amount of Flare

The same amount of flare is usually added at each side of the six-gore seamlines. The seam edges are thus on the

Note straightness of silhouette

Figure 6.46 Basic six-gore skirt.

same bias of the cloth. This makes the flare hang uniformly on both sides of the seam and facilitates the matching of plaids. For the fitted six-gore skirt, add ½ to 2½ in. (1.3 to 6.4 cm) at each side of the gore seamlines. Add also at the side seam if desired.

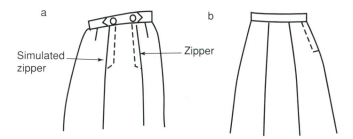

Figure 6.47 (a) Zipper in six-gore seamline topstitched for decorative effect. (b) Six-gore skirt with a side zipper.

More flare can, however, be added to one side of a seam than to the other. Flare can even be added on one side only if desired.

Skirt Closure

The zipper (or other closure) is usually at the side seamline in a six-gore skirt. It cannot be at center front or back. The zipper can be put in a six-gore line and becomes a decorative feature if topstitching is used at both seams to balance the design (Figure 6.47). The waistband can also be a decorative feature.

Directions

1. Start with the basic skirt pattern and locate pivot points P and P'. (See page 112.)
2. Lengthen the front waist-fitting dart to pivot point P.*
3. Draw a guideline from the tip of the dart (Figure 6.48) to the hemline. Make the line parallel to center front (or back). This line will be the six-gore seamline.
4. Mark matching notches on the seamlines as follows:
 - One notch on side seamlines
 - Two notches on front gore lines
 - Three notches on back gore lines
5. Draw a grainline in the side section of the skirt. The grainline will be parallel to center front. Label the grainline (Figure 6.49).
6. Draw dashed lines on each side of the guideline to indicate where the pattern should be slashed to add flare. Connect these dashed lines to point P (Figure 6.49).
7. The front waist dart will be converted to seamline, so shade it to indicate that it will not be used. The side dart remains as part of the pattern.
8. Separate the pattern into two pieces by cutting along the guideline and the left side of the front dart. Fold the dart under to convert it to seamline.
9. Cut along the dotted lines to the pivot point P. Spread the pattern a minimum of ½ in. (1.3 cm) to a maxi-

.
*The middle of the center dart is parallel to center front (or back).

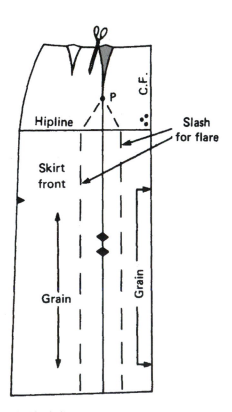

Figure 6.48 The guideline. Lengthen dart to the pivot point when converting a dart to a seam.

Figure 6.49 Slash lines.

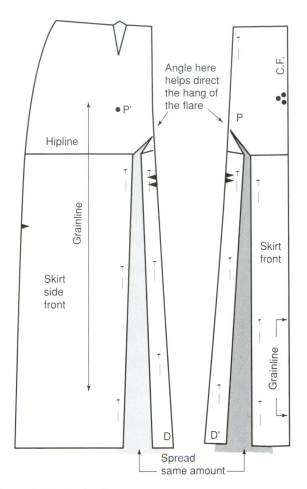

Figure 6.50 Basic six-gore pattern.

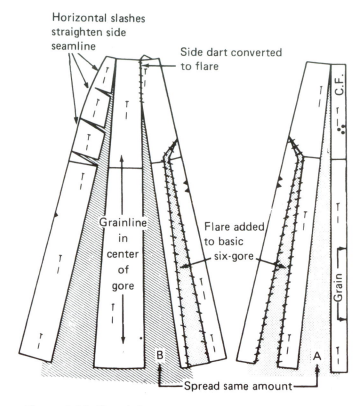

Figure 6.51 Flared six-gore pattern.

mum of 2½ in. (6.4 cm) for a basic six-gore skirt with a straight silhouette. Add the same amount of flare to the center front panel as you do to the side front panel.

10. After spreading the pattern, pin (tape or glue) to an underlay of paper (Figure 6.50).
11. Finish the hemline as a smooth curve and cut off excess paper.
12. Complete the pattern with adequate labels and markings, including "Skirt front" and "Skirt side front" notations.

...

The Flared Six-Gore Skirt

Directions ...

1. Start with a paper basic six-gore pattern and convert the side dart to flare.
2. Slash the pattern from the hemline to, but not through, the waistline in one or more places depend-

ing on the amount of spread desired. Several slashes give a smoother waistline curve (Figure 6.51).
3. Make two or three horizontal slashes to permit the side seamline to be straightened, because the fitting curve is not needed when flare is added *above* the pivot point. (Note the increased curve in the waistline.)

...

Combining a Bodice and Skirt with a Widened Center Gore

The designs in Figures 6.52, 6.53, and 6.54 each have a center panel that is wider than the panel of the basic six-gore skirt. Note that the widened center gore matches the vertical design lines of the bodice.

Use the muslin skirt shell to determine the most becoming width. The panel of the basic six-gore garment is 6 to 7 in. (15.2 to 17.8 cm) wide at the hipline, so the pattern is 3 to 3½ in. (7.6 to 8.9 cm) wide.

Directions ...

1. Combine and move the darts to the desired location for the wider panel.

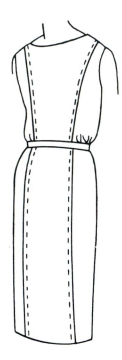

Figure 6.52 Topstitched center panel.

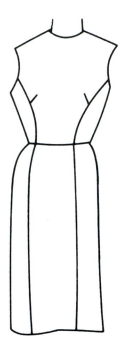

Figure 6.54 Six-gore skirt seams match seams in bodice.

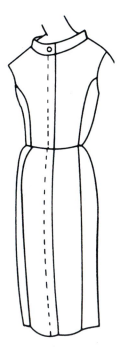

Figure 6.53 Lapped seam opening at center front.

2. Proceed as you would for the basic six-gore pattern.
3. Remember that the bodice darts have to be moved so they match the wider center panel.
4. Topstitching, piping, cording, and slot seams are seam-line treatments that add interest to this design. (In

plaid fabric, a bias piping in the seam or bias side panels will simplify the problem of matching plaids exactly.)

. .

The Simulated Six-Gore Skirt

The skirt front design in Figure 6.55 appears to be a six-gore skirt, but is in reality a skirt with lengthened and enlarged darts. The back of the skirt may be similar in design to the front, or it may be the basic two-gore, four-gore, or six-gore.

Consider the location of the zipper opening before deciding on a style for the skirt back.

Figure 6.55 Lengthened and enlarged darts give impression of gores.

Figure 6.56 Slash to, but not through, hemline.

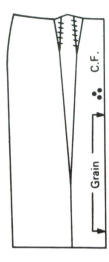

Figure 6.58 Pattern for skirt with lengthened darts.

Directions

1. Use a basic skirt pattern with one fitting dart. Widen the center panel if desired.
2. Slash through the dart to, but not through, the hemline (Figure 6.56).
3. Spread the pattern so the width of the waistline dart is about 4 to 6 in. (10.2 to 15.2 cm). Pin to a large sheet of paper (Figure 6.57).

4. Establish a new dart tip about 4 in. (10.2 cm) above the hemline. Do *not* include hem allowance in the 4-in. measurement.
5. Use the original dart lines and extend them down to the dart tip.
6. Complete the pattern by flat-pattern procedures (Figure 6.58).

The Godet Effect with Added Flare

The **godet** is a triangular piece of fabric sewn into a vertical seam in the lower part of the skirt. See problem 5, page 144. A similar effect can be achieved by the addition of flare at joining seamlines.

Godetlike flare gives a graceful effect because of the asymmetrical lines achieved when flare is added at different heights on either side of a seamline (Figure 6.59).

Although such styles come and go in fashion cycles, making the godetlike flare is a good way to learn the principles involved in adding flare near the hemline.

Study the design in Figure 6.59 and observe that the line that indicates flare in the side panel extends higher than the flare line of the adjacent front gore. These lines give an indication of length and location of the slash lines.

Directions

1. Make a completed six-gore skirt pattern. Slash as indicated by dashed line *DE* in the side gore and *D'E'* in the center gore of the pattern in Figure 6.60.
2. Spread the pattern 2 in. (5.1 cm) or more at each slash and pin to a piece of paper. (See Figure 6.61.)

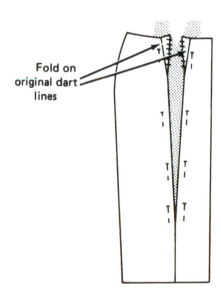

Figure 6.57 Spread pattern and pin to large sheet of paper.

Fold on original dart lines

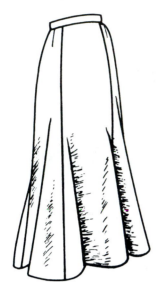

Figure 6.59 Godetlike flare.

3. The seamline will now have an angle at points *E* and *E′*. Godet flare can be added to the side seams also.
4. Complete the pattern.
5. A variation to this pattern is having line *DE* and line *D′E′* the same length before adding flare.

..

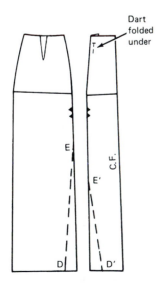

Figure 6.60 Lines for slashing.

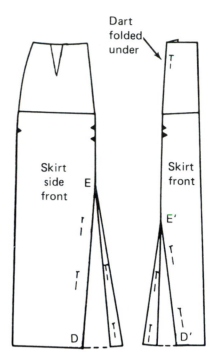

Figure 6.61 An angle is formed at points *E* and *E′*.

Sewing Suggestion

Do *not* clip the seam allowance of the garment at *E* and *E′*, because tension on the seamline controls the drape of the flare.

..

Skirt with Godets (Figure 6.62)

Godets are triangular-shaped wedges of fabric sewn between seams to add more flare at the bottom of the skirt. The height and bottom width of the godet can vary depending on the drape of the fabric and the design effect desired.

1. For the skirt in Figure 6.62, the height or distance from *A* to *B* is about 10 in. (25.4 cm) and the width at the bottom or the distance from *C* to *D* is about 12 in. (30.5 cm).
2. Pin the godet into the seamline to check the appearance. It may be necessary to remove some of the godet width. Remember to remove the same amount on each side of the godet to keep the grainline in the center of each godet.

The Side Seam Eliminated

To make the design shown in Figure 6.63, follow these steps:

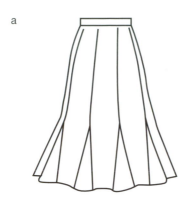

Figure 6.62 Skirt with godets.

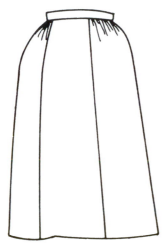

Figure 6.63 Side seam eliminated.

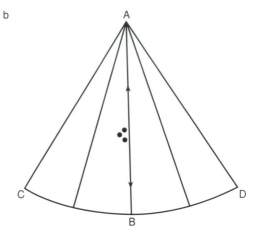

Directions .

1. Start with the basic straight skirt (no flare). If the available basic skirt has flare, fold it under to make a straight skirt.
2. Use the skirt front to make a completed basic six-gore skirt front.
3. Join the side gore of the six-gore front to the basic back so the straight edges of the side seams meet (Figure 6.64) and pin to a large piece of paper. The space between the two curved side seamlines above the hipline will become gathers. Convert the darts to gathers also.
4. Mark out the original side seamlines and perfect the waistline seam. Cut off excess paper and label the pattern.

. .

The Eight-Gore Skirt

This skirt is made by drafting, so no basic pattern is used. An eight-gore skirt is shown in Figure 6.65. Measurements needed are waist plus ease, hip plus ease, and skirt length.

Directions .

1. Divide the waist and hip measurements, which include ease, by the total number of gores (eight) in the skirt.
2. On a sheet of paper, draw a straight line the length of the skirt, line AB in Figure 6.65. Next, measure out to each side of point A on the waistline a distance equal to one-half of the gore measurement at waist and hipline. Connect waist and hipline and continue drawing a line to the hem. This is the minimum width for a fitted gored skirt. More flare can also be added as shown in Figure 6.65.
3. Establish the hemline and the waistline. Both the waistline and hemline will have a curve.
4. If the skirt is an eight-gore skirt, make three more copies of the pattern; if a ten-gore skirt, make four more copies; and so forth. (See Figure 6.66.)
5. Use a double thickness of the fabric, and place the pattern pieces on the fabric as shown in Figure 6.66. (There must be no up or down in the fabric.) Little fabric is wasted with this pattern layout. Remember to add seam allowances, either to the pattern or directly on the fabric.

. .

An attractive pleated skirt pattern can be made by adding a pleat at each seamline.

Sewing Suggestion .

Sew the skirt panels from the wide to the narrow end—that is, from the bottom of the skirt to the top. This works

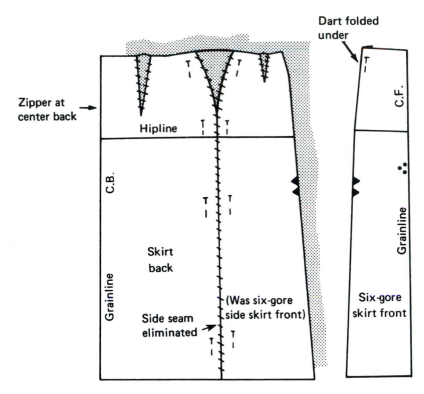

Figure 6.64 For best appearance, make center panel wider at hemline than at hipline. Add the same amount of flare to skirt center front and skirt side front.

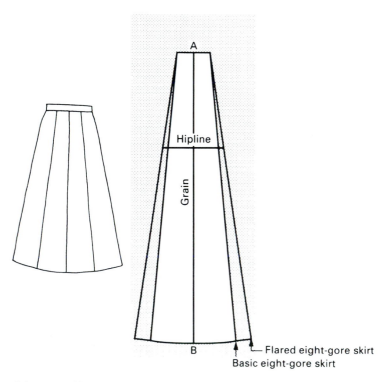

Figure 6.65 Pattern for an eight-gore skirt.

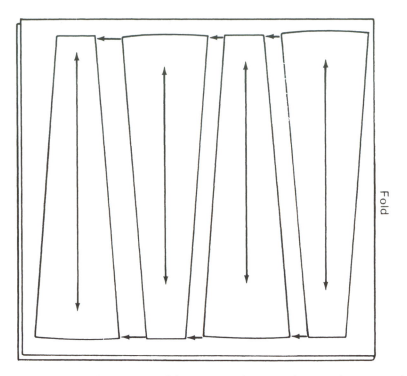

Figure 6.66 Pattern layout for eight-gore skirt. To save fabric, move pieces so they touch one another with common cutting lines. See arrows.

with the fabric grain and also helps prevent seams from rippling.

CIRCULAR SKIRTS

The circular skirt is made from a complete circle of fabric (Figure 6.67). If the fabric is 72 in. (1.8 m) wide, as felt is, the skirt can be made *without* seams.* Thirty-six-in. (0.9-m) fabric, which is half as wide as felt, can be made into a circular skirt with only two seams. The seams can be located either at the sides or at the center of the skirt as determined by the location of the waistline opening. Make the opening by drawing a circle with a radius figured from the following formula:

$$\text{Radius} = \frac{\text{Circumference or waist measure}}{2 \times 3.1416}$$

For example, the radius is 4 in. (10.2 cm) for a 25-in. (63.5-cm) waist measurement.

For a 72-in. (1.8-m) fabric, the circle should be located near the center of a square, and the skirt will measure ½ in. (1.3 cm) longer at the sides than at the front and ¼ in.

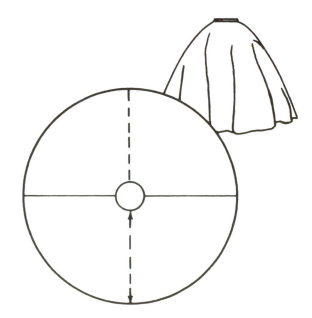

Figure 6.67 Circular skirt.

(0.6 cm) longer at the back than at the front. For specific measurements, check your basic skirt pattern. If the fabric is less than 72 in. (1.8 m) wide, fold it, and draw the pie-shaped segment shown in Figure 6.68 on one corner of the fold. Measure from this line to determine the skirt length.

......

*No hem is needed in felt because it does not ravel. Use a narrow hem on woven fabrics.

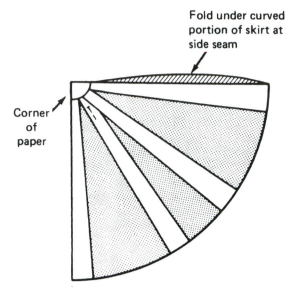

Fold under curved portion of skirt at side seam

Corner of paper

Figure 6.68 Measure skirt length from edge of pie-shaped segment (waistline) to outer curve or hemline.

The circular skirt can also be made from the basic pattern as follows:

Directions

1. Fold in the dart and slash from the hemline to the tip of the dart. Make other slashes (five or more) from hem to waist. Spread the pattern until the side seams are at *right angles* to the center edge of the skirt, and pin to a large sheet of paper at the corner (Figure 6.68).
2. Straighten the side seamline of the pattern, thus removing the fitting curve, which is no longer needed. Perfect the waistline curve and complete the hem.
3. The grainline will be determined by the location of the seams.

PLEATED SKIRTS

A **pleat** is defined as a fold of cloth, usually lengthwise, laid back and held in place by a seam. It adds style fullness to the skirt and is also a design feature.

Darts are *not* converted to pleats, but they may be incorporated into a pleat. Unstitched darts are sometimes called "pleats" erroneously. The diagram in Figure 6.69 shows a simple pleat and its parts.

The fold position and the number of folds determine the kind of pleat. In Figure 6.69, the numbers 1 through 4 identify the following pleat components:

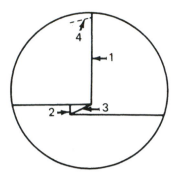

Figure 6.69 A simple pleat.

1. Outer fold of pleat, visible from the outside
2. Inner fold of pleat, visible from the inside
3. Depth of pleat, or distance from inner to outer fold, which measures 1 to 2 ½ in. (2.5 to 6.4 cm)
4. Topstitching, which holds kick pleats in place

Using paper, practice folding pleats 1 through 6 in Figure 6.70.

The Kick Pleat

The **kick pleat** can be a knife pleat or an inverted pleat. It is a short pleat that ends 6 to 8 in. (15.2 to 20.3 cm) above the hemline. (See Figure 6.71.)

The kick pleat is either held in place by topstitching or supported by one pleat layer that extends to the waistline. It is often placed in the center back seam of a long straight skirt to provide walking room.

Directions

1. Add the pleat width as an extension of the center back of the skirt pattern. Add the pleat for only 6 to 8 in. (15.2 to 20.3 cm), or carry the addition all the way to the waistline.
2. For the knife pleat, cut both halves of the skirt from the one pattern piece. If the fabric is cut with the wrong sides out, the skirt can be stitched at the center seam immediately after removing the pattern and without separating the fabric layers.
3. For the inverted pleat, an underlay (or inset) must be made. The patternwork is shown in Figure 6.72.

The Knife Pleat: Parallel Pleat Method

A knife pleat is a fold of cloth turned to either right or left. The amount of material needed for the pleat is the pleat depth multiplied by two.

1. KNIFE PLEAT: a single fold of cloth turned either to right or left

2. DOUBLE KNIFE PLEAT: knife pleats (folds of cloth) superimposed on one another

3. TRIPLE KNIFE PLEAT: three knife pleats (folds of cloth) superimposed on one another

4. KICK PLEAT: a short pleat 6 to 8 in. (15.2 to 20.3 cm) long in lower part of skirt. Variation of the knife pleat or the inverted pleat

5. BOX PLEAT: two knife pleats with outer folds turned away from each other

6. INVERTED PLEAT: two knife pleats turned toward each other so outer folds meet on outside of garment

Figure 6.70 Pleat variations.

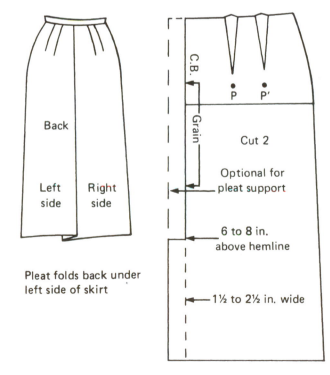

Figure 6.71 Knife kick pleat.

Directions

1. Draw a horizontal line MN on a large piece of paper as a matching line for the pattern hipline.
2. Design lines for the pleats (Figure 6.73), and move the darts to the pleat lines. Make pleat lines parallel to the center front (or back). Mark matching notches—one notch on the first pleat and two notches on the second. Cut the pattern apart on the pleat lines.
3. Spread the pattern pieces the necessary 3 to 4 in. (7.6 to 10.2 cm) apart, and match the hipline of the pieces to line MN. Pin (or tape) in place. (See Figure 6.74.)
4. Fold, bringing the original pattern lines back together and including the dart in the fold. Cut off excess paper, thus giving proper shape to the ends of the pleats.

These knife pleats will be **on grain** and will hold a press better than pleats on the bias.

The Inverted Pleat: Parallel Pleat Method

The inverted pleat consists of two knife pleats with outer fold lines meeting at the center of the pleat.

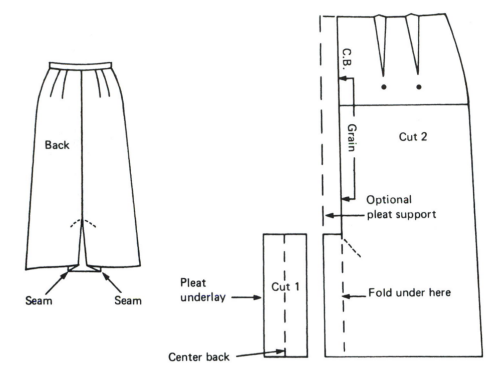

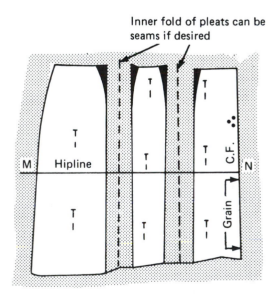

Figure 6.72 Inverted kick pleat.

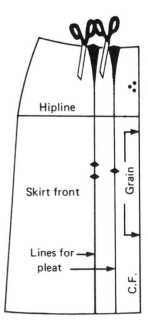

Figure 6.73 Design pleat lines and move darts to pleat lines; then cut pattern apart on pleat lines.

Figure 6.74 Spread 3 to 4 in. (7.6 to 10.2 cm) for pleats and pin to paper.

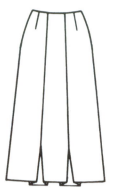

Figure 6.75 Inverted pleat.

The amount of material needed for the pleat is the pleat depth multiplied by four. For example:

2 in. (5.1 cm) pleat × 4 = 8 in. (20.3 cm)

Directions (Front or Back)

1. Design a line for the pleat and move one or both darts to this line. Figure 6.75 shows one dart moved to the pleat line. Mark matching notches. Draw the hipline.
2. Draw horizontal line MN on a large sheet of paper. Cut the basic pattern apart on the pleat line. Match the hipline of each piece to line MN. Spread the pattern pieces to give a pleat of the desired size. Pin or tape.
3. Fold on the pleat lines and include the dart in the pleat by folding along the dart lines. Cut off excess paper while the pleat is folded. This will give the correct shape to the ends of the pleat.

..

The pattern is sometimes more economical to cut out if the inner fold lines of the pleats are seamlines. To make the seamlines, cut the pattern apart on the inner fold lines (dashed lines in Figure 6.76) and add seam allowances to these edges. The back of the pleat will then be a **pleat underlay**, or **pleat inset** (Figure 6.77). If a pleat is cut on the bias of the cloth, a straight-grain underlay will stabilize it.

Sewing Suggestion

Straight-grain pleats hold a better press than pleats on the bias.

..

Nonparallel Pleats

Another method of making pleats is illustrated in Figures 6.78, 6.79, and 6.80. This method is useful when just one

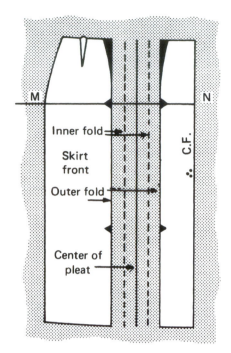

Figure 6.76 Pattern for inverted pleat.

Figure 6.77 Pleat underlay (skirt not yet hemmed).

pleat is required or when the pleat is not parallel to center front (or back) and matching the hipline to line MN of the pleat paper (as in the preceding discussion) would be difficult.

Directions (Pleat with Seam at Inner Fold)

If the skirt is flared and the pleat will be located on the bias, there should be a seam at the **inner fold.** Cut the pattern apart where the pleat is to be (Figure 6.78), and add one-half of the pleat plus seam allowances to both of the

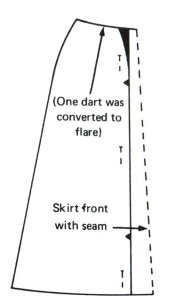

Figure 6.78 Seam at inner fold.

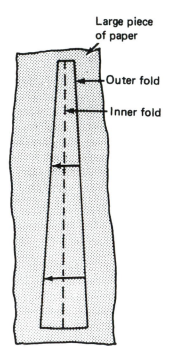

Figure 6.79 The pleat.

cut edges. The side panel of the skirt pattern can now be placed in a grain position that is less bias.

Directions (Pleat with No Seams)

The following directions apply to a skirt pattern that is a single piece.

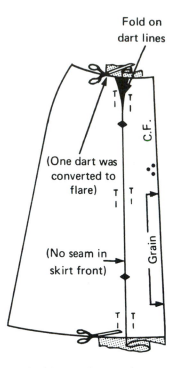

Figure 6.80 Match skirt to pleat and pin in place.

1. Use a large sheet of paper and draw a pleat about 2 in. (5.1 cm) deep at the waist and widening to ±3 in. (7.6 cm) at the hemline (Figure 6.79).
2. Fold the pleat as shown by the arrows in Figure 6.78. Do not cut off the extra paper; it is needed when you attach the pleat to the skirt.
3. Next, design a pleat line on the skirt pattern. Move one dart to the pleat line. Mark notches on the pleat line; then cut apart. The second dart can be kept or can be converted to flare.
4. Match the skirt pieces to the folded pleat, as shown in Figure 6.80, and pin in place. Fasten permanently with tape.
5. Cut off excess paper and unfold the pleat.

Pleating to Waist Measure

Pleats made to waist measure are usually unpressed pleats that spread open at the hipline to adjust to the larger circumference there. Measurements for the size 14 pattern, with ease included, are used in the directions that follow.

Directions

1. Consider the fabric first. Most fabrics are pleated lengthwise because the fabric is more stable and drapes more softly in that direction. Certain fabrics, such as

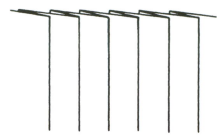

Figure 6.81 Three layers of fabric in each pleat.

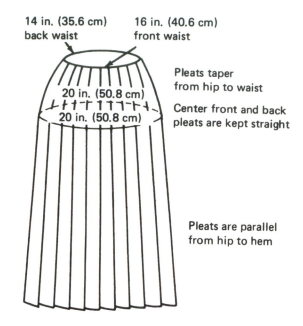

14 in. (35.6 cm) back waist

16 in. (40.6 cm) front waist

20 in. (50.8 cm)

20 in. (50.8 cm)

Pleats taper from hip to waist

Center front and back pleats are kept straight

Pleats are parallel from hip to hem

Figure 6.82 Pleating to hip measure design.

faille, are quite stiff in the crosswise direction and will drape better if pleated crosswise.

Common fabric widths are 36, 40, 42, 45, and 54 in. (0.9, 1.0, 1.1, 1.2, and 1.4 m).

2. Determine the number of skirt lengths needed. Examine the drawing in Figure 6.81, and observe that three layers of fabric are used for each pleat. The ratio of fabric to waist measure is therefore 3:1.

Example for size 14:

Waist measure 28 in. (71.1. cm) + 1-in. (2.5-cm) ease
= 29 in. (73.7 cm or 0.7 m).

29 in. (0.7 m) × 3 = 87 in. (2.1 m) of fabric needed.

Two 45-in. (1.2-m) fabric widths = 90 in. (2.4 m).

Use the extra 3 in. (7.6 cm) for seam allowances.

3. Plan the skirt so all seams are located at the inner fold of a pleat.

4. Sew all skirt seams *except one*, which will be stitched after the pleating is done.

5. Hem at this time, if desired. This is standard procedure in ready-to-wear.

The skirt zipper may be put in before pleating, but the dress zipper must be put in after the skirt and bodice are joined.

6. Pleat the skirt and stitch across the pleats to hold them in place while you establish the seamline at the waist.

7. Sew the remaining skirt seam, and finish the raw edges at the hemline so they are inconspicuous.

8. Pin the skirt to the muslin blouse for support while measuring the distance from hem to floor. All adjustments in skirt length are made at the waistline. After the waistline is established, stitch the skirt to the skirt band (or to a stay tape if the garment is a dress) and complete any remaining construction.

Pleating to Hip Measure

This method is similar to the method for pleating to waist measure, so be sure to study that method as well as the design in Figure 6.82.

Pleating to hip measure involves the problem of adjusting the pleats to the smaller circumference of the waistline. The waistline is longer across the front than across the back, so more reduction must be made in the back pleats than in the front pleats. (See Table 6.3.) If one disregards this size difference between front and back, the pleats will appear to spiral around the body.

Measurements for a size 16 pattern are used in the example. Ease is included. Directions are for 2-in. (5-cm) pleats, 10 in the front and 10 in the back.

Directions

1. Apply the previous directions for pleating to waist measure, but plan the pleats to hip measure.

2. For the entire length of the skirt, baste a fold along the outer fold line of each pleat.

Table 6.3 Pleating to Hip Measure*

	Waist	Hip	Adjustment to Be Made
Total	30 inches (76.2 cm)	40 inches (101.6 cm)	10 inches (25.4 cm)
Front	16 inches (40.6 cm)	20 inches (50.8 cm)	4 inches (10.2 cm)
Back	14 inches (35.6 cm)	20 inches (50.8 cm)	6 inches (15.2 cm)

*Size 16 example used.

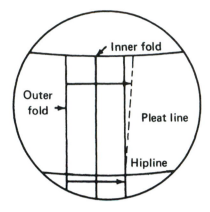

Figure 6.83 Overlap outer pleat fold to dashed line.

3. Pleat the outer fold over to the pleat line; then pin at the hipline and throughout the lower part of the skirt.

4. From hipline to waistline, overlap the outer pleat fold by bringing it to the dashed line shown in Figure 6.83. Refer to the chart for the amount of adjustment to be made, and allocate the proper amount to each quarter-section of waistline. For example, allocate 2 in. (5.1 cm) to each of the right and left fronts and 3 in. (7.6 cm) to each of the right and left backs if you are using a size 16 pattern.

 Divide these amounts among the five pleats in each section.

5. Now mark off a stay tape with the front and back waist measure, and attach the tape to the skirt waistline to hold the pleats in place.

6. Press the pleats lightly, topstitch from hip to waist, remove bastings, and complete the pressing. (See Figure 6.84.)

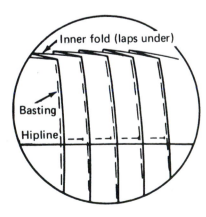

Figure 6.84 Press pleats lightly and topstitch from waist to hip.

WRAP SKIRTS

The wrap skirt usually has a side front opening and a generous overlap to prevent the skirt from spreading apart as the person walks. It is easy to get in and out of because of the tie belt, buttons, or velcro at the waistline. The wrap skirt can be cut in one piece, as shown in Figure 6.85, or it can have a seam at center back or seams at the side. A facing can be added to the extension, or the entire skirt can be lined. Some wrap skirts are reversible.

Directions

1. Make an A-line skirt with the desired amount of fullness or flare at the side seams.
2. Join skirt front and back at the side seams.
3. Add an extension that is approximately one-half of the skirt front pattern width.
4. Curve the hemline on the extension, if desired.
5. Cut center back seam on fold or center front on straight grain with a seam at center back.
6. Add buttons and buttonholes to the waistband or add a tie belt.
7. If there is a curve on the side seams, make the hipline meet and add a waist dart.

Sarong Skirt with a Cascade Ruffle

Directions

1. Draw around the basic skirt pattern. Flip the skirt pattern at center front and draw around the other half of the skirt so you have a skirt front with both right and left sides.
2. On the skirt front, extend the waistline 12 to 14 in. (30.5 to 35.6 cm) from the dart as shown in Figure 6.86.
3. Draw a curved line from the center front hem to the extended waistline.
4. Add three slash lines from the waist to the side seam as shown in Figure 6.86.
5. Slash on these lines and spread 1.5 in. (3.8 cm) from the three tucks. (See Figure 6.87.)
6. Slash and close the two waist darts on the left front.
7. The folded tucks are sewn into the waistline seam and the extension folds into a cascade ruffle.
8. Use the basic skirt pattern for the skirt back and the skirt front.
9. The sarong part of the skirt appears to be a wrap skirt but is really an overlap layer sewn into the skirt side seam.
10. If you want to make the skirt into a true wrap skirt, the underpart of the skirt front should extend nearly to the

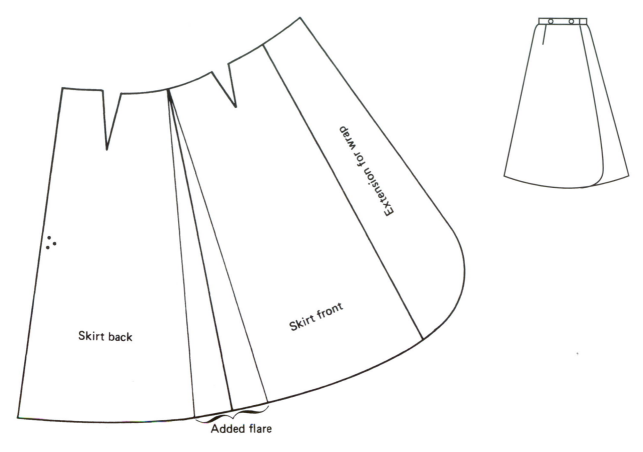

Figure 6.85 Wrap skirt pattern.

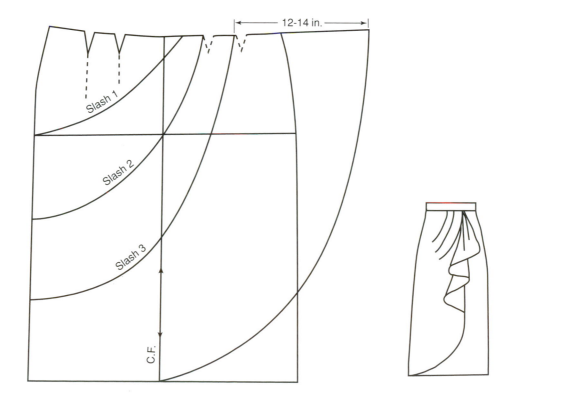

Figure 6.86 Sarong skirt with a cascade ruffle.

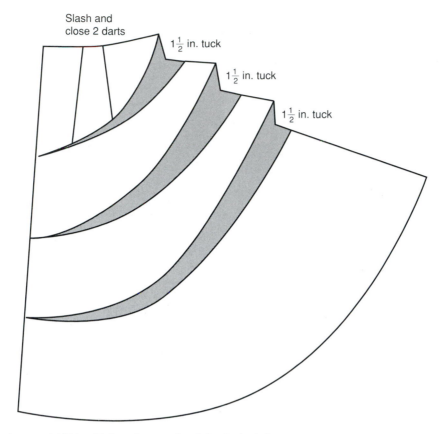

Figure 6.87 Slash and spread 1½ in. (3.8 cm) at each of the 3 slash lines.

side seam to avoid showing where it ends under the outer curved seam of the sarong skirt.

WAISTBANDS

Waistlines can be finished with shaped or bias facings, with a hem and elastic or drawstrings, or with a waistband. The most common finish is the waistband, shown in Figures 6.88 and 6.89. Waistband length is equal to the waistline measurement plus ½ in. (1.3 cm) ease plus 1½ in. (3.8 cm) for underlap. A common width is 1¼ in. (3.2 cm) on each side of the lengthwise fold that divides the outer and inner part of the band. Measure and mark the band according to Figures 6.88 and 6.89.

More length needs to be added to a wide waistband because the body is larger *above* the true waistline seam, as shown in Figure 6.90.

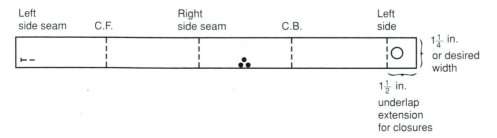

Figure 6.88 Waistband for left side opening.

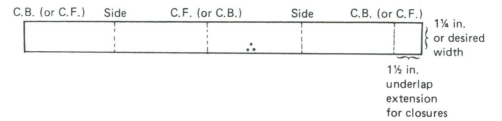

Figure 6.89 Waistband for center back (or center front) opening.

Figure 6.90 Add more length for a wider waistband because measurement above true waistline is larger.

Figure 6.91 Waistband and zipper should be in a straight line.

The waistline can be cut on the lengthwise or crosswise grain. It will stretch less if the lengthwise grain is used.

Hooks and eyes or buttons and buttonholes are the common closures, or fasteners, for waistbands. The lap of the band should be on the **underside** so the waistband edge and the seam with the zipper are in a straight line, as shown in Figure 6.91.

Sewing Suggestion

The circumference of the skirt waistline should be 1 in. (2.5 cm) larger than the skirt band and is eased as it is sewn to the band. Belt interfacings such as Armoflex® attached inside a waistband add stiffness and prevent the waistband from bending or wrinkling. These interfacings come in a variety of widths.

...

Make the patterns for several of these skirts.

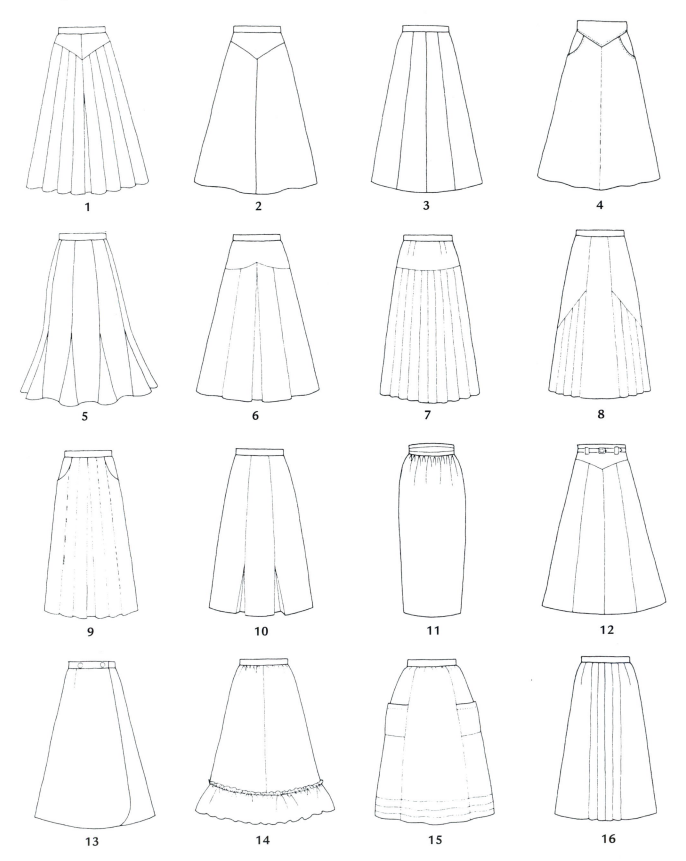

1

2

3

4

5

6

7

8

9

10

11

12

13

14

15

16

7

Pants

MAKING A BASIC PANTS PATTERN

The accompanying illustrations (see Figure 7.1) show a number of pants styles that can be made from the basic pants pattern.

Directions ...

Method I: Using a Commercial Basic Pants Pattern Start with a commercial basic pants pattern. Alter the pattern, and sew it in muslin. The pants should fit well, so make changes as necessary to achieve good fit. You are then ready to start designing with the pants pattern. Instructions begin on page 151.

Method II: Drafting Pants Pattern from Basic Skirt A basic pants pattern can be drafted from the basic skirt that has *no flare*.

The method described here does *not* include the fitting of pants. Pants are more difficult to fit than skirts, so we start with a skirt that fits! If the skirt fits, the pants will fit also.

The pants pattern method, detailed in the pages that follow, employs drafting techniques. Body measurements are therefore needed. An explanation of these measurements is given in the following section.

When the pants are made of stretch fabric, remove some or all of the ease that is normally a part of the basic skirt pattern. Refer to Chapter 15 on knits.

...

MEASUREMENTS FOR PANTS PATTERNS

You will not need measurements to change the skirt pattern to a pants pattern if you use a basic skirt pattern that fits.

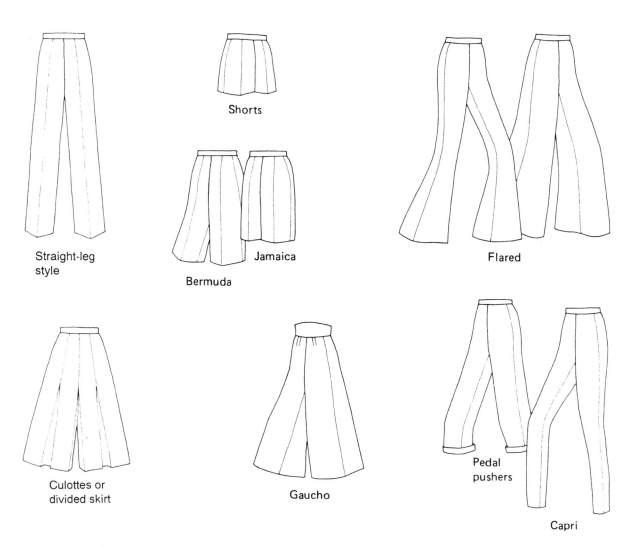

Straight-leg style

Shorts

Bermuda

Jamaica

Flared

Culottes or divided skirt

Gaucho

Pedal pushers

Capri

Figure 7.1 Pants style variations.

Figure 7.2 Crotch depth.

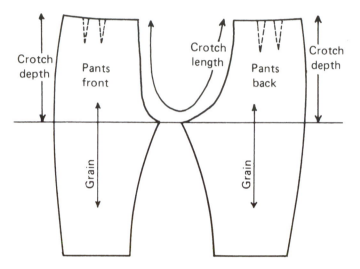

Figure 7.3 Crotch depth is measured at side seamline.

Crotch Depth (Figures 7.2 and 7.3). This is a critical measurement. Mark the waistline by a string tied around the body. The person should sit on a chair that has a flat surface. Measure from the waistline down over the hip to the seat of the chair. Record all measurements on the chart in Figure 7.4. Add ¾ to 1 in. (1.9 to 2.5 cm) of ease to the crotch-depth measurement.

CROTCH DEPTH: Add ¾ to 1 in. (1.9 to 2.5 cm) ease.	_____	inches
CROTCH LENGTH: Add 1 in. (1.5 cm) ease	_____	inches
LENGTH OF LEG		
Waist-to-ankle	_____	inches
Waist-to-knee	_____	inches
Knee-to-ankle	_____	inches
CIRCUMFERENCE: Add 1 to 2 in. (2.5 to 5.1 cm) ease.		
Knee (bent)	_____	inches
Thigh	_____	inches
Calf	_____	inches
Ankle-heel	_____	inches

Figure 7.4 Record measurements for pants pattern.

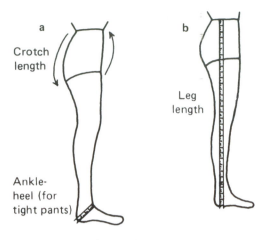

Figure 7.5 (a) Crotch length and (b) leg length.

Crotch Length (Figures 7.3 and 7.5a). Measure from the back of the waistline down between the legs and up to the waistline in front. Add 1 in. (2.5 cm) of ease.

This measurement can be used to check the length of the crotch seamline of the pattern. The front seam usually measures 2 in. (5.1 cm) *less* than the back seam.

Leg Length (Figure 7.5b). Measure from the waistline down to the ankle bone for long length. Measure from the waistline to the middle of the kneecap for knee length. Subtract the second measurement from the first to obtain the knee-to-ankle length.

Leg Circumference The knee circumference is usually the only circumference needed for the straight-leg pants style and should be taken with the knee bent in sitting position. If the thigh and calf are large, taking these circumference measurements is also a good idea.

The ankle measurement for tight pants should be taken diagonally around the ankle and heel (Figure 7.5a).

STRAIGHT-LEG PANTS STYLE

Back Pattern

Procedures for the upper portion of the front and back patterns differ. The back is tipped to put that portion of the garment on the bias of the cloth, thus increasing the amount of stretch for sitting comfort.

The procedures for the leg portion of the front and back are the same except for the measurements used. The back leg will be wider than the front because a larger amount of width is added to the back crotchline. (In the

skirt, recall that the front is wider than the back.) We present two methods for making the leg portion of the pants pattern.

Directions

1. Use a basic skirt pattern and mark the hipline. Measure *along the side seam* to establish the crotch depth, and draw the crotchline at *right angles* to center back.
2. Slash the pattern diagonally, as shown in Figure 7.6, from center back hipline across to the sideseam crotchline. To obtain a bias center back seamline, spread the pattern 1 to 1½ in. (2.5 to 3.8 cm)* at the center back line, as shown in Figure 7.7. Pin the skirt pattern to a large piece of paper. Allow 1¾ in. (4.4 cm) above the waistline if the garment is to have an elasticized waist.
3. Extend the crotchline horizontally beyond center back 4 to 4½ in. (10.2 to 11.4 cm)**—line AC in Figure 7.7.
4. Complete the crotch seam as a nice curve. The diagonal distance from point A to the deepest part of the curve will be about 1 in. (2.5 cm). The basic skirt pattern can now be removed if all markings are transferred to the new pattern.
5. Locate point B on the crotchline in a position about 2 in. (5.1 cm) from point A, as shown in Figure 7.8. This

.............

*If the individual has prominent hips, increase this amount by ¼ to ½ in. (0.6 to 1.3 cm).

.............

**The amount of extension of the crotchline may be figured as
 Back = one-half of hipline of basic skirt
 Front = one-quarter of hipline of basic skirt

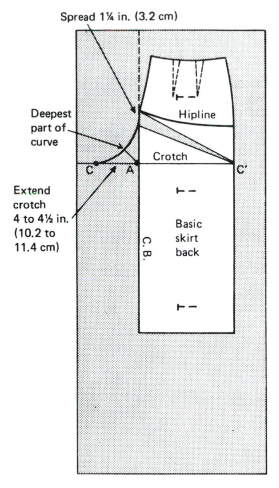

Figure 7.7 Spread pattern and extend crotchline.

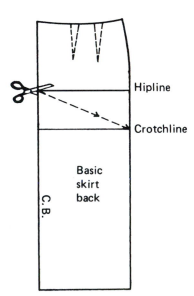

Figure 7.6 Slash from hipline to crotchline.

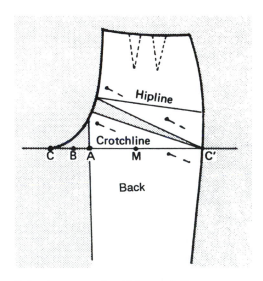

Figure 7.8 Locate point *M* for grainline.

point will be used to determine the position of the grainline, which is also the **crease line**. (Proceed to Method I or Method II.)

Method I: Leg Portion of Pattern

6. Divide crotchline space BC′ in half, and mark point M as the midway point (BM = MC′). Draw the grainline through point M at right angles to the crotchline, and extend the line the entire length of the pattern (Figure 7.9).

7. Mark the location of the ankle (waist-to-ankle measurement), and allow 2 in. (5.1 cm) for the hem. Mark the knee location (knee-to-ankle measurement).

8. Figure the width of the leg as follows:

For the back: one-half of (knee circumference + ease) *plus* ½ in. (1.3 cm)
For the front: one-half of (knee circumference + ease) *minus* ½ in. (1.3 cm)

Now measure and mark off the width of the leg at the knee and ankle. Place half of the amount on each side of the grainline. This formula yields the correct

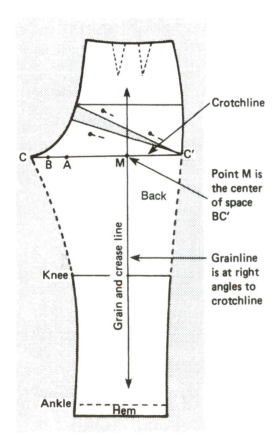

Figure 7.9 Draw straight-leg seamline and gently curving crotch-to-knee seamline.

proportion of about 1 in. (2.5 cm) more width in back than in front.

9. Draw the seamline as a gentle curve from the crotch to the knee, as shown by the dashed line in Figure 7.9. A curved metal tool, called a **hip curve**, works well for tracing the crotch-to-knee curve. Draw a straight line from knee to hem.

10. Cut off excess paper and complete the pattern with labels.

Sewing Suggestions

Before stitching any of the garment, press the crease in each of the four leg pieces. Fold each piece the same way that the pattern is folded in Method II.

Creases in the back extend up to the crotchline. Creases in the front extend to the waistline.

Pants usually fit better in the crotch area if the leg seams are sewn first and the entire crotch seam is sewn second.

Method II: Leg Portion of Pattern

6. After completing step 5, page 148, cut out the portion of the pattern that is above the crotchline. Fold the entire pattern lengthwise *at right angles* to the crotchline and matching point B to point C′ where the side seam meets the crotchline. This fold line is the grainline and is also the *crease line* of the finished garment.

7. Mark the position of the knee and ankle. Use the waist-to-ankle and the knee-to-ankle measurements. Allow 2 in. (5.1 cm) for hem. (See Figure 7.10.)

8. Measure off the pattern width for the knee, N, and the same amount for the ankle, H. Because the pattern is folded, the width will be figured as follows:

For the front: one-quarter of (knee circumference + ease) *minus* ¼ in. (0.6 cm)
For the back: one quarter of (knee circumference + ease) *plus* ¼ in. (0.6 cm)

9. Connect points N and H with a straight line and cut off the excess paper, thus finishing the seamlines here. Be sure to cut both layers at the same time.

10. Unfold the pattern and complete the seamlines from crotch to knee as smooth curves, as shown by the dashed lines in Figure 7.11. Now cut off the rest of the excess paper.

Refold the pattern now that the excess paper is trimmed away, and observe the difference in position of the seams between the crotch and the knee. This will help you to understand where the crease line is to be pressed in the cloth.

11. Label the pattern.

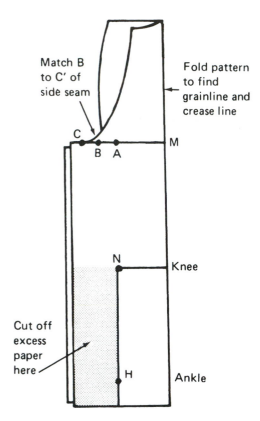

Figure 7.10 Draw a straight line for lower leg seamline.

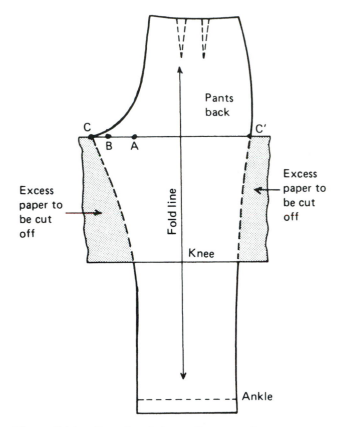

Figure 7.11 Complete leg seamline as a nice curve.

Front Pattern

For smooth fit, the upper portion of the pants front pattern retains the same grain as the basic skirt.

The width of the pants front pattern is less than that of the back pants as measured at the crotchline, knee, and ankle. (The opposite is true of the skirt pattern.)

Directions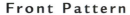

1. Use a basic skirt front. Pin the skirt pattern to a large piece of paper. Allow 1¾ in. (4.4 cm) above the waistline if the design has an elasticized waist. Mark the hipline and crotchline.

 Extend the crotchline 2 in. (5.1 cm) beyond center front. (See AC in Figure 7.12.)

2. Complete the crotch seamline as a nice curve from the hipline to point C. The diagonal distance from point A to the deepest part of the curve should be about 1 in. (2.5 cm).

3. Now remove the basic skirt pattern after transferring all markings to the pants pattern.

4. Locate a point, B, on the crotchline halfway between A and C. This point is used to determine the grainline, or crease line. (See Figure 7.13.)

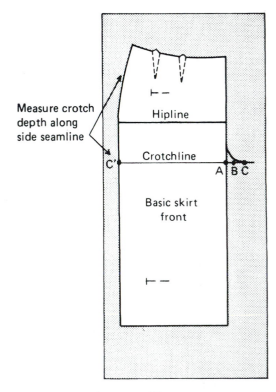

Figure 7.12 Extending crotchline.

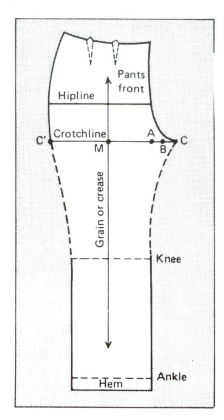

Figure 7.13 Designing the leg portion

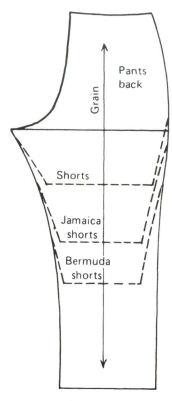

Figure 7.14 Shortened pants styles.

5. The front leg portion is made by following the same directions given for the back pants leg (see step 8 on page 149).

The formula for figuring the front leg width at the knee (and ankle) for straight-leg style pants is

One-half of (knee circumference + ease)
minus ½ in. (1.3 cm)

Check the length of the crotch seamline, front plus back, by comparing it with the crotch-length measurement recorded in Figure 7.4.

Observe the difference in width of the front and back patterns.

DESIGNING WITH THE PANTS PATTERN

Pants patterns can be tightened, shortened, or both tightened and shortened, as shown in Figures 7.14 and 7.15.

Flare can be added

- Below the knee, as shown in Figure 7.16
- Below the crotch only, as shown in Figure 7.17
- Below the waist, as shown in Figure 7.18

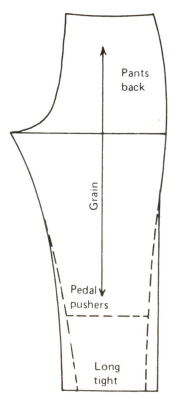

Figure 7.15 Tight pants: three-quarter and long. Alter for fullness evenly on each side of the leg.

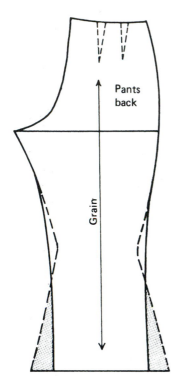

Figure 7.16 Flared below knee.

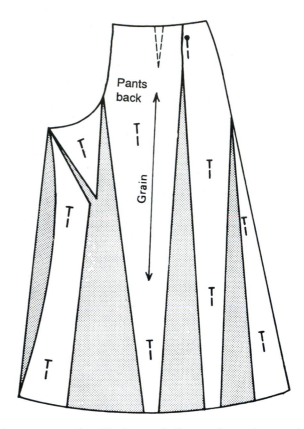

Figure 7.18 Flared below waistline; gather at lower edge for harem pants.

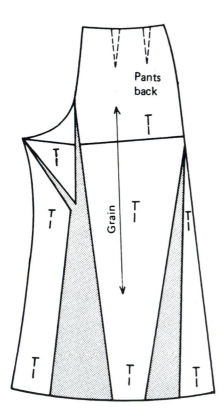

Figure 7.17 Flared below crotch only; gather at lower edge for harem pants.

Front pleats and pockets are added to women's pants in the same way that they are added to men's pants. (Refer to Chapter 13, Figures 13.9 and 13.10.)

HAREM PANTS

Gather the lower edge of either pattern shown in Figures 7.17 and 7.18.

CULOTTES OR DIVIDED SKIRT

Culottes are pants with enough fullness added, either as flare, pleats, or gathers, to make the garment resemble a skirt.

Use a basic pants pattern *shortened to knee length* as shown in Figure 7.19. Restore straight grain to the upper back portion by reversing the process used in step 2 on page 148. (The stretch obtained from the bias is not needed in culottes.) Straighten the leg seams until they, too, are on the straight grain (Figure 7.19). Add length to achieve the desired fashion look.

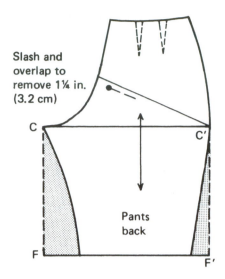

Figure 7.19 Restore straight grain to legs and center back.

Flared Culottes

Directions

1. Using the pattern as prepared, slash, spread, and pin to a large piece of paper (Figure 7.20). Convert one or both darts to flare.

2. Add width to the inner leg seam: 2¼ in. (5.7 cm) for the back pants* and 1 in. (2.5 cm) for the front pants.
3. Allow 1½ in. (3.8 to 5.1 cm) for the hem.
4. Label and complete the pattern.

Pleated Culottes

Directions

1. Use the basic pants pattern as prepared for the flared culottes.
2. Design a pleat line following the straight grain from hipline to hem, as shown in Figure 7.21. Slash the pattern, spread enough for a 2½- to 3-in. (6.4- to 7.6-cm) pleat, and pin to a large piece of paper.
3. Add width at the inner leg seam as directed in step 2 for flared culottes. The inner leg seam GE should measure the same in both front and back.
4. Fold the pleat, cut off excess paper, and label the pattern.

Sewing Suggestion

Stitch crotch seam last to achieve proper "hang" of culottes.

*1¼ in. (3.2 cm) of this addition restores the length that was lost when the back pattern was restored to straight grain (Figure 7.19).

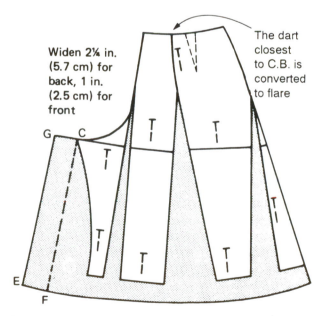

Figure 7.20 Flared culottes.

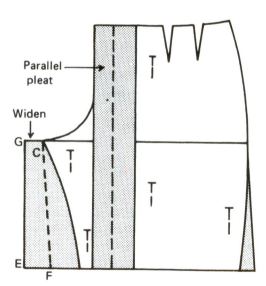

Figure 7.21 Pleated culottes.

Make the patterns for several of these pants.

Review the section on pleats and pockets for pants in Chapter 13. Lines down the front of the leg are creases, not seams. Most companies have basic pants patterns for men and women with and without front darts. For the problems with front darts such as #4, use the misses basic pants in the appendix. For the problems without front darts such as #3, start with the men's basic pants front in Appendix A.

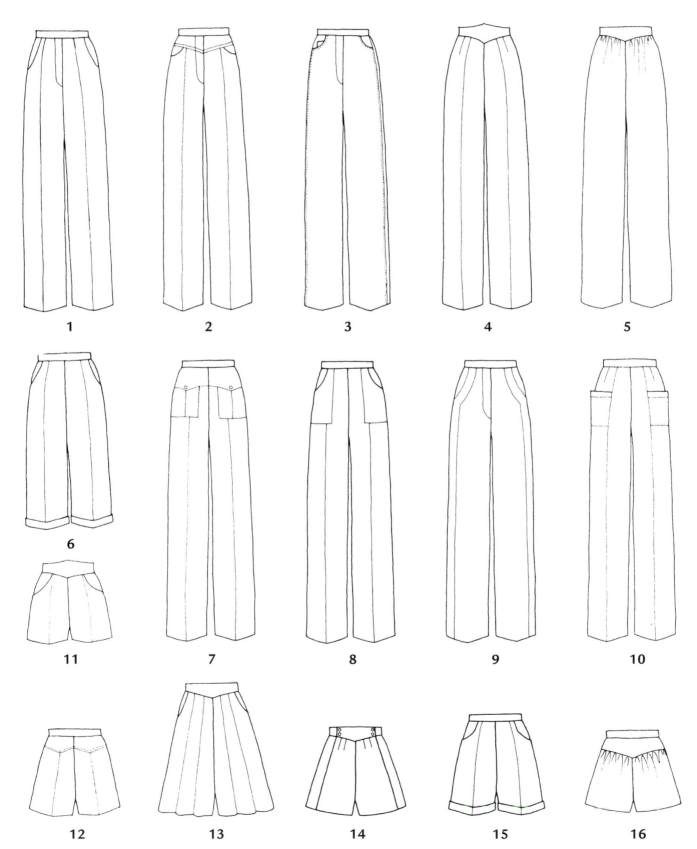

1 2 3 4 5

6 11

7 8 9 10

12 13 14 15 16

8

Dresses

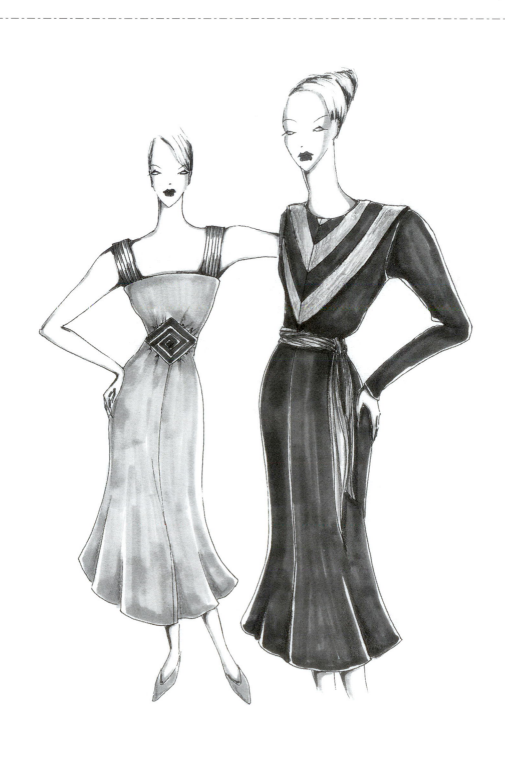

THE BASIC SHEATH

A basic dress has a waistline seam as shown in Figure 8.1. A **sheath** is a dress with a simple fitted silhouette and *no* **waistline seam**. Figure 8.2 shows sheath dresses made from slopers with one waistline dart and two waistline darts. Two darts often give a smoother fit.

The sheath dress pattern is made by joining the basic bodice to the basic skirt, thus eliminating the waistline seam. Figure 8.3 is a sheath sloper with one dart. (Slopers for the front are provided in Appendix A.)

Many designs can be made from the basic sheath pattern. Indeed, all the design methods that you have learned

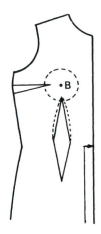

Figure 8.3 Sheath sloper with curved dart.

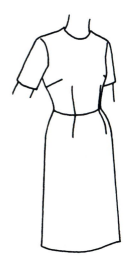

Figure 8.1 The basic dress.

so far can be applied to designing with the basic sheath pattern. Some design possibilities are listed here.

1. Designing with darts
 - Waist-dart designs
 - Bust-dart designs
 - (No armhole dart in kimono sheath)
2. Converting darts to gathers
3. Converting darts to seams
 - Center front seamline
 - Dart seam
 - Princess dress
 - Yokes
4. Raised and lowered waistlines
5. A-line, flare, and so forth
6. Kimono sleeve
7. Raglan sleeve

Making the Front

Alterations often change patterns so the bodice waistline and skirt do *not* join in quite the same way that they joined in the unaltered pattern. You should therefore practice with an unaltered pattern before using your personal basic pattern.

Directions .

1. Start with **paper copies** of the bodice and skirt.* Cut away the seam allowances and the dart areas.

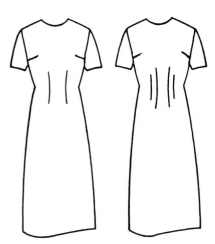

Figure 8.2 The basic sheath dress made from slopers with one waistline dart and two waistline darts.

.

*The basic skirt must have 1½ in. (3.8 cm) to 2 in. (5.1 cm) of ease. If it does not, add ease at the side seamline.

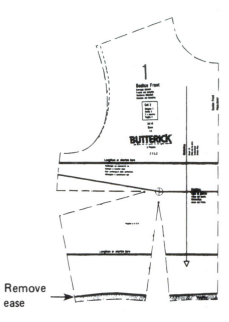

Figure 8.4 Remove normal lengthwise ease.

2. Remove the normal lengthwise bodice ease (Figure 8.4) of about ⅜ in. (1 cm) by drawing a new bodice waistline above the original waistline (see arrow).

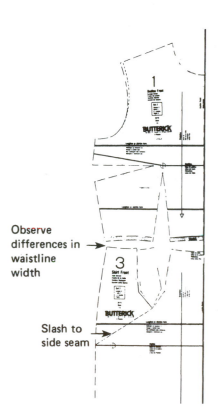

Figure 8.5 Combine skirt darts by slash method.

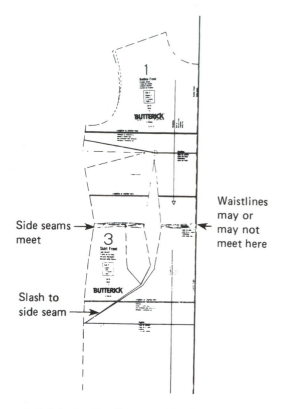

Figure 8.6 Join bodice front to skirt front.

3. Combine the skirt darts by the slash method. Place the center front edge of both patterns in a straight line. Observe the waistline width of the patterns. The skirt is narrower than the bodice, so slash the combined skirt dart to, but not through, the side seamline (Figure 8.5). Spread the skirt pattern.

4. Join the waistlines by lapping the skirt over the bodice until the side seamlines match at the *new* bodice waistline (Figure 8.6). Waistlines may or may not meet at center front. Directions for drawing the waist dart are given on page 158.

. .

Making the Back

Directions .

1. Remove the normal lengthwise bodice ease of about ⅜ in. (1 cm) by drawing a new, raised waistline (see arrow in Figure 8.7). Be sure to allow at least 2 in. (5.1 cm) of ease in the skirt at the hipline.

2. Combine the darts of the skirt by the slash method (Figure 8.8). The center of the new dart will be parallel to center back. Lengthen dart to the pivot point.

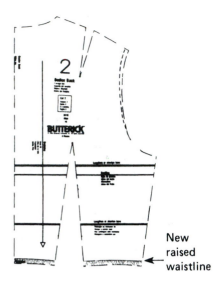

Figure 8.7 Remove normal lengthwise bodice ease.

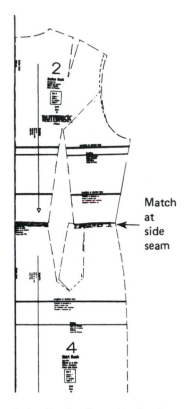

Figure 8.9 Join bodice back to skirt back.

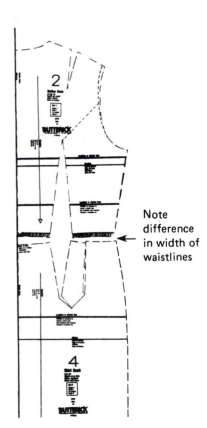

Figure 8.8 Slash and spread bodice pattern to fit larger skirt waistline.

3. Observe that the waistline of the bodice is narrower than that of the skirt. Slash through the bodice dart to, but not through, the armhole. The bodice pattern can then be spread.

4. Join bodice back to skirt back by lapping the skirt over the bodice until the skirt waistline matches the *new* bodice waistline *at the side seamline* (Figure 8.9). Note that the waistlines do not meet at center back. **(Always widen the pattern piece with the narrower waistline.)**

...

DARTS IN THE BASIC SHEATH

The Two-Ended Dart

The waistline dart in the basic sheath dress is a two-ended dart. It may be a curved dart or a straight-line dart, but the two sides must be symmetric. (See Figure 8.10.)

Curved dart lines help the garment fit the curves of the body, especially in the front. When the garment is quite fitted, all of the dart space is used as dart (i.e., none released).

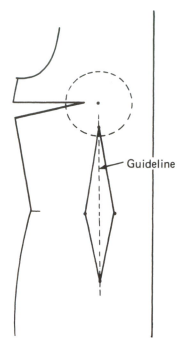

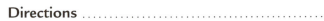

Figure 8.10 Two-ended waistline dart. Guideline is parallel to center front.

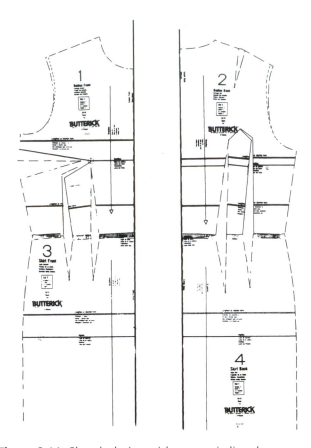

Figure 8.11 Sheath design with two waistline darts.

Directions

1. To draw the dart, first draw a guideline bisecting the dart space at the waistline. Make the guideline parallel to center front (or back). The length of the dart will be similar to that of the original basic pattern.
2. The skirt portion of the dart can be lengthened in the front where the skirt was spread as the sheath pattern was made. Draw the lines of the dart as shown in Figure 8.10.

If the sheath design has two waistline darts (Figures 8.11 and 8.12), plan for them when the two basic patterns are being joined. In Figure 8.12, note that the space at center front can remain the same width as it was in the pattern with one dart.

SHEATH DRESS DESIGNS

Releasing the Waist-Fitting Dart

The waist-fitting dart of the sheath dress is usually kept at the waistline. The dart can be either partially or fully

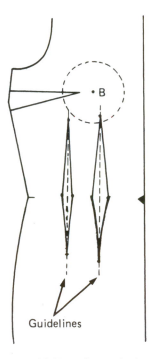

Figure 8.12 Draw guidelines for each dart.

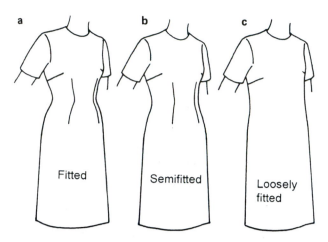

Figure 8.13 Sheath silhouette when (a) all darts are present and fitted, (b) waist dart is partially released, and (c) waist dart is fully released.

released. Study the silhouettes of the sheath designs in Figure 8.13 to determine how the dart is used.

When the dart is fully or partially released, the side seamline should be straightened a comparable amount to maintain design balance. Figure 8.14 illustrates the patternwork for releasing darts.

In all flat-pattern work involving the sheath dress, it may be helpful to straighten the skirt portion of the waist dart in the front pattern. The dart in the final pattern should, however, be curved.

Sewing Suggestion

Although darts are drawn as straight lines in flat-pattern work, they will often fit the body better if they are curved. The muslin shift can be tried on and straight darts reshaped or curved to achieve better fit.

..

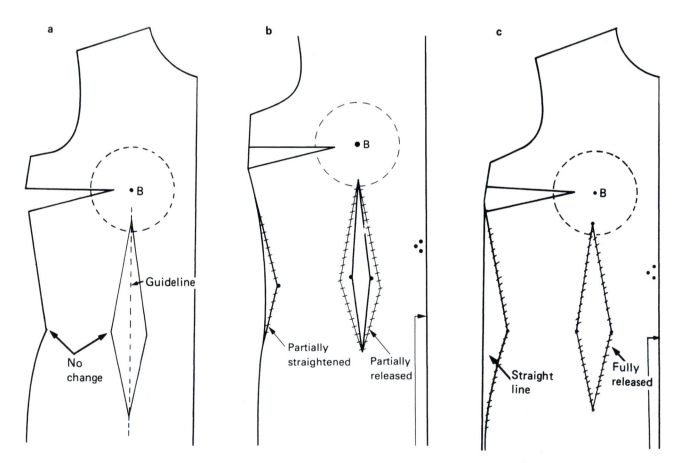

Figure 8.14 Patternwork for releasing darts: (a) No change in dart or side seam for the fitted sheath, (b) waist dart partially released and side seam partially straightened for the semifitted sheath, (c) waist dart fully released and side seam a straight line for the loosely fitted sheath.

Moving the Waist-Fitting Dart

Part of the waist-fitting dart in Figure 8.15 has been moved to the center front fold line. Remember that a center front dart is a narrow decorative dart. Pattern procedures for the center front dart are illustrated in Figure 8.16.

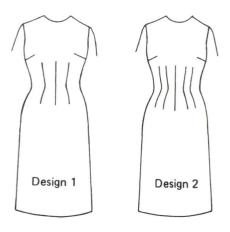

Figure 8.15 Waist-fitting dart removed.

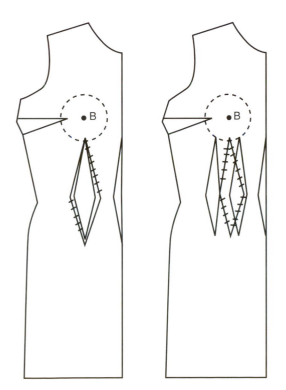

Figure 8.16 Patterns for designs 1 and 2 in Figure 8.15.

Dart Converted to Seamline

Part of the waist-fitting dart in Figure 8.17 has been converted to the seamline at center front.

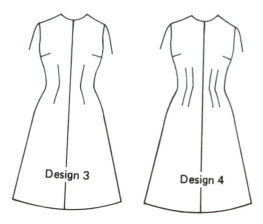

Figure 8.17 Dart converted to seamline.

Flare Added

The presence of a seamline at center front makes it possible to add flare there.

Figure 8.18 shows the conversion of dart to the center front seam and the addition of flare at both center front and side seamlines.

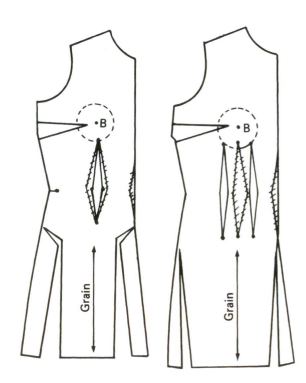

Figure 8.18 Patterns for designs 3 and 4 in Figure 8.17.

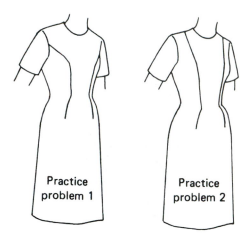

Figure 8.19 Two practice problems.

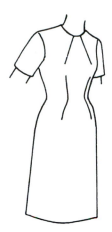

Figure 8.20 The neckline dart.

Moving the Bust-Fitting Dart

The bust-fitting dart of the sheath pattern has much more flexibility for design purposes than the waist-fitting dart. The bust-fitting dart can be

- Moved to any seamline
- Combined with the waist dart (waistline area only)
- Converted to gathers
- Converted to seamlines (e.g., yokes, princess dress)

Review the section on moving darts by the slash method. Figure 8.19 presents two practice problems.

Figure 8.20 shows the neckline dart in the sheath dress, and Figure 8.21 shows the pattern procedures for moving the bust-fitting dart to the neckline.

When the bust-fitting dart is moved to the waistline, as in Figure 8.22, it must be lengthened to reach the side seamline. In this design, the waist-fitting dart is fully released, and the side seam is straightened (Figure 8.23).

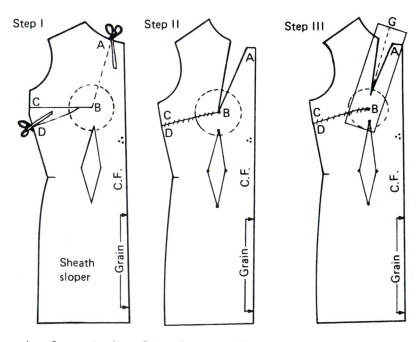

Figure 8.21 Pattern procedure for moving bust-fitting dart to neckline.

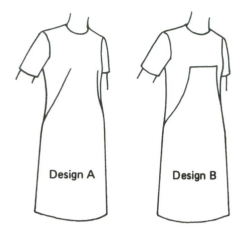

Figure 8.22 Bust-fitting dart moved to waistline.

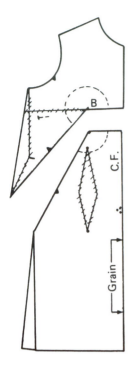

Figure 8.24 Pattern for design B in Figure 8.22.

Study the two designs in Figure 8.25 and their pattern in Figure 8.26. Although the designs look quite different, the bust dart pattern development is essentially the same.

Waistline Treatments

Lowering the waistline, raising the waistline, adding a yoke, and adding flare are design features found in the

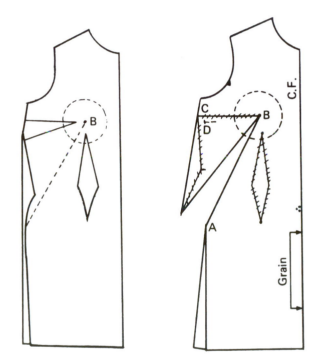

Figure 8.23 Steps in making pattern for design A in Figure 8.22.

Adding a single line, as in Figure 8.24 (design B in Figure 8.22), can often create a new design.

Combining the Darts

The bust-fitting dart can be combined with the waist dart only at the waistline.

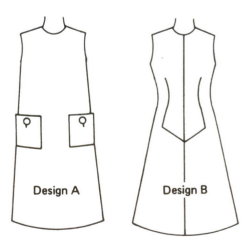

Figure 8.25 Designs made by moving bust dart.

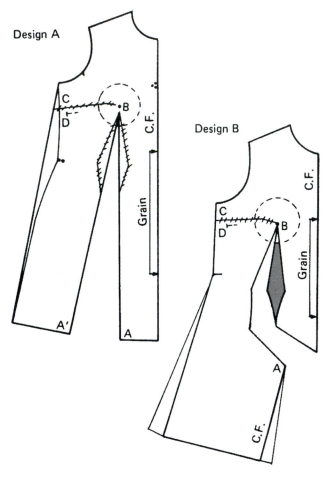

Design A

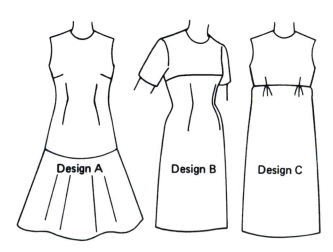

Design B

Figure 8.26 Patterns showing bust dart moved to waistline and combined with waist-fitting dart. Remove the original dart when sewing Design B together.

Figure 8.27 Three designs made from the basic sheath pattern.

three designs in Figure 8.27. The pattern development is shown in Figures 8.28, 8.29, and 8.30.

The Dart Seam

Figure 8.31 shows two dart-seam designs in which both fitting darts merge to form line *ABD* (Figure 8.32). The special problem with this design is obtaining adequate seam allowance at point *B*.

Sketch the design line to point *D* and continue it to the hemline at *H*. Follow the arrows and cut along the design line to, but not through, the hemline.

Spread the pattern enough for two seam allowances at point *B*. Draw the dart with curved lines down to point *D*, approximately 10 in. (25.4 cm.) below the waistline. Remove original waist dart. Add seam allowances and complete the pattern.

The Princess-Line Panel

The design in Figure 8.33 has a seam at the normal waistline on the side front panels. The center panel is cut in one piece.

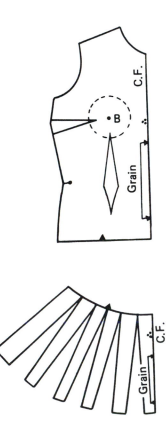

Figure 8.28 Pattern for lowered waistline and flared skirt. The design line is near the hipline.

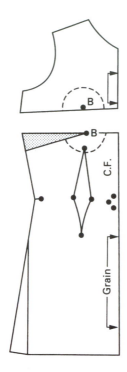

Figure 8.29 Pattern for raised waistline, also called a yokeline. The design line crosses the bustline. Remove the bust dart when you sew the yoke to the dress.

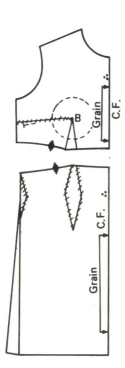

Figure 8.30 Pattern for raised waistline. Design line is under the bustline.

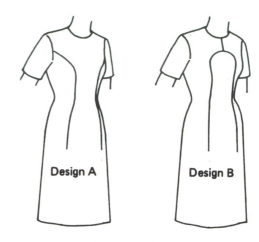

Figure 8.31 Sheath dart-seam designs.

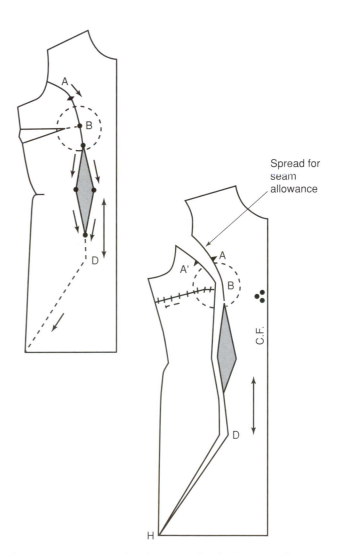

Spread for seam allowance

Figure 8.32 Pattern development for design A in Figure 8.31.

Figure 8.33 Design with princess-line panel.

Directions ...

1. Make a basic princess bodice pattern (page 52).
2. Make a basic six-gore skirt pattern (page 125).
3. Shorten the bodice pattern at the waistline enough to remove the lengthwise ease of ¼ to ⅜ in. (0.6 to 1 cm) allowed in the pattern, but make no change at the side seam. (See Figure 8.34.)
4. Join the center gore of the six-gore skirt to the center section of the princess bodice at the shortened waistline and tape the pattern pieces together. Mark out all waistline seams, for this panel will now be one continuous pattern piece from which the waistline seam has been eliminated. (See Figure 8.35.)
5. The side sections of both skirt and bodice will still be separate pieces.

...

Figure 8.34 Bodice pattern shortened.

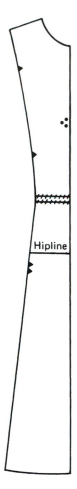

Hipline

Figure 8.35 Center panel.

THE PRINCESS DRESS

The basic princess dress, shown in Figure 8.36, has no waistline seam, and all fitting darts have been converted to one vertical seamline. The dress can be made directly from the princess bodice and six-gore skirt. You will find, however, that it is much easier to follow the directions given here and make the pattern from the basic sheath.

Review the directions for the princess bodice, page 52, and for the six-gore skirt, page 125.

Directions ...

1. Start with a *paper copy* of the basic sheath pattern with no seam allowances. Draw a grainline in the side section of the skirt.
2. Extend the waist-fitting dart to the bust point. Make the side line curve inward from the tip to the bust point.

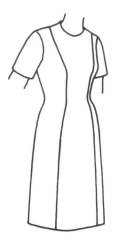

Figure 8.36 Basic princess design.

3. Use the slash method and move the bust dart to the middle of the shoulder seam.
4. Draw a guideline from the lower end of the waist dart to the hemline. Make it parallel to center front.
5. Draw slash lines for flare on each side of the guideline, as shown in Figure 8.37.
6. Separate the pattern into two pieces. Clip the waist dart at the center, and fold it under the front pattern piece or remove it completely.

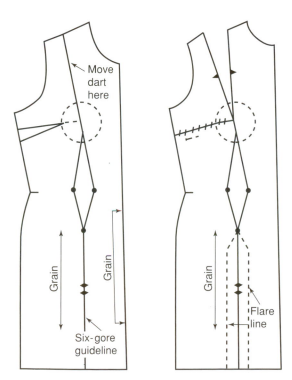

Figure 8.37 Make the princess dress from the sheath pattern.

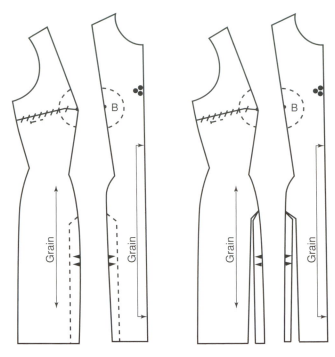

Figure 8.38 Cut pattern into two pieces and fold waist dart under front piece.

7. Slash and spread for the amount of flare desired (Figure 8.38).
 • The minimum flare for a basic princess style with a straight silhouette is ½ in. (1.3 cm) at each slash.
 • The maximum flare for the basic princess style is 2½ to 3 in. (6.4 to 7.6 cm).

Added Fullness For more fullness, study the design in Figure 8.39. Slash from the hemline to the waistline, as shown in Figure 8.40.

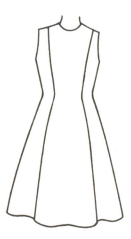

Figure 8.39 Princess dress with added fullness.

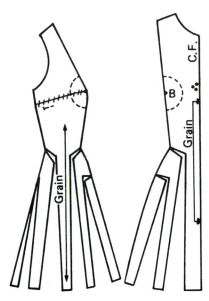

Figure 8.40 Pattern for princess dress with added fullness.

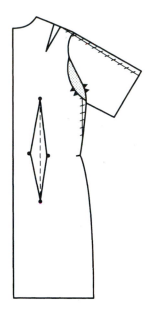

Figure 8.42 Back pattern.

Note that the slashes must be directed to the princess seamline because the design has no waistline seam.

THE KIMONO SHEATH

The kimono sleeve sheath dress (Figure 8.41) can be made by

1. Starting with the basic sheath and adding the basic sleeve

2. Starting with the basic kimono sleeve bodice and adding the skirt

Figures 8.42 and 8.43 illustrate the pattern procedures for adding the basic sleeve to the basic sheath dress. Use the directions on pages 189 and 190 for making the kimono sleeve.

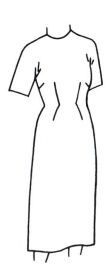

Figure 8.41 Sheath dress with kimono sleeve.

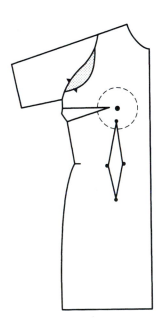

Figure 8.43 Front pattern.

BLOUSES FROM A SHORTENED SHEATH DRESS PATTERN

The Fitted Overblouse

Make the overblouse (Figure 8.44) from the sheath sloper. Determine the blouse length desired; then copy that much of the sheath sloper onto a piece of paper. Add 1 in. (2.5 cm) for the hem, and draw the hemline at right angles to the center front (or back).

Figure 8.44 Overblouse design with darts.

Widen the pattern, as shown by the slashes in Figure 8.45, to make the overblouse large enough to be worn over a suit skirt.

Draw new waist darts, thus releasing up to one-half of the original dart. Two darts in the front or back may be used if desired. The side seamline may also be straightened somewhat. If no waist darts are desired in the design, they can be released for added fullness. Keep the front bust-fitting dart so side seams are the same length.

To make a sleeveless overblouse, refer to the sleeveless bodice directions on pages 84 to 85.

The Shirtwaist Blouse

The shirtwaist blouse (Figure 8.46) usually has more ease through the bust area than the overblouse. The pattern-work is similar to that of the overblouse, except that slashes for adding fullness must extend *up to the armhole* (or shoulder) area to provide bustline ease.

The side seamline of the shirtwaist blouse is usually a straight line.

One or two small waistline darts may be retained for a tailored fit and may be lengthened to the hemline. Or waistline darts can be omitted (Figure 8.47). The blouse will tuck or gather at the waistline when it is worn inside a

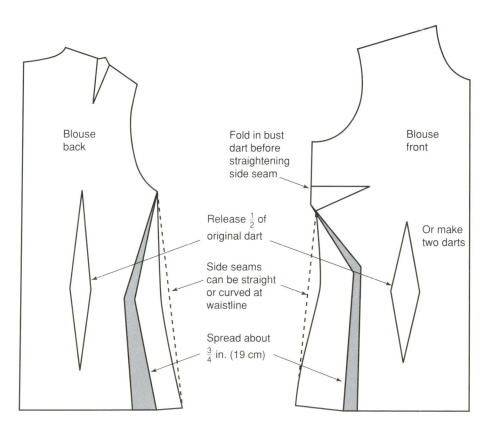

Figure 8.45 Overblouse pattern.

Figure 8.46 Shirtwaist blouse.

skirt. Don't forget to add the extension for the buttons and buttonholes.

DRESS WITH ELASTIC IN THE WAISTLINE SEAM

Figure 8.48 shows the changes that are necessary to change a basic bodice front and skirt front to a pattern for a dress with elastic in the waistline seam. Waistline darts are converted to gathers, side seams are straightened, skirt is widened, more length can be added to the bodice front and back, and elastic is inserted in a casing made from the waistline seam allowance.

This is a comfortable dress style that can fit more than one size. The elastic waistline is a useful design feature for the person whose weight changes frequently.

Directions ...

1. On the bodice front, move the bust-fitting dart to the waistline by the pivot or slash method. This changes the side seam to a line that is parallel to center front and parallel to the lengthwise grain of the fabric.
2. Cross out the waist-fitting dart, which will be converted to gathers that form when elastic is added to the waistline.
3. If more blousiness is wanted at the bottom of the bodice, add 1 in. (2.5 cm) to the bodice hemline.
4. Complete the bodice back pattern by straightening the side seam and drawing out the back waist-fitting dart. If extra length was added to the bodice front, it also must be added to the bodice back.

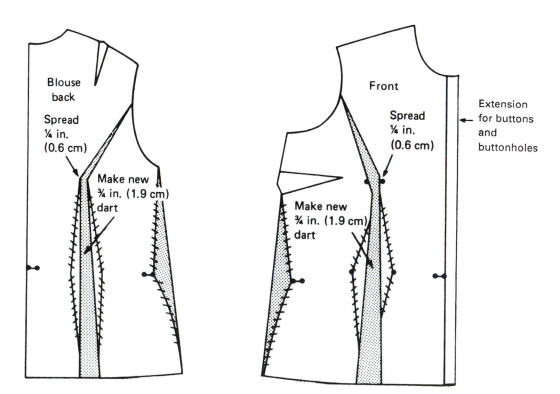

Figure 8.47 Shirtwaist blouse pattern.

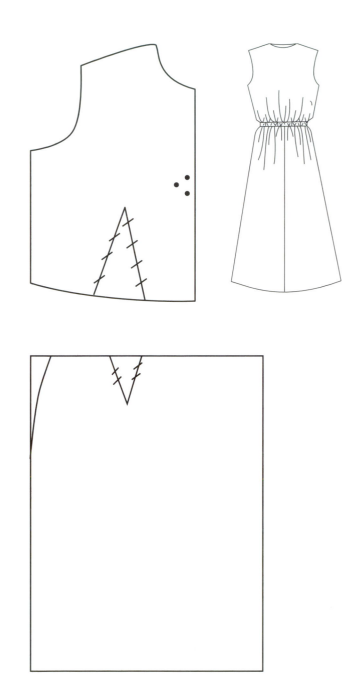

Figure 8.48 Dress with elastic in waistline seam. For greater comfort, add more width to the skirt pattern.

5. On the front and back skirt, draw through the darts and add extra width until the side seam is on the straight grain from hipline to waistline. Add extra width at the center front for comfort.

6. Match center front, center back, and side seams; then pin and sew the skirt to the bodice with right sides together.

7. If more skirt fullness is desired, add more width to the skirt front and back. This fuller skirt can be gathered onto the bodice, which has less fullness at the waistline.

8. To form the waistline casing, cut the bodice seam allowance to ¼ in. (0.6 cm) from the stitching line. Press the seam allowance toward the bodice. Stitch the skirt seam allowance to the bodice ⅜ in. (1 cm) from the seamline, leaving an opening for insertion of the ¼-in. (0.6-cm) wide elastic. A separate casing fabric could also be used.

9. Cut the elastic to accommodate a comfortable waist measurement plus ½ in. (1.3 cm) for overlap.

10. Insert the elastic through the casing. Lap the ends of the elastic ½ in. (1.3 cm) and sew together. Stitch closed the opening in the casing.

PROBLEMS

Make the patterns for several of these dresses and blouses.

Princess-Line Dress Variations

Dresses with Tucks and Pleats

Blouses with Tucks and Pleats

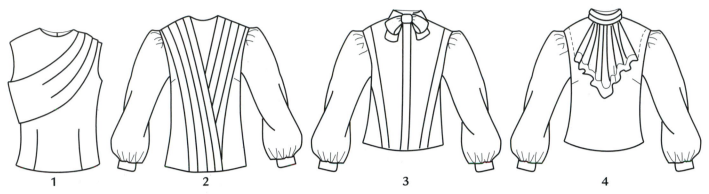

1 2 3 4

Dresses with Asymmetric Designs

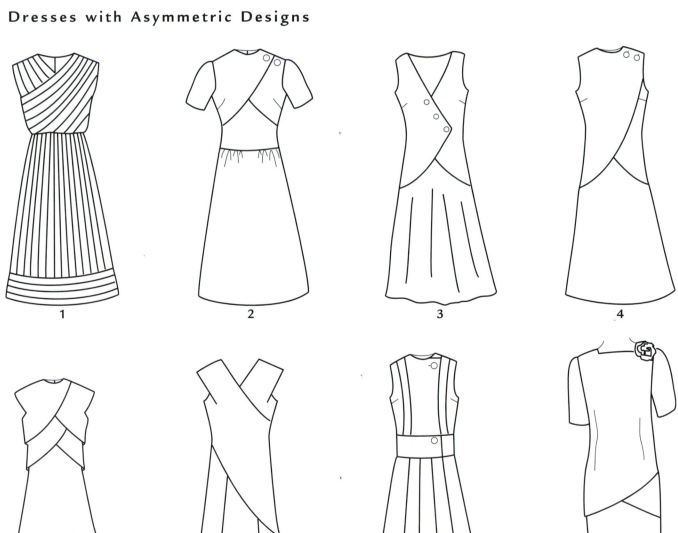

1 2 3 4

5 6 7 8

Dresses with Midriff Designs

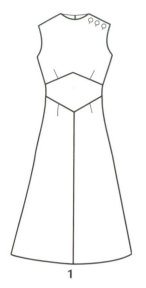

1

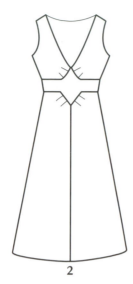

2

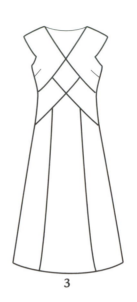

3

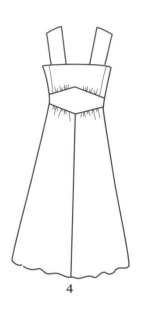

4

Dresses with Gathers

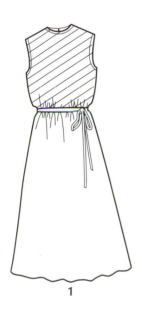

1

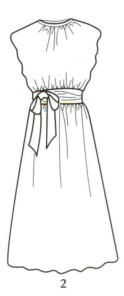

2

3

4

5

6

7

8

Dresses with Front Openings

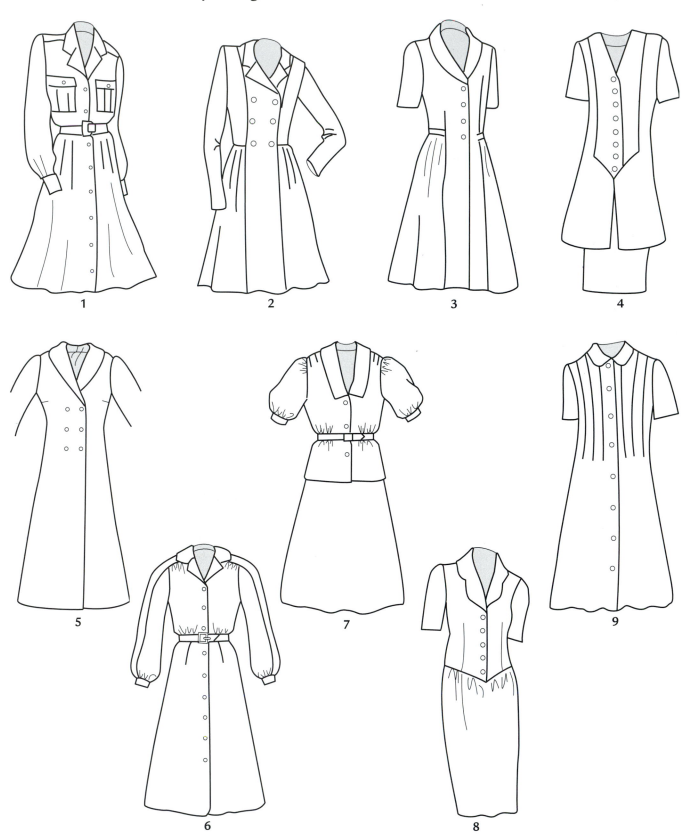

1

2

3

4

5

6

7

8

9

Sleeves

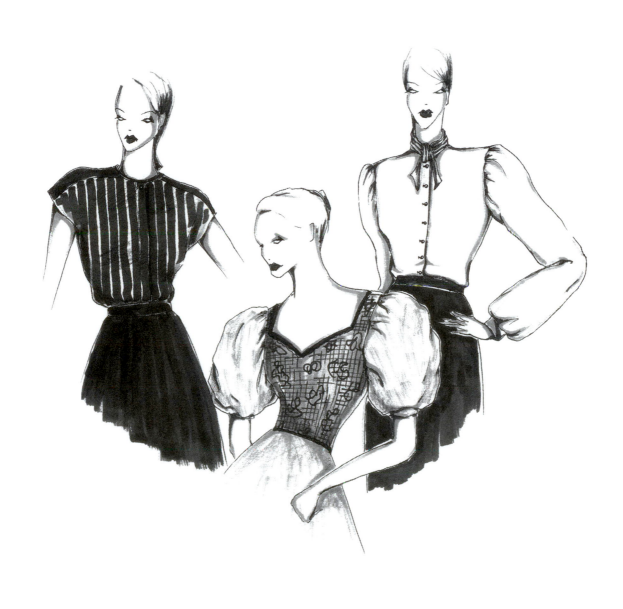

THE BASIC SLEEVE

The basic fitted sleeve pattern can be used to make all the sleeve variations shown in Figure 9.1.

Fashion is a factor in basic sleeve differences as you can see by examining the two basic sleeve patterns in Figures 9.2 and 9.3.

Figure 9.2 shows a sleeve with one elbow dart and more room at the wrist. Figure 9.3 shows a sleeve with two elbow darts and a zipper opening at the wrist.

Parts of the Basic Sleeve

See Figure 9.4 to identify the terms defined here.

- Capline—A horizontal line from underarm to underarm. It is the crosswise grainline, and it separates the upper and lower sections of the sleeve.
- Sleeve cap—The part of the sleeve *above* the capline.
- Cap seamline—The curved line around the top of the sleeve. Two notches in the back and one notch in the front ensure the proper distribution of ease.
- Grainline—A line at right angles to the capline.
- Fold line—A line created by folding the sleeve in half. It will follow the grain above the elbow. Because of the elbow darts, the fold line angles off grain below the elbow.

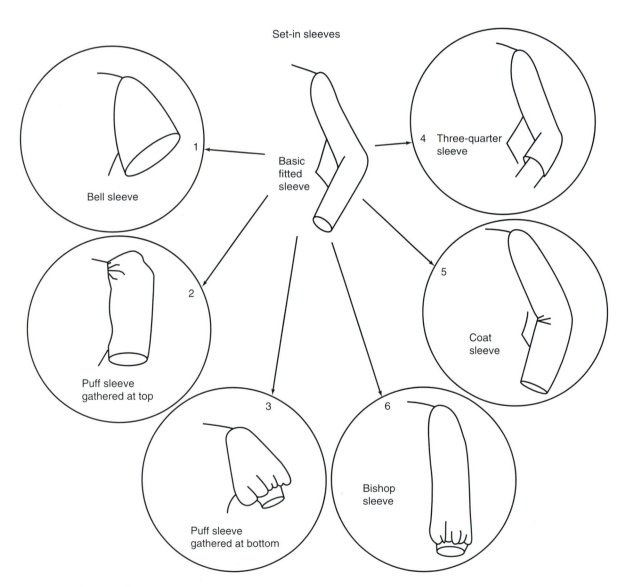

Figure 9.1 Set-in sleeve styles.

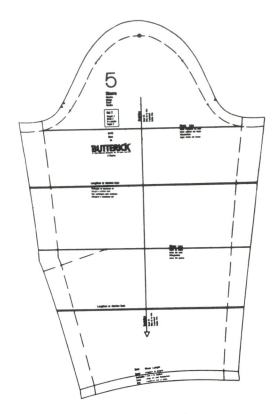

Figure 9.2 Sleeve pattern with one dart.

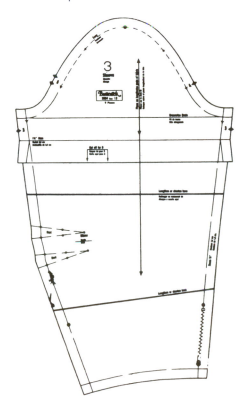

Figure 9.3 Sleeve pattern with two fitting darts and a hem.

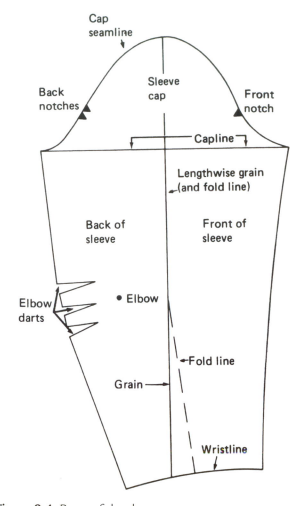

Figure 9.4 Parts of the sleeve.

- Elbow darts—Fitting darts in the back of the sleeve that create a bulge in the sleeve so the arm can bend. A basic pattern may have one, two, or three darts.
- Notches—Notches are added on the cap seamline at the point where the inward curve becomes an outward curve. Use one notch on the sleeve front and two notches on the sleeve back.

How to Check a Sleeve

Sleeve patterns that are designed from the basic sleeve should always be checked to be sure that they will fit without twisting.

Directions ...

1. Lengthen all darts to the fold line and fold them shut.
2. Fold the sleeve lengthwise, matching the ends of the capline. If the sleeve is well designed, the underarm seams will now match.

3. If the underarm seams do not match, use a tracing wheel to mark the same line on both sides.

..

Ease in the Sleeve Cap

Ease is the difference in length between the sleeve cap seamline and the bodice armhole. Measure this difference as follows:

Directions ...

1. Stand a flexible plastic ruler on edge and fit it around the armhole curves as shown in Figure 9.5.
2. Measure the seamline in these four sections:
 • Underarm to back notch
 • Back notch to top of cap
 • Top of cap to front notch
 • Front notch to underarm
3. Measure the corresponding spaces on the bodice armhole and calculate the amount of ease.

 Sleeve notches are necessary to keep the correct amount of ease in each segment of the armhole.

 ..

Reducing Ease in the Sleeve Cap

When a crisp fabric is used, the amount of ease in the sleeve cap may need to be reduced to achieve a smoother cap. Be cautious, however, because poor sewing technique is often the problem rather than too much ease.

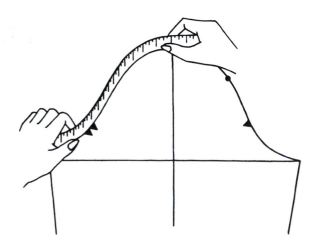

Figure 9.5 Measure sleeve cap by standing a flexible plastic ruler on edge and fitting it to curves.

Draw a new line here to reduce amount of curve 1/8 in. (0.3 cm)

Figure 9.6 Use a French curve to redraw the sleeve cap.

Use a French curve* and place it as shown in Figure 9.6. Draw a new seamline that flattens the curve about ⅛ in. (0.3 cm) at the widest point. Remember, a little reduction makes a big difference—and *never* reduce the cap height. To do so would cause lengthwise wrinkles in the front and back of the sleeve.

Note that the less-rounded end of the French curve is used. The rounder end can be used to increase the curve, thus increasing the amount of ease.

CUFFS

Shaped Cuffs

The procedures for making the shaped cuff pattern are somewhat similar to those used to make sleeve facing patterns.

Directions ...

1. Use the two-layer method. Place a second piece of paper under the end of the sleeve as the sleeve pattern is being made. Pin. (See Figure 9.7.)
2. Because the cuff goes around the outside of the sleeve, it must be made long enough to become this outside circle. (Remember that the facing was the inside circle, so it had to be reduced in size to fit that position.) Measure out ⅛ in. (0.3 cm) or more at the sides of the

..............

*See Appendix A.

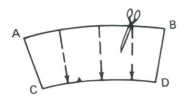

Figure 9.9 Slash to flare upper cuff edge.

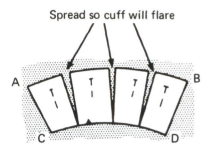

Figure 9.10 Spread the necessary amount for desired flare.

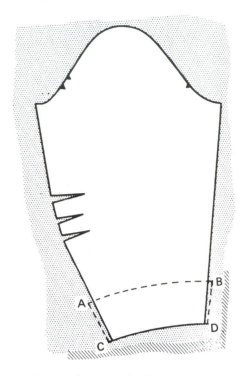

Figure 9.7 The two-layer method.

sleeve and draw lines to mark this added width. The amount of added width depends on the thickness of the fabric.

3. Measure up the sleeve and mark line *AB*, which is determined by the width of the cuff to be made. Run a tracing wheel across the end of the sleeve and around dashed lines *CABD*. Unpin, remove the second layer of paper, and cut off the excess paper.

4. The cuff can be shaped as in Figure 9.8a. It can also be made as a complete circle resulting in a ruffle cuff as in Figure 9.8b or it can be made into a curved cuff as in Figure 9.8c.

..

If the cuff is to have an opening, design the curve.

If the upper edge is to flare out, slash as shown in Figures 9.9 and 9.10 and spread the necessary amount. The grain may be in the center of the cuff, or it may be placed on the bias.

In Figure 9.11, a one-button straight cuff, the cuff and facings are a single piece. Make the cuff about 2 in. (5.1 cm) longer than the wrist measurement and about 2 to 3 in. (5.1 to 7.6 cm) wide (when finished). Lines *AB* and *CD* are sewn to the sleeve.

Note that the pattern for the two-button straight cuff in Figure 9.12 says *cut 4*. The cuff and its facings are separate pieces joined by a seam. This cuff corresponds in size

a b c

Ruffle cuff Shaped cuff Curved cuff

Figure 9.8 Various cuff styles.

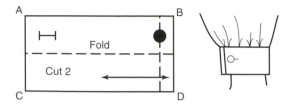

Figure 9.11 One-button straight cuff. The extension is marked with a dotted line.

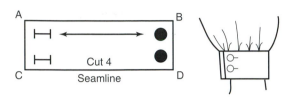

Figure 9.12 Two-button straight cuff.

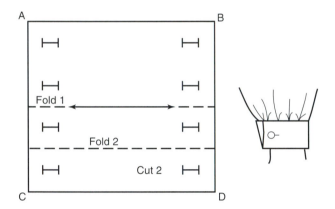

Figure 9.13 French cuff.

to the one-button straight cuff in Figure 9.11. Line *AB* is sewn to the sleeve. Line *CD* is the outer seamline of the cuff.

The French cuff folds back on itself and is designed for cuff links (Figure 9.13). The finished width should be approximately 3 in. (7.6 cm). Lines *AB* and *CD* are attached to the sleeve.

MOVING DARTS

The fitting darts at the elbow create a pouch that gives room for the arm to bend. Depending on the tightness of the lower part of the sleeve, the basic sleeve may have one, two, or three darts at the elbow. (See Figures 9.2, 9.3 and 9.4.)

The elbow-fitting darts may be converted to gathers at the underarm seam (or to ease if the basic sleeve has only one dart), or they may be moved to the wristline or capline. Because the elbow fits into the back half of the sleeve, the darts are not moved to the underarm front seam.

Locate the pivot point. It should be 1 in. (2.5 cm) (+) from the tip of the elbow dart or darts. To move the elbow dart to the wrist, follow these steps:

Directions ...

1. Draw a line straight down from the pivot point to the sleeve wristline.
2. Slash along the lower side of the elbow dart (or darts) to the pivot point and also along the slash line to, but not through, the pivot point.
3. Close the elbow dart (or darts), and an opening is created for a new dart, for gathers, or for a wider sleeve bottom, as shown in Figure 9.14.
4. Fold pattern in half and cut off excess width on the side with the closed dart. Straighten bottom of sleeve.

...

To move the elbow darts to the sleeve cap, follow these steps:

Directions ...

1. Draw lines from the sleeve cap to the pivot point. Slash along these lines and along the lower side of the elbow dart (or darts).

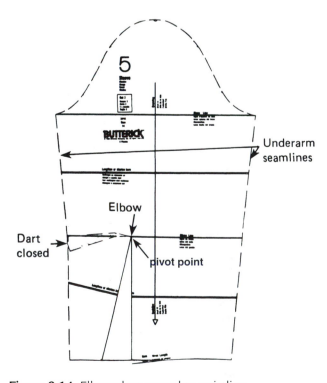

Figure 9.14 Elbow dart moved to wristline.

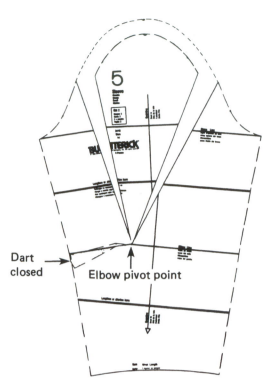

Figure 9.15 Elbow dart moved to capline for gathers.

2. Close the elbow dart, and openings will form in the sleeve cap (Figure 9.15). The new seamline curve should add length to the sleeve cap.
3. Redraw capline and correct grainline in lower part of sleeve.

...

SLEEVE FACING

The sleeve facing is a duplicate of the bottom of the sleeve. It may be a fitted facing with the same number of seams and the same grain as the sleeve, or it may be a shaped bias facing. Because the end of the finished sleeve is tubular, the shaped bias facing can usually be more easily adjusted to fit the smaller inner circle of the sleeve tube.

When a fitted sleeve is to be finished with a facing, the seamline at the bottom of the sleeve is a gentle curve. This curve corrects the uneven effect in the hemline caused by the arm seam's inward slant. Knowing how to establish this curve if it is not present on the pattern is helpful.

Directions ...

1. Decide on the sleeve length; then draw dashed lines at a *right angle* to the underarm seamlines, first at A and then at B, as shown in Figure 9.16.

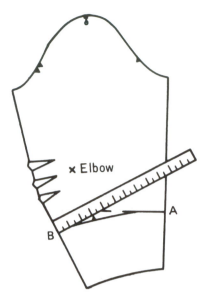

Figure 9.16 Draw lines at a right angle to underarm seamlines.

2. The dashed lines will meet at an angle in back of the center of the sleeve.
3. Sketch a gentle curve (solid line AB in Figure 9.16) to round off the angle. The new curve is parallel to the old curve line at the bottom of the sleeve.
4. Erase all extra lines. Mark a notch on the curved line at a point below the elbow.

Follow these steps to make the sleeve facing:

Directions ...

1. Place a piece of paper under the area to be faced.
2. Measure up 2 in. (5.1 cm) and draw dashed line CD (Figure 9.17) to mark the upper edge of the facing.

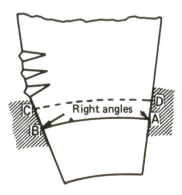

Figure 9.17 Line CD is upper edge of facing on three-quarter length sleeve.

3. Trace with the tracing wheel around the area *ABCD*. Mark the matching notch.

4. Remove the sleeve from the facing and cut off excess paper.

5. Label the pattern.

6. Establish the grainline on the shaped bias facing by folding the facing through the center as shown in Figure 9.18, dashed line *AB*. Unfold, and draw a square around the dashed line. Use the diagonal of the square as the grainline.*

7. You may have to reduce the size of the facing (i.e., make it a smaller circle), so it will fit smoothly inside the sleeve tube (Figure 9.19). To do this, take a larger seam allowance, ⅛ in. (0.3 cm) or more, as determined by the thickness of the fabric. If the facing is too large in the finished garment, vertical wrinkles will be evident inside the sleeve.

...

Sewing Suggestions

Think through the process of attaching the facing to the sleeve and plan to keep the facing *inside the sleeve* at all times. This will prevent stretching and will enable you to check the facing fit. Start with the sleeve wrong-side-out and insert the facing so the right angles of the fabric are together (Figure 9.20). Match seams, stitch, trim, layer, and clip seam allowances; then understitch.

..

.............
*Or follow directions for using a plastic ruler on page 180.

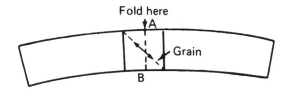

Figure 9.18 Establish grainline.

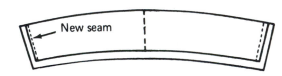

Figure 9.19 Reduce facing size.

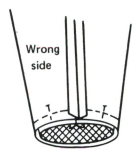

Figure 9.20 Keep facing inside sleeve when sewing.

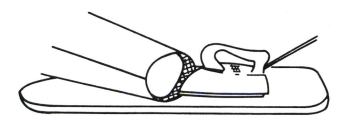

Figure 9.21 Press sleeve facing.

Pressing

The sleeve facing has been made proportionately smaller than the sleeve so it is the inner circle with a smaller circumference. Press as shown in Figure 9.21 to retain this smaller size.

Fabric for Facing

When the garment is made of thick fabric, it may be preferable to make the facing of a thin fabric, such as lining fabric of a matching color. This will reduce the bulk at the end of the sleeve.

DESIGNING WITH SLEEVES

The Short Sleeve

The basic sleeve can be changed to a short sleeve by cutting off the sleeve at the desired length above the elbow. Be sure to keep the underarm seams the same length.

The lower edge of the short sleeve can be finished with a hem or a facing. Directions for making the hem are given here, and directions for making facings are given on page 183.

Directions ...

1. Decide first on the length of the sleeve; then add some paper at each side of the sleeve to provide enough

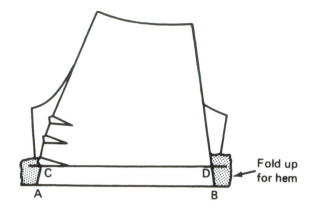

Figure 9.22 Making short sleeve hem.

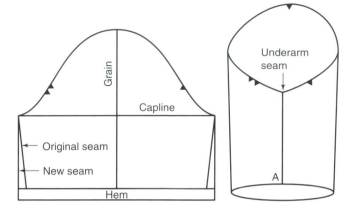

Figure 9.24 When seamlines slant inward, sleeve hangs short at underarm seamline.

width for the hem. (This is needed because the basic sleeve seamlines slope inward.)

2. Fold up the lower portion of the sleeve as shown in Figure 9.22.
3. Measure up 2 in. (5.1 cm) for the width of the hem, and draw line CD. While the sleeve is folded, cut off the excess paper and cut off the end of the sleeve.

 Figure 9.23 shows the hem unfolded. Note that the hem angles out to fit the sleeve.

If the underarm seamlines of the sleeve are straightened, as shown in Figure 9.24, the lower edge of the sleeve will hang straight. The hem of the sleeve is cut straight without an angle.

The Puff Sleeve or Bell Sleeve with Fullness at the Bottom

To make the puff sleeve gathered at the bottom, follow these steps:

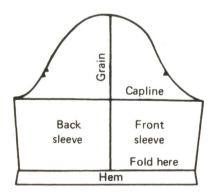

Figure 9.23 Finished pattern for hem.

Directions

1. Change the long, fitted sleeve pattern to a short sleeve.
2. Slash the pattern from the lower edge to, but not through, the cap seamline.
3. Spread the pattern the same amount on each side of the grainline and pin or tape to a piece of paper (Figure 9.25).
4. Sketch a smooth curve for the hem. Add some length. Cut off paper and label the pattern. Draw the new capline.
5. This sleeve may be gathered onto a band or left full as a bell sleeve.

The Puff Sleeve with Fullness at the Top Only

To make the pattern for the puff sleeve gathered at the top, follow these steps:

Directions

1. Change the long, fitted sleeve to a short sleeve.
2. Slash through the cap seamline (Figure 9.26) to, but not through, the opposite edge.
3. Spread the pattern as desired and pin to a piece of paper.
4. Perfect the cap seamline by adding length as shown. The added length will make the sleeve puff more.
5. The lower edge is now a curve and must be finished with a fitted facing or binding.
6. Draw the new capline and add marks for gathers.

Note the increased length of the cap height line.

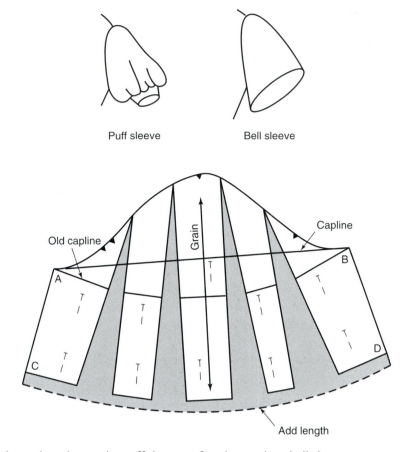

Figure 9.25 Sleeve may be gathered to make puff sleeve or faced to make a bell sleeve.

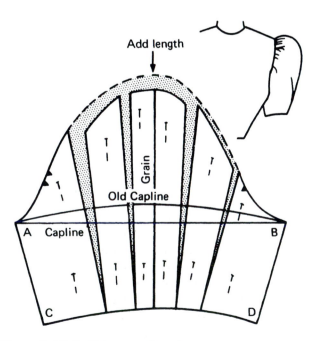

Figure 9.26 Puff sleeve gathered at top.

A rule of thumb is: The amount of height added approximates the difference between the old and new capline.

The Bishop Sleeve

The bishop sleeve is a long (or three-quarter) sleeve that has fullness gathered or pleated to a band or cuff (Figure 9.27). The design has no fitting darts at the elbow because they have been converted to length and width at the wrist.

The method for making a bishop sleeve described here is a combination of the slash method and drafting. It is very easy to do.

Directions ...

1. Move the elbow darts to the sleeve wristline (Figure 9.28) by using the directions on page 182.
2. Pin the sleeve to a large piece of paper. (The sleeve shown in Figure 9.28 is a commercial basic sleeve with the seam allowances cut off.)

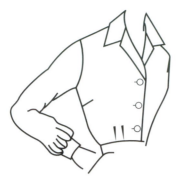

Figure 9.27 The bishop sleeve.

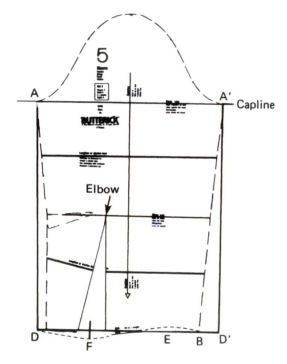

Figure 9.28 Making the bishop sleeve. A, A', D & D' will have right angle corners.

3. Draw a capline *AA'*; then drop lines at right angles from each end of the capline, as shown in Figure 9.28. Lines *AD* and *A'D'* are perpendicular to *AA'* and *DD'*.
4. Draw line *DD'* through point *B* of the sleeve. This serves as a guideline for the sleeve curve and also completes the rectangle *AA'DD'*.
5. Design the curve for the lower end of the sleeve (Figure 9.29) as follows:

 Raise the curve about ¼ in. (0.6 cm) at *E* above line *DD'*.

 Make the deepest part of the curve drop ½ to 1 in. (1.3 to 2.5 cm) below line *DD'* at point *F*. The deepest part of the curve thus comes below the elbow, and the

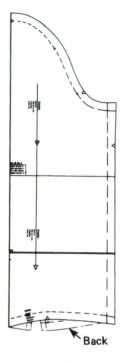

Figure 9.29 Curve at end of bishop sleeve.

length added there is equivalent to the fitting dart. The added width at the elbow also reduces the need for elbow darts.

6. The slash opening for the lapped placket is added at point *F*. It is 3 in. (7.6 cm) long on each side and ¾ in. (1.9 cm) wide at the seamline. Note the placement of the lapped placket in Figure 9.30.
7. Gather or pleat the bottom of the sleeve to fit the sleeve band.

..

With Added Fullness The bishop sleeve may be made wider at the lower edge than the design shown in Figure 9.27. The sleeve in Figure 9.31 is 2 in. (5.1 cm) wider at the lower edge. Add one-half of this amount at each side of the pattern.

Sleeves for designs made of a fabric that is sheer, or very soft, or both, may be made very wide and very full. Design this kind of sleeve by the slash method. Figure 9.32 shows a bishop sleeve that has been slashed and spread to add fullness. If the pattern is spread uniformly at the slashes, the curve at the lower edge will be quite easy to perfect. Note also that the effect created by the fullness is enhanced if the curve is deepened.

Observe the change at the capline. The new capline, the dashed line in Figure 9.32, is higher than the original capline; thus the sleeve cap height is shortened.

The armhole length of the sleeve remains the same.

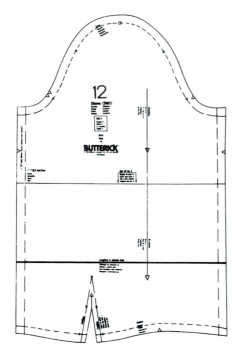

Figure 9.30 Commercial bishop sleeve pattern.

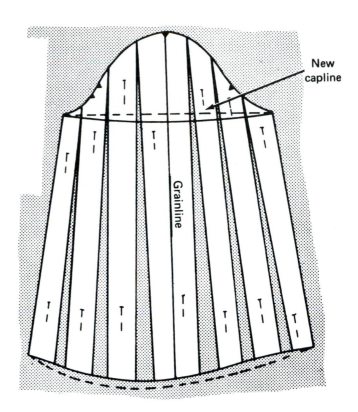

Figure 9.32 Adding fullness by the slash method.

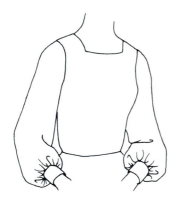

Figure 9.31 Bishop sleeve with fullness added.

Shirt-Style Sleeve with Shortened Sleeve Cap

The shoulder seamline is usually lengthened to go with this sleeve, as shown in Figure 9.33. Sport garments require a sleeve cap that is shorter than normal to accommodate freer arm movement. Note that the height of the cap decreases as the width of the cap increases, but the armhole length remains constant.

Directions

1. Lengthen the shoulder seamline of the bodice 1 in. (2.5 cm). Draw the new armhole.

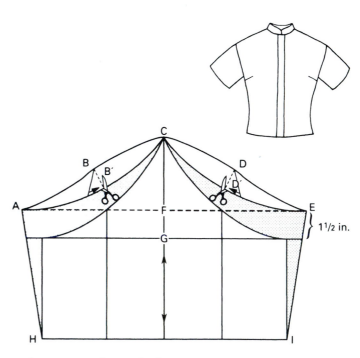

Figure 9.33 Shirt-style sleeve pattern.

2. Make a copy of the basic sleeve. Either a short sleeve or long sleeve can be used.

3. Divide the sleeve into four equal sections, and label each point along the top of the sleeve (A, B, C, D, and E, as shown in Figure 9.33).

4. Draw a curved line from A to C and from E to C. Cut on these two lines and also slash from B' to, but not through, B and from D' to, but not through, D to create a smoother curve.

5. Draw two horizontal parallel lines 1½ in. (3.8 cm) apart on a sheet of paper. Place the sleeve pattern on the paper with points A and E on the upper line. Connect points A and H and points E and I. The new cap height line, CF, is now shorter than the old line, CG. The length of the sleeve, line ABCDE, is unchanged and still fits the original armhole.

Flatter sleeve caps look better with less ease. For greater comfort add more width at the bottom of the sleeve at points H and I.

THE KIMONO SLEEVE

The basic kimono sleeve pattern is made by joining the basic sleeve to the basic bodice, thus eliminating the arm-hole seam.

The basic kimono sleeve, Figure 9.34, normally has vertical wrinkles at the armhole position. Reducing the size of the angle at the pattern underarm will reduce the amount of wrinkles but will necessitate using a gusset to restore "reaching room."

Directions

1. Cut the basic sleeve pattern into two pieces to separate the sleeve front from the sleeve back.

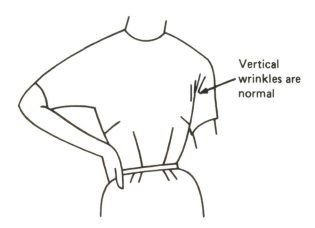

Figure 9.34 Basic kimono sleeve.

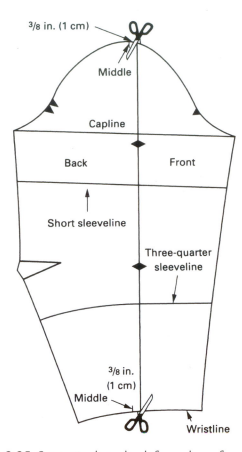

Figure 9.35 Separate sleeve back from sleeve front.

a. Fold the sleeve lengthwise to find the middle of the sleeve cap and the middle of the wristline. Mark both of these points.

b. Measure ⅜ or ½ in. (1 or 1.3* cm) toward the front of both points and mark. Draw a straight line between these two new marks.

c. Draw lines for a short sleeve and for a three-quarter sleeve. Mark matching notches on the lengthwise line; then cut the sleeve into two pieces (Figure 9.35). Label the pieces as sleeve front and sleeve back.

2. Join the sleeve front to the bodice front as follows:

a. Overlap the sleeve ½ in. (1.3 cm) across the bodice at the end of the shoulder. Thumbtack there.

b. Pivot the sleeve at the thumbtack until the sleeve and bodice shoulder make a straight line (Figure 9.36). This should leave a space of ⅜ to 1 in. (1 to 2.5 cm) between the sleeve and bodice at the under-

..............

*Design for the individual with a large bust by altering the pattern and raising the underarm level of the armhole by 1/2 in. (1.3 cm) or more.

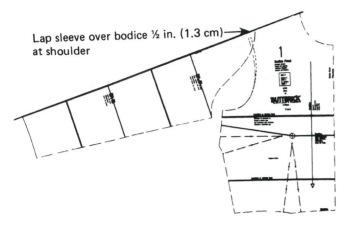

Figure 9.36 Join patterns so shoulderline is straight.

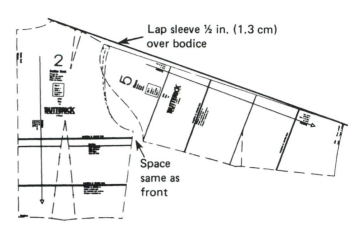

Figure 9.38 Join back patterns at shoulder.

arm and will make the *largest possible angle* there. The angle should be close to a right angle in size.

Remember that the largest underarm angle gives the most reaching room. Test the pattern in muslin when it is finished to see if it is comfortable or if a gusset is needed.

c. Draw a new underarm seamline to widen the bodice until the new seamline meets the seamline of the sleeve pattern piece (Figure 9.37). The underarm corner can be rounded off as a small curve if desired.

3. Join the sleeve back and the bodice back as follows:
 a. Lap the sleeve ½ in. (1.3 cm) over the bodice at the end of the shoulder and thumbtack (Figure 9.38).
 b. Adjust the space at the underarm so it measures the same as that of the front.
 c. Add lengthwise ease at the shoulder to help compensate for the loss of an armhole seam. Add ½ in.

(1.3 cm) at the end of the shoulder and taper to nothing at the neck and wrist. Mark out the original seamline (Figure 9.39).
 d. Draw a new underarm seamline for the bodice to widen it enough to meet the sleeve (Figure 9.39).
4. Now check to see if the seamlines of the kimono front and back are the same length at the underarm.
5. The grainline for both the back and front patterns will be the original bodice grainlines.
6. Complete the pattern with labels.
7. When checking the front and back kimono sleeve patterns, note that the angle at the underarm must be the same on the front and back patterns. You may have to adjust the front pattern by moving all or part of the bust-fitting dart to the waistline dart, or you can shift part of the bust-fitting dart to the armhole area to keep the underarm angle the same on the front and back patterns.

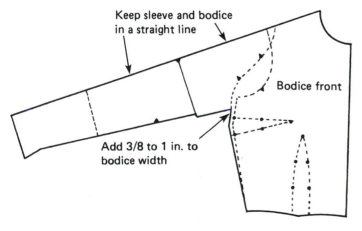

Figure 9.37 Draw new underarm seamline for bodice.

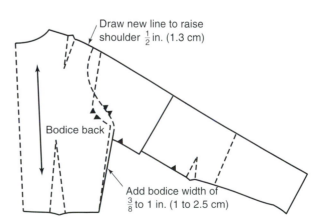

Figure 9.39 Raise shoulder seamline and add width at bodice underarm.

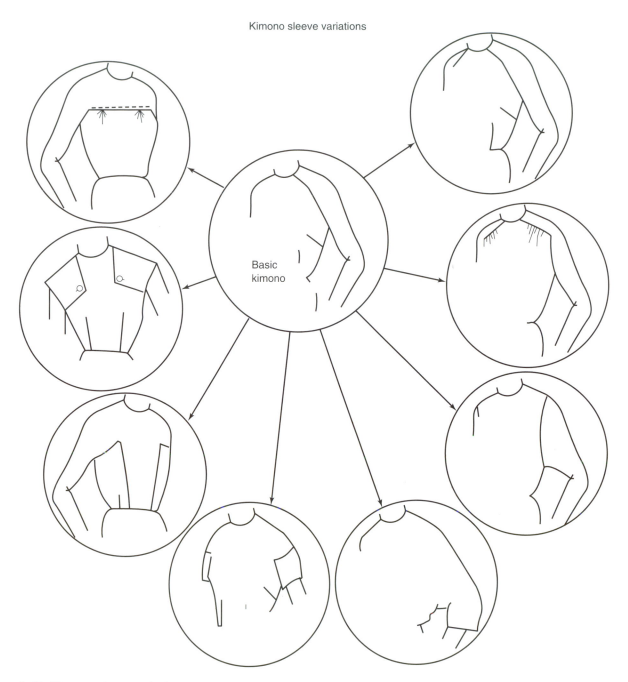

Figure 9.40 Kimono sleeve variations.

Designing with the Kimono Sleeve

Some designs that can be made from the basic kimono pattern are shown in Figure 9.40. Darts can be moved, combined, and divided, and seamlines can be introduced.

The Kimono Sleeve and Darts

Use a paper copy of the basic kimono sleeve pattern. The short sleeve will be easier to manage and will illustrate procedures as well as the long sleeve.

The principles of designing with darts are the same for all kinds of patterns. Use the slash method.

Figure 9.41 Neckline dart.

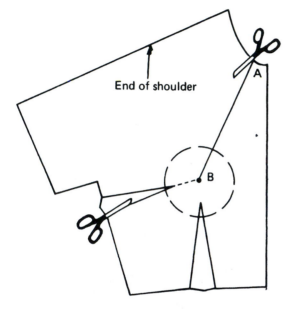

Figure 9.42 Design a line for the neckline dart.

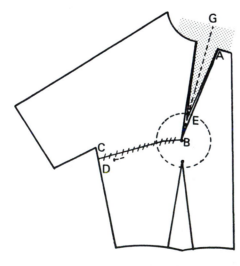

Figure 9.43 Move the dart by the slash method.

Directions .

1. Mark the end of the shoulder so darts will not be moved down into the sleeve. Remember that the kimono sleeve has *no armhole seamline*, so darts cannot be moved to an armhole position and no slashes for fullness can be directed to that area.
2. Design a line for a neckline dart (Figures 9.41 and 9.42).
3. Apply the directions for moving darts by the slash method. Study the illustrations of the pattern procedure in Figures 9.42 and 9.43.
. .

THE BATWING SLEEVE

The batwing sleeve is developed from the basic kimono sleeve and has folds in the underarm area. The kimono sleeve pattern is slashed from the underarm seam to the shoulder seam and spread until it has a slight upward curve at the shoulder seam. More length can be added to the underarm seam, as shown in Figure 9.44. The lower edge of the sleeve can be made smaller, if desired.

THE RAGLAN SLEEVE

The term **raglan** identifies a sleeve that continues in one piece to the neckline (Figure 9.45). It is made from the basic kimono pattern.

Front Pattern

Directions .

1. On a paper copy of the basic kimono front pattern do the following:
 a. Lower the bust-fitting dart.
 b. Widen the bodice ⅜ in. (1 cm) at the underarm and taper to nothing at the waist.
 c. Draw a guideline from the underarm to the end of the shoulder for a slash.
 Figure 9.46 illustrates all these changes.
2. Slash along the guideline and lap the sleeve over the bodice 1⅜ in. (3.5 cm).
 Restore part of the sleeve width by drawing a curved line from the end of the shoulder to the end of the sleeve (Figure 9.47).
3. Trace the full-scale armhole device* in Figure 9.48. Cut out the tracing and glue it in position at the

.
*If the armhole device is to be used successfully, the pattern *must have an angle* at the underarm. The device will *not* work if the underarm seam is a curve.

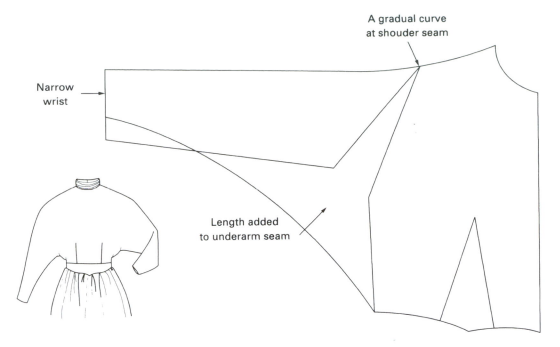

Narrow wrist

A gradual curve at shoulder seam

Length added to underarm seam

Figure 9.44 The batwing sleeve.

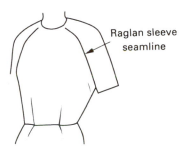

Raglan sleeve seamline

Figure 9.45 Raglan sleeve bodice.

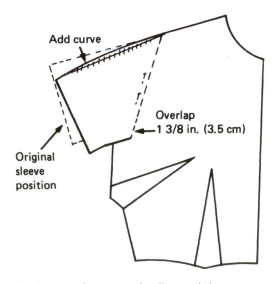

Add curve

Overlap 1 3/8 in. (3.5 cm)

Original sleeve position

Figure 9.47 Lap sleeve over bodice and draw a curved sleeve seamline.

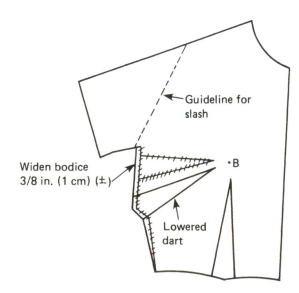

Guideline for slash

Widen bodice 3/8 in. (1 cm) (±)

•B

Lowered dart

Figure 9.46 Lower dart, widen bodice, and draw a guideline.

underarm so it points toward the shoulder. A straight line drawn from the device tip to the shoulder should intersect at about 1 in. (2.5 cm) from the neckline (Figure 9.49).

4. Now design the raglan seamline from the end of the device to the neckline. Curve the line slightly, shaping it as shown in Figure 9.50.

5. In the sleeve portion, draw a grainline parallel to the center front line. The two raglan sleeve pattern pieces will be made from this pattern.

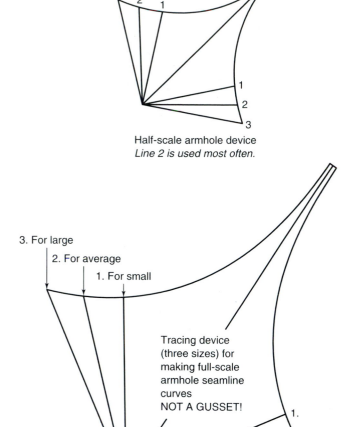

Half-scale armhole device
Line 2 is used most often.

3. For large

2. For average

1. For small

Tracing device
(three sizes) for
making full-scale
armhole seamline
curves
NOT A GUSSET!

1.

2.

3.

Full-scale armhole device

Figure 9.48 For most patterns, trace the line for the average.

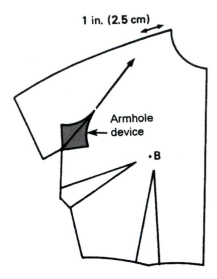

1 in. (2.5 cm)

Armhole
← device

•B

Figure 9.49 Glue armhole device in place at underarm.

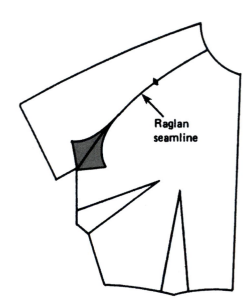

Raglan
seamline

Figure 9.50 Design raglan seamline.

6. Place a piece of transparent paper over the sleeve section of the bodice, and trace the seamlines and grainline as shown in Figure 9.51.

Add ⅝-in (1.6-cm) seam allowances around the entire sleeve pattern.

The pattern in Figure 9.51 will need a hem, so fold up the paper, measure, and mark a 1-in. (2.5-cm) (+) hem.

Label the pattern and cut off the excess paper.

7. Now place a piece of transparent paper over the bodice section and trace the bodice (Figure 9.52). Draw the grainline parallel to center front and center back.

Add seam allowances, label the pattern, and cut off the excess paper.

...

Figure 9.53 shows a completed bodice and sleeve pattern for a three-quarter raglan sleeve.

Raglan Design Line from Original Armhole Line

The original armhole lines of the bodice pattern can also be used in making the design line for the raglan sleeve—rather than using the armhole device.

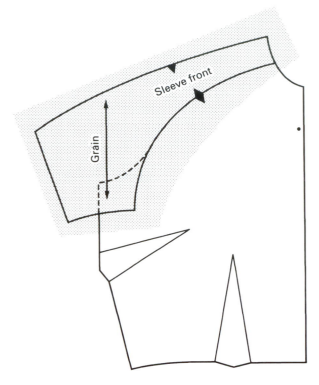

Figure 9.51 Trace the sleeve and draw grainline parallel to center front (and center back).

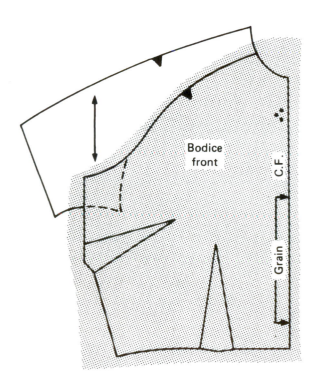

Figure 9.52 Trace the bodice and draw grainline parallel to center front.

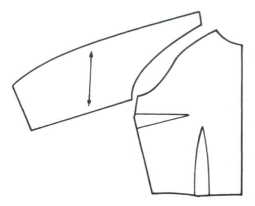

Figure 9.53 The two pieces of the raglan sleeve bodice.

Directions

1. Read the descriptions given with Figures 9.54 and 9.55, and study the illustrations carefully.
2. After the raglan design line has been drawn, make a tracing of the raglan sleeve and of the raglan bodice.
3. The grainline of the raglan sleeve is parallel to the grainline of the original bodice center front (or back).

Back Pattern

The shoulder dart of the back pattern may be dealt with in one of two ways:

1. Move it to the neckline, but be careful not to crowd the design lines there if the garment has a center back opening.

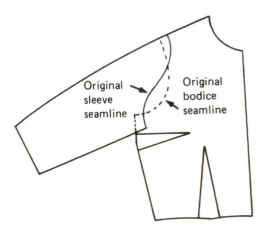

Figure 9.54 This bodice shows original armhole lines when sleeve overlaps bodice 1⅜ in. (3.5 cm).

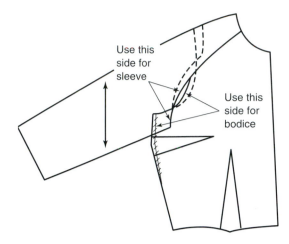

Figure 9.55 Dark lines are guidelines for raglan seamline.

2. Leave the dart where it is until you are designing the raglan line and tracing the final pattern. (See Figures 9.56 and 9.57.)

Instructions for making the back pattern follow:

Directions

1. Move the shoulder dart to neckline if desired or leave it. Proceed as you did for the front pattern until you are ready to design the raglan seamline
2. Fold the shoulder dart and design the raglan seam. In Figure 9.57, the seamline crosses near the center of the dart.

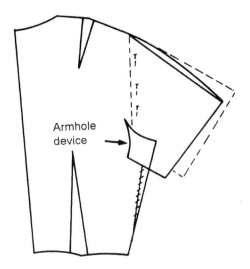

Figure 9.56 Glue armhole device in place and direct it to a point on the shoulderline about 1 in. (2.5 cm) from the neckline.

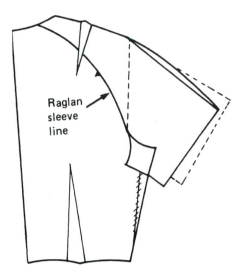

Figure 9.57 Raglan seamline may cross the dart or cross at the end of the dart (Figure 9.60).

3. Unfold the dart and leave it open while the two pattern pieces are being traced.
4. If the part of the dart that remains in the bodice is short, it can be lengthened about 1 in. (2.5 cm) to give it more importance in the design.

 The part of the dart that remains in the sleeve section can be traced and then folded out of the final sleeve pattern.

Figure 9.58 shows the raglan sleeve design line crossing the back shoulder dart. This small dart can be eased in when sewing the raglan seamline.

Figure 9.59 shows the completed back pattern for a three-quarter raglan sleeve.

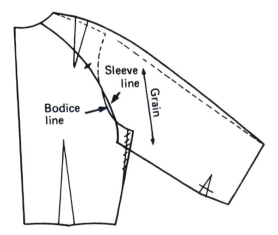

Figure 9.58 Design line crosses dart.

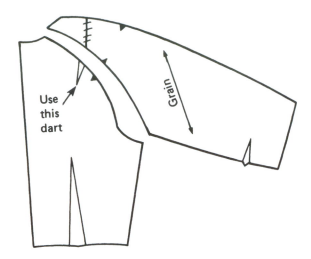

Figure 9.59 Shoulder dart is folded shut in sleeve pattern, but part of dart remains in bodice section.

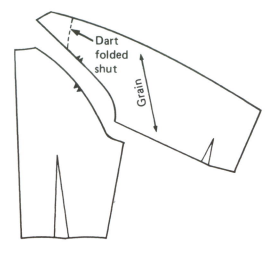

Figure 9.61 Dart is folded shut in finished sleeve pattern, and bodice section has no dart.

Figures 9.60 and 9.61 show a raglan design line that crosses at the tip of the shoulder dart.

The One-Piece Raglan Sleeve

A one-piece raglan sleeve can be made by joining the back and front raglan sleeve patterns from the shoulder to the lower end of the sleeve, as shown in Figure 9.62. The original shoulder seamlines will then *form a dart*.

Caution When joining the two patterns, overlap the curved areas until the original sleeve seamlines coincide. This removes the ½ in. (1.3 cm) that was added to each sleeve for reaching room. The sleeve will fit a little more snugly than the two-piece raglan sleeve.

The grainline will now be in the sleeve center (Figure 9.62), which also contributes to a lack of give. Observe that this area of the two-piece raglan sleeve was on the bias.

Designing with the Raglan Sleeve

The bodice raglan sleeve device (page 194) can be used to make designs other than the basic raglan.

The pattern in Figure 9.63 shows two design guidelines, one for each of the designs pictured.

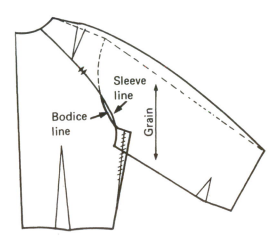

Figure 9.60 Design line crosses at tip of dart.

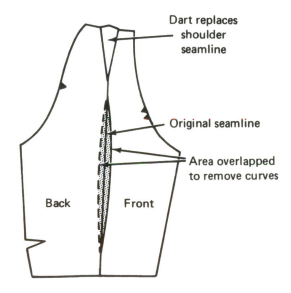

Figure 9.62 The one-piece raglan sleeve.

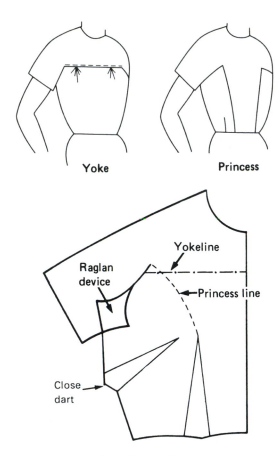

Figure 9.63 Design lines for a yoke and princess bodice can be made by using the raglan sleeve device.

If the design seamline comes from the normal underarm position, the pattern can be made with this device.

CAP SLEEVE

Directions

1. On this pattern the bust dart was combined with the waistline dart and released for added fullness.
2. Note in Figure 9.64a that the cap sleeve will be too tight if you just extend the shoulder seam and use the original underarm seam.
3. To make the cap sleeve comfortable to wear, widen the side seam by $\frac{1}{2}$ in. (1.3. cm) in bodice front and back. (See Figure 9.64b.)
4. Raise the shoulder point $\frac{1}{2}$ in. (1.3 cm.) and draw a new straight line from neck point to end of cap sleeve.
5. Lower the armhole by $1\frac{1}{2}$ in. (3.8 cm.) so that the armhole opening is comfortable to wear.
6. Add a cap sleeve facing that folds back on the bodice or a separate facing sewn with a seam.

Separate Cap Sleeve

Directions

1. A separate cap sleeve can be made by extending the shoulder seam from point C to point A (Figure 9.65). The distance is approximately 2 in. (5.1 cm.).

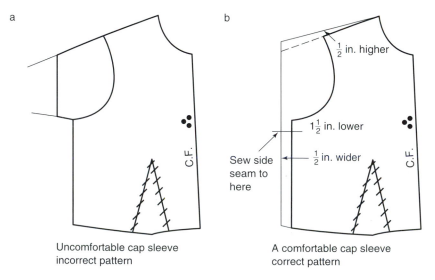

Figure 9.64 A comfortable cap sleeve needs a larger armhole opening to prevent the sleeve from binding.

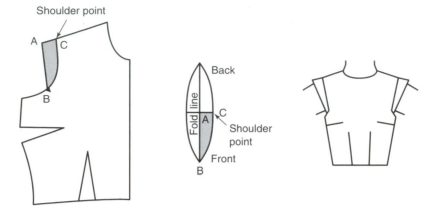

Figure 9.65 Separate cap sleeve.

2. Point *B* is the notch on the bodice front armscye. Draw a line from *A* to *B*. There is a right angle corner at point *A* and line *A* to *B* is a ruler straight line.
3. Line *B* to *C* is a curved line and follows the bodice outline in that area.
4. Complete the back cap sleeve the same way the front was completed.
5. Combine the front and back cap sleeve patterns on line *AC* so the cap sleeve is cut without a shoulder seam.
6. No hem is needed if the cap sleeve is folded on the straight line *AB*. The double-thickness cap sleeve is sewn to line *CB* in front and the corresponding line in back.

SLEEVE VARIATIONS

More sleeve variations are discussed in other chapters:

- The two-part sleeve and tucks at the top of the sleeve are described in Chapter 11 on jackets.
- Puffed sleeves with fullness at both top and bottom are analyzed in Chapter 14 on girls' clothing.
- Gathered bell-shaped sleeves are dealt with in Chapter 10 on sleepwear.
- The leg-of-mutton sleeve, the shirred cap sleeve and the sleeve with a V point at the wrist are shown in Chapter 17 on evening wear.

PROBLEMS ...

Make the patterns for several of these sleeves.

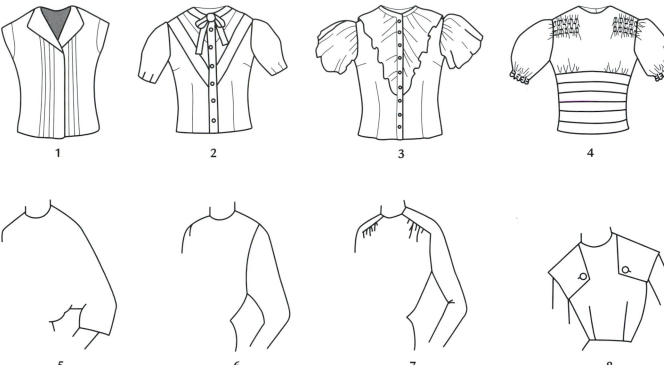

1 2 3 4

5 6 7 8

More Sleeve Variations

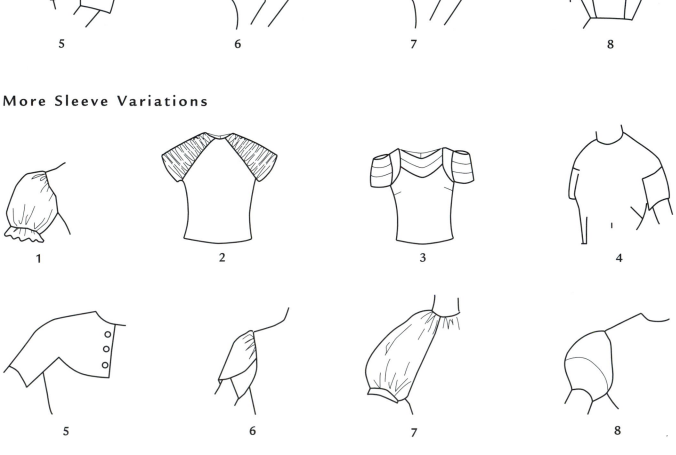

1 2 3 4

5 6 7 8

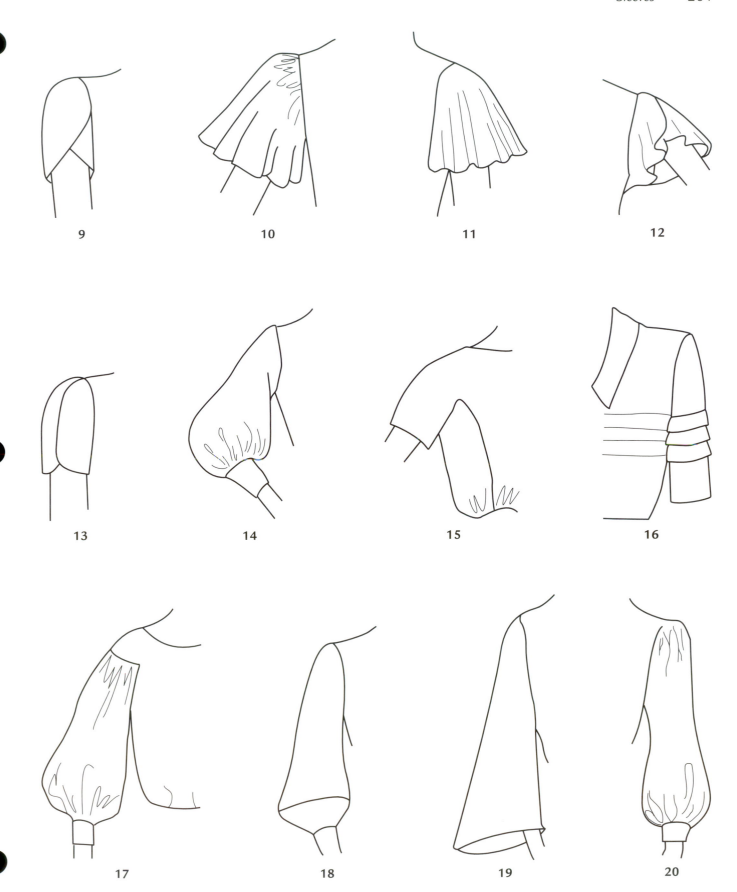

9

10

11

12

13

14

15

16

17

18

19

20

Nightgowns, pajamas, and robes should be comfortable as well as beautiful. Nightgown and robe sets can be made with matching fabric and lace. Robes often have raglan or kimono sleeves and a center front opening with buttons, gripper snaps, a zipper, or a tie belt.

For sleeping comfort, nightgowns should not be binding. Fullness below a yoke is a common style. If a fitted look is desired, elastic can be added at or above the normal waistline. The neckline and armholes are generally cut with more room in sleepwear than in daytime clothing. Cap sleeves, petal or bell-shaped short sleeves, or sleeves with gathers are common. Ruffles can be used in place of a sleeve.

The most decorative part of the nightgown is the yoke area, as shown in Figure 10.1. Lace trim, embroidery, ruffles, tucks, and quilted designs can add beauty to the differently shaped yokes.

The width of the gown below the yoke is equal to the bust measurement plus 10 to 20 extra inches (25.4 to 50.8 cm). This amount of fullness at the bustline and hipline gives sleeping comfort when the nightgown is made of a lightweight fabric such as tricot or batiste. Heavier fabrics such as cotton flannel or brushed tricot are used for winter nightgowns, which have less added fullness, about 6 to 12 in. (15.2 to 30.5 cm) at the bustline and hipline. A higher neckline, longer sleeves, and longer length are common features of winter gowns.

Pajama tops are usually shaped like a shirt or a nightgown top. The sleeves can be either long or short and typically have less curve at the cap than a regular set-in sleeve. Pajama bottoms are cut with more fullness than regular pants and usually have an elastic waistband. Many different fabrics are used to make pajamas including flannel, tricot, percale, plisse, and broadcloth.

In the following pages, we discuss the patternwork for several sleepwear garments and show some decorative details. Start with the sheath sloper for each of these nightgowns. The measurements are for a medium size 12 or 14 pattern.

NIGHTGOWN WITH STRAIGHT YOKE

Directions

1. Use the sheath sloper and draw the yokeline from armhole to center front.
2. Draw the V-shaped neckline; then cut the yoke from the rest of the pattern.

Figure 10.1 Summer nightgown and winter nightgown.

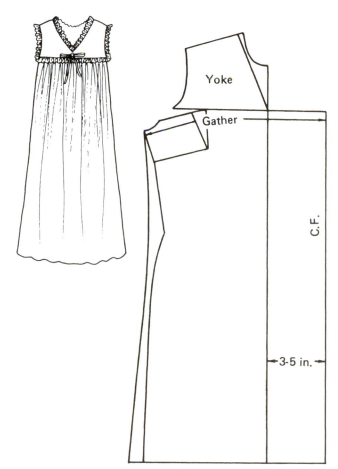

Figure 10.2 Nightgown with straight yoke.

3. Move the side bust-fitting dart to the top of the pattern by the slash method. This dart fullness is converted to gathers.

4. Add A-line flare from the underarm to the hemline.

5. Extend the center front outward 3 to 5 in. (7.6 to 12.7 cm) for the gathers, as shown in Figure 10.2. Cut the center front on the fold. (The back of the gown is similar to the front, with the same amount of fullness.)

6. The back yoke follows the neckline curve. It is cut straight across the bottom, as in the front yoke design. Note that the yoke is cut double. As a finishing touch, add lace edging around the yoke.

· ·

NIGHTGOWN WITH V-SHAPED YOKE

Directions ·

1. Start with the sheath sloper and draw the yokeline and V neckline. Separate the yoke from the rest of the pattern.

2. Use the slash method to close the bust-fitting dart. This dart is converted to fullness at the top of the pattern.

3. Slash the sheath sloper pattern, cut, and spread apart as shown in Figure 10.3. Add 1 to 2 in. (2.5 to 5.1 cm) between each slash mark to create the gathered fullness.

4. Design puffed sleeves with elastic near the hemline.

5. Complete the back with a curved yoke. Be sure to add the same gathered fullness in the back that you added in the front. A ruffled edge around the yoke is an attractive finishing touch.

· ·

NIGHTGOWN WITH CURVED YOKE

Directions ·

1. Use the sheath sloper and draw the curved yoke. Extend the yoke ½ in. (1.3 cm) at center front for buttons and buttonholes.

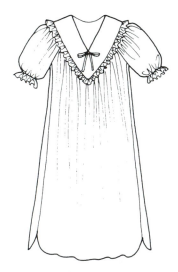

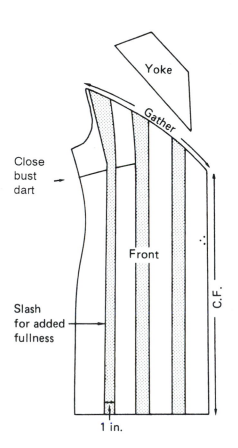

Figure 10.3 Nightgown with V-shaped yoke.

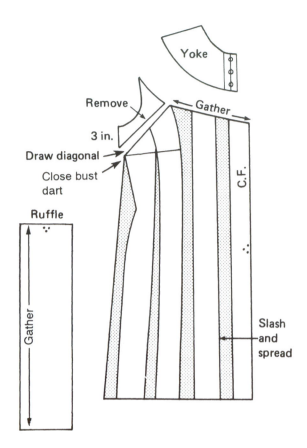

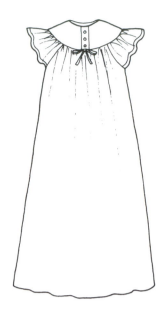

Figure 10.4 Nightgown with curved yoke.

2. To give greater comfort in the underarm area, draw a diagonal line from the yoke to approximately 3 in. (7.6 cm) below the regular armhole (Figure 10.4).

3. Close the bust-fitting dart and move it to the top of the pattern.

4. Slash and spread the pattern to add a total of 3 to 5 extra inches (7.6 to 12.7 cm) for gathered fullness.

5. Draw the ruffle 3 in. (7.6 cm) wide. The length of the ruffle should be two to three times the measured distance from side front to side back where the ruffle is attached to the yoke. Each ruffle will be about 24 to 36 in. (61 to 91.4 cm) long, depending on the weight of the fabric. Lighter fabrics can have more gathers than heavier ones. The ruffle is gathered and attached to the yoke and body of the garment as shown.

6. Complete the back pattern by adding a yoke and fullness similar to that added in the front.

GATHERED PETAL SLEEVE DETAIL

Directions

1. Complete a yoke and gown pattern similar to the design in Figure 10.4.

2. An attractive sleeve variation is the gathered petal-shaped sleeve shown in Figure 10.5a. Draw intersecting curved lines on the sleeve for the overlapping petal shape (Figure 10.5b).

3. Slash through the sleeve cap and to, but not through, the hemline. Spread for the gathers (Figure 10.5c) and gather the sleeve edge into the armhole. Some petal sleeves are spread the same distance at the top and bottom of the sleeve to have more fullness at the bottom.

4. Add one notch to the sleeve front and two notches to the sleeve back so sleeve is set in the correct armhole.

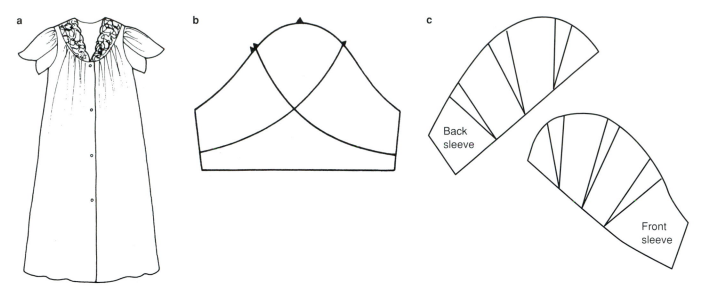

Figure 10.5 Gathered petal sleeve detail.

ASYMMETRIC YOKE DETAIL

Since the yoke is asymmetric (Figure 10.6), draw both sides of the sheath sloper pattern. Draw in the yoke, and be sure to extend it over the shoulder seams. Decorate the yoke with appliqué, trapunto designs, embroidery, or lace trim. Add loops and ball-shaped buttons. The completed lower part of the gown should be similar to Figure 10.4.

SCALLOPED YOKE DETAIL

Trace both sides of the sheath pattern; then draw in the petal-shaped, or scalloped, yoke with the help of a compass or French curve. (See Figure 10.7.)

You can make the yoke the same color as the gown or choose a contrasting color. Use lace trim or colored piping for a more decorative effect. The completed gown will be similar to Figure 10.7.

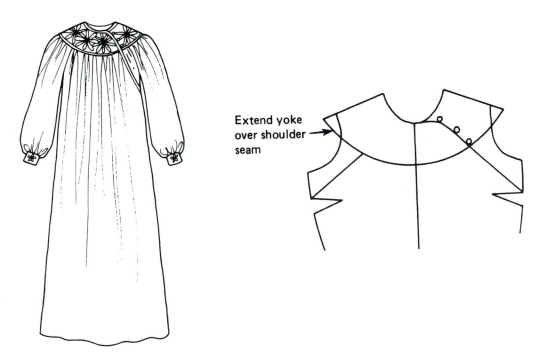

Extend yoke over shoulder seam

Figure 10.6 Asymmetric yoke detail.

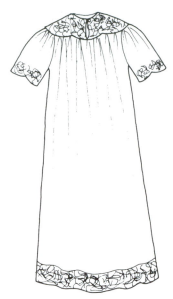

Figure 10.7 Scalloped yoke detail.

PROBLEMS ...

Make the patterns for several of these garments. List the steps required to make each of these designs.

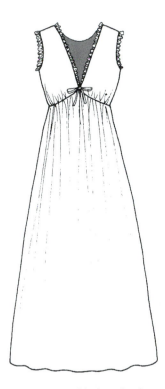

1. Yoke is constructed of woven strips of fabric

2. Elastic added under bust

3. Lowered armhole with ruffle

4. Nightgown and robe set

5. Short pajamas

6. Nightshirt

Jackets

Most jackets are worn with a skirt or pants of matching or contrasting color to create a coordinated outfit for indoor wear. Other jackets are used as lightweight wraps in chilly outdoor weather.

The Butterick Company classifies jackets as fitted, semifitted, loose fitting, and very loose fitting. The company's ease allowance chart (Table 11.1) shows the combined wearing and design ease added to each jacket type.

Fitted jackets (also called suit dresses) are made of medium-weight fabrics. They have $3\frac{3}{4}$ to $4\frac{1}{4}$ in. (9.5 to 10.7 cm) of ease at the bustline and are usually fitted at the waistline. Semifitted jackets have 4 3/8 to $5\frac{3}{4}$ in. (11.1 to 14.5 cm) of ease at the bustline and some waistline fitting. These jackets are usually made of suitweight fabric and are worn with a blouse. Loose-fitting jackets can be worn with either a blouse or sweater. They have $5\frac{7}{8}$ to 10 in. (14.9 to 25.5 cm) of bustline ease and a loose-fitting waistline. Very loose-fitting jackets have over 10 in. (25.5 cm) of bustline ease and are often sportswear apparel. The jackets in this category have an oversized, bulky appearance; sweaters and vests can be worn under them for extra warmth.

Jackets are designed in a variety of lengths. They can end at the waistline, between the waist and hip, at the hipline, or lower than the hipline. An appropriate skirt or pants should be chosen to go with each jacket. Straight, A-line, or gored skirts can be worn with several different jacket lengths. The full-circle skirt does not combine successfully with a long jacket.

A jacket pattern usually has a one- or two-part sleeve, a single- or double-breasted front, a back, a collar, and facings. The collar styles used for jackets include the stand-up, shawl, revere, banded, and notched collar. Some jackets are collarless.

The jacket patternwork in this chapter builds on the information and instructions in earlier chapters. The in-structions in this chapter may therefore seem incomplete if you try to make jacket patterns *before* making bodice patterns, collars, and facings.

Be sure to cut the undercollar slightly smaller than the upper collar to help prevent the undercollar from showing at the outer edge of the collar.

The lapel of the collar that shows to the outside of the jacket will also be slightly larger than the underpart of the lapel to help the lapel and collar lie flat.

Jackets can be lined or unlined. When a lining is used, it is cut like the jacket pattern but stops where the facing begins. In the lining, an action pleat at center back is good to include because the lining is usually made of a fabric that has less stretch than the fashion fabric used in the jacket. The action pleat allows extra ease to prevent the armhole seams from breaking when the arms are moved forward.

After you have completed the paper pattern for the jacket, make a trial garment out of muslin. Fit the garment with shoulder pads and make any necessary alterations. For example, a loose-fitting jacket can be converted to a semifit-ted garment by taking in the jacket on the vertical seam-lines. Working with a muslin garment helps achieve the type of fit wanted *before* cutting into an expensive suit or coat fabric. Construction of the final garment will go faster and more smoothly if you do most of the fitting with a trial garment.

We discuss the patternwork for several jackets in this chapter. A suit pattern can be made from a basic bodice or basic dress pattern. When shoulder pads are used, the shoulder seamline must be raised and extended at the sleeve edge, but *not* at the neck edge of the bodice front or back. How much the shoulder seamline is raised or extended depends on the size of the shoulder pad used. The sleeve capline measurement must also be adjusted. Fewer changes will be necessary if a commercial basic suit pattern is used because it will have the bustline, waistline, and hipline ease already added, as well as the allowance for shoulder pads.

Table 11.1 Misses' Ease Allowance*
(includes both wearing and design ease)

| Description | Dresses Blouses, Shirts, Tops, Vests | Bust Area (inches) | | Hip Area (inches) |
		Jackets (lined or unlined)	Coats (lined or unlined)	Skirts Pants Culottes
Close fitting	$0-2\frac{7}{8}$	Not applicable	Not applicable	Not applicable
Fitted	3-4	$3\frac{3}{4}-4\frac{1}{4}$	$5\frac{1}{4}-6\frac{3}{4}$	2-3
Semifitted	$4\frac{1}{8}-5$	$4\frac{3}{8}-5\frac{3}{4}$	$6\frac{7}{8}-8$	$3\frac{1}{8}-4$
Loose fitting	$5\frac{1}{8}-8$	$5\frac{7}{8}-10$	$8\frac{1}{8}-12$	$4\frac{1}{8}-6$
Very loose fitting	Over 8	Over 10	Over 12	Over 6

*Ease allowances given are not applicable for stretchable knit fabrics.
Source: Butterick Company, Inc., 161 Avenue of the Americas, New York, NY 10013.

ARMHOLE AND SLEEVE FOR A SUIT OR COAT

Converting the basic bodice armhole and the basic sleeve to a suit armhole and sleeve is an easy operation. Simply widen and deepen the underarm section of the bodice and sleeve as shown by the dashed lines in Figure 11.1.

For the average-weight suit, the suggested alterations to the basic bodice and sleeve are

- $\frac{3}{8}$ in. (1 cm) down
- $\frac{3}{4}$ in. (1.9 cm) out

The alteration should start at about the location of the matching notches. The dashed lines in Figure 11.1 are the seamlines of the suit.

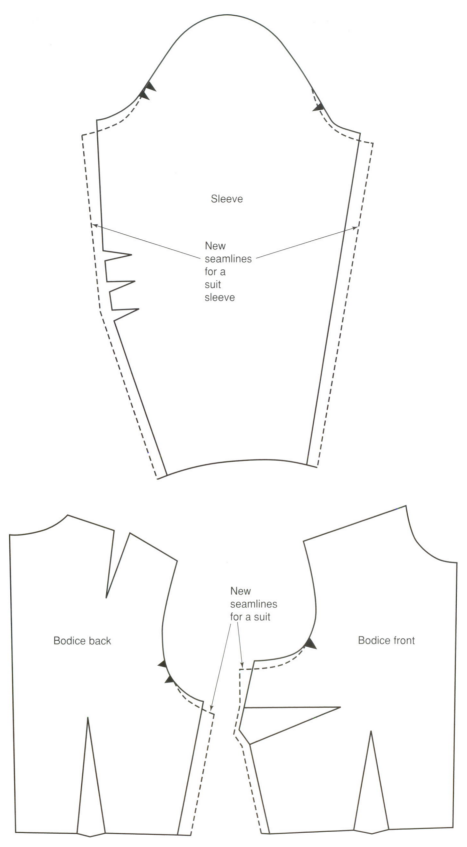

Figure 11.1 Dashed lines show alteration of basic dress sleeve and bodice patterns for suit sleeve and armhole.

For the average-weight coat, the suggested alterations of the basic bodice and sleeve are

- ¾ in. (1.9 cm) down
- 1½ in. (3.8 cm) out

These measurements will vary with the type of fit desired in the jacket or coat.

After making these alterations, measure the sleeve capline to see if it is about 2 in. (5.1 cm) larger than the jacket armhole. This amount of ease is necessary because the sleeve must be eased into the armhole and not the armhole into the sleeve. Adjusting the sleeve and jacket in the underarm area may be necessary to obtain the right amount of ease in a set-in sleeve.

A regular set-in dress sleeve fits the body high in the underarm area. Raising the arm should *not* raise the garment. A coat or jacket must have extra room in the underarm area to accommodate a blouse or sweater worn underneath. The sleeve and the front and back bodice patterns are adjusted as shown in Figure 11.1. When the arm is raised, however, the entire coat or jacket tends to be raised as well. This is usually acceptable, for coat and suit jacket patterns have more ease than dress patterns.

Adding length to the underarm sleeve seam prevents the garment from being raised as the arm is lifted upward because the placement of the underarm seamline makes the sleeve fit closer to the body. This sleeve adjustment is especially appropriate for a belted coat or jacket design.

Experimenting with the coat or jacket sleeves in a muslin trial garment is the best way to determine if length needs to be added or subtracted in the underarm area to achieve better fit and the desired effect when the arm is raised.

JACKET WITH NOTCHED COLLAR

Figure 11.2 shows a semifitted jacket with a notched collar. To make this a shorter, more tailored jacket, proceed as follows:

Directions ..

1. Start with a basic suit pattern or draw around the sheath sloper and make the necessary changes for the jacket pattern. (See Figure 11.1.) End the jacket at the hipline.
2. Add the extension for the buttons and buttonholes. Curve the hemline of the jacket in the front.
3. Make the waistline dart one-half the original width since this design is semifitted.

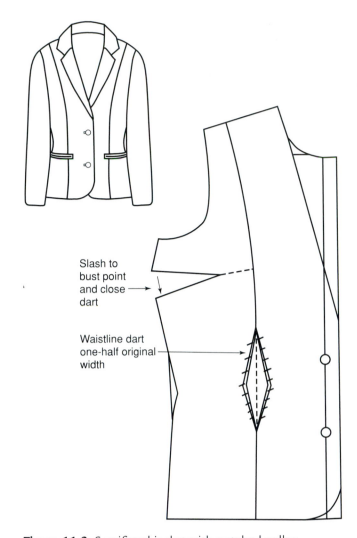

Slash to bust point and close dart →

Waistline dart one-half original width

Figure 11.2 Semifitted jacket with notched collar.

4. Close the side bust-fitting dart by the slash method and cut the pattern apart on the vertical seamline. Add notches at center front and side front.
5. Complete the jacket back with vertical seamlines that match the front seamlines at the shoulder.
6. Add a notched collar and welt pockets. (See Figure 11.10, for an illustration of the notched collar; Chapter 5 for a review of convertible collars; and Chapter 4 for front facings. Refer to any beginning clothing construction book for instructions on welt pocket construction.)
..

JACKET WITH SIDE TUCKS

The sheath sloper can be used to make this loose-fitting jacket with side tucks from shoulder to hemline (Figure 11.3).

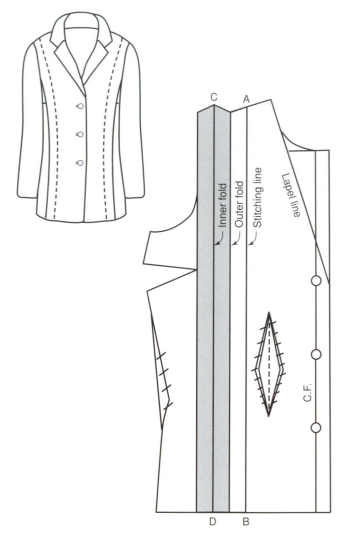

Figure 11.3 Loose-fitting jacket with side tucks.

fitting. The side seam should form a gradual curve at the waistline.

5. Draw two lines from shoulder to hemline parallel to center front. The first line starts at the end of the shoulder and goes to the hemline. The second line, parallel to the first, is drawn 1½ in. (3.8 cm) from the first line. This is the stitching line.

6. Cut and slash the pattern and add a total of 3 in. (7.6 cm) to complete the 1½-in. (3.8-cm) finished width of the vertical tucks. Bring line *AB* to meet line *CD* before stitching the tuck.

7. One in. (2.5 cm) below the waistline, in the fold of the tuck, make a 5½-in. (14-cm) opening for a pocket. The attached curved pocket pieces are about 9 to 10 in. (22.9 to 25.4 cm) long and 6 in. (15.2 cm) wide.

8. Complete the jacket back with the same width tuck. Sew the shoulder seam *before* sewing in the tuck so the tuck continues in an unbroken line from front to back of the jacket.

9. Complete the convertible collar, front facing, and sleeve pattern as described in earlier chapters. The undercollar of suits and coats is cut ¼ in. (0.6 cm) smaller than the outer collar and is often cut on the bias.

10. The lining pattern is cut like the garment but with the side tuck folded in the pattern. An action pleat is often added to the center back lining for comfort. The lining should end where the facing of the jacket front begins.

JACKET WITH BUILT-UP NECKLINE

Figure 11.4 shows a loose-fitting jacket with curved seaming and a built-up neckline. This style jacket can be worn either open or buttoned. A blouse with a tie collar goes well with the built-up neckline.

Directions .

1. Start with the jacket changes shown in Figure 11.1.
2. Draw around the sheath sloper pattern and mark the hemline 6½ in. (16.5 cm) below the waistline.
3. Add the front extension for buttons and buttonholes, and position the one buttonhole at the waistline.
4. Draw a curved line from the armhole to 1 in. (2.5 cm) below the waistline. Make a square corner 1 in. (2.5 cm) below the center of the old waistline dart. Draw a line crosswise from A to the side seam, but curve the line at the end. A pocket can be added to this seamline.
5. Mark out the old waistline dart, for this style of jacket is loose fitting. Close the bust-fitting dart by the slash

Directions .

1. Start with a basic suit pattern or change the dress pattern to the jacket pattern as previously described. (See Figure 11.1.)
2. Trace around the changed sheath sloper pattern, and draw the hemline about 2 in. (5.1 cm) below the hipline.
3. Review the information on buttons and buttonholes (see pages 82 to 84). Add the front extension, which is equal to the diameter of the button. Mark the position of the buttons and buttonholes. (For a woman's jacket, buttons are placed on the left side and buttonholes on the right.)
4. Retain the bust-fitting dart but shorten it so the dart ends before or under the side tuck. Mark out the waistline dart. It is not sewn in, because this jacket is loose

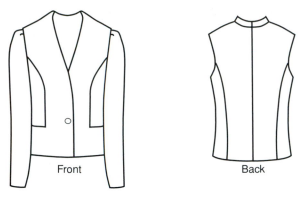

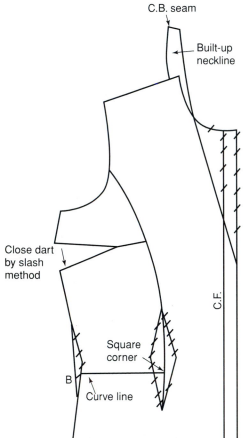

Figure 11.4 Loose-fitting jacket with built-up neckline and sleeve with tucks.

method so the side front is cut in one piece without a dart.

6. The jacket has a built-up neckline, cut in one piece with the jacket front, which continues to center back. It is 1 in. (2.5 cm) wide at the shoulder and 1 in. (2.5 cm) wide at center back. The length of this neckband extension is the length of the jacket back neckline.

7. Complete the jacket back pattern with a center back seam. The curved seamline from armhole to hemline complements the curved front seamlines.

When a jacket has several vertical seams, it can be left boxy or loose fitting, or it can be made into a semi-fitted jacket.

8. The sleeve pattern for this jacket is shown in Figure 11.12.

...

JACKET WITH REVERE COLLAR

The revere collar folds back over the jacket front. Revere collars vary in width, depending on jacket design. They

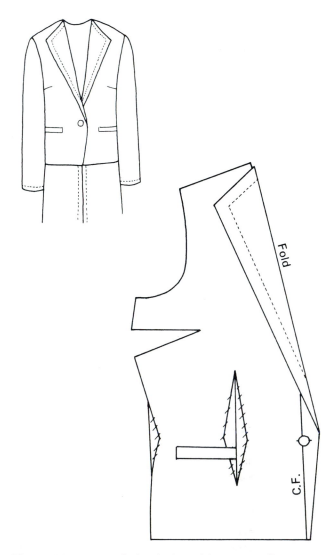

Figure 11.5 Loose-fitting jacket with revere collar.

can be faced with matching or contrasting fabric. Topstitching adds a decorative touch, as shown in Figure 11.5.

Directions

1. Draw around the sheath sloper and make the changes necessary for the jacket pattern.
2. Add the extension for buttons and buttonholes and draw in the buttonhole at the waistline.
3. Retain the bust-fitting dart, but convert the waistline dart to ease since this jacket style is loose fitting at the waistline.
4. Fold the revere collar back from the neckpoint to waistline. Make a front facing.
5. Angle the jacket at center front so it is 1 in. (2.5 cm) narrower at the hemline than at the waistline.
6. Add pocket tabs 4 in. (10.2 cm) long and 1 in. (2.5 cm) wide.
7. Complete the jacket back. Make it the same length as the jacket front and eliminate the waistline dart. Make a back neck facing.

JACKET WITH NOTCHED COLLAR

The short jacket in Figure 11.6 has a notched collar and folded-back lapels.

Directions

1. Because this is a short jacket, start with the bodice front sloper and add 2 in. (5.1 cm) to the length. Make the necessary changes to convert the bodice to a jacket.
2. Sketch the curve of the skirt pattern at the side waistline to ensure that the jacket is not too tight below the waistline.
3. Draw a straight line parallel to center front from the neckline to the hemline. The lapel will be about $2\frac{1}{2}$ in. (6.4 cm) wide.
4. Fold this part back and design the top edge and bottom curve of the lapel.
5. Cross out the original waist-fitting dart since the jacket is designed to fit loosely at the waist.
6. Close the bust-fitting dart by using the slash method and create a new waist-fitting dart that is parallel to the front lapel and about 1 in. (2.5 cm) from the original waist dart.
7. Add a notched collar. Front of collar is sketched on Figure 11.6.
8. Complete the jacket back by making it the same length as the front.

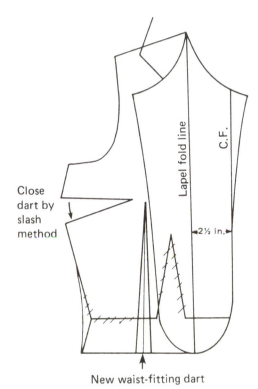

Figure 11.6 Short jacket with notched collar and folded-back lapel.

JACKET WITH DOUBLE-BREASTED DOUBLE REVERE COLLAR

The long, loose-fitting jacket in Figure 11.7 has a distinctive double revere collar. This design can have a two-tone look when the top band of the pocket and the smaller revere collar are made of a fabric that contrasts in color or texture with the fabric of the jacket body.

Directions

1. Draw around the basic sheath sloper and make the adjustments to convert the dress to a jacket. The

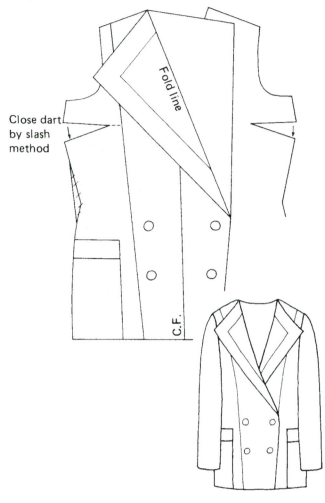

Figure 11.7 Long, loose-fitting jacket with double revere collar.

jacket hemline should be 12 in. (30.5 cm) below the waistline.

2. Mark out the waist-fitting dart, for this is a loose-fitting jacket.

3. Since the design is double-breasted, draw both right and left sides of the front and design the extension for buttons and buttonholes that are placed an equal distance from the center front line.

4. Draw in design lines from shoulder to hemline and use the slash method to close the bust-fitting dart on the side front.

5. Sketch the first revere collar that folds back from the neckline to above the buttons. A second revere collar is 2 in. (5.1 cm) narrower on the two outer edges.

6. Add patch pockets that extend from the side seam to the hemline.

7. Complete the jacket back with vertical lines, as in the jacket front.

···

Sewing Suggestion ·····························

To lie flat, the smaller revere collar may have to be tacked to the larger collar at the pointed lapel corner.

···

JACKET WITH S-SHAPED CURVE

Figure 11.8 pictures a loose-fitting jacket with an S-shaped curve and a partial-roll collar on a lowered neckline.

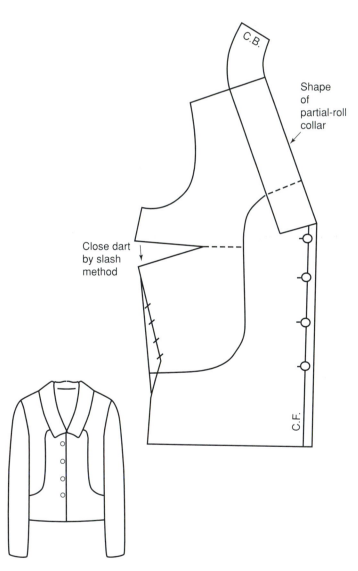

Figure 11.8 Loose-fitting jacket with S-shaped curve and partial-roll collar.

Directions

1. Start with the sheath sloper and make the corrections for the jacket fit.
2. Straighten the side seam at the waistline to form a gradual curve.
3. Add the extension for the buttons and buttonholes, and indicate placement of the four buttons.
4. Draw the collarline from the shoulder neckpoint to a point 5½ in. (14 cm) below the neckline at center front.
5. Draw in the S-shaped curved line on the jacket front.
6. Close the bust-fitting dart and cut the side front pattern in one piece.
7. Make a full- or partial-roll collar with a seam at center back. The shape of the partial-roll collar is shown in Figure 11.8.
8. Complete the jacket back by making it the same length as the jacket front. The S-shaped curve line can end at the side seam, or it can continue in a straight line across the back of the jacket.

LONG JACKET WITH REVERE COLLAR

Many revere collars have the widest part of the fold near the top of the collar. An interesting variation is the revere collar in Figure 11.9, which has the widest fold at the bottom of the collar. This jacket just meets at center front; there is no overlap for buttonholes or buttons. The jacket is designed to be worn over a blouse or sweater.

Directions

1. Draw around the basic sheath sloper and make the required changes for a loose-fitting jacket pattern.
2. The hemline of this long jacket is 11 in. (27.9 cm) below the waistline.
3. The jacket just meets at center front, so do *not* add an extension for buttons and buttonholes.
4. Draw in the collarline from the neckpoint to a maximum 4-in. (10.2-cm) width at the base of the lapels.
5. Label the neckpoint A and the collar points B and C.
6. Cut lines AB and BC, and fold on line AC. The lapel thus folds back over the center front to position ACB'.

NOTCHED COLLAR AND LAPEL

The notched collar and lapel is popular on suits and coats. The placement of the notch can be higher or lower on the

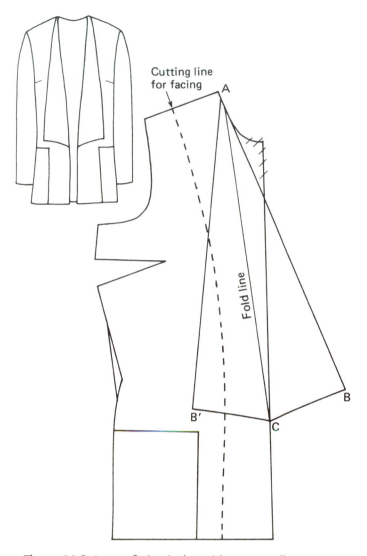

Figure 11.9 Loose-fitting jacket with revere collar.

garment. A high notched collar shows more lapel than a smaller collar, while a low notched collar has a longer collar and a smaller lapel. Both collars are illustrated. This collar can be adapted to many suit and coat patterns.

High Notched Collar

Directions

1. Add 1 in. (2.5 cm.) for the front extension for buttons and buttonholes.
2. Extend the shoulder seamline at the neck area. Add a point 1 in. (2.5 cm.) from the original neck point and draw the roll line to the extension.
3. Draw the shape of the lapel and collar on the jacket front.

4. Duplicate the neck curve and the lapel line on the opposite side of the roll line.
5. To finish the collar shape, add the distance from the shoulder to center back on the collar pattern as shown in Figure 11.10.

Low Notched Collar

Directions

1. Add the front extension for the buttons and button-holes.
2. Extend the shoulder seamline at the neck area. Add a point 1 in. (2.5 cm.) from the original neck point, as shown in Figure 11.11.

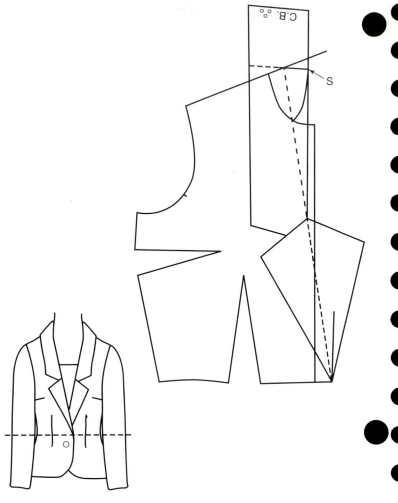

Figure 11.11 Low notched collar.

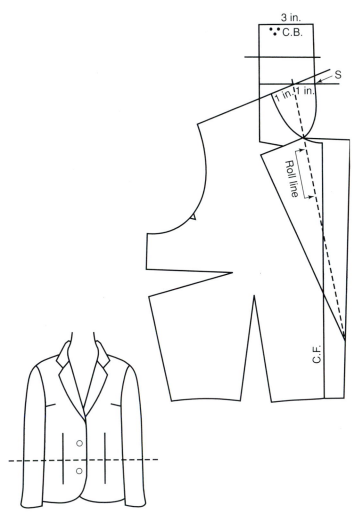

Figure 11.10 High notched collar.

3. Draw the roll line from the new point to the extension line.
4. Draw the shape of the lapel and the collar on the jacket front.
5. Duplicate the neck curve and the lapel line on the opposite side of the roll line.
6. To finish the collar shape in back, add the distance from shoulder to center back. Straighten the bottom collar line from the shoulder to the roll line.
7. Make the collar facing.
8. Complete the jacket back; make it the same length as the front.

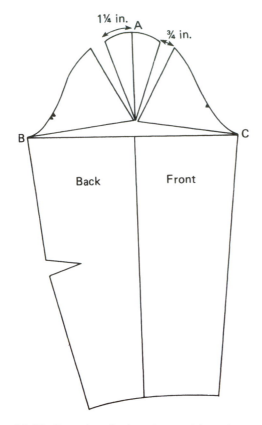

Figure 11.12 One-piece jacket sleeve with tucks at top.

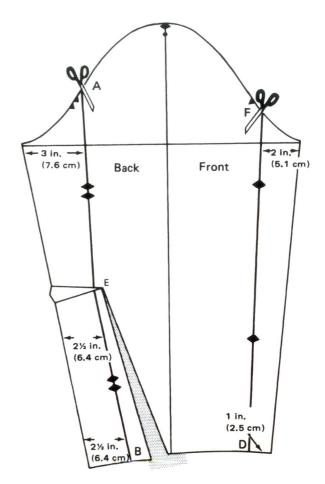

Figure 11.13 Basic suit sleeve showing location of seamlines for a two-piece sleeve.

ONE-PIECE JACKET SLEEVE WITH TUCKS

The pattern for a one-piece jacket sleeve with two tucks at the top is shown in Figure 11.12.

Directions .

1. Start with the basic dress sleeve and alter for a jacket, as shown in Figure 11.1.
2. Draw around the regular one-piece sleeve that has been changed into a jacket sleeve.
3. Mark two points 1¼ in. (3.2 cm) on either side of point A at the center top of the sleeve.
4. Make slashes to, but not through, points B and C as shown in Figure 11.12.
5. Spread the tucks ¾ in. (1.9 cm) or more. Pin each tuck and sew it into the sleeve seamline.

. .

TWO-PIECE JACKET SLEEVE

The two-piece sleeve is most often used in coats and suits. To make this sleeve, start with the basic sleeve that has been modified for a suit.

Directions .

1. Move half of the elbow dart to the wristline to increase the width there. (See Figure 11.13.)
2. Establish lines *AEB* and *FD* for the new seamlines. Measurement spacings are given in Figure 11.13. Put matching notches on these lines; then cut the pattern apart (Figure 11.14).
3. Join the front and back underarm sections at the original seamline. Cut the front section so it will spread open at the dart. (See Figure 11.14b.) Fold the dart

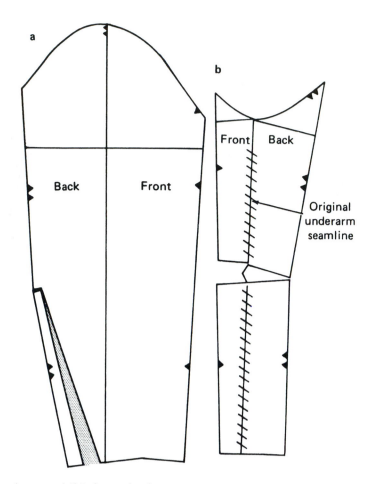

Figure 11.14 (a) The upper sleeve and (b) the undersleeve.

shut, thus closing the opening in the front section. This gives a forward slant to the lower end of the undersleeve. (See Figure 11.15.)

4. Redraw the **front seam** of the upper sleeve, line *FD*, as a curve that takes off about ¾ in. (1.9 cm) at the elbow. This curve should be about the same as the curve of the front edge of the undersleeve when it is superimposed on the upper sleeve.

5. To the **back seam** of the upper sleeve add an amount equal to that taken off at the front edge, thus restoring the sleeve width at the elbow. These changes in the upper sleeve give a forward slant to the lower part of the sleeve, thus permitting the sleeve to adapt to the normal bent position of the arm.

6. Label the pattern pieces.

Sewing Suggestion

For a smoother appearance, sleeve headers and shoulder pads can be purchased and added when constructing suit and coat sleeves.

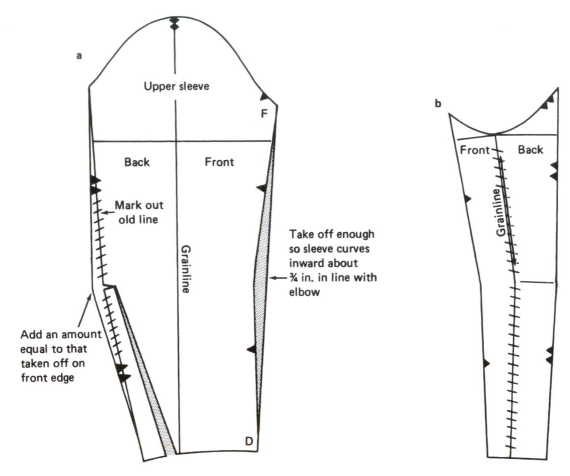

Figure 11.15 (a) The upper sleeve and (b) the undersleeve.

PROBLEMS ..

Make the patterns for several of these jackets.

1

2

3

4

5

6

7

8

9

Coats and Capes

Coats and capes are usually worn outdoors as protection against cold or rainy weather. Raincoats are generally light-weight and are often made of poplin, twill, or a warp sateen fabric. They are lined and can have an extra zip-in lining for added warmth.

Dress coats are often made of a heavier wool fabric and are always lined. They can also be underlined for extra warmth. Shoulder pads and interfacing in the collar and under buttonholes and buttons impart a more tailored look to the coat. Tailoring books that show a variety of hand- and machine-tailoring techniques should be consulted.

Coat length can vary from three-quarter or seven-eighths length to skirt length to floor length. The most popular length is about 2 to 3 in. (5.1 to 7.6 cm) longer than the dresses or skirts that will be worn with the coat.

For patternwork, start with a basic coat pattern from a pattern company. If you begin with a basic bodice or sheath dress pattern, more adjustments will be needed. (See Figure 11.1 showing adjustments required in the sleeve and under-arm area to convert the basic bodice or sheath to a jacket pattern.) Similar instructions apply for coats: Go down ¾ in. (1.9 cm) and out 1½ in. (3.8 cm) in the underarm area.

The Butterick chart (Table 11.1, page 210) in the jacket chapter lists the amount of bust ease required for four coat styles. The fitted coat has 5¼ to 6¾ in. (13.3 to 17.1 cm) of bust ease. The semifitted coat has 6⅞ to 8 in. (17.5 to 20.3 cm) of bust ease. The loose-fitting coat has 8⅛ to 12 in. (20.6 to 30.5 cm) of ease, and over 12 in. (30.5 cm) of bust ease is needed for the very loose-fitting coat.

Capes hang from the shoulder seams and have no sleeves. They can be any length—waist length, hip length, dress length, or floor length. The style may vary also. Capes can be a full circle, or they can be designed to fit the body more closely. Flare can be added to a cape or coat in the same way flare is added to a skirt.

CAPE WITH YOKE

Figure 12.1 pictures a moderately full cape with a yoke.

Directions .

1. Draw around the front bodice pattern and extend lines from the shoulder to the hemline at the angle shown. The rounded curve allows for the fullness of the shoulders.
2. Design the yokeline. Three possible yoke styles are indicated by the dashed lines. The yoke of a cape should be faced and interfaced for durability, for the weight of the cape hangs from the yoke.

Figure 12.1 Cape with yoke. Capes can be long or short and the fullness or flare can vary. Note that the pattern is for a shorter and fuller cape than the sketch.

3. The yoke can be designed to meet exactly at center front with button and loop closures, or it can overlap at center front with button and buttonhole closures.

4. Add design lines from yoke to hemline, and make 10-in. (25.4-cm) long openings for arm slits in the seam-lines. Short capes do not need arm slits.

5. Capes can be long or short depending on the design effect desired. Design the long cape to be 2 in. (5.1 cm) longer than the skirts or dresses over which it will be worn.

6. Complete the back with the same shaped yoke and with vertical design lines similar to those of the front.

7. This cape can be lined or made reversible with a fabric of contrasting color.

8. The cape pictured here has no collar, but an alternative pattern can be made with a notched collar or hood.

..

SINGLE-BREASTED DRESS COAT

The coat in Figure 12.2 is a semifitted, tailored design, which looks best when made in a wool coat fabric.

Directions ..

1. Start with a basic coat pattern or with the basic bodice front or sheath dress front that has extra width added to convert it to a basic coat pattern.

2. Add the extension for the three buttons and button-holes. One button is at the waistline, one is approximately 5 in. (12.7 cm) above the waist, and one is an equal distance below the waist.

3. Using the slash method, move one-half of the bust-fitting dart to the neckline dart and the other half to the waist-fitting dart.

4. The inner line of the neck dart starts 2 in. (5.1 cm) from the neckpoint. This dart will be hidden by the collar lapel.

5. Cross out the original waist-fitting dart, and make a new waistline dart that is 1 in. (2.5 cm) wide at the waist and tapers to nothing at the bust and nothing at the hipline. This will give the coat a semifitted look.

6. Pocket flaps are approximately 6 in. (15.2 cm) long and 3 in. (7.6 cm) wide.

7. Draw a diagonal lapel fold line from the neck dart to just above the top button and buttonhole.

8. Fold back the lapel on this line and design the lapel shape. The lapel extends outward and is wider than the extension for buttons and buttonholes.

9. Finish the coat back with a shoulder dart, but release part of the waistline dart for a less fitted look.

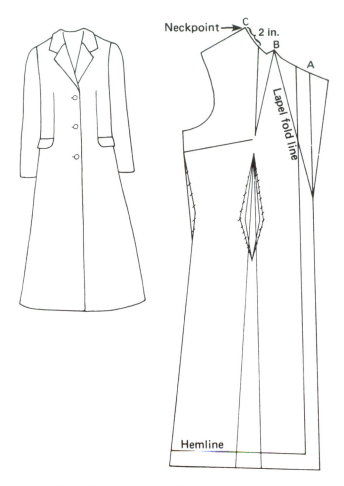

Figure 12.2 Single-breasted dress coat.

10. Use the coat sleeve pattern described in the next section.

11. Make the front facings and cut a lining pattern that is the same shape as the coat, but extend the lining just to the front facing. Add a pleat to the lining pattern at center back.

12. The coat length should be about 2 in. (5.1 cm) longer than the skirts or dresses worn under the coat. Add a 2-in. (5.1-cm) hem to the pattern.

13. The shape of the convertible collar pattern is shown in Figure 12.3. Note that line AB corresponds to the distance from the start of the collar to the lapel fold line. BC is the distance from the lapel fold line to the shoulder neckpoint. C to center back is the distance from the shoulder neckpoint to center back. Point A is in line with the midpoint of the center back collar seam. The width of the collar at center back is 3½ in. (8.9 cm).

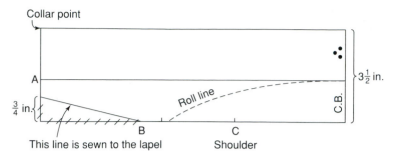

Figure 12.3 Collar for dress coat, enlarged to show details.

14. Cut the upper collar on the straight grain and the undercollar on the bias with a seam at center back.

. .

Sewing Suggestion .

To prevent the undercollar from showing at the outside seam edge of the collar, make the undercollar slightly smaller than the upper collar, cut the undercollar on the bias, and understitch.

. .

COAT-STYLE SLEEVE

The coat-style sleeve is looser and roomier than the basic sleeve. (See Figure 12.4.) It may be long or three-quarter length.

The true coat sleeve must be widened and the armhole deepened, as discussed in Chapter 11.

The coat-style dress sleeve has a smaller elbow dart than a jacket because some of the basic darts have been converted to width at the lower part of the sleeve.

Directions .

1. Use the slash method to move part of the elbow dart (Figure 12.5) to add fullness in the lower arm. Pin or tape the slashed pattern to a large piece of paper.
2. Fold the remaining dart (being sure to fold *through* the layer of paper, too), and pin the dart shut.
3. Fold the sleeve lengthwise and match A and A′ exactly. Allow the lower part of the sleeve to fold where it wants to.
4. Without unfolding, turn up enough of the sleeve end to make a hem of any depth desired.

Figure 12.4 Coat-style sleeve.

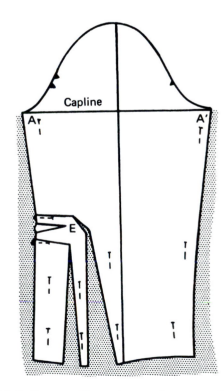

Figure 12.5 Convert elbow darts to lower arm fullness.

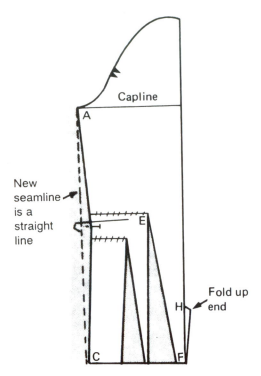

Figure 12.6 Fold up end of sleeve to make the hem.

5. Draw a new underarm seamline (dashed line AC in Figure 12.6).
6. Cut off excess paper and complete the pattern.

Keep the fold of the hem even with the fold of the sleeve.

DOUBLE-BREASTED RAINCOAT WITH NOTCHED COLLAR

The raincoat in Figure 12.7 has raglan sleeves, princess seamlines, double-breasted front opening, notched collar, and tie belt. A zip-in lining can be added to extend the length of time the coat can be worn.

Directions

1. Start with the basic bodice front and back patterns with kimono sleeve. Make adjustments for the coat pattern by adding to the underarm and side seams. Attach the skirt pattern to the bodice.
2. Because this is a double-breasted style, draw around both the right front and the left front.
3. Add the extension for the buttons and buttonholes.
4. Design a raglan sleeveline from the underarm seam to the neckline.

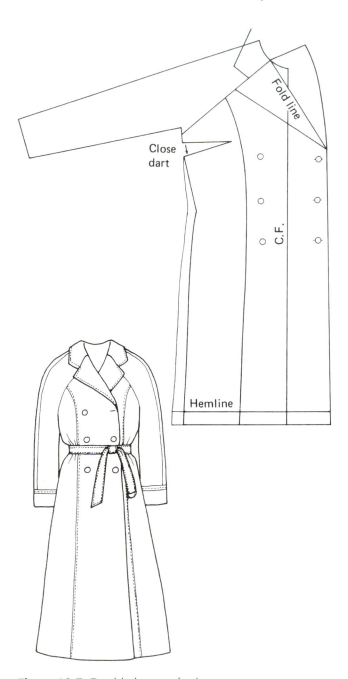

Figure 12.7 Double-breasted raincoat.

5. Draw a vertical princess seamline from the raglan sleeveline to the hem. From the waistline to the hem, this line is parallel to the center front. Then flare is added to each side of this seamline.
6. The center front panel should be about 2 in. (5.1 cm) wider at the hemline than at the waistline.
7. The coat back can be plain or have design lines similar to those of the center front.

8. Draw in a fold line for the collar lapel. The fold line begins where the raglan sleeveline joins the neckline and ends just above the top button and buttonhole.

9. Make the convertible collar similar to the collar for the dress coat in the preceding section.

10. The coat length should be about 2 in. (5.1 cm) longer than the skirts or dresses worn under the coat.

11. Add a tie belt approximately 60 in. (152.4 cm) long and 2 in. (5.1 cm) wide, and design belt loops at the side seams to hold the belt in place.

12. Cut a front facing for the coat.

13. The coat lining is cut like the coat pieces and extends just to the front facing. A 1-in. deep action pleat at center back will make the lining more comfortable and will prevent the lining seams from breaking.

14. If shoulder pads are desired, the pattern should be enlarged in the shoulder area to accommodate the pads.

Make the patterns for several of these coats and capes.

1

2

3

4

5

6

13 CHAPTER

Shirt and Pants
Patterns for Men and Boys

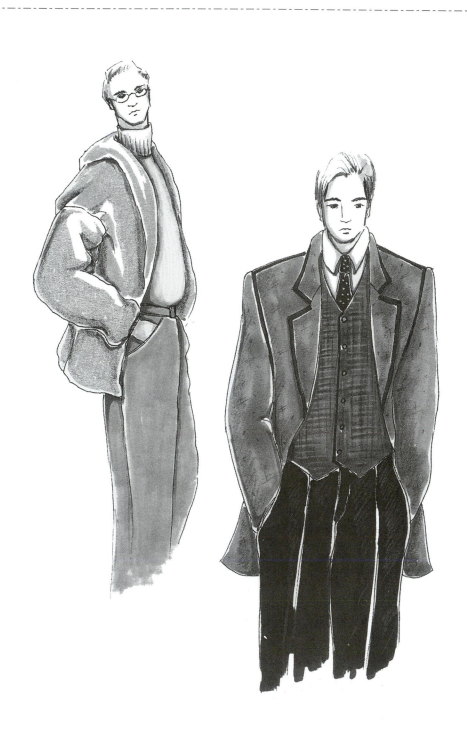

Most clothing styles for men and boys are classic; that is, men's clothing has fewer design variations than women's clothing. Some flat-pattern techniques used for women's clothing can be applied to clothing for men and boys also. The major differences between the patterns for females and males are listed in Table 13.1.

The clothing industry uses basic shirt and pants patterns, called **blocks,** that have been draped or drafted to fit standard fitting forms. For practice patternwork, use the basic shirt and pants blocks in Appendix A. For full-scale patternwork, buy a basic shirt or pants pattern made by a pattern company.

BASIC DRESS SHIRT

The shirt pattern in Figure 13.1 can be used to make a dress shirt when a woven polyester-cotton blend fabric is selected. The same pattern results in a more casual shirt when the fabric chosen is a cotton flannel or a wool plaid. Remember that all measurements are for full-scale patternwork.

Directions ...

1. Start with a basic shirt front and back pattern like the ones in Appendix A. Add ½ in. (1.3 cm) to the center front for the button and buttonhole extension. Standard shirt buttons are ½ in. (1.3 cm) in diameter.
2. Add a facing that is 1½ to 2 in. (3.8 to 5.1 cm). The buttonholes are placed horizontally or vertically when no front band is used. If a front band is added, the buttonholes are placed vertically in the center of the 1-in. (2.5-cm) band. The buttons on a man's shirt are sewn on the right side, and the buttonholes are on the left.
3. At center back, measure down 3 in. (7.6 cm) from the neckline, and draw a horizontal line from center back

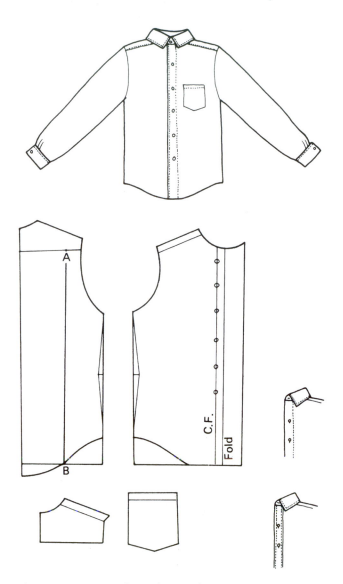

Figure 13.1 Basic dress shirt and pattern.

Table 13.1 **Differences in Pattern Detail for Females and Males**

Pattern Detail	Female	Male
Silhouette	Curved bustline	Flatter chest
	Bust darts needed	No bust darts
Center front opening	Buttons on left	Buttons on right
	Buttonholes on right	Buttonholes on left
Pants fly front	Fly on right or left	Fly on left
Sleeve cap	More curve	Less curve
Sleeve length measurement	Shoulders to wrist	Center back to wrist
Pants waistband	Cut in one piece	Seam at center back

to the armhole. This is the back yoke and is combined in one pattern piece with the front yoke, which is only about 1 in. (2.5 cm) wide. Cut the yoke double. Change the point to a curve where front yoke joins back yoke at armhole edge.

4. Draw a pocket and position the top outside edge 1 in. (2.5 cm) above the lower edge of the armhole and the top inside edge about 1½ in. (3.8 cm) from center front. A boy's shirt pocket is about 4¼ in. (10.8 cm) square. A man's shirt pocket is 4½ to 5 in. (11.4 to 12.7 cm) square. Pockets can be cut straight across the bottom or can have extra length added to form a point. Add 1 in. (2.5 cm) at the top of the pocket for a hem or facing.

5. For the shirt hemline, draw a gradual curve that peaks at the side seamline where the finished garment is approximately 3 to 4 in. (7.6 to 10.2 cm) shorter than the basic pattern (see Figure 13.1). The shirt is lengthened 2 in. (5.1 cm) at the center back to keep it from pulling out of the pants.

6. For better fit, the side seams can be curved inward ½ in. (1.3 cm) at the waistline and tapered at both ends.

7. Slash and spread the pattern at line *AB* to add a pleat in the back. Spread the pattern 1½ in. (3.8 cm) at the pleat top and taper to nothing at the hemline. Fold each pleat toward center back. These pleats add comfort to the shirt. Instead of the two pleats over the shoulder blades, a single pleat at center back can also be used.

SHIRT SLEEVE

Figure 13.2 shows the parts of a men's shirt sleeve. Compare this sleeve with a misses' sleeve pattern. The men's sleeve is cut with more crosswise fullness and less curve in the sleeve capline.

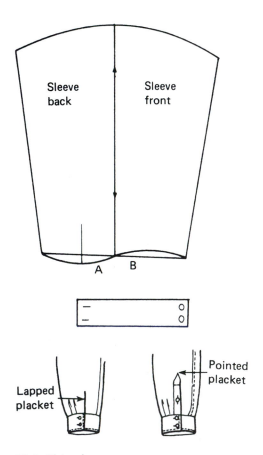

Figure 13.2 Shirt sleeve.

Directions

1. Draw around the basic sleeve block, and mark the grainline down the center of the sleeve.

2. At the end of the sleeve, draw a curved line that peaks ½ in. (1.3 cm) above the straight edge in front and ½ in. (1.3 cm) below the edge in back.

3. In the middle of the back sleeve section, draw a placket 3½ in. (8.9 cm) long for the continuous lapped placket or 5½ in. (14 cm) long for a pointed placket (see Figure 13.2). A shirt pattern guide sheet or a clothing construction book will show you how the lapped or pointed placket piece is sewn to the sleeve.

4. Points A and B mark the origin of two 1-in. (2.5-cm) pleats in the sleeve.

5. The length of the cuff is the wrist measurement plus ¾ to 1 in. (1.9 to 2.5 cm) for ease plus a 1-in. (2.5-cm) extension for buttons and buttonholes. A typical men's cuff pattern is about 8½ to 9 in. (21.6 to 22.9 cm) long and 2¼ in. (5.7 cm) wide. This includes the extension for buttons and buttonholes.

TWO-PART COLLAR

A two-part collar (Figure 13.3) is the most common collar for men's dress shirts. Although a one-piece collar can be made, the two-piece collar fits better, especially with a necktie.

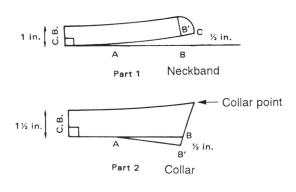

Figure 13.3 Two-part collar.

Directions

1. For the neckband or part 1 of the two-part collar, draw a vertical line and a horizontal line at right angles to each other. Mark off the neckline distance from center back to the shoulder (point A) and the distance from the shoulder to center front (point B).
2. At point B, measure ½ in. (1.3 cm) up to point B′. Draw a straight line from point A to B′. This line should be the same length as the original line AB. Measuring from B′, add an extension of ½ in. (1.3 cm) to the neckband (B′C in the part 1 diagram). This corresponds to the amount added to the shirt at center front for the buttons and buttonholes.
3. Note that part 1 of the collar is 1 in. (2.5 cm) wide at center back, shoulder, and center front, but is curved above point C.
4. For part 2 of the collar, draw a vertical line and a horizontal line at right angles to each other. The width of the collar at center back is 1½ in. (3.8 cm).
5. Again mark the length of the collar from center back to shoulder (point A) and from shoulder to center front (point B). These points correspond to the shirt back and front neck measurements. Mark new point B′ ½ in. (1.3 cm) *below* the horizontal line. Line AB′ is the same length as the original line AB. This part of the collar should meet exactly at center front and does not need an overlap.
6. The outer edge of the collar can be pointed or curved. Buttons and buttonholes are added for a button-down collar.

SPORT SHIRT WITH SHORT SLEEVES

The sport shirt pictured in Figure 13.4 can be made from a basic shirt pattern like the one in Appendix A. The hemline is cut straight across the bottom, so the shirt can be worn outside the pants rather than tucked in.

Directions

1. Complete the yoke and pocket as described in the basic dress shirt instructions. Men's shirt yokes are cut double for greater durability.
2. Draw the short sleeve from the basic sleeve pattern and add a 1-in (2.5-cm) hem.
3. Slash the shirt back pattern and add a 1½-in. (3.8-cm) pleat from the top of the pattern to the hemline. This pleat will be folded toward center back and sewn in the yoke seam.

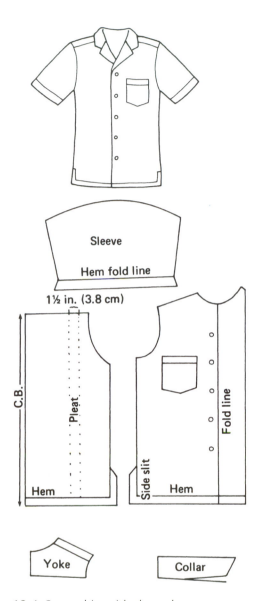

Figure 13.4 Sport shirt with short sleeves.

4. Sport shirts are often made of a plaid fabric and are not tucked into the pants. The plaid lines will look straight across the bottom hem if the pleat is *not* tapered and if it is extended from the top to the bottom of the shirt.
5. The sport shirt has slits at the two side seams, so add a 1-in. (2.5-cm) hem at the bottom and extend the hem 3½ in. (8.9 cm) up each side seam for the slits.
6. Make a one-piece convertible collar that is 2¾ to 3 in. (7 to 7.6 cm) wide at center back. The collar length is the neckline pattern measurement from center back to center front.

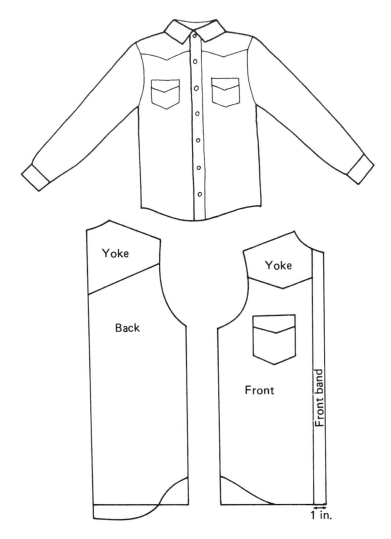

Figure 13.5 Western shirt.

WESTERN SHIRT

Figure 13.5 shows the pattern pieces for a Western shirt with pointed yokes.

Directions

1. Trace around the basic shirt front and back sloper.
2. Draw the shirt hemline and pocket as described in the dress shirt instructions.
3. Draw the front and back yokelines. These yokes usually remain as two separate pattern pieces with the original shoulder seam retained. If a plaid fabric is used, the yokes, front band, pocket, and cuff are often cut on the bias. Other variations include using a two-tone fabric or adding piping at the yoke and collar edge.
4. The front band is 1 in. (2.5 cm) wide, and buttons are positioned in the middle of the band on center front line.
5. The shirt has a two-piece collar. (See the dress shirt instructions for the collar and sleeve patterns.)
6. Add pointed pockets to complement the design lines of the yoke.

TUXEDO SHIRT

The differences between this shirt and the dress shirt pattern are the tucked front, the French cuffs, and the tuxedo collar, which is worn with a bow tie. A tucked cummerbund and tuxedo jacket and pants complete this formal outfit.

Directions

1. Draw around the dress shirt front and back basic patterns. A tucked band that extends from the neckline to the waistline is sewn to the tuxedo shirt front (Figure 13.6). For a boy's size 8 shirt, the tucked band is 15 in. (38.1 cm) long. Five ½ in. (1.3 cm) tucks are used to make a 2½-in. (6.4-cm)-wide tucked band on

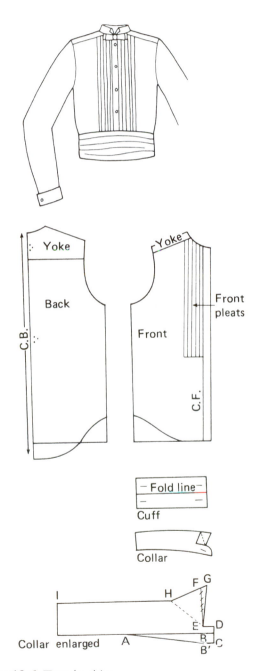

Figure 13.6 Tuxedo shirt.

each side of center front. For a men's size 40 shirt, the band is 18 in. (45.7 cm) long. Five ¾ in. (1.9 cm) tucks are used to make a 3½-in. (8.9-cm) wide band on each side of center front.

2. For the tuxedo collar, square a line vertically and a line horizontally (see the collar enlarged diagram, Figure 13.6). The collar length is equal to the measurement from center back to shoulder and shoulder to center front. Point A is the shoulder point, and point B marks the center front. Measure down ½ in. (1.3 cm) from point B to point B', and draw line AB'. Measure ½ in. (1.3 cm) horizontally from point B' to point C; then measure ¾ in. (1.9 cm) up from point C to point D and ½ in (1.3 cm) from point D to point E. The width of the collar at center back is 1½ in. (3.8 cm). Draw dashed line EF, which is 1¾ in. (4.4 cm) long and perpendicular to line ED. Measure ⅛ in. (0.3 cm) outward from F and mark point G. Draw a solid line, EG, which is 1¾ in. (4.4 cm) long. The measurement from G to H is also 1¾ in. (4.4 cm), and line GH should intersect horizontal line HI. Draw fold line HE.

3. The French cuff is made twice as wide as the regular cuff and is folded back on itself. Four buttonholes are added to the cuff for the cuff links.

VEST WITH COLLAR

The vest in Figure 13.7 can be made of denim or any firmly woven fabric. Contrasting colored thread can be used to add a decorative touch.

Directions

1. Shorten the basic shirt pattern to 2 in. (5.1 cm) below the waistline.
2. Lower the underarm seams of the basic shirt pattern ¼ to ½ in. (0.6 to 1.3 cm), and make the vest pattern ¼ to ½ in. (0.6 to 1.3 cm) wider than the shirt pattern to allow a shirt to be worn under the vest.
3. Draw yokelines on the front and back shirt patterns, cut the pieces apart, and add seam allowances.
4. Make the convertible collar (see Chapter 5, page 93) and pocket similar to those demonstrated in the instructions for the sport shirt pattern.
5. Add a 1¾-in. (4.4-cm) band down the center front and along the lower edge of the vest, and make the front facing pattern.
6. Add gripper snaps or button and buttonhole closures. Topstitch with matching or contrasting colored thread.

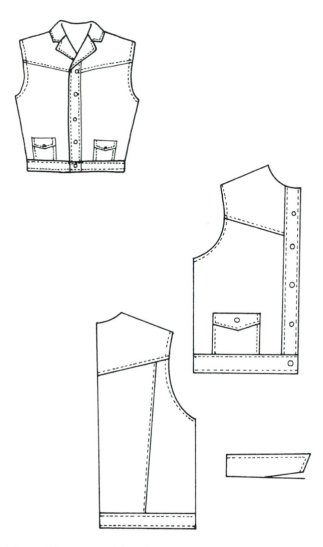

Figure 13.7 Vest with collar.

KNIT SHIRT WITH RAGLAN SLEEVES

Less ease is needed when garments are made of knit fabric because knit fabrics stretch more than woven fabrics. When sewing with knit fabric, it is preferable to use a basic shirt pattern designed for knits. If a basic shirt pattern designed for woven fabrics is used, fit the knit shirt on the body form and deepen the side seams and underarm seams for better fit.

Directions ...

1. Draw a diagonal line on the front and back shirt patterns for the raglan sleeve, as shown in Figure 13.8. Cut the patterns apart on these lines, and label the front and back yoke patterns.

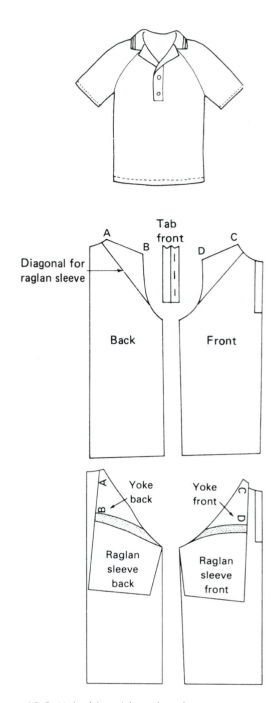

Figure 13.8 Knit shirt with raglan sleeves.

2. Shorten the sleeve and cut the sleeve pattern in half.
3. Lay the sleeve back pattern and the pattern for the back yoke area on a drawing of the shirt back. Fill in the extra amount needed for the raglan sleeve pattern, as shown in Figure 13.8. Lay the sleeve front and front yoke area pattern on the drawing of the shirt front, and fill in the needed amount.

4. Tape the two completed sleeve pieces together, and cut the sleeve in one piece.

5. Cut the pattern for the tab front 1¼ in. (3.2 cm) wide and 7 in. (17.8 cm) long. The facing is the same width. Make three vertical buttonholes.

6. Add a purchased knit collar to the shirt neckline.

7. If you started with a basic pattern for woven fabric, pin and fit the side seams before the final sewing. The side seams will be sewn deeper on the knit garment for a better fit.

BASIC PANTS WITH DIAGONAL SIDE POCKET

Basic pants for men can be plain (Figure 13.9) or pleated.

Directions

1. Draw around the basic front and back pants pattern.

2. On the left front, draw the sewing line for the fly front opening. A typical fly front sewing line is 1⅜ in. (3.5 cm) wide and 7 to 8 in. (17.8 to 20.3 cm) long with a curved bottom. The fly facing piece should be ½ in. (1.3 cm) wider than the top stitching line of the fly and should have seam allowances added on the other sides.

3. Draw a diagonal line for the pocket on the pants front. This line starts on the waistline seam about 1¾ in. (4.4 cm) from the side seam. The diagonal line is approximately 7 in. (17.8 cm) long.

4. The two pocket pattern pieces consist of the triangular side front piece that was cut from the pants front and added to the inside pocket piece, and a lining piece that fits under the outer part of the pants.

5. The waistband is cut in two pieces with a seam at center back. The pants pattern center back seam allowance is 1½ in. (3.8 cm) wide and tapers to ⅝ in. (1.6 cm) at the lower curve. Most pants alteration involves this back seamline. The length of the waistband is equal to the front pants pattern waist measurement plus the back pants pattern waist measurement, which includes the extra seam allowance at center back plus the 1-in. (2.5-cm) overlap at center front. The left waistband can be cut even with the fly extension.

6. Patch pockets or welt pockets can be added to the pants back. Welt pockets are typically 5 in. (12.7 cm) long and are placed about 2½ in. (6.4 cm) from the waistband and 2 in. (5.1 cm) from the side seam. The back left pocket is often buttoned because it is commonly used to hold the billfold.

7. Pants legs are usually tapered from the inseam and

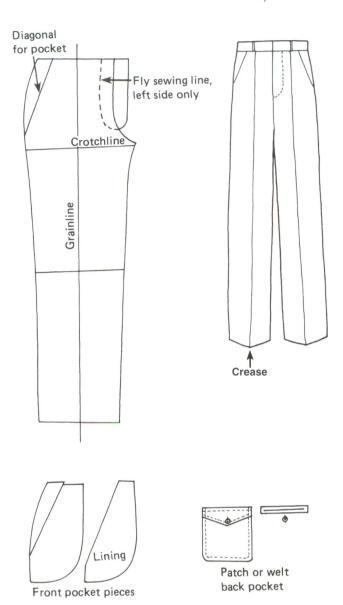

Figure 13.9 Basic pants with diagonal side pocket.

hipline to the hemline. A crease is pressed into the center of each front leg piece. The crease starts about 7 in. (17.8 cm) from the top of the pants and goes through the hemline.

8. Pants can be left long or cut off for shorts.

PANTS WITH HORIZONTAL FRONT POCKET

Another popular style of pants pocket is shown in Figure 13.10. Construction of the horizontal front pocket is similar to that of the diagonal pants pocket. The two pattern

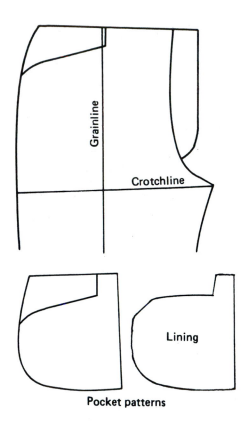

Figure 13.10 Horizontal front pants pocket.

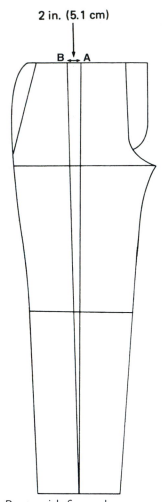

Figure 13.11 Pants with front pleat.

pieces are shown. The minimum pocket length is 7 in. (17.8 cm).

PANTS WITH FRONT PLEAT

To add a pleat to the pants front, follow these steps:

Directions .

1. Draw a line from waist to hemline on grain and approximately in the middle of the pants leg from the waist to the hem.
2. Slash and spread (Figure 13.11). Add 2 in. (5.1 cm) at the top of the pants and taper to nothing at the hemline to form the pleat.
3. Fold the pleat by bringing point A to point B and sew the pleat into the waist seamline.
4. Add a diagonal side pocket and a waistband.

. .

A unisex pants for informal shorts, slacks, and pajama bottoms is shown in Chapter 14.

BATHROBE WITH KIMONO SLEEVES

Directions .

1. Make a copy of the men's shirt front and back and sleeve. These basic patterns are shaded in Figure 13.12. Add the desired length for a short or long robe. The sleeve can be left long or it can be shortened to 2 or 3 in. (5.1 to 7.6 cm) below the elbow.
2. Extend the shoulder seamline of the back shirt in a straight line from the neck point.
3. Cut the sleeve in half and place the back sleeve on the extended line. The underarm part of the sleeve should touch the shirt back. Note that the top of the sleeve does not touch the back shoulder seam.
4. Curve the underarm seam and add 2 in. (5.1 cm) at the side seam of the robe.

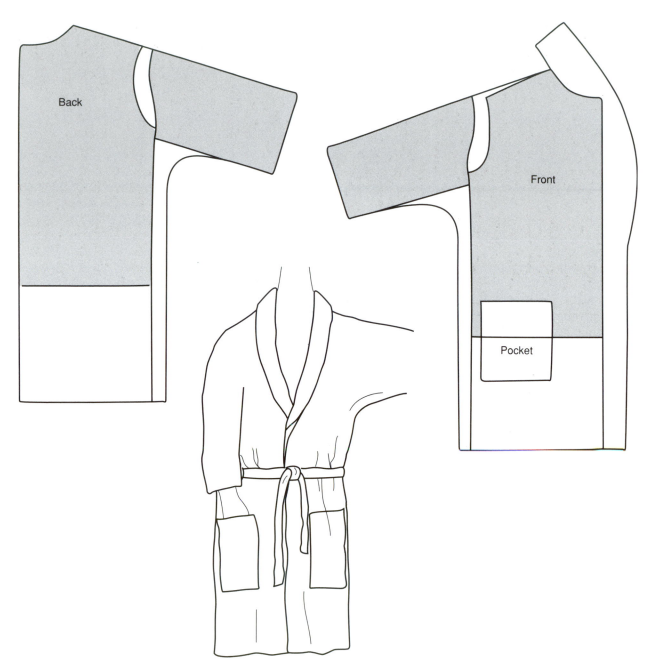

Figure 13.12 Bathrobe with kimono sleeves.

5. The front shirt pattern has a greater slant at the shoulder seam than the shirt back. For this robe the front and back shoulder seams should have the same slant and the same curve in the underarm area. Cut the back robe out and superimpose it on top of the front, matching the neck points and center front and back seamlines.

6. Draw the front shoulder seamline the same angle as the back shoulder seamline and also draw the underarm curve and side seam the same as the back. Tape the front sleeve in place.

7. Add 3 in. (7.6 cm) extension for the front overlap.

8. Refer to Chapter 5 on collars to complete the shawl collar that is 3 in. (7.6 cm) wide at the center back.

9. A roomy pocket about 7 in. (17.8 cm) wide and 7 in. (17.8 cm) long can be added to one or both sides of the robe.

10. Make a long tie belt about 1 1/2 in. (3.8 cm) wide and about 75 in. (190.5 cm) long.

PROBLEMS

Make the patterns for several of these garments.

Shirts and Vests

1

2

3

4

5

Pants

1. Pants with tucks

2. Shorts with a bib and patch pockets

3. Jogging pants

Clothing for Girls

STYLES

Like all well-designed garments, children's clothing should be comfortable and attractive and planned with the needs and activities of children in mind. Designers should familiarize themselves with the current fashion trends by visiting large department stores and specialty shops and by reading fashion publications such as *Women's Wear Daily*. Children's fashions often have features similar to the current adult clothing styles. For example, a young girl's dress may have a high waistline, a normal waistline, or a lowered waistline, as shown in Figure 14.1. A successful design should be good looking, functional, comfortable, easy to care for, and liked by the child who will wear the garment.

SELF-HELP FEATURES

Children's clothing should be easy to put on and take off, so the child is encouraged to dress without help. Elasticized pull-on pants and skirts can be managed easily by young children. Large buttons and zippers with pull tabs require less manual dexterity than small buttons and zippers without pull tabs. Velcro and gripper snaps can be handled successfully by most children.

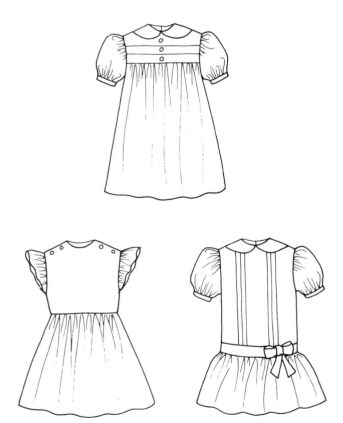

Figure 14.1 Dresses with high, normal, and lowered waistlines.

FIBERS AND FABRICS

A variety of serviceable and comfortable fabrics and trims are available to the designer and home sewer. Children generally like brightly colored clothing. Plaids and prints should be selected in proportion to the child's size. Young children usually enjoy prints with popular television and cartoon characters. Typical current favorites might include Barney, Elmo, Mickey and Minnie Mouse, Winnie the Pooh and Tigger, Cinderella, and Snow White. Blended fabrics made of cotton and synthetic fibers have increased strength and wrinkle resistance as well as easy care properties. Woven fabric blends of 65 percent polyester and 35 percent cotton are commonly used by the children's wear industry. For knit fabrics, a blend of 50 percent polyester and 50 percent cotton is popular. These woven and knit fabric blends combine the abrasion resistance of polyester with the comfort of cotton. They are washable and generally have a permanent press finish for easy care.

TRIMS

Besides being functional, children's clothing should be attractive. Fabrics and trims inspire many designers of children's clothing, and a basic garment can be repeated in a variety of fabrics and trims to give several different looks. Commonly used trims are braid, rickrack, eyelets, lace edging, embroidery, smocking, appliqué, ruffles, and tucks. Fasteners used as trim include buttons, belts, gripper snaps, and zippers. Figure 14.2 shows some examples of trim on dresses for little girls.

GROWTH FEATURES

Growth features can be added to children's clothing to extend the length of time the garment can be worn. Decorative tucks near the hemline can be let out as the child gets taller. Tucks that do not show can be put on the inside of the skirt in the hem area. Hems that are 3 to 6 in. (7.6 to 15.2 cm) deep are often used, especially in thin fabric, so the garment can be let down. Elastic in the waistband of dresses, skirts, or pants, and in the hem of sleeves will expand with the child. Attaching two sets of buttons, grippers, or Velcro fasteners to shoulder straps or belts also allows for growth.

SAVING MONEY

Those who sew for children can save approximately 50 percent of the cost of ready-to-wear garments. Inexpensive fabric remnants are readily available, and trims are often on sale. Quick construction techniques can be used, for one's time is also money. Older children can experience

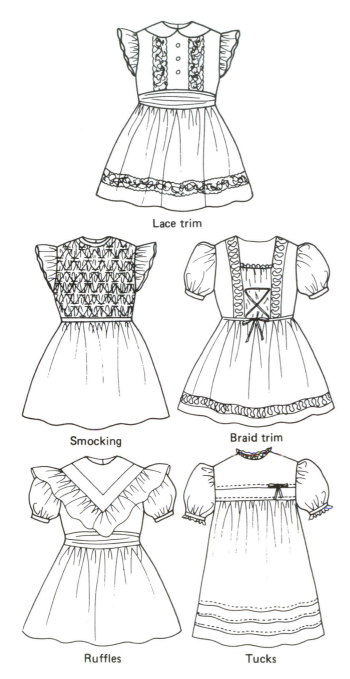

Lace trim

Smocking

Braid trim

Ruffles

Tucks

Figure 14.2 Lace, smocking, braid, ruffles, and tucks used as decorative trim.

the pleasure of helping to select the fabric and trim, so the garment is truly custom-made to suit the child's taste and needs.

PATTERNWORK

Basic patterns for children can be purchased from Butterick, McCalls, Kwik-Sew, Simplicity, or Vogue pattern companies. You can also start with a knockoff of a favorite

garment that fits the child well, or draft a pattern from accurate body measurements. If you have a commercial body form of a child you can drape muslin on the form to make a pattern. Full-scale patterns for a bodice front, bodice back, and sleeve for a child size 3 are found in Appendix A for practice in making the clothing for girls in this chapter. The measurement chart in Appendix C gives standard pattern company measurements for various sizes.

Many of the pattern-making techniques used to make women's clothing can be applied to the construction of children's clothing. Because children have little or no bust development, however, the patterns for children's clothing have no bust-fitting darts or, at most, only small bust darts. In this section, we concentrate on clothing for girls. Pants and shirts for boys were covered in Chapter 13 on men's and boys' clothing. Dresses for girls incorporate such design features as the Peter Pan collar, puff sleeves, yokes, and gathered skirts. The pattern-making techniques used for these features are shown in this section.

PETER PAN COLLAR

Directions ..

1. To make a flat Peter Pan collar like the one shown in Figure 14.3, place the front and back pattern pieces together at the neckline.
2. Overlap the front and back patterns $\frac{1}{2}$ in. (1.3 cm) at the armhole edge.
3. Trace the neckline from center front to center back.
4. Shape the Peter Pan collar $1\frac{1}{2}$ to 2 in. (3.8 to 5.1 cm) wide with the curved ends at center front.
5. Make a fitted neck facing $1\frac{1}{2}$ in. (1.3 cm) wide or less.

..

BERTHA COLLAR

Directions ..

1. Overlap the shoulder seams $\frac{1}{2}$ in. (1.3 cm) at the armhole edge, as shown in Figure 14.4. The front and back should meet exactly at the neckline.
2. Design the collar, which can extend to the armhole line or 1 to 2 in. (2.5 to 5.1 cm) beyond the armhole. The collar can be a gradual curve, or it can have a scalloped edge. Construct a double collar when a thin fabric is used.
3. Make the neck facing $1\frac{1}{2}$ in. (3.8 cm) wide. The facing should have the same shape as the dress front and back at the neckline.

..

Figure 14.3 Peter Pan collar.

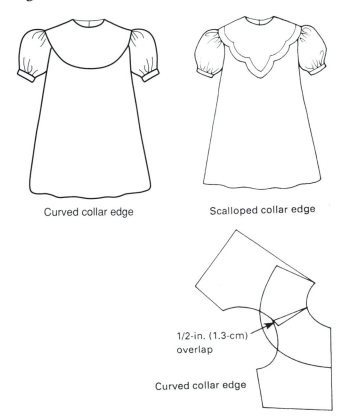

Curved collar edge Scalloped collar edge

Curved collar edge

Figure 14.4 Bertha collar.

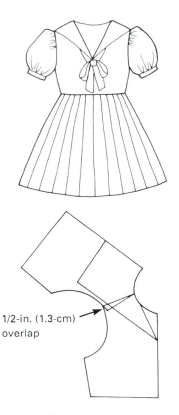

Figure 14.5 Sailor collar.

SAILOR COLLAR

Directions ..

1. Place the front and back bodice patterns together with an overlap of ½ in. (1.3 cm) at the armhole (Figure 14.5).
2. Draw the collar outline at right angles to the center back.
3. Lower the center front neckline, and connect the back collar line to the front with a straight or slightly curved line.
4. Make a fitted neck facing.
...

SHORT PUFFED SLEEVE

This sleeve has gathers at the top where it is sewn into the armhole and gathers at the bottom where it is attached to a sleeveband.

Directions ..

1. Draw around the basic short sleeve pattern.
2. Cut and slash the sleeve as shown in Figure 14.6. The new sleeve pattern will be 2 in. (5.1 cm) taller in the

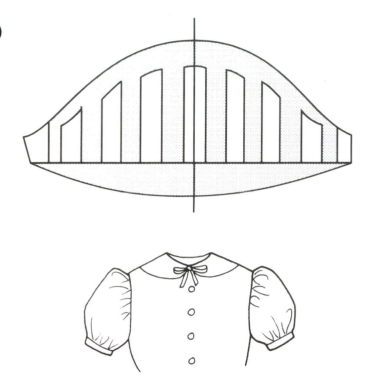

Figure 14.6 Short puffed sleeve.

sleeve cap area and 2 in. (5.1 cm) deeper at the bottom than the basic sleeve pattern. It will be double the basic pattern in width. For example, if the basic sleeve was 8 in. (20.3 cm) wide, the new puffed sleeve pattern will be 16 in. (40.6 cm) wide. Gather both the upper and lower sleeve edge.

3. Make a straight sleeveband 1 in. (2.5 cm) wide, to be folded in half. The band length is the upper arm measurement plus ½ to 1 in. (1.3 to 2.5 cm) for comfort.

...

BABY DOLL SLEEVE

This sleeve has a smooth shoulder line with a soft puff at the bottom of the sleeve.

Directions ...

1. Cut and slash the basic short sleeve pattern from the bottom of the sleeve to, but not through, the upper edge. Spread as shown in the diagram in Figure 14.7.
2. Gather the sleeve onto a sleeveband.

...

FLARED OR BELL SLEEVE

The pattern for this sleeve (Figure 14.8) is similar to the baby doll sleeve. It also has a smooth shoulder line but is flared at the bottom. This style sleeve has a fitted facing but no sleeveband.

DRESS WITH YOKE AND PLEATS

Directions ...

1. Draw in a yokeline and a lowered neckline.
2. Draw lines for pleats. The center pleat is half as wide as the other pleats because it is positioned on the center front fold line.

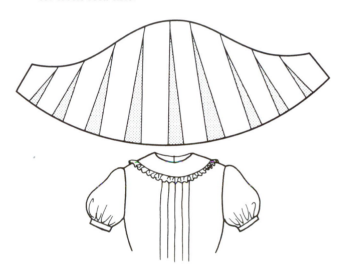

Figure 14.7 Baby doll sleeve.

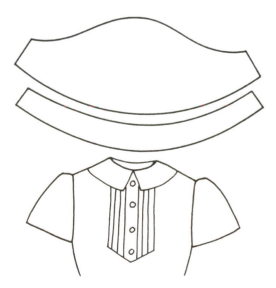

Figure 14.8 Flared or bell sleeve and facing.

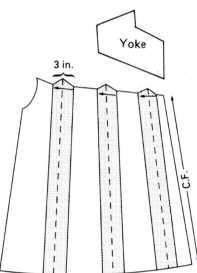

Figure 14.9 Dress with yoke and pleats.

3. Spread the pattern 3 in. (7.6 cm) between each pleat line to give a 1½-in. (3.8-cm) deep pleat (Figure 14.9). Three pleats will open toward the right side seam, and three pleats will open toward the left side seam.
4. The back of the dress can be completed with or without pleats. The flare at the side seam should be the same on the front and back patterns.

DRESS PATTERN WITH FOUR DIFFERENT YOKES

Many dresses for girls have a yoke with gathered or pleated fullness under the yoke (Figures 14.10 and 14.11). An A-line dress pattern (see Figure 14.10) is used to make the four dress designs pictured in Figure 14.11. Line A in

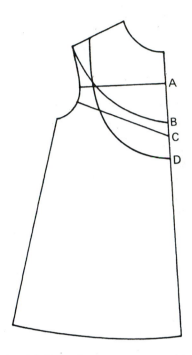

Figure 14.10 Child's basic dress pattern with yokelines to match dresses in Figure 14.11.

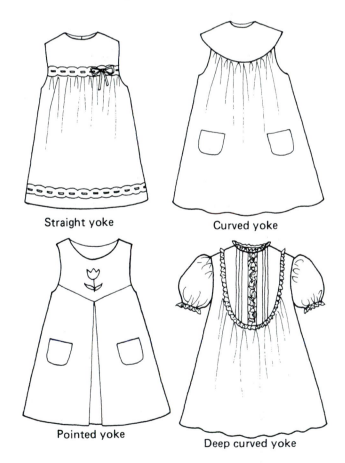

Straight yoke Curved yoke

Pointed yoke Deep curved yoke

Figure 14.11 The same basic pattern looks quite different when different yokes and trims are used.

Figure 14.10 corresponds to the straight yoke, line B to the round yoke, line C to the V-shaped yoke, and line D to the deep, curved yoke. If the bodice sloper is used to make the dress with yokes, add 9 to 12 in. (22.9 to 30.5 cm) length from the waistline to the hem. Also add approximately 2 in. (5.1 cm) of flare at the side seam hemline. Draw a straight line from the hem to the under-arm point.

Complete each of the patterns by slashing and adding fullness for gathers or pleats (Figure 14.9).

VEST

Directions ..

1. Draw around the basic bodice front as shown in Figure 14.12.
2. Add ½ to ¾ in. (1.3 to 1.9 cm) to the center front-line for the extension for buttons and buttonholes. Mark the placement of the buttons and buttonholes.
3. Draw a curved princess line from the middle of the armhole over the bust to the middle of the waist.
4. Extend the side seam ½ to ¾ in. (1.3 to 1.9 cm) wider and lower the armhole ½ in. (1.3 cm) in the underarm area. This allows room for a blouse or sweater to be worn under the vest.

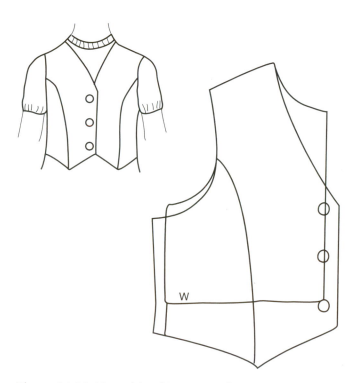

Figure 14.12 Vest with princess seamlines.

5. Make the vest 2 to 3 in. (5.1 to 7.6 cm) longer than the normal waistline at center front and at the side seam.
6. Make the curved princess-line end either at the V point in the front hem or 1 in. (2.5 cm) toward the side seam. On heavier fabric there will be less bulk at the V point if the seamline does not end at the V point.
7. Design the vest back to be the same length at the side seams as the vest front. Make the hemline straight across the back. Widen and lower the armhole as you did on the front.
8. Make facings for the vest 1½ in. (3.8 cm) wide. Facings will include a back neck facing, back and front armhole facings, front neck, down center front, and front hem continuous facing. The back vest hem area can be a facing or a hem since it is cut straight across the bottom. The entire vest can be lined or unlined.

..

DRESS WITH PRINCESS-LINE BODICE AND GATHERED SKIRT

Directions ..

1. Draw around the bodice front. Extend the center front line the desired length to the hemline. (See Figure 14.13.) Draw the side seam from waist to hemline parallel to the center front line.
2. For a slightly lowered waistline, draw the waistline seam 1 in. (2.5 cm) lower at the side seam and 3 in. (7.6 cm) lower at center front. This seamline can be a gradual curve or can end in a point at center front. However, when the gathered skirt is sewn to the bodice, a curved line is easier to sew than a V point at center front.
3. Draw a princess seamline from the armhole over the bust through the normal waistline.
4. A belt designed to tie in back can be sewn in the front princess seamline or in the side seam.
5. Slash the skirt in 4 or 5 places to add the desired fullness to the gathered skirt. The skirt should have the same fullness in back as in front.
6. Design the back with a zipper in the center back seamline or add an extension for buttons and buttonholes. The bodice back can be made with or without a princess seamline.
7. Use the puffed sleeve pattern and the Peter Pan collar pattern to complete the dress.

..

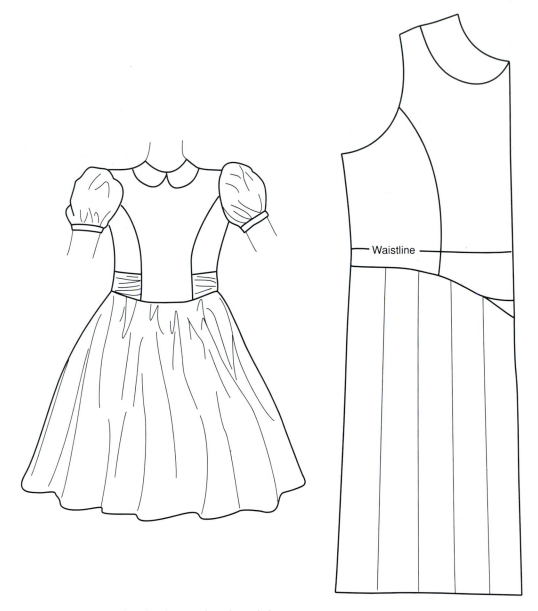

Figure 14.13 Dress with princess-line bodice and gathered skirt.

DRESS WITH TUCKS

Directions ..

1. Draw around the basic bodice front and extend the bodice into a dress by adding the appropriate length from center front to hemline and sideseam to hemline. Add 2 in. (5.1 cm) flare to the sideseams to hemline. (See Figure 14.14.)
2. Add ¾ in. (1.9 cm) for the center front extension. This allows for ¾ in. buttons. Draw a lowered V-shaped neckline and design a flat collar with scallops.

Decide on the number and placement of buttons and buttonholes.

3. Draw 4 parallel lines to center front from the neckline and shoulder area. Extend these lines 3 in. (7.6 cm) below the normal waistline.
4. Cut and slash the pattern and add 2 in. (5.1 cm) width for each tuck. Sew tucks to the inside of the garment. Pleats will form in the lower part of the skirt below each tuck.
5. The dress back can be designed with similar tucks or a princess seamline with flared skirt for comfort and ease of movement. Make sure the front and back dress are

Normal
waist line →

Figure 14.14 Dress with tucks.

the same length at the sideseams. The flare at the side back is 2 in. (5.1 cm) like the front.

6. Make a back neck facing and a front facing that extends from the shoulder to the hemline. It should be 1½ in. (3.8 cm) wide.

7. Complete the pattern with the short set-in sleeve pattern.

SLIPDRESS AND JACKET

Directions

1. For the slipdress, draw around the bodice front and design the slipdress bodice as shown in Figure 14.15.

2. Extend the center front line the desired length to the hemline. For a size 3 add about 12 in. (30.5 cm) length at both the center front and at side waist. These lines will be parallel to each other.

3. Draw a line from the shoulder through the bust and waistline to the hemline. Make the skirt flared by adding 2 to 3 in. (5.1 to 7.6 cm) to both seamlines where the center front panel joins the side front. Also add the same flare to the side seam.

4. A slipdress does not need as much ease in the bust area as a basic bodice. For a snugger fit remove ½ in. (1.3 cm) from the seamline above the bust and taper this seam to the bust point. A deeper side seam can also remove excess bodice fullness.

5. The back should be designed with similar design lines, as well as a center back seamline. A zipper is usually placed in the center back seamline.

6. Finish the upper edge and the straps with bias binding.

7. Design the jacket front with curves at the neckline and center front hemline.

8. Use the bodice back and the set-in-sleeve patterns to complete the jacket.

9. Finish the jacket and sleeve edges with bias binding.

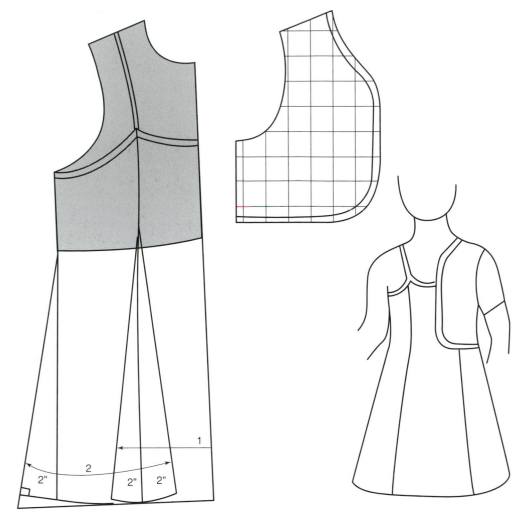

Figure 14.15 Slipdress and jacket. Arrow 1 shows the width of the center panel at the hemline. Arrow 2 shows the width of the side panel at the hemline.

JUMPER WITH BIB

Directions .

1. Draw around the bodice front. Design the bib and pocket as shown in Figure 14.16.
2. The straps can be straight or crossed in back. Buttons or bib overall hooks can be used to attach the straps to the bib.
3. Extend the center front line to the desired length. Draw the side seamline parallel to the center front line. The width of the bottom edge of the entire skirt is between 64 and 80 in. (161.7 and 202 cm) wide. The total width divided by 4 equals 16 to 20 in. (40.6 to 50.5 cm) for the front skirt pattern and the same amount for the back skirt pattern. Smaller sizes should have fewer gathers than larger sizes. Also heavier fabrics like denim should have fewer gathers than thinner fabrics.
4. For an interesting variation to this jumper, convert the skirt pattern into a flared gathered skirt by spreading the skirt panels further apart at the bottom than at the top. If a seam at center front is used, the grainline of the skirt panel is in the middle of the skirt pattern. If center front is placed on the fold the grainline is the center front line.

. .

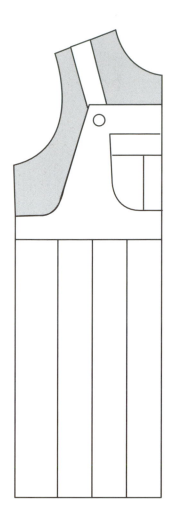

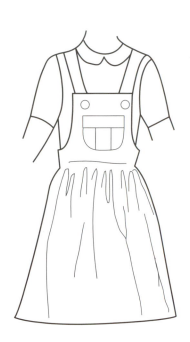

Figure 14.16 Jumper with bib.

NIGHTGOWN

Directions ...

1. Start with the bodice front and back basic patterns. Add length to the bodice to make the nightgown as long as desired. A knee-length gown is shown in Figure 14.17.
2. Design a yoke with a lowered neckline on both the front and back. Make the yoke the same width at the shoulder on the front and back pieces.
3. Draw 3 parallel lines in the bodice front and back. Spread and add 1 to 1½ in. (2.5 to 3.8 cm) at each line for the gathers.
4. Use the puff sleeve pattern and add 1 in. (2.5 cm) for the gathered hem. Place elastic 1 in. (2.5 cm) from the hem edge.
5. The narrow hemline can be straight or curved upward at the two side seams.

...

BASIC STRAIGHT SKIRT DRAFTED FROM FOUR MEASUREMENTS

Measurements needed:

- Waist circumference
- Hip circumference
- Waist to hipline length
- Waist to knee length

Directions ...

1. Use a large sheet of paper and an L square to draft the basic skirt in Figure 14.18. Draw a rectangle and label the four corners A, B, C, and D. Lengthwise measurements are in direction 2 and crosswise measurements are in direction 3.
2. Use the waist to knee measurement for the two parallel lengthwise lines $A–B$ and $C–D$. Line $A–B$ is the center back and line $C–D$ is the center front.

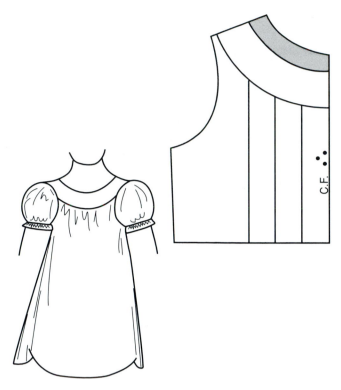

Figure 14.17 Nightgown with curved yoke.

3. For the width measurements A–D and B–C, use ½ the hip circumference plus 1 in. (2.5 cm.) ease.
4. Use the waist to hip measurement to measure down from point A to mark point E. Draw line E–F parallel to lines A–D and B–C.
5. Divide the rectangle into half lengthwise and label this vertical line G–H. This is the sideseam from hip to hem.
6. From point A, measure over 2½ in. (6.4 cm.) on line A–D. Label this point I. Draw the back dart ⅝ in. (1.6 cm.) wide to point J. From the middle of the dart space draw a line 3½ in. (8.9 cm.) long and label this point K.
7. From point D, measure over 2½ in. (6.4 cm.) on line D–A. Label this point L. Draw the front dart ½ in. (1.3 cm.) wide to point M. From the middle of the dart space draw a line 2 in. (5.1 cm.) long and label this point N.
8. Divide the total waist measurement into fourths and add ¼ in. (0.6 cm) ease. Use this back waist measurement for the distance from A to I and J to O. Extend point O ⅛ in. (0.3 cm) above the original waistline so you have a slight upward curve from J to O.
9. The distance from D to L and M to P is the front waistline measurement of ¼ the total waist measurement

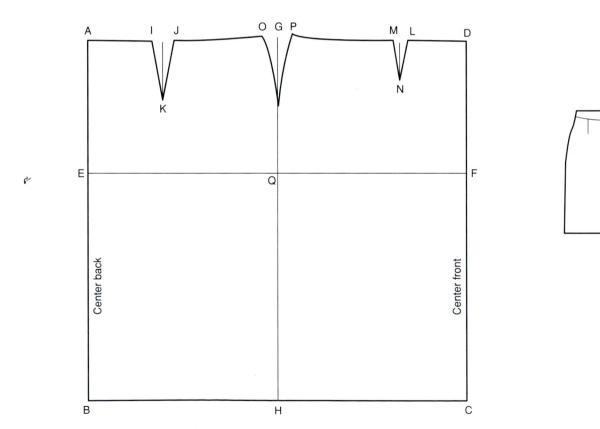

Figure 14.18 Straight skirt drafted from 4 measurements.

plus ¼ in. ease. Extend point *P* ⅛ in. (0.3 cm) above the original waistline so you have a slight upward curve from *M* to *P*.

10. Connect lines *O* to *Q* and *P* to *Q* with a gradual curve. A hip curve ruler works well. Cut the front and back pieces apart before seams are added.

..

FULL-CIRCLE SKIRT

Directions ...

1. Fold the fabric or paper in fourths as shown in Figure 14.19.
2. Use the following formula to determine the waistline radius:

$$\frac{W - 1 \text{ in.}}{6} = r$$

For example, if the waistline measures 25 in.,

$$25 \text{ in.} - 1 \text{ in.} = 24 \text{ in.}$$
$$24 \text{ in.} \div 6 = 4\text{-in. radius}$$

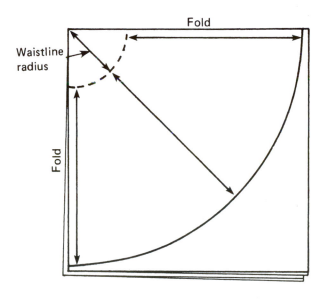

Figure 14.19 Full-circle skirt.

3. Measure the desired skirt length and add ½ in. (1.3 cm) for the hem. A narrow finished hem ¼ in. (0.6 cm) wide is easier to sew on a circle skirt than a wider hem.
4. The length of the waistband pattern is the waist measurement plus 1 in. (2.5 cm) for the buttons and buttonholes or hooks and eyes. The finished width of the band is usually 1 or 1½ in. (2.5 or 3.8 cm).

..

GATHERED SKIRT

Directions ...

1. Determine the finished length of the skirt; then add 3 to 4 in. (7.6 to 10.2 cm) for the hem allowance and ⅝ in. (1.6 cm) for the side seams and waistline seam. If the fabric is sheer or thin, 5 to 6 in. (12.7 to 15.2 cm) can be added for the hem.
2. Determine the amount of fullness. Gathered skirts range from 45 in. to 90 in. (114.3 to 228.6 cm) in width. Two widths of a 36-in. fabric give about 72 in. (182.8 cm) of fullness, and two widths of a 45-in. fabric give about 90 in. (228.6 cm) of fullness.
3. Add a zipper to the left side seam.
4. Gather the skirt onto a waistband (Figure 14.20).

..

Figure 14.20 Gathered skirt.

PULL-ON UNISEX PANTS WITH NO SIDE SEAMS OR ZIPPER

A simple pull-on pants pattern for shorts, slacks, or pajama bottoms can be made with no side seams (Figure 14.21).

Directions

1. Draw the front and back pants patterns close together, allowing from 0 to ½ in. (0 to 1.3 cm) extra on each side seam. Pajamas need the extra ½ in. (1.3 cm) for comfort, but shorts and slacks can have less fullness.
2. Straighten the waistline seam and mark the grainline.
3. Cut on the shorts line or the long pants line.
4. Add a 1½-in. (3.8-cm) hem at the bottom of the pants and a 1-in. (2.5-cm) hem at the top for the elastic waistband.

JACKETS AND COATS

Table 14.1 gives the adjustments needed on the front, back, and sleeve to change the basic dress pattern to a jacket or coat pattern.

The dashed lines in Figure 14.22 show where the basic dress pattern must be adjusted to make a jacket or coat pattern. A typical weight jacket fabric is cotton poplin, and a typical weight coat fabric is a lightweight wool with a lining. If heavier fabrics are used, further adjustments to the pattern will be necessary.

PRINCESS-LINE COAT

Directions

1. To make the coat in Figure 14.23, adjust the basic dress pattern according to Table 14.1 and Figure 14.22. Widen the shoulder seam ¼ in. (0.6 cm), lower the armhole ½ in. (1.3 cm), and make the side seam ½ in. (1.3 cm) wider.
2. Add the extension at center front for buttons and buttonholes.
3. Draw the princess line and cut the pattern apart. Add the seam allowances.
4. Make the coat 1 to 2 in. (2.5 to 5.1 cm) longer than the dress pattern to cover all dresses worn under the coat. Add 2½ to 3 in. (6.4 to 7.6 cm) at the bottom for the hem.

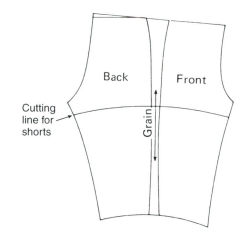

Figure 14.21 Pull-on pants with no side seams.

Table 14.1 **Changing Basic Dress Pattern to Jacket or Coat Pattern**

Garment Front and Back	Adjustments	
	Jacket	Coat
Lower neckline	⅛ in. (0.3 cm)	¼ in. (0.6 cm)
Raise shoulder at armhole	⅛ in. (0.3 cm)	¼ in. (0.6 cm)
Extend shoulder	⅛ in. (0.3 cm)	¼ in. (0.6 cm)
Lower armhole	¼ in. (0.6 cm)	½ in. (1.3 cm)
Extend side seam	¼ in. (0.6 cm)	½ in. (1.3 cm)
Sleeve	Adjustments	
Raise sleeve cap	⅛ in. (0.3 cm)	¼ in. (0.6 cm)
Extend side seam	¼ in. (0.6 cm)	½ in. (1.3 cm)
Lower underarm seam	¼ in. (0.6 cm)	½ in. (1.3 cm)

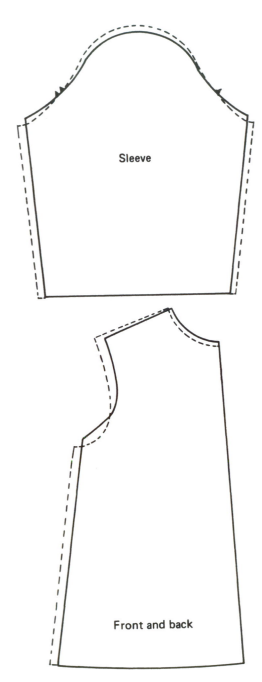

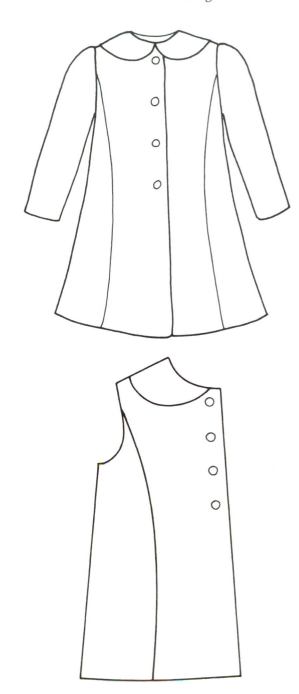

Figure 14.22 Basic pattern changes for jackets and coats. The solid line is the basic sloper.

Figure 14.23 Princess-line coat.

5. Design the Peter Pan collar. (Use the directions accompanying Figure 14.3, but make the collar wider for the coat than for a dress.)
6. Complete the back pattern with princess seamlines.
7. Make a fitted facing 2 to 2½ in. (5.1 to 6.4 cm) wide for the neckline and front areas.

8. The coat can be lined or unlined. If a lining is used, cut it the same shape as the coat less the width of the facing. Add an action pleat at the center back. Make the lining shorter than the coat at the hemline.

Make the patterns for several of these garments.

Dresses

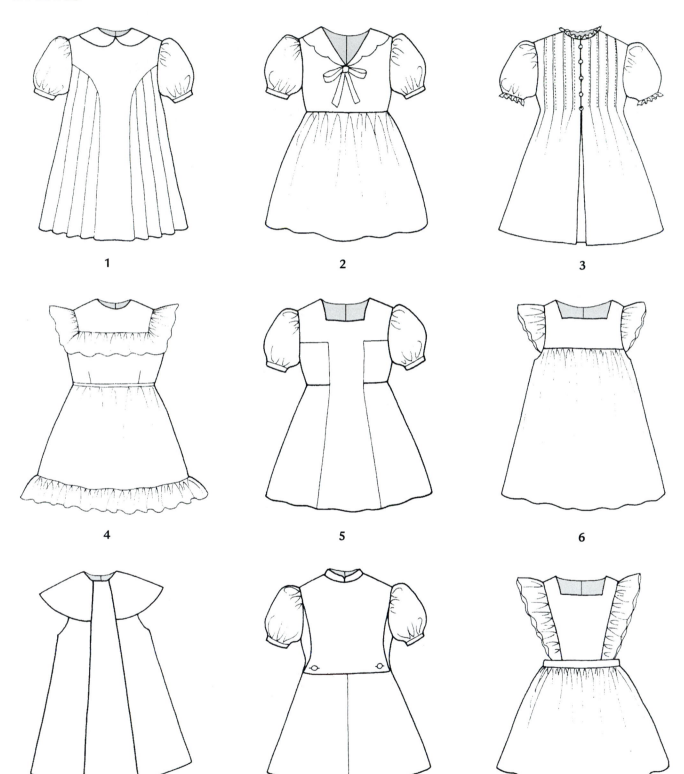

1

2

3

4

5

6

7

8

9

Sportswear

1. Sweatshirt with color blocking

2. T-shirt with appliqué design

3. Plain and print jumper

4. Jumpsuit

5. Jumpsuit

6. Overalls

Patterns for Knit Garments

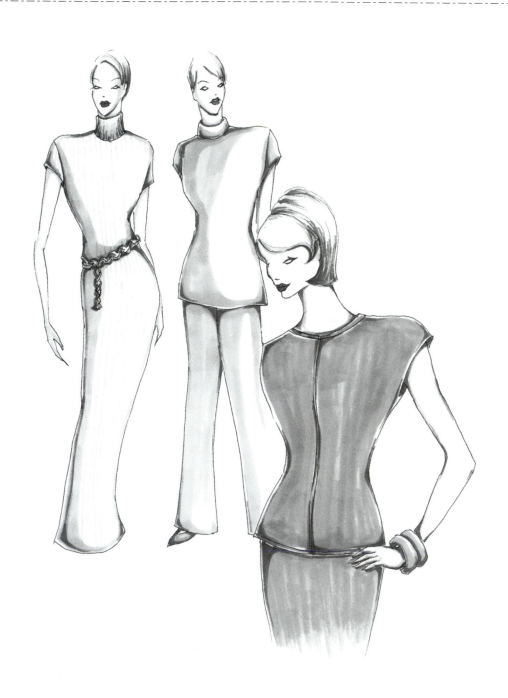

Knits are popular apparel fabrics for dressy, daytime, and active wear because they are stretchable, comfortable, and versatile. The two main methods of producing knit garments are the full-fashion and cut-and-sew methods. The full-fashion method is mainly used for sweaters. Each garment piece is knitted by hand or machine to the garment shapes, and the pieces are then hand assembled and blocked. Cut-and-sew knits are made from yardage from which garment pieces are cut. This chapter concentrates on cut-and-sew knits.

Most apparel firms have specific patterns for knit garments that are different from patterns for woven garments. They also have patterns for knit fabrics with small, medium, or large amounts of stretch. Patterns for women's knit garments usually do not have bust- or waist-fitting darts. Darts are not necessary on most knit garments because of the stretch of the fabric.

STRETCH AND RECOVERY

Stretch is the amount of elongation per inch that occurs when the knit fabric is stretched to its maximum length and width. If the knit fabric returns to its original shape after being stretched, it has good recovery. Fabrics with poor recovery will bag or stretch out of shape when worn and should be avoided. Some fabrics contain spandex and are called two-way stretch because they stretch in both the lengthwise and crosswise directions. Fabrics made of cotton or nylon blended with spandex usually have excellent recovery.

VARIATION IN STRETCH

Knit fabrics are made with different amounts of stretch. Some knit fabrics have 18 to 20 percent stretch in the crosswise direction. These fabrics are described as knits with slight stretch. Fabrics such as jersey, double knits, and interlock knits are in this category. Some knits stretch 25 to 35 percent. These are called knits with moderate stretch and include fabrics such as velour, terry, tricot, and sweater knits. Knits that stretch 75 to 100 percent are called superstretch and include ribbing and fabric with spandex. It is necessary to modify the basic pattern for the type of knit fabric that will be used for the garment. Table 15.1 indicates the amount of stretch that 4 in. (10.2 cm) of crosswise folded knit fabric should stretch, to be classified as slight, moderate, or superstretch.

SHRINKAGE

Due to the looped yarn construction, most knit fabrics shrink more than woven fabrics. Therefore preshrinking knit fabrics is recommended for home sewers. Apparel manufacturers do not preshrink knit fabrics. When they purchase fabric from fiber producers they can write specifications for the amount of shrinkage they will allow for the various knit fabrics they purchase. They can also cut knit garments larger to compensate for shrinkage.

PATTERNS FOR KNITS

Patterns for knits can be adapted from patterns designed for woven fabrics by removing length, width, and darts from the pattern pieces. Less ease is needed on knit garments because the stretch of the knit fabric compensates for the ease that is removed. Cotton spandex knits that fit close to the body are cut several inches smaller than body measurements due to the great elasticity of the spandex. Zippers and other closures and waist darts can be eliminated on pull-on styles of pants and skirts.

Instructions are given for length and width reductions of the basic bodice, sleeve, skirt, and pants patterns to make them appropriate for knit fabric with slight stretch of 18 to 20 percent or moderate stretch of 25 to 35 percent. Instructions are also given for a dartless bodice with centered side seams and a sleeve that is appropriate for slight

Table 15.1 **Stretch Chart for Knit Fabrics**

Stretch	Unstretched Knit	Stretched Knit	Approximate Stretch*	Typical Fabrics
Slight	4 in. (10.2 cm)	4¾ in. (12.1 cm)	18%	Double-knit, Raschel knit
	4 in. (10.2 cm)	4⅞ in. (12.4 cm)	20%	jersey, interlock
Moderate	4 in. (10.2 cm)	5¼ in. (13.3 cm)	25%	Velour, terry, tricot
	4 in. (10.2 cm)	5½ in. (14 cm)	35%	sweater knit
Super	4 in. (10.2 cm)	7 in. (17.8 cm)	75%	Knits with spandex
	4 in. (10.2 cm)	8 in. (20.3 cm)	100%	ribbing

*When the unstretched knit of 4 in. is stretched to 4¾ in., the stretch factor is obtained by dividing the difference of ¾ in. by the unstretched amount of 4 in. For example, 4 in. divided by ¾ in. stretch equals 18.75% instead of 18%. However, the percentages in the table are approximate and are the percentages used in pattern books for knitwear.

or moderate stretch knits. Patterns for a close-fitting bodice, skirt, and bicycle shorts for superstretch knit with spandex are also included.

LENGTH AND WIDTH REDUCTIONS

Measurements given are for slight stretch knit with 18 to 20 percent stretch. For moderate stretch knits, add ¹⁄₈ in. more reduction (0.3 cm) to all the measurements given.

Bodice (Figure 15.1)

1. Raise the front neckline ¹⁄₄ in. (0.6 cm).
2. Remove ¹⁄₄ in. (0.6 cm) from the side seams of the bodice front and back, parallel to the original seamline.
3. On the bodice front, raise the bust dart ¹⁄₄ in. (0.6 cm), and the waist dart tip ¹⁄₄ in. (0.6 cm).
4. Remove ¹⁄₄ in. (0.6 cm) from the waistline parallel to the original waistline.
5. Raise the armhole ¹⁄₂ in. (1.3 cm) in the underarm area in the front and back. Draw a new curve in this area.

Sleeve (Figure 15.2)

1. Raise capline ¹⁄₂ in. (1.3 cm).
2. Draw a new curve that blends into the original sleeve curve.
3. Raise the elbow dart ¹⁄₄ in. (0.6 cm).

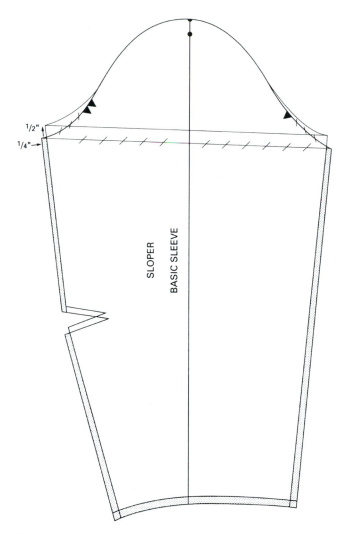

Figure 15.2 Length and width reductions for the sleeve.

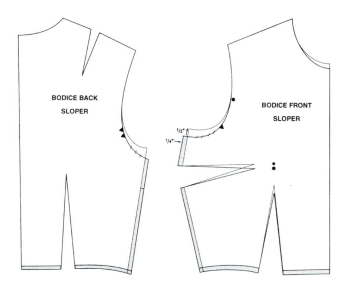

Figure 15.1 Length and width reductions for the bodice front and back.

4. Remove ¹⁄₄ in. (0.6 cm) from both side seams, parallel to the original lines.
5. Remove ¹⁄₄ in. (0.6 cm) from the bottom of the sleeve.

Skirt (Figure 15.3)

1. Remove ¹⁄₄ in. (0.6 cm) from the side seams parallel to the original line.
2. Remove ¹⁄₄ in. (0.6 cm) from the bottom of the skirt.

Pants (Figure 15.4)

1. Raise the crotchline ¹⁄₂ in. (1.3 cm) and draw a new curve line in this area.
2. Remove ¹⁄₄ in. (0.6 cm) from the side seams parallel to the original lines.
3. Remove ¹⁄₄ in. (0.6 cm) from the bottom of the pants.

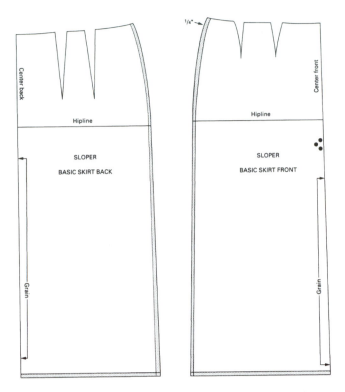

Figure 15.3 Length and width reductions for the skirt.

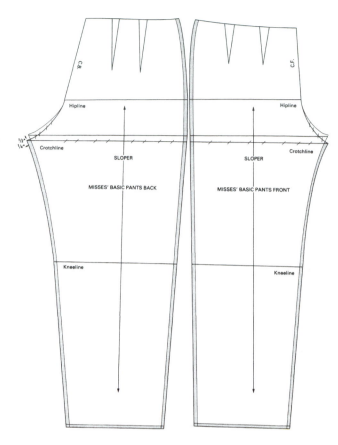

Figure 15.4 Length and width reductions for the pants.

4. Remove ¼ in. (0.6 cm) from the inseam of the pants, parallel to the original line.
5. Darts in the waistline seam are usually converted to gathers when elastic is used in the waistband.

DARTLESS BODICE BLOCK WITH SLEEVE FOR A KNIT WITH SLIGHT OR MODERATE STRETCH

This block is appropriate for a casual knit garment that does not cling to the body. There is more room in the armhole for a looser fit and about 1 in. (2.5 cm) less ease across the bust than the block for woven fabrics. Most knit fabrics will shrink more than woven fabrics. Therefore it is advisable to preshrink the knit fabric. If the fabric is not preshrunk, or if a roomier bodice is desired, start with the next larger size basic pattern.

Bodice Back (Figure 15.5)

1. Remove ¼ in. (0.6 cm) from the side seam for slight stretch or ⅜ in. (1 cm) for moderate stretch.
2. Extend the shoulder dart to the pivot point and use the slash method to close this dart and move it to the armhole for a looser fit.

3. Raise the underarm seam ½ in. (1.3 cm) and draw a gradual curve in this area.
4. Draw lines through the waist dart which is not sewn in and allows for a loose fit at the waistline.
5. Remove ¼ in. (0.6 cm) in hemline, or add length, if desired.

Bodice Front (Figure 15.6)

1. Remove ¼ in. (0.6 cm) from the side seam for slight stretch or ⅜ in. (1 cm) for moderate stretch.
2. With the slash method, close the bust dart and move it to the armhole. This provides more room in the armhole.
3. Raise the underarm seam ½ in. (1.3 cm).
4. Draw lines through the vertical waist dart because this dart is not sewn in, which allows for a loose fit at the waist.
5. Remove ¼ in. (0.6 cm) in hemline, or add length, if desired.

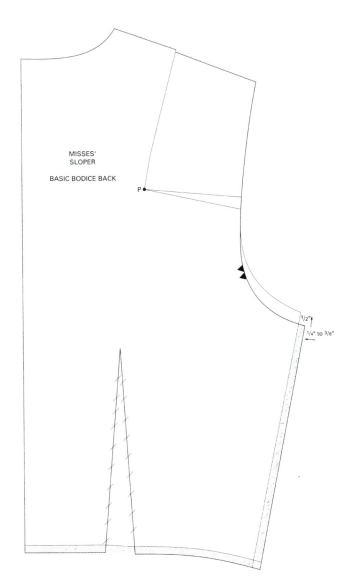

Figure 15.5 Bodice back changes for more room in the armhole.

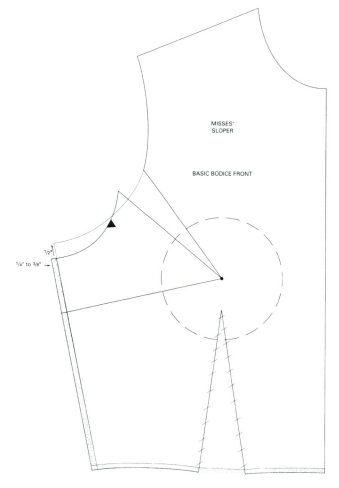

Figure 15.6 Bodice front changes for more room in the armhole.

Centered Side Seams
(Figure 15.7)

To center the side seams of the front and back patterns, draw the underarm seamline across the bodice front and back. Measure the bodice front and the bodice back on this line. Since the bodice front is wider than the bodice back, add half of this difference to the bodice back side seam and remove half of this difference from the bodice front side seam. Also check to see that the bodice front and back side seams are the same length and adjust, if necessary.

Short Sleeve (Figure 15.8)

1. Raise the sleeve capline ½ in. (1.3 cm).
2. Draw a new curve in the underarm area.
3. Remove ¼ in. (0.6 cm) from underarm seams.

Knit sleeves need less ease than woven sleeves. After centering the side seams on the bodice front and back, measure the new armhole of the bodice front and back patterns. Then measure the curve of the sleeve. If this line is the same length or ½ to 1 in. (1.3 to 2.5 cm) larger, the pattern does not need to be changed. If it is smaller than the armhole, enlarge the sleeve in the underarm area until the curved sleeve capline measures at least the same length or slightly larger than the armhole.

If a dropped shoulder design is wanted, length can be added to the upper part of the bodice armhole and removed from the height of the sleeve capline resulting in a sleeve with a flatter curve.

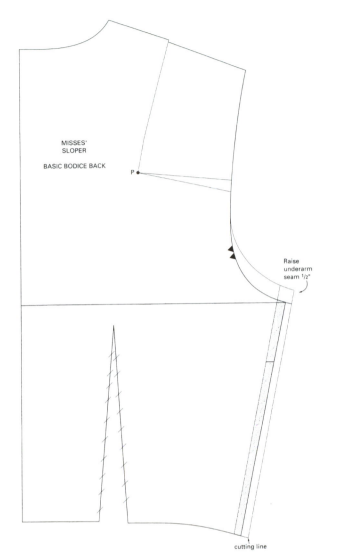

Figure 15.7 Bodice back showing centered side seams.

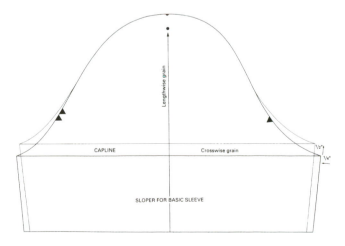

Figure 15.8 Short sleeve pattern to fit bodice front and back with more room in the armhole.

CLOSE-FITTING BODICE FOR SUPERSTRETCH KNIT (FIGURE 15.9)

This pattern is approximately 4 in. (10.2 cm) smaller in the bust than actual body measurements.

1. Begin with the dartless knit block for the bodice front and back.
2. Remove 1 in. (2.5 cm) from the front and back sideseams parallel to the original seamline and ½ in. (1.3 cm) from the bottom, parallel to the original hemline.
3. Lower the neckline by the desired amount in front and back.

A neckline that begins 1½ in. (3.8 cm) away from the neck point on the shoulder seam and lowered to 4 in.

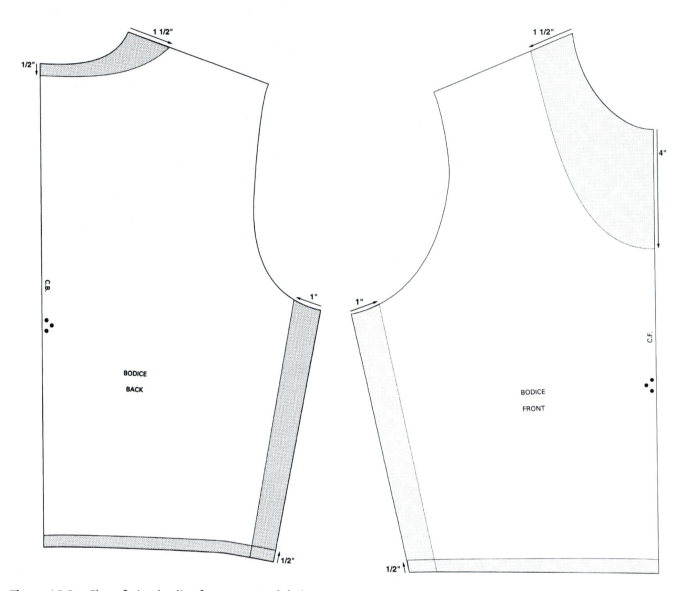

Figure 15.9 Close-fitting bodice for superstretch knit.

(10.2 cm) at center front is low enough to go over the head without a zipper in center back. Then the center back and center front can both be placed on the fold.

BODY-CONFORMING SHORT SKIRT MADE OF SUPERSTRETCH KNIT (FIGURE 15.10)

1. Remove ⅜ in. (1 cm) from the skirt front and back side seams to make the basic skirt appropriate for moderate stretch.

2. This skirt is approximately 4 in. (10.2 cm) smaller than body measurements at the hipline. Therefore, remove 1 in. (2.5 cm) more from both the side seams of skirt front and back.

3. Skirt front and skirt back are placed on the fold.

4. Draw out darts in back and front because an elastic waistband is used.

5. Knits with spandex have so much stretch that you can keep the curve from hipline to waistline.

6. Add 1 in. (2.5 cm) extension above the waistline to be folded down for the casing for the elastic.

7. Shorten the skirt to above the knee.

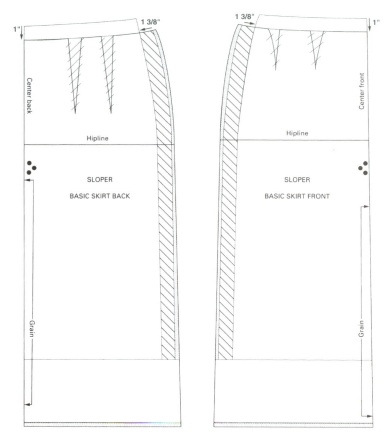

Figure 15.10 Body-conforming short skirt for superstretch knit.

BICYCLE SHORTS FOR SUPERSTRETCH KNIT FABRIC WITH SPANDEX (FIGURE 15.11)

1. Remove ⅜ in. (1 cm) from pants front and back side seams to make the basic pattern appropriate for moderate stretch.
2. This pair of pants is approximately 4 in. (10.2 cm) smaller than body measurements at the hipline. Therefore remove 1 in. (2.5 cm) more from the side seams of the pants front and back parallel to the original seamline.
3. After removing both of these amounts from the side seam, join the pants front and back at the hipline.
4. Draw out the darts in front and back because the pants will have an elastic waistband.
5. Draw waistline seam connecting center front and center back with a straight line.
6. Add 1 in. (2.5 cm) extension above the waistline to be folded down for a casing for the elastic.

Figure 15.11 Bicycle shorts for superstretch knit. Figure 15.11 shows the patternwork for the bicycle shorts after ⅜ in. (1 cm) and 1 in. (2.5 cm) were removed from both the front and back pants side seams.

7. Raise the crotchline a total of 1 in. (2.5 cm) because you are working with two-way stretch fabric. Blend in the new curve from the crotch to the hipline.

8. Draw a new inseam line that is ½ in. (1.3 cm) narrower at the crotchline and 1 in. (2.5 cm) narrower at the knee. Even more width can be removed in this area depending on thigh circumference.

9. Draw hemline above the kneeline and allow 1 in. (2.5 cm) for the hem.

BODYSUITS

Bodysuits are a popular garment for dance and exercise activities where complete freedom of movement is desired. It is necessary to use superstretch knits made of a blend of nylon and spandex or cotton and spandex. Patterns for these form-fitting garments should be placed on the knit fabric with the lengthwise grain in the direction of greatest stretch. The basic bodysuit is made with seams at center front, center back, and the two sideseams. Because of the superstretch of the knit fabric, the side seams can be eliminated or even the center front and side seams can be eliminated. Directions are given for drafting the basic bodysuit and modifying the pattern to have only a center front and center back seam or only a center back seam.

Drafting a Bodysuit

Lengthwise measurements needed:

- Neck point to bust
- Neck point to waist
- Neck point to crotch level
- Neck point to knee
- Neck point to ankle
- Center front to waist

Crosswise measurements needed:

- Center front over bust to side seam
- Center front waist to side seam
- Center front hip to side seam
- ½ leg circumference at crotch
- ½ knee circumference
- ½ ankle circumference
- Neck to arm shoulder width

Directions

1. Use an L square and a large sheet of paper about 72 in. (182.8 cm) long and 36 in. (91.4 cm) wide. Fold the paper in half lengthwise so you can draft the front bodysuit on the top layer. Later you will cut through both layers of the paper as the front and back draft are the same except at the back neckline which is 1½ in. (3.8 cm) higher at center back.

2. Use the measurement taken to draft the bodysuit in the same places as shown in Figure 15.12. Trace the armhole curve, shoulder seam and front neck from a basic pattern. The neck to ankle line is a dominant line. The center front line is parallel to this line and 2½ in. (6.4 cm) from it. Center the crotch, knee, and ankle measurements on the neck to ankle line. The bust line to the underarm seamline is about 1½ in. (3.8 cm) and the front neck point to the back neck point is 1½ in. (3.8 cm).

3. After completing the drafted bodysuit, remove ¼ in. from the entire side seam. Because of the great lengthwise stretch of the knit, it is necessary to remove 4 in. (10.2 cm) of length in the places marked on Figure 15.12. To remove 1 in. (2.5 cm) of fullness, fold in a ½-in. (1.3-cm) tuck. The four tucks are between the waist and bust, the waist and hip, the crotch and knee, and the knee and ankle.

4. Cut through the two thicknesses of paper for the front and back patterns. Make a trial garment of spandex blend knit fabric. Cut the garment with the greatest stretch in the lengthwise direction. Add ⅝-in. (1.6-cm) seams and sew the garment together with large stitches. Check the fit and resew the seams with a serger or overedge industrial machine using ⅜-in. (1-cm) seams. Lower the front neckline if desired.

Bodysuit with No Side Seams

It is possible to eliminate the side seams by placing the front and back patterns so they touch at the underarm, hip, and ankle areas. Make the front and back seams deeper by the amount of excess fabric that is in the side seam area. The great stretch of the knit fabric makes it possible to transfer the excess fabric to the deeper seams at center front and center back torso and leg areas. (See Figure 15.13.)

Bodysuit with No Center Front or Side Seams

It is possible to eliminate all seams except the center back seam. Transfer the front crotch to the back crotch. Also transfer the excess side seam area fullness to a deeper center back seam. The center back seam looks distorted, but will still fit due to the great stretch of the knit fabric with spandex. (See Figure 15.14.)

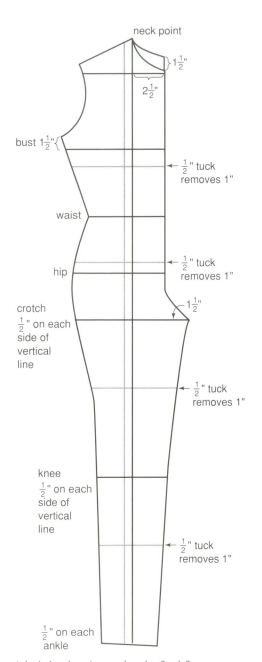

neck point

$1\frac{1}{2}$"

$2\frac{1}{2}$"

bust $1\frac{1}{2}$"

$\frac{1}{2}$" tuck removes 1"

waist

$\frac{1}{2}$" tuck removes 1"

hip

crotch $\frac{1}{2}$" on each side of vertical line

$1\frac{1}{2}$"

$\frac{1}{2}$" tuck removes 1"

knee $\frac{1}{2}$" on each side of vertical line

$\frac{1}{2}$" tuck removes 1"

$\frac{1}{2}$" on each ankle

Figure 15.12 A knit bodysuit can be drafted from accurate body measurements.

TEST PATTERN WITH A TRIAL GARMENT

Most apparel firms that work with a variety of knit fabrics will have basic slopers or blocks for each type of knit garment with different amounts of stretch from slight to moderate to superstretch. After adjusting the basic pattern for working with a specific type of knit fabric, it is always a good idea to test the pattern in a trial garment made of the same type of knit fabric that will be used in the final garment. Consider the appropriate fit to make the style look right. Generous side seams are useful in fitting and can be trimmed shorter later.

Basic patterns for knits can be used to design garments for knit fabric just as the original basic patterns were used to design patterns for woven fabrics. Remember to consider both the stretch and weight of the knit when designing knit garments. If a knit is soft and lightweight, such as

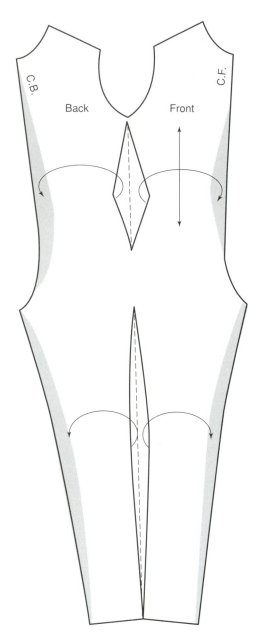

Figure 15.13 Bodysuit with seams at center front and center back but no side seams.

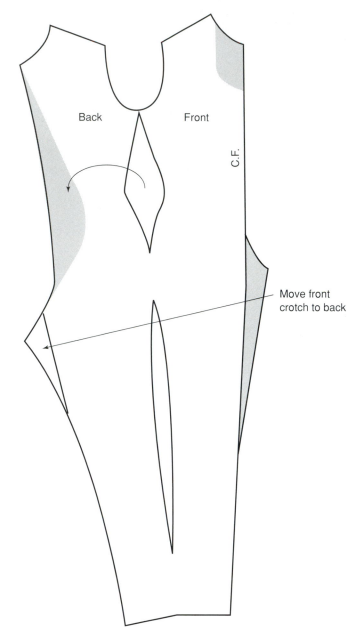

Move front crotch to back

Figure 15.14 Bodysuit with a center back seam and no seams at center front or sides.

jersey, it is suitable for patterns that have gathers or draped fullness. If a knit is firm, such as doubleknit, a tailored silhouette is appropriate. If it is bulky like a sweater knit, a pattern with few seams and details will show off the knit texture. Patterns for swimsuits, leotards, or tops and pants that fit close to the body should be made with few seams to allow the knit with spandex to stretch to its full advantage.

SEWING SUGGESTIONS FOR KNITS

For best results, preshrink the knit fabric.

Before cutting it, allow the knit fabric to relax overnight by unrolling the fabric from the bolt and laying it on a flat surface.

Mark a crosswise line with chalk. Follow the lengthwise and crosswise rows of knit stitches when laying out the pattern pieces.

Use a "with nap" layout to avoid subtle shading differences caused by the knit structure.

If there is a permanent crease in the knit fabric that won't come out with steaming, refold the fabric and position the pattern pieces so the crease is in an inconspicuous place.

Knits such as some interlocks have a tendency to run. If the knit runs, place that edge at the garment hemline during pattern layout.

Stabilize the shoulder seams with stay tape to prevent stretching.

Use vertical buttonholes and interface knits to stabilize the areas where buttonholes and buttons will be placed.

The types of interfacing suitable for knits are fusible tricot and stretch nonwoven.

Elastic waistbands are appropriate for many knit pants and skirts. Cut the elastic for waistlines 4 to 6 in. (10 to 15 cm) smaller than the waist measurement according to the degree of snug fit desired. Check to see that the elastic fits comfortably over hips.

Sergers work well on knit fabrics. Seam allowances of $\frac{3}{8}$ in. (1 cm) are sufficient for many knit garments.

A good reference on working with knitted fabric is Chapter 9 in the book, *Unit Method of Clothing Construction*, Seventh Edition, by Phyllis Brackelsberg and Ruth Marshall for the Iowa Home Economics Association. Iowa State Press, Ames, Iowa, 1990.

The ability to copy or knock off clothing designs is a very useful technique for a pattern maker to learn. Good designers and pattern makers are familiar with clothing that is selling well for competing companies. Instead of designing a lookalike garment by drafting, flat-pattern, or draping, designers or pattern makers can purchase the best-selling clothing items made by their competitors and copy, or knock off, the design. This is legal because there are no copyrights on clothing designs. A manufacturer of less-expensive garments frequently copies the design lines or details of more-expensive ones. Companies that sell moderate- to lower-priced merchandise may not have a designer on staff, so they rely on knockoff pattern styles. Even companies that sell designer apparel copy styles from other companies.

Knockoffs are a way to duplicate the fit as well as the look of a garment. They can be made by home sewers who want to make a garment similar to one of their own garments that fits well. A custom sewing business can provide this service to a client who wants a new garment to fit exactly like one he or she already owns that is no longer available in retail stores.

It is usually easier to make knock-off patterns of woven garments than knit garments. Most knit fabrics stretch more and need to be handled carefully to obtain an accurate knockoff pattern. However, knit garments have fewer darts or none at all, which helps the garment lie flatter during this process. Since a knit garment will stretch when worn, it should be pressed to help it return to its original shape before the knockoff pattern is made. It is also necessary to press wrinkled garments made of woven fabric before starting the knockoff process.

The four main techniques for making knockoff patterns of ready-to-wear include the following:

1. Taking a garment apart at the seamlines to copy the shapes
2. Using muslin and a soft lead pencil to rub off the shape of each pattern piece
3. Using paper and tracing wheel to copy each garment piece
4. Using a tape measure to measure simple garment shapes and draft patterns to these dimensions

Sometimes more than one technique is used to knock off a pattern of a garment. If the garment is symmetric, only one half of the garment needs to be copied. For the garment parts that are asymmetric, the entire piece needs to be copied.

TAKING THE GARMENT APART AT THE SEAMLINES

A seam ripper is used to take the garment apart at the seamlines. The thread holding the seams, darts, tucks, and gath-

Figure 16.1 Take the garment completely apart at the seamlines. Also take out darts so the piece will lie completely flat like the bodice back on the right. Use the garment as the pattern or make a paper copy and mark the seams, darts, and hem on it.

ers is removed so all garment pieces lie flat as shown in Figure 16.1. The garment pieces are pressed with the grain to maintain their original shape. The width of the seams and hem is noted. Seam widths may need to be modified if different equipment or techniques are used to assemble the new garment. The actual garment pieces or a paper copy can then be used as the pattern to cut out the new garment.

This method is accurate but time-consuming. This method can be used when a favorite old garment that is nearly worn out is copied because the client likes the fit or design lines of the original garment, which is no longer available at retail stores. The original garment pieces will probably not be sewn together again if the garment shows wear. This method is not recommended if the garment is new or if it is to be returned to a retail store. It may not be possible for the home sewer or designer to put the garment together exactly the same way it was sewn in the clothing factory where specialized industrial sewing machines were used to sew the seams, hems, topstitching lines, and other details.

USING THE RUB-OFF TECHNIQUE

A rectangle of inexpensive muslin fabric can be cut on grain to approximately the same size as each garment piece to be copied. A nonwoven semitransparent fabric for tracing patterns can also be used. The muslin is placed on top of the garment to be copied. The grain must be carefully aligned and a soft lead pencil or tailor's chalk is used to rub

off the outline of the exact shape of each pattern piece and the placement of buttons, buttonholes, darts, topstitching lines, and so on. The muslin must lie tight against the garment that is being copied. Pins are used to hold the two fabrics together as shown in Figure 16.2. Once the muslin is removed, a French curve and a ruler are used to true the pattern edges. After cutting the muslin, recheck the pattern shape on the garment for accuracy and make any

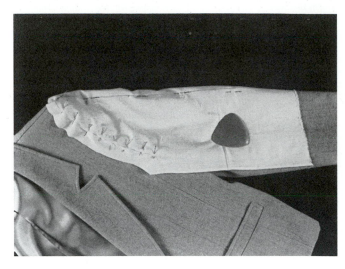

Figure 16.4 Muslin is pinned on top of the sleeve to duplicate the sleeve pattern. Use a longer piece of muslin for a long sleeve pattern.

Figure 16.2 Muslin and a soft pencil or chalk are used to rub off garment shapes, such as the midriff section of the dress shown.

Figure 16.3 You can produce exact copies only by exercising extreme accuracy and great care. After cutting the muslin shape without seam allowance, recheck it on the garment. If there is a difference in the muslin pattern and the garment, redo the muslin, because accurate patterns are necessary for good-fitting garments.

necessary changes. This is especially important on curved lines (Figure 16.3). Accurate patterns are essential for good-fitting garments. Seam allowances and hems are then added to the pattern pieces. Care should be taken to put all pencil marks on the muslin and not on the wearable garment.

With a little practice, one can be quite accurate with this knock-off technique. It works especially well on clothing that has darts, tucks, or gathers, because the muslin, which is aligned on grain, can follow the folds of the original garment to give a more accurate copy than with the paper and tracing-wheel method outlined in the next section. The muslin fabric can also be folded to go around corners on garments, as when the back crotch of a pair of pants extends around to the front, or for the front and back of a sleeve, as shown in Figure 16.4. A good reference on this technique is found in the book *101 Sewing Secrets*, A Singer Reference Library Book, published by Cy De Cosse, Inc., Minnetonka, Minnesota, 1989.

USING THE PAPER AND TRACING-WHEEL METHOD

In the paper and tracing-wheel method, the symmetric garment to be copied is folded in half and pinned securely as shown in Figure 16.5. The front half is laid flat on a large sheet of paper. The shapes of the different parts of the garment are marked on the paper with the help of a tracing-wheel with long points or a marking tool with a sharp needle. It is helpful to use a cork board as a work surface. You should place it under the paper and garment and pin the

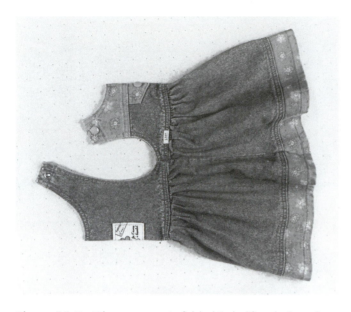

Figure 16.7 Chalk or hand basting is used to mark the grainline on the garment to be copied.

Figure 16.5 The garment is folded in half and pinned so it can be copied. The top of the jumper lies completely flat and is copied first. The gathered skirt pattern can be made by the measurement technique.

The lengthwise grain should be marked on the garment and on the paper. A line of hand basting or chalk is used to mark the grainline (Figure 16.7). The garment is pinned to the paper and laid completely flat before the tracing wheel or marking tool is used to mark the seamlines, buttonholes, and so on. Princess seamlines are a fairly common design line on suit jackets for women. Trace the seamline closest to the center front line first (Figure 16.8). Allow enough paper for seam allowances to be added

Figure 16.6 The yoke of this blouse lies completely flat before it is copied with a tracing-wheel or sharp needle tool.

garment to it. The needle-pointed tracing-wheel or pointed needle tool can be used to pierce the garment fabric and the underlayer of paper along the seamlines to make a perforated line that outlines each pattern piece (Figure 16.6). Use a pencil, ruler, and French curve to connect the perforation dots and true the edges of each pattern piece. Seam allowances and hem are added last. Repeat each process for the back half.

Figure 16.8 A sharp tracing wheel or marking tool is used to mark the princess seamlines of the jacket. Note that pushpins can be used to hold the garment in place on thick wool fabric, but dressmaker pins should be used on fabric with finer yarns.

Figure 16.9 The grainline in a plaid fabric shows up well.

Figure 16.11 Step 1. Copy the side seams and yokeline of the pants back. Add pins to the grainline in the middle of the garment.

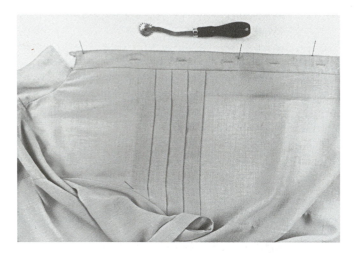

Figure 16.10 If tucks are part of the design, mark where they are placed and add them later with the slash method.

Figure 16.12 Step 2. Reposition the pants so the crotch area lies flat and copy the remainder of the pants back without moving the pins on the grainline.

before repositioning the garment to trace the side panel. Garments with plaids (Figure 16.9) and stripes are easy to work with because their grainlines show up well. It is helpful to use squared patternmaking paper marked off in inches and pin the garment grainline to the parallel lines on the paper. If a blouse has sewn-in tucks (Figure 16.10), just copy the shape of that garment piece. Mark lines with the tracing wheel to show where the tucks are placed and add them later by the slash method.

A two-step process is used on a pants back with a back crotch that folds around to the front of the garment. For step 1, pin the grainline in the center of the piece and then secure the side seam of the pants through the paper to the cork board (Figure 16.11). Mark the side seam and yoke line with a tracing wheel. Then release the pins except for those securing the grainline. Reposition the pants to lie flat in the crotch area and continue to pin and mark this part of the pants (Figure 16.12).

Since gathers, darts, or tucks do not permit a blouse front to lie flat, garments with these features must be completed in two steps also. For step 1, for a blouse with gathers above the bustline (Figure 16.13), pin the center front

Figure 16.13 Use the two-step method on a blouse with gathers. For step 1, lay as much of the blouse front completely flat before copying that part.

Figure 16.14 For step 2, release the pins at center front from the neckline to the bustline. Lay the rest of the blouse flat and copy it.

to the paper and mark this straight seamline. Then mark the yokeline, hemline, and lower part of the side seam. For step 2 (Figure 16.14), release only the pins along center front from the neckline to the bustline so the second part of the blouse can now lie flat. Repin and copy this part of the blouse. Note that a diagonal line will appear as the upper part of the blouse pulls away from center front in this area. The distance between the center front line and this diagonal line is the amount of fullness that was gathered into the yoke.

A good reference for copying garments with a two-step process is the book *Copy Creations* by Kari Newell. The book and a handy marking tool can be purchased from Kari Newell at this address: Copy Creations, P.O. Box 172, Whitewater, Wisconsin 53190.

USING A TAPE MEASURE

Garment pieces that have straight lines or are rectangular, such as waistbands, cuffs, and pockets, can be measured easily and drafted on paper. A ruler is used to true the pattern, and seam allowances and hems are added to the pattern edges.

Gathered skirts made of rectangular shapes are very easy to knock off with the measurement method because it is only necessary to measure the length of the skirt plus the hem and the width of the skirt at the hemline (as shown in Figure 16.15).

Gored skirts are easy to knock off because you need only measure the width of the top and bottom of each gore, the length including the hem, and the amount of curve in the waistline and hemline. Check to see if the grainline is in the center of each gore. These measurements are transferred to paper, and seam allowances are added to complete the pattern. The skirt can be placed on top of the pattern to recheck the curve of the hemline.

Unstitched pleated skirts are also easy to copy by noting the number of pleats, the top width of each pleat, the spacing between pleats, and the width under each pleat. A piece of paper approximately 2 in. (5.1 cm) wide can be folded to duplicate the pleat plan; length is added to finish the pattern (Figure 16.16).

Some designers and pattern makers shop the market with tape measure in hand to check the width and length

Figure 16.15 A tape measure is used to determine the length and width of a gathered skirt.

Figure 16.16 A 2-in.-wide paper pattern duplicates the pleats on a skirt. Fold the paper into each pleat to obtain the correct depth of each pleat. Also measure the length of the skirt.

Figure 16.17 Details such as pockets are easily copied by the measurement method.

of various styles, for example, a gathered, pleated, or flared skirt; a puff sleeve; a yoke; or pleats and tucks. Details such as the size of a pocket are easily copied by measuring (Figure 16.17).

It is important for a pattern maker to be able to do knockoff designs. This process is a typical first assignment as a new pattern maker with an apparel firm. It is also used by retail stores as they develop private label merchandise.

GARMENT SPECIFICATIONS

As the cost of apparel has escalated, retailers have sought ways to reduce their costs and increase their profits. Some large retailers create products to sell in their retail stores and then hire sewing contractors to make the garments. Retailers such as Target have a product development staff in charge of specification buying. Instead of hiring pattern makers they hire persons who can write garment specifications.

After specifications are written for each garment, the flat sketch and specification sheets with measurements are sent by computer or fax to the clothing manufacturer in the United States or abroad. A sample garment is made by the sewing contractor and returned to the retail company for approval of the size and fit before multiple garments are sewn in different colors and fabrics.

Writing garment specifications is a job opportunity for students who have had classes in design and pattern making. Students interviewing for jobs have even been asked to write specifications for a specific garment before being hired by an apparel company. Therefore, pattern making students need to be familiar with garment specifications and have experience in measuring garments accurately and writing the specifications for them. An experienced specification writer can even write specs from sketches and previous company data without having an actual garment to measure.

Garments made from specifications are usually fairly basic styles that can be measured accurately on a flat surface. The specification sheets for each garment include the flat sketch, the leadsheet, and the measurement sheet.

KNIT BLOUSE SPECIFICATIONS

The leadsheet describes the clothing item accurately and lists information such as the manufacturer, style number, type of garment, size range, description of garment details, fabric and source, care instructions, number and size of buttons, thread color, and any additional instructions. A sample leadsheet for a knit blouse is shown in Figure 16.18.

The measurement sheet lists all the important measurements on the garment. Different measurement sheets are used for shirts, blouses, pants, skirts, dresses, jackets, and coats. Figure 16.19 is a measurement sheet for a knit blouse.

The sketch includes lines with numbers to show each measurement on the garment. These numbers correspond to the numbers on the measurement sheet. A sketch for a knit blouse showing where measurements were taken is shown in Figure 16.20.

LEADSHEET FOR KNIT BLOUSE

First Revision Date: _____ Second Revision Date: _____

Line # _____ Line # _____

Manufacturer: _____ Division: _____ Style #: _____

Country: _____

Group Name: _____ Sub Group: _____ Date: _____

Season: _____

Type of Garment: _____ Content: _____

Size Range: _____ Logo: _____ Color: _____ Place: _____

Price List Description: _____

Description: _____ Sleeves, _____ Shoulder, _____ Placket, _____

Collar _____ , Pocket, _____ Sleeve bottom, _____ Bottom, _____

Vents, _____

Fabric: _____

Source: _____

Stripe: _____ Horizontal: _____ Vertical: _____

Type: _____

Yarn: _____ Care Instructions: _____

Label: _____

of Buttons: _____ Size: _____ Thread Color: _____

Samples: Size: _____ Color: _____

Additional Instructions: _____

Figure 16.18 Leadsheet for a knit blouse.

KNIT BLOUSE SIZE SPECIFICATION

Line _____ Season _____ Proto # _____ Style # _____

Fabric: Yarn _____ Stitch _____ Cut _____ Content _____

Garment Description _____ Pattern# _____

_____ Issue Date _____

Revision 1: _____ / _____ /_____ Revision 2: _____ / _____ /_____

Lines: _____ Lines: _____

FLAT GARMENT MEASUREMENT POINTS (In Inches)	SIZES					
						toler-ance
1. BODY LENGTH (from high shoulder to bottom hem)						$\pm\frac{1}{2}$
2. SHOULDER LENGTH (shoulder pt. to shoulder pt.)						$\pm\frac{3}{8}$
3. SHOULDER LENGTH (shoulder pt. to collar seam)						$\pm\frac{1}{4}$
4. CHEST AT MIDPOINT (striaght from center of armhole)						$\pm 1\frac{3}{8}$
5. BODY WIDTH (start from 1" below armhole)						$+\frac{1}{2}$ $-\frac{1}{4}$
6. BOTTOM WAIST (at waist seam or narrowest point)						$+\frac{1}{2}$ $-\frac{1}{4}$
7. BOTTOM OPENING (from top of vent or side seam)						$+\frac{1}{2}$ $-\frac{1}{4}$
8. SLEEVE LENGTH (OVERARM) (from shoulder pt. to sleeve hem)						$\pm\frac{1}{4}$
9. SLEEVE LENGTH (UNDERARM) (from underarm to sleeve hem)						$\pm\frac{1}{4}$
10. UPPER SLEEVE WIDTH (from 1" underarm parallel to hem)						$\pm\frac{1}{4}$
11. SLEEVE HEM (from inner edge to inner edge)						$\pm\frac{1}{4}$
12. NECK DROP (from C.F. seam down to collar band)						
13. NECK CIRCUMFERENCE (along neck seam)						$\pm\frac{1}{4}$

Figure 16.19 Measurement sheet for a knit blouse.

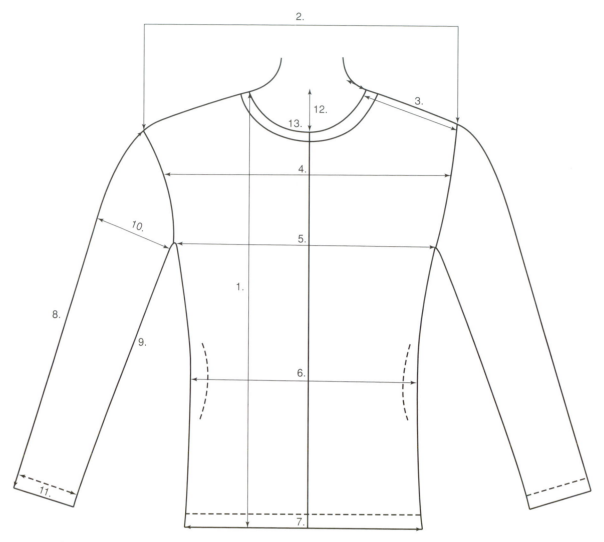

Figure 16.20 Sketch of a knit blouse.

WOVEN PANTS SPECIFICATIONS

Specification sheets for a pants made of a woven fabric are shown in Figures 16.21, 16.22, and 16.23. The leadsheet, the measurement sheet, and the sketch must be completed accurately. Students who are skilled in measuring garments and writing specifications have another apparel career opportunity available to them.

LEADSHEET FOR PANTS

First Revision Date: _____ Second Revision Date: _____

Line #: _____ Line #: _____

Manufacturer: _____ Division: _____ Style #: _____

Country: _____

Group Name: _____

Type of Garment: _____ Content: _____

Size Range: _____ Logo: _____ Color: _____

Price List Description: _____

Description: _____ Waistband: _____ Extension: _____

_____ Closure, _____ Flyfront _____

_____ Back Pockets, _____ Front Pockets _____

_____ Hem, _____ Trim _____

Fabric: _____

Source: _____

Care Instructions: _____

Label: _____ Special Label: _____

#/Size of Buttons: _____

_____ Waistband, _____ Extension,

_____ Pocket, _____ Flap,

_____ Tab, _____ Thread Color

Type: _____ Source: _____

Trim Class: _____

Samples: Size: _____ Color: _____

Swatch Yardage: _____

Additional Instructions: _____

Figure 16.21 Leadsheet for woven pants.

PANT SIZE SPECIFICATION

Line _____ Season _____ Proto # _____ Style # _____

Fabric: Yarn _____ Stitch _____ Cut _____ Content _____

Garment Description _____ Pattern # _____

_____ Issue Date _____

Revision 1: _____ / _____ / _____ Revision 2: _____ / _____ / _____

Lines: _____ Lines: _____

FLAT GARMENT MEASUREMENT POINTS (In Inches)	SIZES				
					tolerance
1. TOTAL LENGTH (top of waistband to bottom)					± 1/2
2. WAISTLINE (inside of fold to fold)					± 3/8
3. HIPS (7" below waistband)					± 1/4
4. THIGH (1" below crotch)					± 1/4
5. KNEE (22" below waistband)					+ 1/4 − 1/4
6. LEG OPENING (fold to fold)					+ 1/4 − 1/4
7. FRONT RISE (from below waistband)					± 1/4
8. BACK RISE (from below waistband)					± 1/4
9. OUTSEAM (from below waistband)					
10. INSEAM (from below crotch)					

Other instructions:

Figure 16.22 Measurement sheet for woven pants.

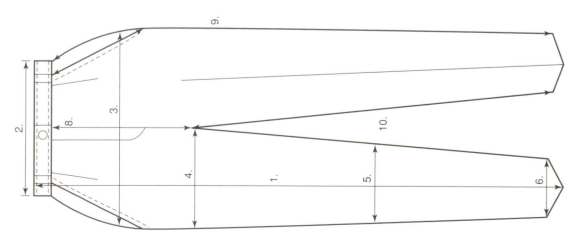

Figure 16.23 Sketch of woven pants.

Evening Wear

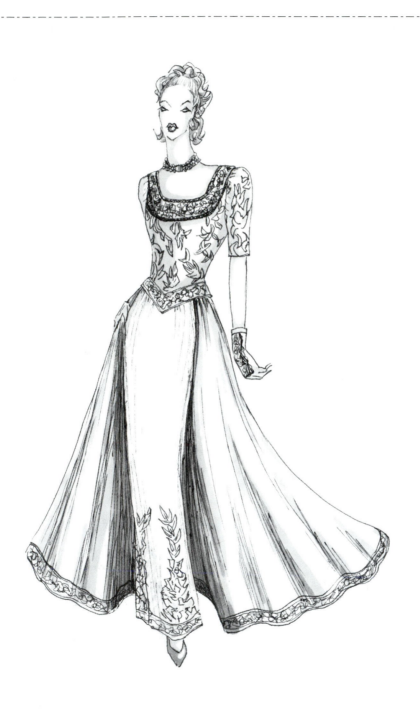

Evening wear includes clothing for special occasions such as high school proms, formal dances, and weddings. These garments usually include such features as longer skirts, lowered necklines, and interesting design details on the back as well as the front of the garment. Elegant fabrics such as satin, taffeta, brocade, lace, chiffon, georgette, crepe, crepe de chine, and velvet are often used. For wedding gowns, lace is often appliquéd over part of the gown.

Perfect fit is desired by customers purchasing evening and bridal gowns. Design students making an evening gown for themselves or another person should make a muslin trial garment of the bodice or the entire garment and fit it to the person it is designed for. Altering a muslin trial garment helps ensure good fit in the final garment and also prevents wasting expensive fashion fabric. In the clothing industry, garments are made in standard sizes and are fitted on a dress form or a live fit model. Garments are refit to the customer's figure in retail stores.

Patterns for several different evening gowns and parts of gowns will be described and shown in this chapter.

EVENING GOWN WITH TRUMPET FLARE SKIRT

This evening gown with trumpet flare skirt and lacing in back is shown in Figure 17.1. The fabric used for this gown should drape well.

1. Use the one piece dress basic pattern. (See Figure 17.2.)
2. Lower the neckline at center front. Remove unused area.
3. Draw a diagonal line from the neckline to 1 in. (2.5 cm.) above the bust dart on the side seam. Cut apart and remove the shoulder area of the bodice front.
4. Draw a princess line that goes from the diagonal line through the bust point and waist dart to the hemline.
5. Slash the side bust dart to the bust point and close this dart.
6. Cut and separate the center front from the side front. Remove most of the waist-fitting dart for a fitted effect. Add notches.
7. Add the appropriate length from the knees to the hemline. The trumpet flare is achieved by adding 5 to 8 in. (12.7 to 20.3 cm.) flare that starts at the hemline and tapers to the knee on the center front and side front seamlines that join together. The same amount of flare is added to front and back side seams as well as the center back and side back pieces that join together.
8. The back of the gown is designed with a curve from the underarm to the waistline. Begin the curve 1 in. (2.5 cm.) lower than the underarm side seam so it matches the front. Fold in the waistline dart and draw a deep curve from the underarm seam to the center

back waist seamline. Remove the upper section and discard it.
9. The lower part of the back waist dart becomes part of the seamline that is drawn to separate the center back and side back pattern pieces.
10. Add a 7- to 9-in. zipper at the center back seamline to ensure a snug fit.
11. Extend the skirt the same length in back as in front. The back skirt has flare from knee to hemline like the skirt front.
12. Make 3 loops for each side of the curved back seamline. Make facing patterns for the garment.
13. Make the neckband or cording long enough to finish the neckline front and to lace through the loops crisscrossing in the back of the gown. The cording can tie in a bow at center back.

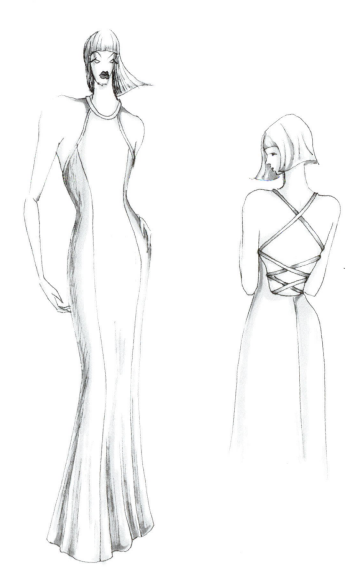

Figure 17.1 Evening gown with trumpet flare skirt.

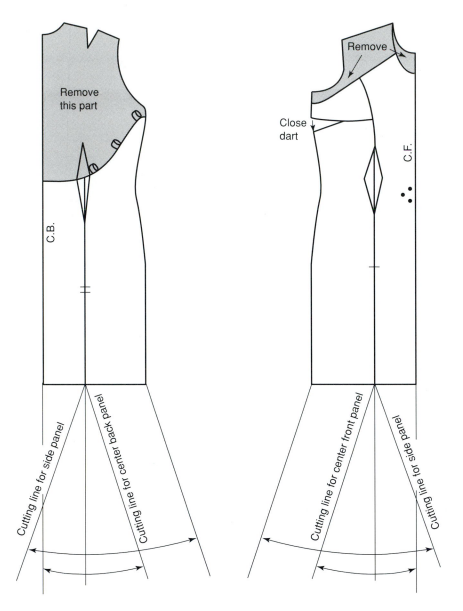

Figure 17.2 Pattern for evening gown with trumpet flare skirt and lacing in back.

14. Fit the garment before sewing on the facings. If the garment is too loose above the bustline, make a deeper seam in that area as well as the sideseams.

ASYMMETRIC TOP WITH ONE BARE SHOULDER

An asymmetric top with one bare shoulder is popular in blouses and evening dresses (Figure 17.3). Either the right or left shoulder can be left bare. Directions for a blouse are given. For evening wear, the blouse can be worn with a separate skirt or it can be attached to a long slim skirt with a slit at the center back or side seam. A dress can also have an uneven hemline matching the diagonal line of the neckline.

Directions ...

1. Start with the one-piece dress pattern. On asymmetric garments where both sides are different it is necessary to trace both the right and left front pattern as well as a right and left back pattern.
2. Design the lines from the shoulder to both underarm seams as shown in Figure 17.4.
3. Cut away the unwanted section and make armhole and neckline facings 1½ to 2 in. (3.8 to 5.1 cm) wide.
4. Decide on the length and draw the hemline.

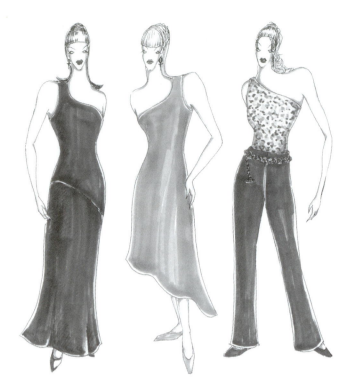

Figure 17.3 Asymmetric garments with one bare shoulder.

5. Complete the back pattern with similar design lines. Keep the shoulder seam the same width in front and back.
6. This top is designed for woven fabric. For good fit, keep the bust darts as part of the pattern. The waist darts can be omitted for added fullness. If a zipper is needed, use a separating zipper and place it in the sideseam.
7. For knit fabrics, start with a basic pattern designed for knits that eliminates both the bust and waist darts. If the knit has enough stretch, the zipper can also be eliminated.

..

STRAPLESS TOP

Strapless tops need built-in support such as interfacing and boning sewn into the seamlines in the bust area to give the garment shape. Spaghetti straps can be added for persons with a smaller bustline.

1. Start with the bodice front pattern. Slash the bust dart to the bust point, as shown in Figure 17.5. Close the bust dart and combine it with the waist dart.
2. Design the top line that curves upward over the bust area. The grainline on the side panel is perpendicular to the waistline seam.
3. Draw a princess seamline from the middle of the shoulder to the bust point. Remove the shaded area.
4. The strapless gown does not need as much ease as the basic bodice front had. Therefore remove ½ in. (1.3 cm) in the underarm area and ½ in. (1.3 cm) on each seamline above the bust area.
5. On the bodice back, make sure the front and back side seams are the same length.
6. Remove ½ in. (1.3 cm) in the underarm area and 1/4 in. (0.6 cm) on the other back seamlines for a better fit.
7. A zipper can be used at the center back opening.

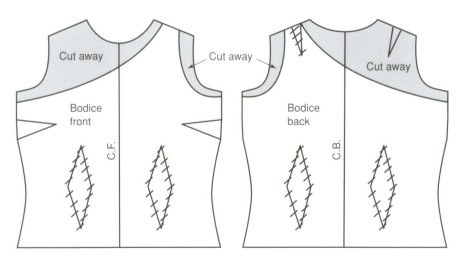

Figure 17.4 Blouse pattern for an asymmetric top with a bare shoulder.

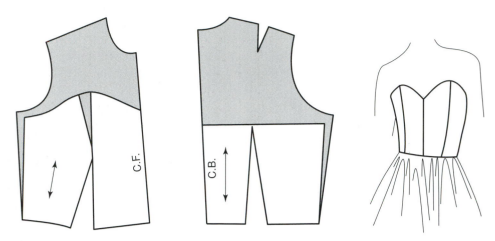

Figure 17.5 Pattern work for strapless top.

Figure 17.6 An overskirt attached to a tie waistband.

8. This top combines well with a short or long gathered or flared skirt. If a long slender skirt is used, add a center back slit to make it easier to walk in the garment.

9. Good fit is very important, so make a muslin of this bodice and fit it to the person or dress form before cutting the pattern in fashion fabric.

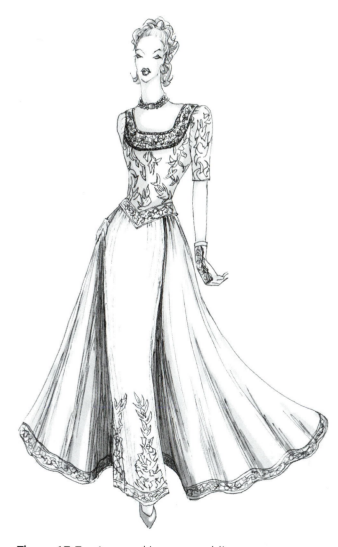

Figure 17.7 An overskirt on a wedding gown.

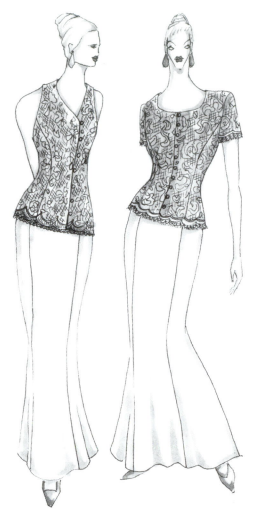

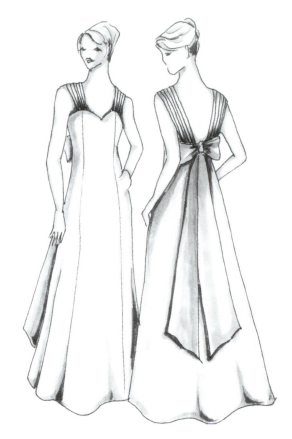

Figure 17.9 Gown with back interest.

Figure 17.8 A combination of two or more fabrics adds interesting texture to evening wear.

OVERSKIRTS

Bridal and evening gowns can be designed with a short or long slim skirt worn under a full overskirt that is permanently attached or detachable. Overskirts attached to a separate waistband usually have gathers all around from center front to center back as shown in Figure 17.6. Some overskirts start at the side seam and are gathered in the back only. Overskirts can be the same length as the gown they are worn over or they can have a longer train in the back. It is helpful to work with muslin and a dress form to decide on the length of the train and the curve of the train. Overskirts can be completely lined or be finished with a narrow hem. A wedding gown with an overskirt that has a long train in back can have a snap, hook, button, or Velcro system to make the overskirt detachable for dancing after the wedding ceremony. Figure 17.7 illustrates an overskirt on a wedding gown.

NECKLINES

A variety of necklines are used on wedding and evening gowns. Some of the popular front necklines include V-shaped, U-shaped, square, and sweetheart shaped. A U-shaped neckline is shown in Figure 17.7. If a lowered neckline looks too loose on the body, the front and back shoulder seamline can be deepened near the neck edge by ¼ to ½ in. (0.06–1.3 cm). Also refer to tightening the neckline to improve fit in the chapter on necklines.

WAISTLINES

Waistlines on gowns can be at the normal waistline or be higher or lower on the body. Upward V points or downward V points are also popular. The dress may be all in one with no waistline seam or it may have princess lines starting at the armhole or shoulder seamline and extending to the hemline. When waist darts are used in both the bodice and the skirt, they should be in line with each other.

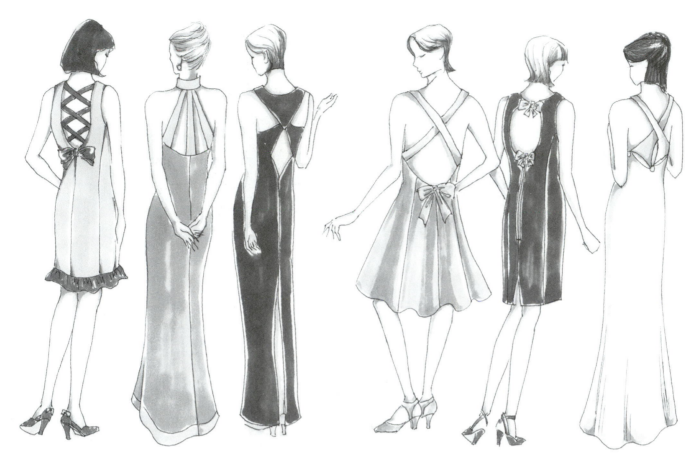

Figure 17.10 Evening gowns with cutaway areas and back interest.

COMBINATIONS OF FABRICS

Instead of using only one fabric in wedding gowns and evening wear, a combination of two or more fabrics can add interesting texture to the garments. Lace combines well with satin and crepe either in a one-piece garment or when a jacket or blouse is worn with a skirt as shown in Figure 17.8. Learn to experiment with combining interesting textures of fabrics together.

BACK INTEREST IN GOWNS

There are many ways to decorate the back of a gown to give a distinctive look to a wedding gown or prom dress.

A rectangle of bias-cut chiffon can be gathered or pleated. This panel of fabric can be attached to the bodice front and back of the gown as shown in Figure 17.9. A large bow of the same fabric is used to complete the gown.

CUTAWAY AREAS

Cutaway areas exposing the skin are popular features on the back of evening gowns and sundresses. Cutaway areas can be used on bodice fronts, backs, sides, and sleeve areas. The edges should be finished with a facing or lining. Straps covering part of the cutaway area can add a decorative touch. Several cutaway designs are shown in Figure 17.10.

FLARED RUFFLE FRONT DETAIL

A photograph of a flared ruffle detail on a blouse or dress can be duplicated by folding paper back and forth, each time tracing the shape shown in the photograph.

1. Begin with tracing paper and trace shape 1.
2. Fold the paper back on itself and trace shape 2.

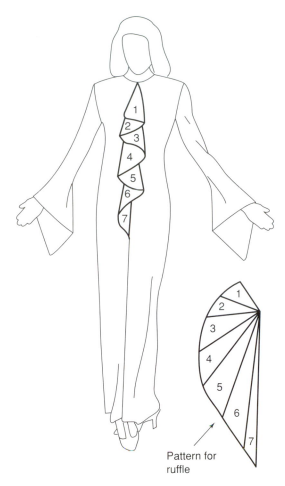

Pattern for ruffle

Figure 17.11 Evening gown with ruffle at center front.

Figure 17.12 Dresses with several layers of fabric.

3. Fold the paper and trace shape 3 and continue doing this until you have completed the entire folded ruffle.
4. The pattern in Figure 17.11 shows the shape of the ruffle.
5. Use fabric that drapes well for this design.

LAYERS OF FABRIC

Dresses can be designed with several layers of fabric sewn on top of each other to form a pleasing design. When the fashion fabric is lightweight, the layers can all be made of the same fashion fabric. When the fabric is thicker or fairly expensive, lining fabric can be used for that part of the multiple layers that does not show to the outside. Figure 17.12 shows two dresses made with multiple layers of fabric.

JACKETS WITH FANCY TRIMS

A simple jacket can be designed to be worn over an evening dress. Matching or contrasting fabric can be used for the jacket. Figure 17.13 shows a dress and jacket of the same fabric with the same trim. The long dress has a short bolero jacket made of a different fabric but trimmed with the same trim that was used on the gown.

THE LEG-OF-MUTTON SLEEVE

The leg-of-mutton sleeve is used on many formal gowns and wedding dresses. It looks like a gathered puffed sleeve

Figure 17.13 Jacket dresses with fancy trims.

Figure 17.14 Leg-of-mutton sleeve.

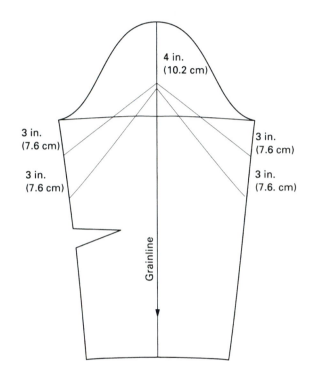

Figure 17.15 Draw slash lines on sleeve.

at the top of the sleeve but is fitted near the bottom as shown in Figure 17.14. To make the pattern, mark 4 in. (10.2 cm) down from the top of the sleeve. Mark diagonal slash lines 3 in. (7.6 cm) and 6 in. (15.2 cm) down from the capline as shown in Figure 17.15. Slash from the top of the sleeve diagonally to the sides of the sleeve. Spread from 4 to 8 in. (10.2 to 20.3 cm) crosswise and raise the cap 1½ to 3 in. (3.8 to 7.6 cm), depending on how full a sleeve is desired. (See Figure 17.16.) A moderate leg-of-mutton sleeve will have about a 4-in. (10.2-cm) spread crosswise and 1½ in. (3.8 cm) higher cap. A fuller leg-of-mutton sleeve will have about an 8-in. (20.3 cm) spread crosswise and a 3-in (7.6-cm) higher cap. Gathers on the sleeve capline are sewn from front notch to back notch.

Try the sleeve in muslin to see if the desired effect is achieved.

SLEEVE WITH A V POINT AT THE WRIST

Wedding gown sleeves often have an extended V point at the wrist. Buttons and loops are used to close the sleeve opening that results from transferring the elbow dart to the sleeve hemline. Directions for this sleeve are as follows:

1. Trace the basic sleeve.
2. Draw a line from the pointed end of the elbow dart to a point on the bottom of the sleeve 2 in. (5.1 cm) in

Raise cap 1 ½ to 3 in. (3.8 to 7.6 cm)

Spread 4 to 8 in.
(10.2 to 20.3 cm)

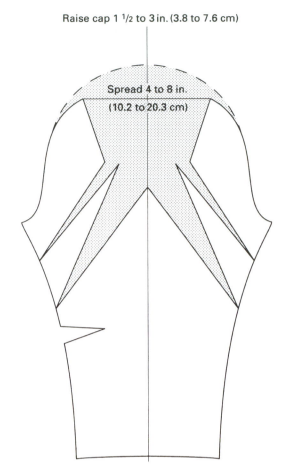

Figure 17.16 Add width and height to sleeve.

inal shoulder seam line and extend it approximately 4 in. (10.2 cm), as shown in Figure 17.18.

4. Take rectangle *ABCD* and slash the pattern lengthwise and add three times the fullness of line *AB* in the width.

5. Complete the pattern the same way in back. Join front shoulder seamline *AB* to back shoulder seam so there is a fold and no seam at line *AB*.

6. Gather line *AB* and line *CD* to form the shirring before sewing it to the bodice.

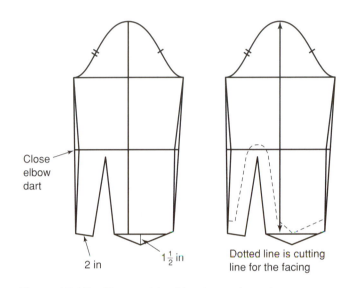

Close elbow dart

2 in

1½ in

Dotted line is cutting line for the facing

Figure 17.17 Sleeve with a V point at the wrist.

from the side seam (Figure 17.17). Cut this line to the dart point and close the elbow dart. Straighten the seamline.

3. Measure 1 in. (2.5 cm) over from the sleeve grainline and 1½ in. (3.8 cm) downward. This point marks the deepest part of the V point.

4. Mark the placement for the loops. The sleeve opening can be made shorter if fewer buttons and loops are desired.

5. Make a facing 1½ to 2 in. (3.8 to 5.1 cm) wide. See the dotted line on the sleeve.

SHIRRED CAP SLEEVES

1. The bodice for this pattern is very similar to the pattern for the strapless top so information will be given for the shirred cap sleeve only.

2. Plan the neckline of the garment.

3. Draw a straight line from the neck point over the orig-

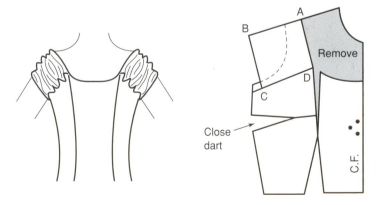

A

B

Remove

D

C

Close dart

C.F.

Figure 17.18 Shirred cap sleeve.

18 CHAPTER

Decorative Design

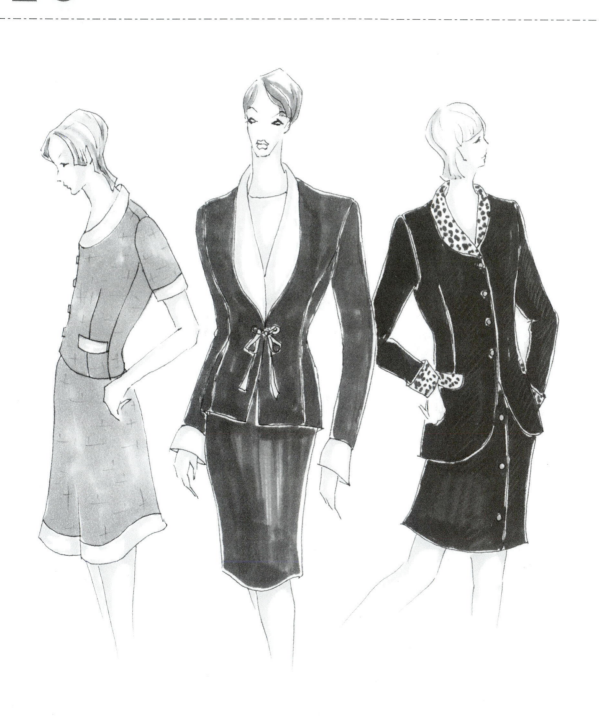

There are many ways to decorate and embellish items of clothing to make them more beautiful or more unique. When decorative design is fashionable, clothing designers need to constantly think of creative ways to use fabrics, trims, and design details.

Decorative design is more popular on some types of garments than on others. For example, work clothing will have less decoration than a bridal gown. Also clothing for women and children will have more decorative details than clothing for men.

Historically garments follow a fashion cycle that reflects when decorative design is more or less popular. Many ideas for decoration can be obtained from looking at historic costume books or actual historic clothing in museums or private collections.

Currently decorative design on clothing is very popular. Clothing designers need to be aware of the variety of decorative techniques that can be used to create beautiful and distinctive clothing that is in demand by consumers. A variety of different ways to decorate clothing are described and shown in this chapter.

APPLIQUÉS

Appliqués have been used as designs on quilts for hundred of years. More recently appliqué designs have been popular on clothing for children and women.

Appliqué designs used on children's clothing are usually recognizable objects such as fruits, flowers, hearts, animals, toys, and cartoon and movie characters. Appliquéd fabrics are usually sewn on the front of children's clothing or on garment details such as pockets, bibs, or large flat collars. Some appliqués used on children's clothing are shown in Figure 18.1. Appliqué designs used on women's clothing can be just an attractive design without resembling a specific object. An example is a curved piece of matching or contrasting fabric faced with organza and sewn to a dress and jacket as shown in Figure 18.2.

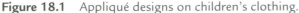

Figure 18.1 Appliqué designs on children's clothing.

Figure 18.2 Appliqué designs on women's clothing.

Figure 18.3 Pockets used as decorative design on women's clothing.

POCKETS

Patch pockets can be functional as well as decorative. However, carrying too many items in a pocket can detract from the neat appearance of a garment. Pockets can be designed with a V point or with round or square corners. Some pockets have flaps at the top of the pocket. A button can be used to hold the pocket closed.

When pockets are used on a blazer, the upper pocket is always smaller in size than the lower pockets. Sometimes only the pocket flap shows because the pocket bag is sewn to the inside of the garment.

The upper hem of a patch pocket should be about 1 in. (2.5 cm) wide. Pockets will be more durable when they are sewn onto the garment with reinforced stitches at the upper edges. Several pocket designs are shown in Figure 18.3.

Figure 18.4 Bows on a child's dress are decorative and functional.

Figure 18.5 Bows add a decorative touch to these garments.

BOWS

Bows can be functional when they are used to tie garment parts together. A child's dress with a tie belt ending in a bow in the back is an example as shown in Figure 18.4. The belt can be tied as loose or tight as necessary. It takes a little practice to tie bows neatly each time the garment is worn.

Many times bows are decorative rather than functional and they remain tied on a garment. Depending on the desired effect, bows can be made of the same fabric as the garment or they can be made of a fabric that has a different texture or color. Ribbon of various widths can also be used for bows. Figure 18.5 shows several places where bows can be used on different garments.

3-D FLOWERS

Three-dimensional (3-D) flowers can add a decorative touch to the back waistline of a wedding dress, bridesmaid dress, flower girl's dress, or prom dress. Separate flower petals can be cut and sewn together or a continuous length of fabric or ribbon can be gathered on one of the long edges and then rolled in a circle to resemble a rose. Another use

Figure 18.6 Decorative 3-D flowers used on sleeves and the back of dresses worn for special occasions.

Figure 18.7 Dresses with vertical and horizontal tucks.

of decorative 3-D flowers is on the front and back of a vest or other garment. Two garments with 3-D flowers are shown in Figure 18.6.

TUCKS

Tucks are stitched folds of fabric of various widths. The folded edge can be worn toward the inside or outside of a garment. Tucks can all be the same length or they can be different lengths on each side of the center front or center back of a garment. Tucks can be sewn the entire length of a garment or they can be released for added fullness in a skirt. Tucks folded to the outside of a garment are usually pressed toward the sideseam rather than toward the center front. Three dresses with tucks are shown in Figure 18.7.

Tucks can also be folded and stitched in two directions to form a diamond-shaped pattern; a jacket and shirt with these tucks is shown in Figure 18.8.

Figure 18.8 Tucks stitched in two directions to form a diamond-shaped pattern.

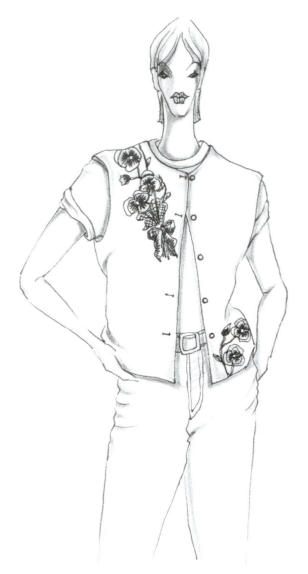

Figure 18.9 Vest with embroidered flowers.

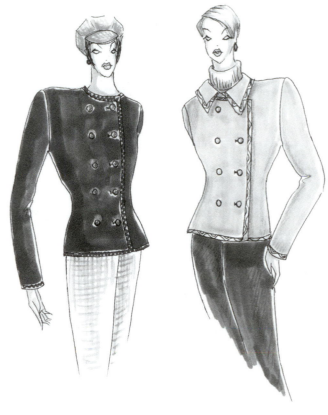

Figure 18.10 Braid trim on two jackets.

EMBROIDERY

Embroidered designs are made of colored thread and can be sewn directly on a finished garment or sewn on a garment part that is constructed into a garment later. Embroidery can be done by hand, by a home sewing machine, by a single- or multiple-head embroidery machine, or by a Schiffli embroidery machine. Embroidered designs usually accent just one area of a garment unless an all-over embroidered fabric is used. A vest with embroidered flowers is shown in Figure 18.9.

BRAID TRIM

Prefolded braid trim can be purchased to sew onto garment edges. The braid is pliable and can go around corners or curved edges well. The corners on a pointed collar and on a jacket hemline should be mitered. The side of the braid that is slightly wider should be placed on the inside of the garment so that when the outside is top-stitched near the edge it will catch the underneath edge as well. This gives a neat appearance to both the outside and inside of the garment. Braid trim on a garment is shown in Figure 18.10.

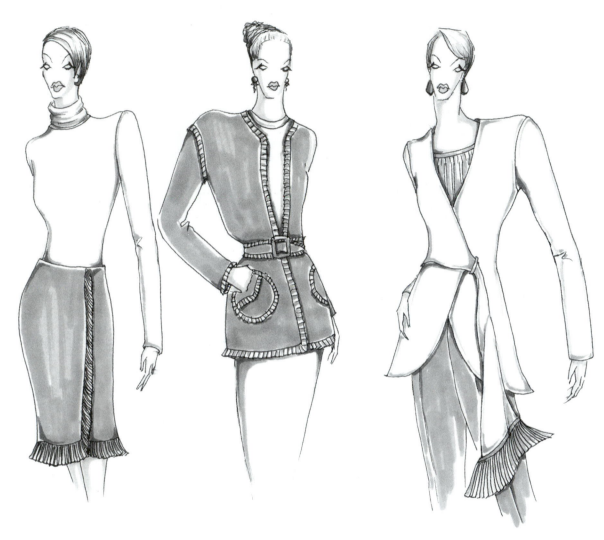

Figure 18.11 Fringe can add a decorative touch to skirts and jackets.

FRINGE TRIM

Loosely woven fabrics can be raveled out in the length-wise and crosswise directions to form fringe of the desired width. Sew a zigzag or straight stitch where you want the fringe to stop. This will help prevent further raveling while wearing or cleaning the garment. A wrap skirt with self-fabric fringe can have the fringe on the side as well as in the hem.

Fringe can also be made on narrow strips of fabric leaving an unfringed edge ½ in. (1.3 cm) wide to make it easier to sew the fringe into the garment seamline. This type of fringe can be sewn into curved, diagonal, or straight seamlines on the garment. Commercial fringe of different widths can also be purchased and sewn to garment edges. Three garments with fabric fringe are shown in Figure 18.11.

COLOR BLOCKING

Color blocking can be done on almost any garment to add interesting accents. Print or plain fabrics that contrast with each other or that blend well together should be chosen.

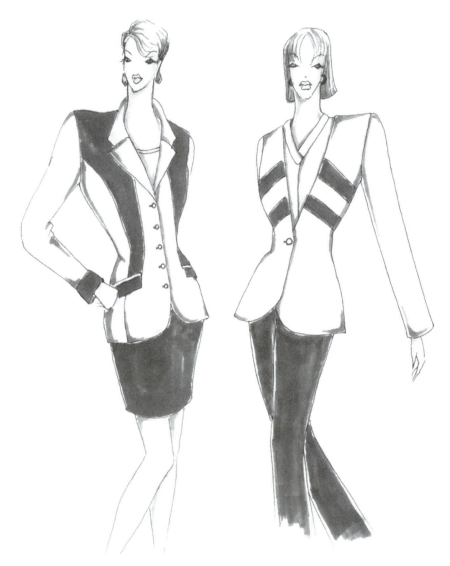

Figure 18.12 Jackets with color blocking.

Decide where you want the different colors on the garment. Cut the pattern pieces apart and add seam allowances. Two jackets with color blocking are shown in Figure 18.12.

Two or three different solid colors of fabric can be combined together or prints can be combined with solid colors or prints can be combined with other prints.

Figure 18.13 shows a jackets and vest where color blocking has been used successfully.

PIPING

Piping can be purchased or it can be made with bias strips of fabric covering the cord and then sewn with a zipper foot close to the cording. Piping can be used in various seamlines such as yokes, waistlines, and necklines of garments to help define the design lines. Matching or contrasting colors of piping can be used. Several examples are shown in Figure 18.14.

Figure 18.13 Color blocking combining prints and solid colored fabrics.

Figure 18.14 Piping can be used to trim the edges of garments.

Figure 18.15 Quilt designs can be used to decorate shirts, jumpers, vests, and jackets.

QUILT DESIGNS

Small squares or other geometric shapes of fabric can be sewn together to resemble a quilt design. A 3-D effect can be achieved if batting is used under the design. After the fabric is pieced together the garment shape can be cut out. Figure 18.15 shows a quilt design in several garments.

FROGS

Purchased frogs or frogs made with braid trim can be used in place of buttons and buttonholes as a decorative closure to vests, jackets, and coats. Figure 18.16 shows some garments with frogs used in place of regular buttons and buttonholes.

Figure 18.16 Decorative frogs can be used in place of buttons and buttonholes.

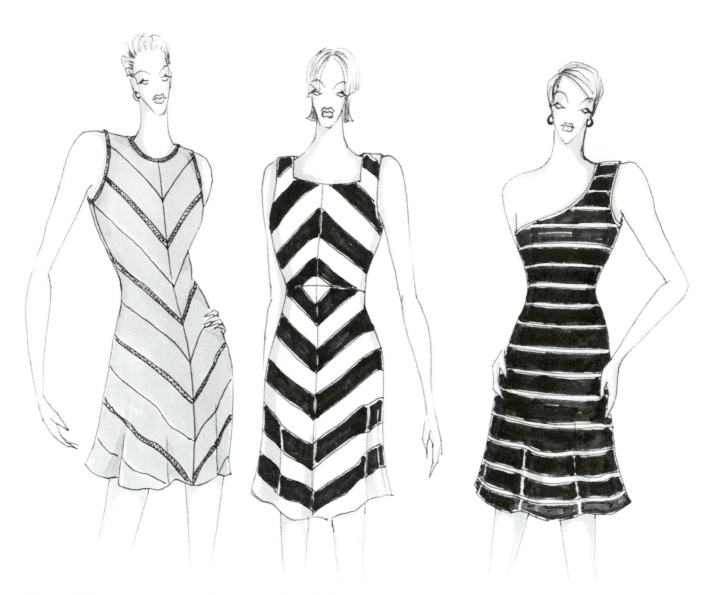

Figure 18.17 Stripes cut on straight grain and on the bias.

STRIPES

Interesting design effects can be achieved when stripes are cut on the bias as well as on the straight grain of the fabric. When diagonal stripes are used in a dress, try to match the chevron stripes at the side seams as well as at the center front and center back. A 45 degree angle seamline makes this possible. Figure 18.17 shows several garments using stripe fabric cut on straight grain and on the bias.

PLAIDS

Plaids can also be cut on the bias or straight grain and bias plaids can be combined with straight grain plaids in the same garment as shown in Figure 18.18. Plaids look best when the different colored yarns in the plaid match at the side seams as well as at center front and at center back. The plaids in the front bodice should also match the plaid lines in the front sleeve. A typical layout plan

Figure 18.18 Plaids cut on the straight grain and on the bias can be combined in the same garment for an interesting design detail. These garments take more fabric but are easier to sew because matching the plaid is unnecessary.

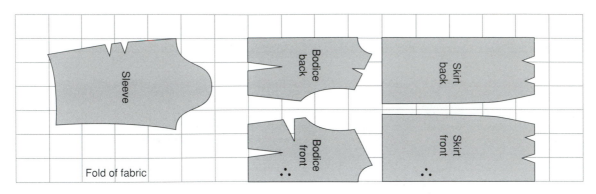

Figure 18.19 A pattern layout showing matching seams in a skirt, bodice, and sleeve.

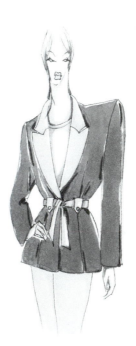

Figure 18.20 Tabs are both functional and decorative.

a lap of fabric or the zipper can be exposed and be part of the design of the garment. Figure 18.21 shows a lapped zipper in one jacket and exposed zippers in another jacket.

BUTTONS AND BUTTONHOLES

Buttons and buttonholes are used to hold garment areas together. The typical placement of buttons and buttonholes is at the center front or center back opening of blouses, dresses, jackets, and coats, as well as on waistbands of pants and skirts.

Buttons and buttonholes can be completely hidden under a tuck or layer of fabric such as down the front of a blouse or jacket. Buttons can be inconspicuous when they are the same color or covered with the same fabric as the garment. Buttons can be very conspicuous and be part of the decoration of the garment as shown in Figure 18.22. There

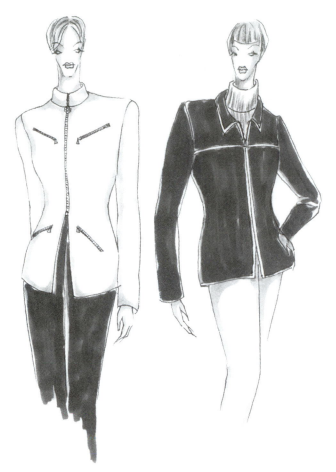

Figure 18.21 Exposed and covered zippers add a decorative touch to these jackets.

for a plaid garment is shown in Figure 18.19. In a shirt, the yoke and front band and cuffs can be cut on the bias for an interesting effect. Balanced plaid fabric is easier to match than unbalanced plaid fabric.

TABS

Tabs can serve as a decorative touch as well as a functional detail on pants and jackets to hold a belt in place. Tabs can be sewn to the garment on both sides or they can button on one side. Two smaller tabs can be used in place of one larger tab. Figure 18.20 shows garments using tabs as a functional and decorative trim.

ZIPPERS

Zippers are a quick and easy way for children and adults to get in and out of clothing. Zippers can be covered with

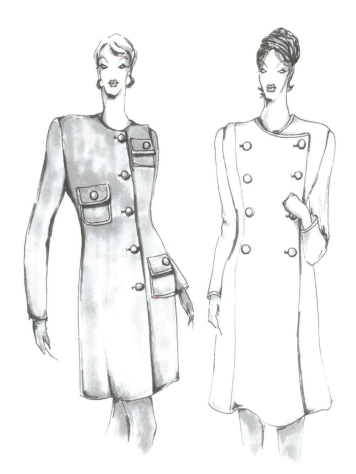

Figure 18.22 Buttons are part of the decoration on these garments.

Figure 18.23 Curved and scalloped edges are used on the front of these two garments.

are hundreds of different decorative buttons to choose from. Buttons made of plastic are usually less expensive than buttons made of gold- or silver-colored metal or buttons with imitation jewels. Special decorative buttons can be ruined during home laundry or dry cleaning and should be removed and resewn each time the garment is cleaned.

Buttons are usually placed an even distance apart. However groups of 2 or 3 buttons placed close together can serve as one button unit with the next button unit or group placed farther apart.

When planning the placement of buttonholes on a dress with a belt, the belt with a snap or hook underneath it takes the place of a button at the center front waistline. The distance from the lowest button to the hemline is vari-

able. On a long straight skirt, buttons can be left unbuttoned to allow more freedom of movement.

On home sewing machines buttonholes can be placed in a vertical or horizontal position on a garment. If a shirt or blouse has a narrow band down the center front, the buttonholes are placed vertically in the middle of the band on the center front line. Industrial buttonhole machines for medium-weight fabric are designed to sew vertical buttonholes on shirts, blouses, and dresses. Industrial buttonhole machines for heavyweight fabric are designed to sew horizontal buttonholes on coats, jackets, and suits.

For an interesting variation a curved or scalloped edge can be used down the front of a dress or jacket as shown in Figure 18.23.

Figure 18.25 Buttons are used for decoration on this vest.

Figure 18.24 Buttonholes can be placed in seamlines.

Buttonholes can be placed in seamlines as shown in Figure 18.24. This type of buttonhole is much easier to sew than bound buttonholes or thread buttonholes made with zigzag stitches sewn close together.

Loops can be used in place of buttonholes. An extension is not needed when loops are used.

Buttons can be used for decoration only as shown on the vest in Figure 18.25.

Figure 18.26 Jewel-like buttons are used on this jacket.

Jewel-like buttons are used to decorate the jacket in Figure 18.26.

BELTS

Figure 18.27 shows a variety of different belts that can be used to decorate a basic dress and change it from an ordinary outfit into a special outfit. Belts can be made out of leather, Ultrasuede®, or colored cords braided together. A variety of different buckles or fasteners can be purchased to give an interesting design effect to the belt.

CONTRASTING COLORED CUFFS, COLLARS, AND POCKETS

Figure 18.28 shows three garments with contrasting colored fabric used on collars, cuffs, pocket flaps, and skirt bands. A dark suit with white collar makes a striking garment that draws attention to the face of the person wearing the garment and away from the waistline or hipline. Prints can also be used in place of solid-colored fabric on collars and cuffs.

ASYMMETRIC DESIGNS

Two asymmetric garments are shown in Figure 18.29. Use both the right and left front of the garment to make the design that is different on each side. Creativity is necessary when making asymmetric designs. Color blocking can be used on the different parts. When an asymmetric design is completed, ask yourself if the design still has a balanced effect to the whole garment.

SHIRRING

Shirring on a blouse and a skirt is shown in Figure 18.30. The pattern can be slashed and two, three, or four times as much fullness as the original pattern is added. If the garment fits the body snugly, a lining may not be necessary. The downward drape between the shirred edges could add to the effect desired by the designer. Cording can be used to help hold the shirred area in place.

APPROPRIATE FABRICS FOR PATTERNS

A comprehensive textiles class provides design students with information on fibers, yarns, fabrics, and finishes. This background in textiles is a wonderful help to pattern makers as they select fabrics for clothing because a design can be ruined when made with inappropriate fabric. Choosing appropriate fabrics for clothing design is a skill that comes

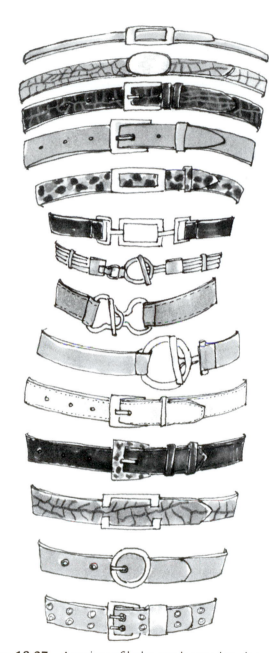

Figure 18.27 A variety of belts can be used to decorate a basic dress.

Figure 18.28 Garments with contrasting colored collars, cuffs, and pockets.

Figure 18.29 Asymmetric designs add a dramatic touch to the garment.

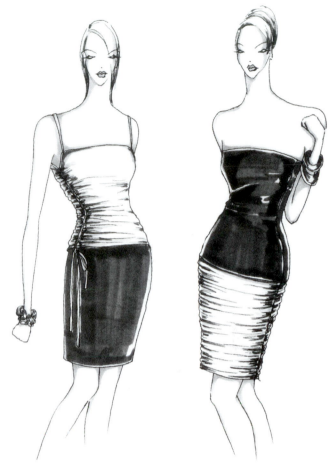

Figure 18.30 Shirring can be done on bodices or skirts.

with practice over time. However, there are some general things to remember when selecting fabric for patterns that can help prevent costly mistakes or disastrous results in the final garment.

Fabric Weight

In the apparel industry fabrics are usually described by weight. Top-weight fabrics are medium weight and are appropriate for blouses, shirts and dresses. A few examples of fabrics include gingham, broadcloth, oxford cloth, and percale prints and solids. Bottom-weight fabrics are heavier and are appropriate for pants, skirts, and lightweight jackets. Poplin, denim, gabardine, and corduroy are examples of bottom-weight fabrics. Thick heavyweight fabrics

are appropriate for coats and suits and thin, sheer fabrics are appropriate for scarves and some evening wear.

Occasion

Fabrics should be appropriate for the occasion. Apparel companies usually specialize in one type of clothing such as sportswear, tailored career wear, evening wear, children's clothing, women's dresses, men's shirts, or men's pants.

Sportswear needs to be comfortable, durable, and washable. Knit and woven fabrics made of 100 percent cotton and cotton-polyester blends are comfortable, durable, and easy care. Typical knit fabrics for sportswear include single-knit jersey, interlock knits, double knits, sweatshirt fleece, and sweater knits. Typical woven fabrics include broadcloth poplin, denim, flannel, herringbone, twill, and oxford cloth. All these fabrics are easy to sew, resulting in good-looking sportswear that is durable and easy to care for.

Men's shirts are often made of top-weight fabrics including broadcloth, oxford cloth, gingham, chambray, and flannel. A high count or high number of yarns per square inch is preferred to low-count fabric. Shirt fabrics are usually made of spun yarns of 100 percent cotton or cotton and polyester blends. These fabrics are easy to sew and usually have a durable press finish to make them easy to care for. Skirting fabric with stripes and plaids require special attention when cutting and sewing to give the shirts a professional matched plaid or stripe appearance.

Typical fabrics for evening wear include beautiful but less durable fashion fabrics such as satin, moiré taffeta, brocade, lace, georgette, chiffon, crepe, velvet, and velveteen. These fabrics should have a high yarn count. To test for yarn slippage, hold the edge of the fabric between your fingers and thumbs or both hands and bend the fabric back and forth. Examine the fabric to see if the yarns moved and became distorted. Avoid fabric that does not pass this "thumb test."

Another simple test is to shake hands with the fabric. Crush the fabric edge and check the amount of wrinkling that results.

Evening wear fabrics are often made of filament yarns which have greater shine and beauty. Durability and easy care qualities are less important than aesthetic because these garments are worn for special occasions and are worn less often. Filament yarn fabrics are harder to sew because the fabric is slippery and ravels more than spun yarn fabrics. Seams that pucker may be another problem.

Tailored career wear includes jackets, skirts, and pants for women and suits, sports jackets, and pants for men. Spun yarn fabrics made of wool, polyester and cotton and blends of these fibers are widely used. These spun yarn fabrics are easy to sew. Sleeves can be eased in with excellent results on 100 percent wool fabric. Worsted wool holds a better press and has a harder finish than woolen fabric for men's suits.

Care—Washable or Dry-Clean

Most consumers want easy-care clothing that they can care for with their own laundry equipment. They want clothes that maintain their good looks with no ironing or minimum pressing. Consumers expect the following types of clothing to be washable: undergarments, children's clothing, work clothing, sportswear, men's shirts, and women's blouses and some dresses. Trims used on these clothing items also need to be washable and not fade or deteriorate in the cleaning process. Figure 18.31 shows a girl's dress made of washable fabric and trim. Although many polyester and cotton blend jackets, skirts, and pants are washable, they may look better when professionally dry-cleaned and pressed.

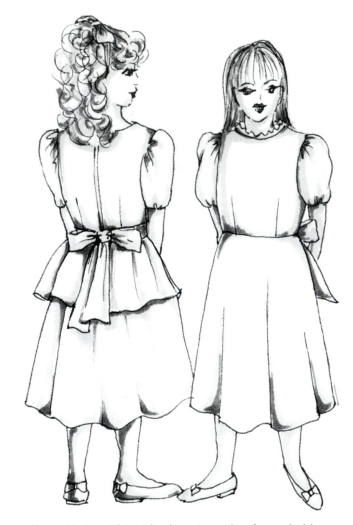

Figure 18.31 This girl's dress is made of a washable fabric and washable trim.

Some dresses, most evening gowns, and most career apparel of suits and coats should be dry-cleaned. Consumers will usually pay to dry-clean more expensive garments made of wool, silk, rayon, and acetate because these fibers do not launder well. Silk, polyester, rayon, and acetate wedding gowns, evening dresses, and other special-occasion clothing made of lace, satin, taffeta, brocade, and velvet should always be dry-cleaned for best results. Wool and wool blend coats and suits for men and women should be dry-cleaned. Although polyester fiber used in career apparel is washable, the trim, lining, and shoulder pads may not be washable and a dry-clean label is justified.

Slopers

A

½-Scale	MISSES' SLOPERS (Size 14)
	Bodice Front and Back
	Skirt Front and Back
	Sleeve
	Pants Front and Back
¼-Scale	MISSES' SLOPERS (Size 14)
	Bodice Front and Back
	Skirt Front and Back
	Sleeve
	Kimono Sleeve
	Sheath Dress (Front only)
	Pants Front and Back
½-Scale	MENS' SLOPERS
	Pants Front and Back (Size 32)
	Shirt Front and Back (Size 38)
	Sleeve
Full-Scale	GIRLS' SLOPERS
	Bodice Front and Back (Size 3)
	Sleeve
	FRENCH CURVE
Full-Scale	Full-Scale French Curve
½-Scale	½-Scale French Curve
¼-Scale	¼-Scale French Curve

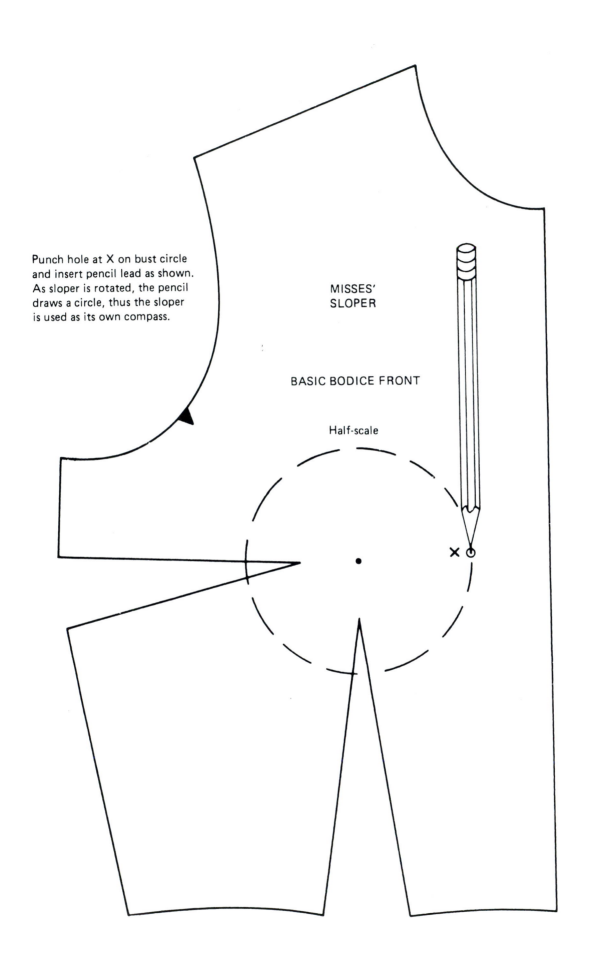

Punch hole at X on bust circle
and insert pencil lead as shown.
As sloper is rotated, the pencil
draws a circle, thus the sloper
is used as its own compass.

MISSES'
SLOPER

BASIC BODICE FRONT

Half-scale

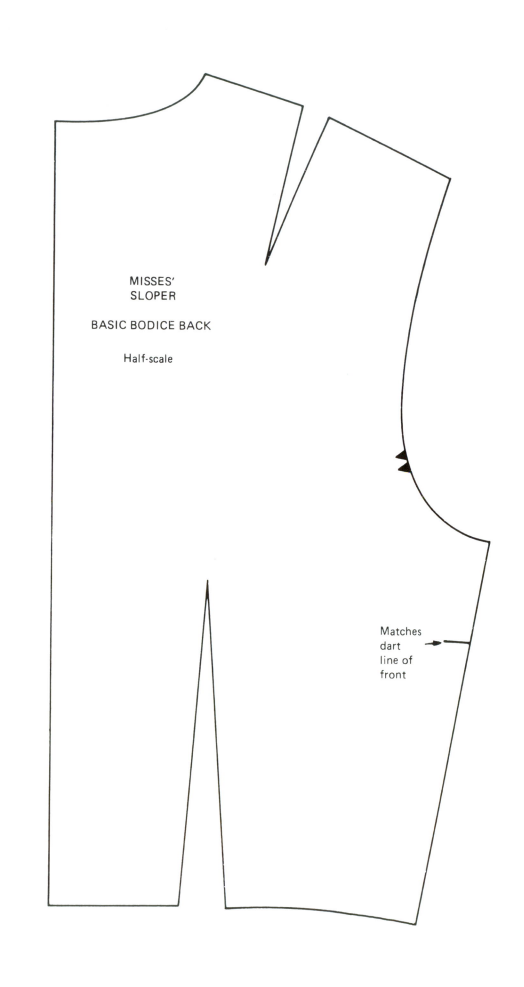

MISSES'
SLOPER

BASIC BODICE BACK

Half-scale

Matches
dart
line of
front

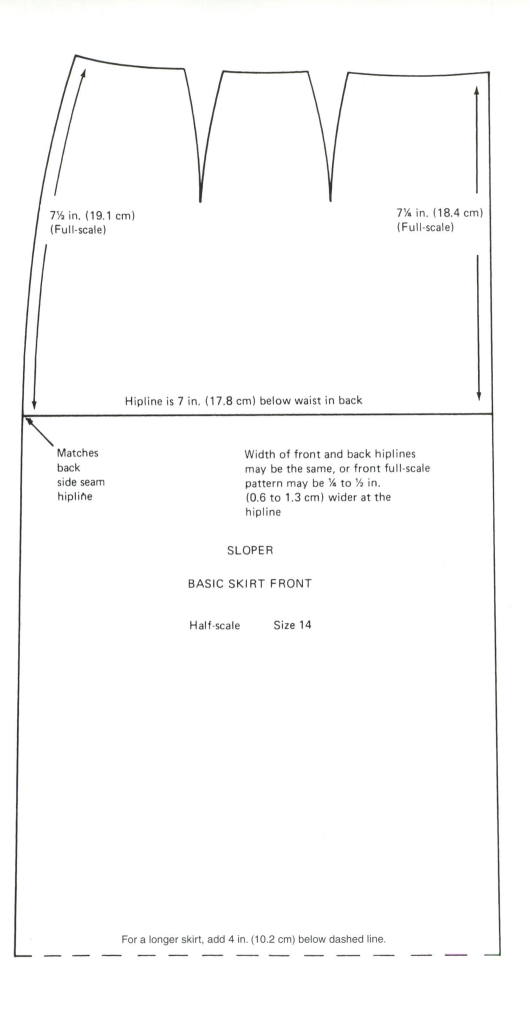

7½ in. (19.1 cm)
(Full-scale)

7¼ in. (18.4 cm)
(Full-scale)

Hipline is 7 in. (17.8 cm) below waist in back

Matches
back
side seam
hipline

Width of front and back hiplines
may be the same, or front full-scale
pattern may be ¼ to ½ in.
(0.6 to 1.3 cm) wider at the
hipline

SLOPER

BASIC SKIRT FRONT

Half-scale Size 14

For a longer skirt, add 4 in. (10.2 cm) below dashed line.

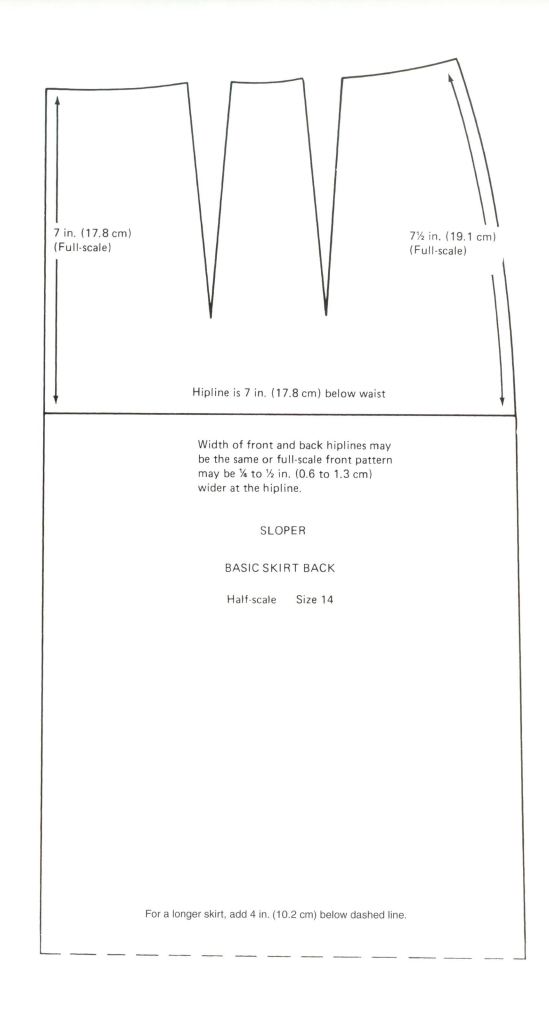

7 in. (17.8 cm)
(Full-scale)

7½ in. (19.1 cm)
(Full-scale)

Hipline is 7 in. (17.8 cm) below waist

Width of front and back hiplines may
be the same or full-scale front pattern
may be ¼ to ½ in. (0.6 to 1.3 cm)
wider at the hipline.

SLOPER

BASIC SKIRT BACK

Half-scale Size 14

For a longer skirt, add 4 in. (10.2 cm) below dashed line.

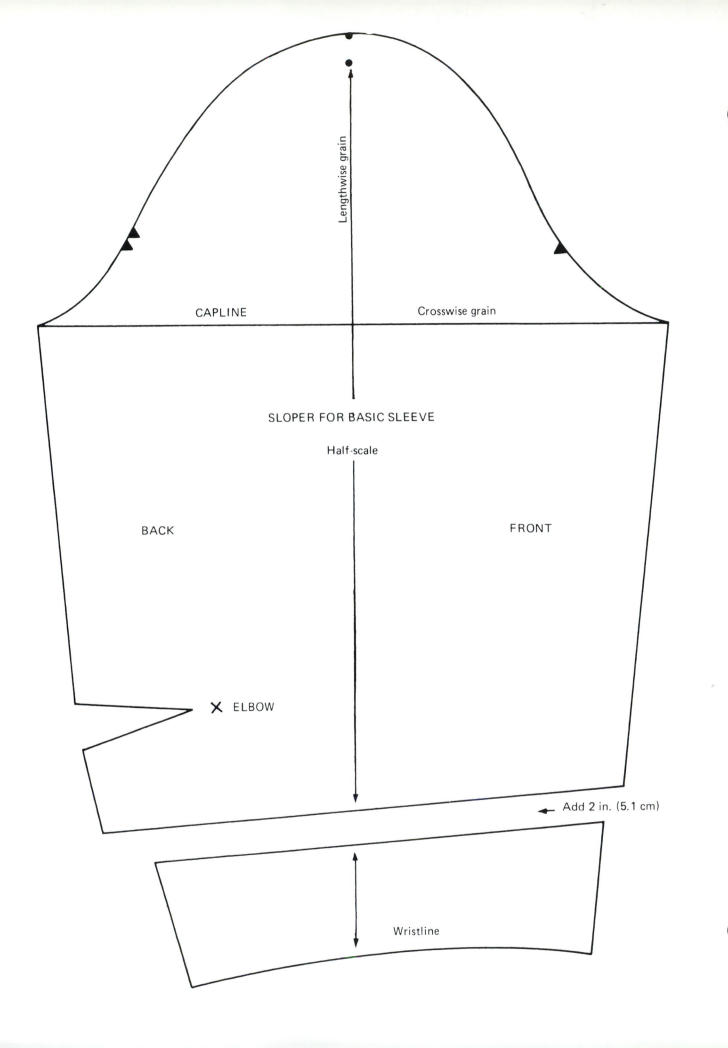

Lengthwise grain

CAPLINE Crosswise grain

SLOPER FOR BASIC SLEEVE

Half-scale

BACK FRONT

✗ ELBOW

← Add 2 in. (5.1 cm)

Wristline

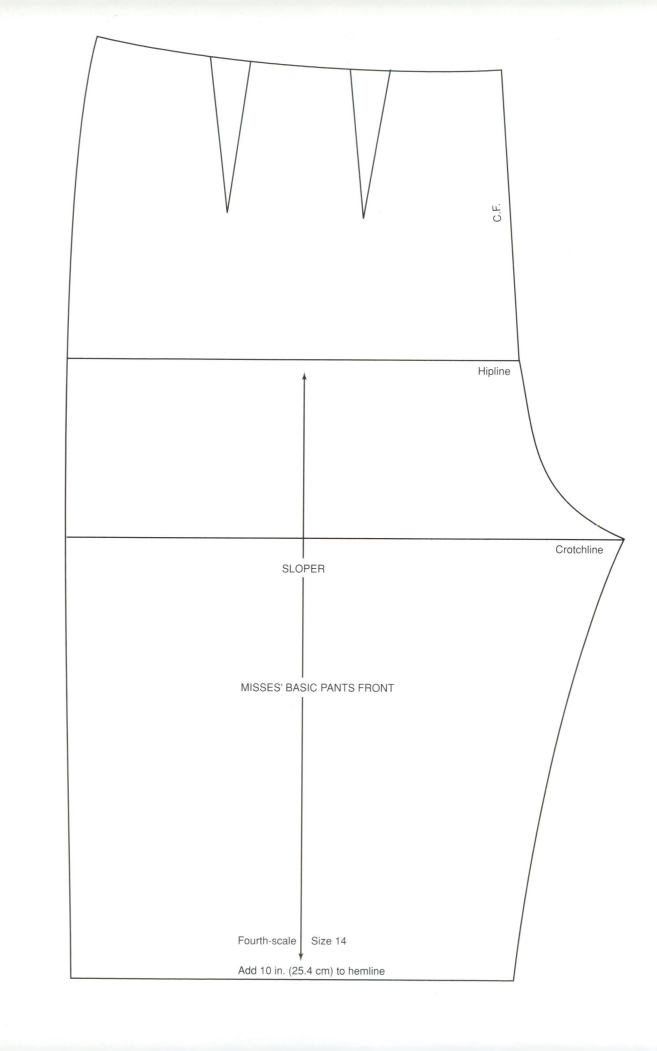

C.F.

Hipline

Crotchline

SLOPER

MISSES' BASIC PANTS FRONT

Fourth-scale Size 14

Add 10 in. (25.4 cm) to hemline

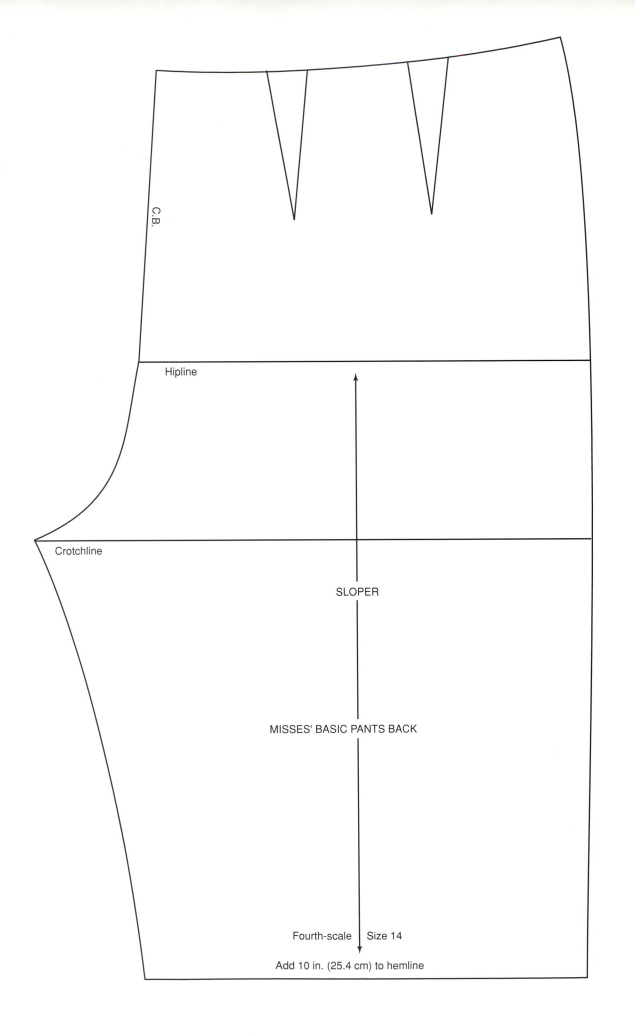

C.B.

Hipline

Crotchline

SLOPER

MISSES' BASIC PANTS BACK

Fourth-scale Size 14

Add 10 in. (25.4 cm) to hemline

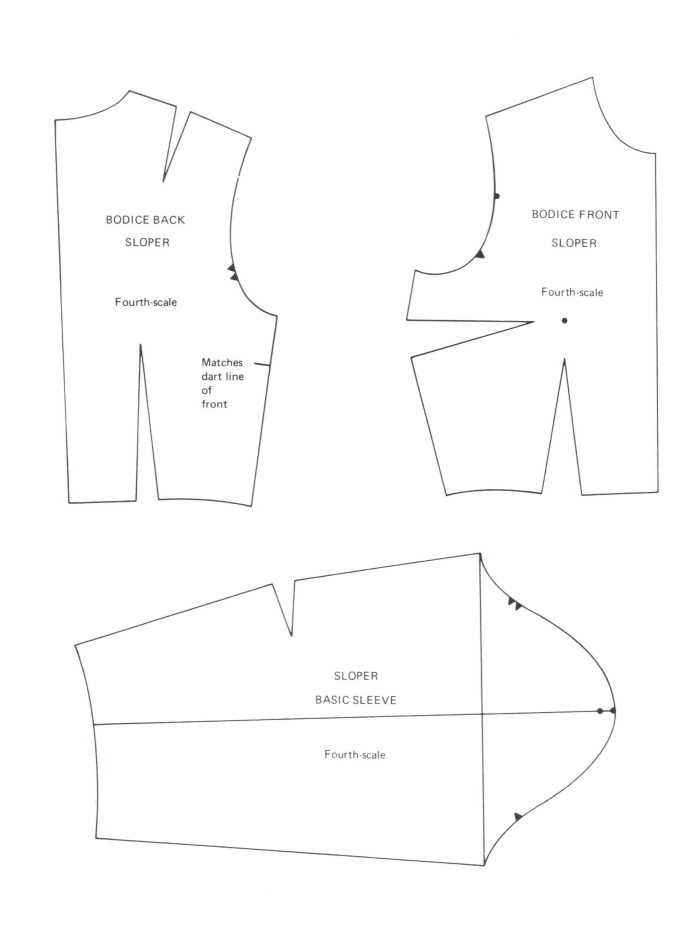

BODICE BACK
SLOPER

Fourth-scale

Matches
dart line
of
front

BODICE FRONT
SLOPER

Fourth-scale

SLOPER
BASIC SLEEVE

Fourth-scale

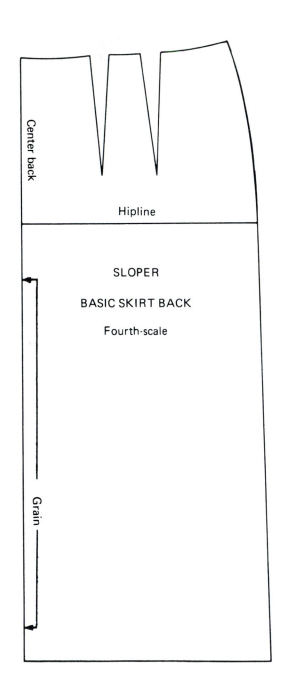

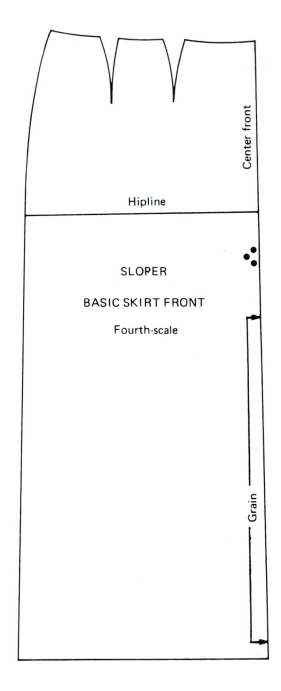

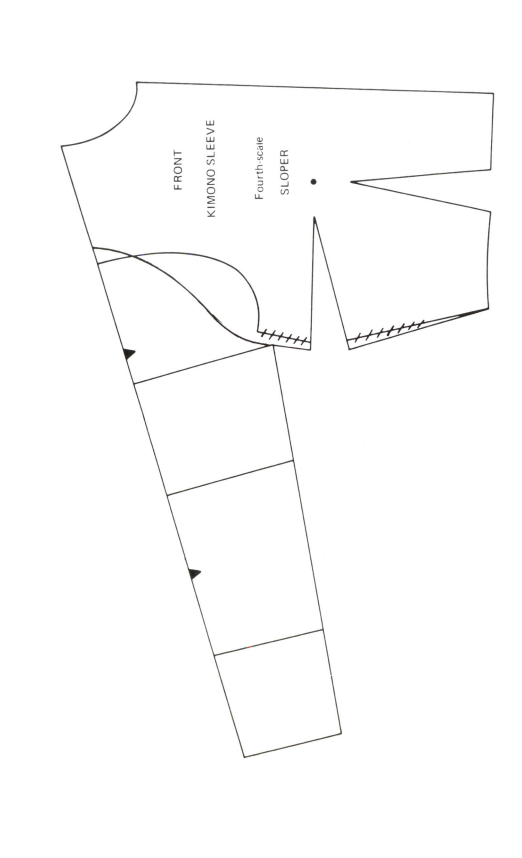

FRONT

KIMONO SLEEVE

Fourth-scale

SLOPER

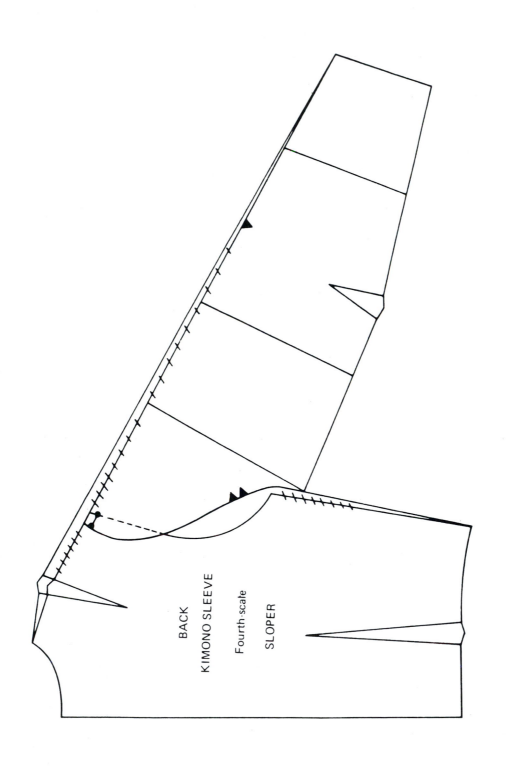

BACK
KIMONO SLEEVE
Fourth-scale
SLOPER

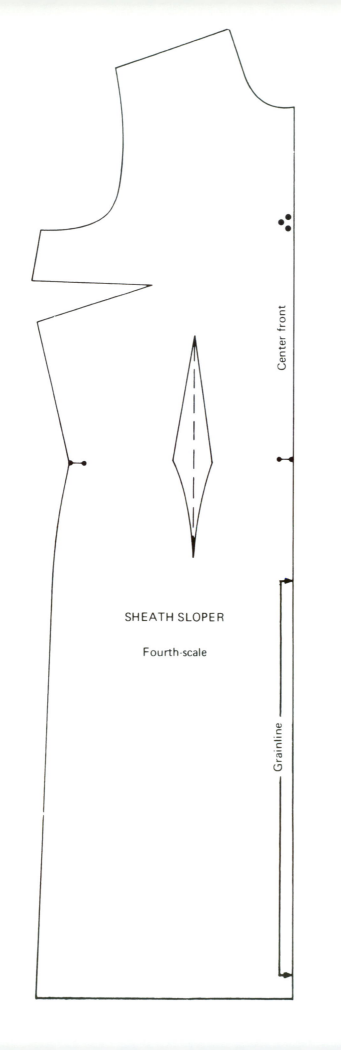

**SLOPERS for
SHEATH BASIC PATTERN**

Center front

SHEATH SLOPER

Fourth-scale

Grainline

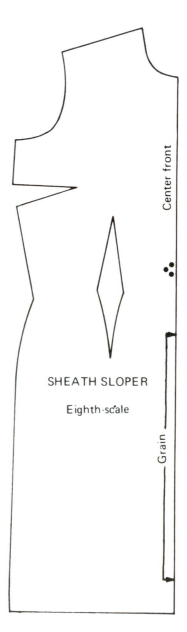

Center front

SHEATH SLOPER

Eighth-scale

Grain

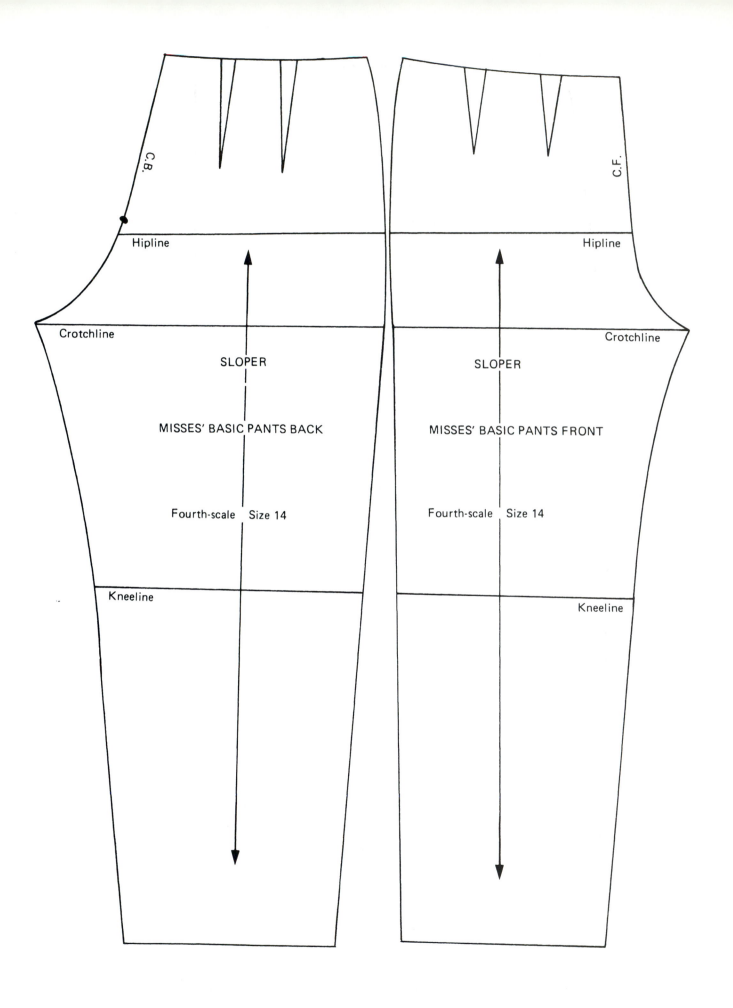

C.B.

Hipline

Crotchline

SLOPER

MISSES' BASIC PANTS BACK

Fourth-scale Size 14

Kneeline

C.F.

Hipline

Crotchline

SLOPER

MISSES' BASIC PANTS FRONT

Fourth-scale Size 14

Kneeline

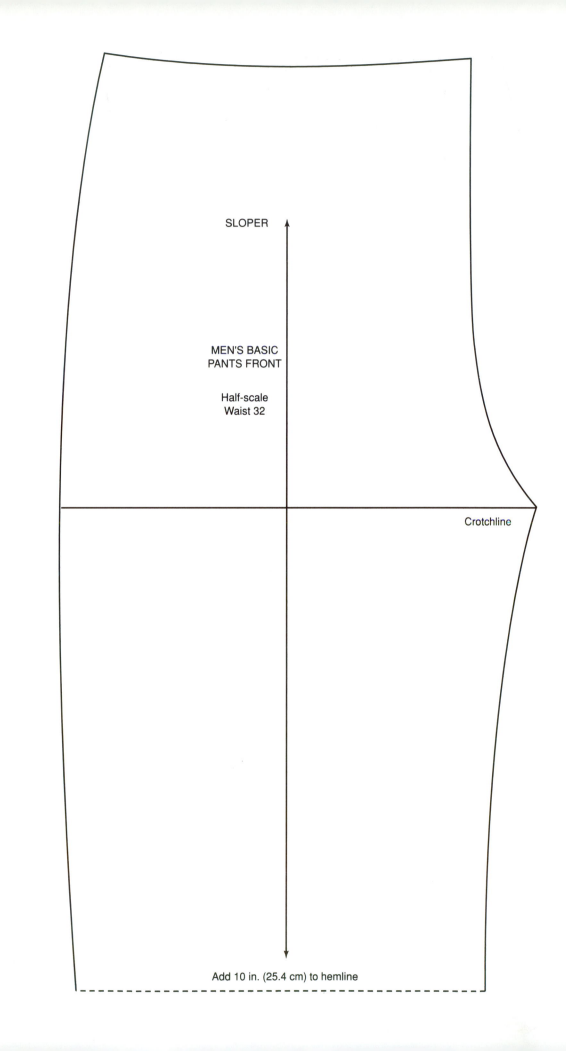

SLOPER

MEN'S BASIC
PANTS FRONT

Half-scale
Waist 32

Crotchline

Add 10 in. (25.4 cm) to hemline

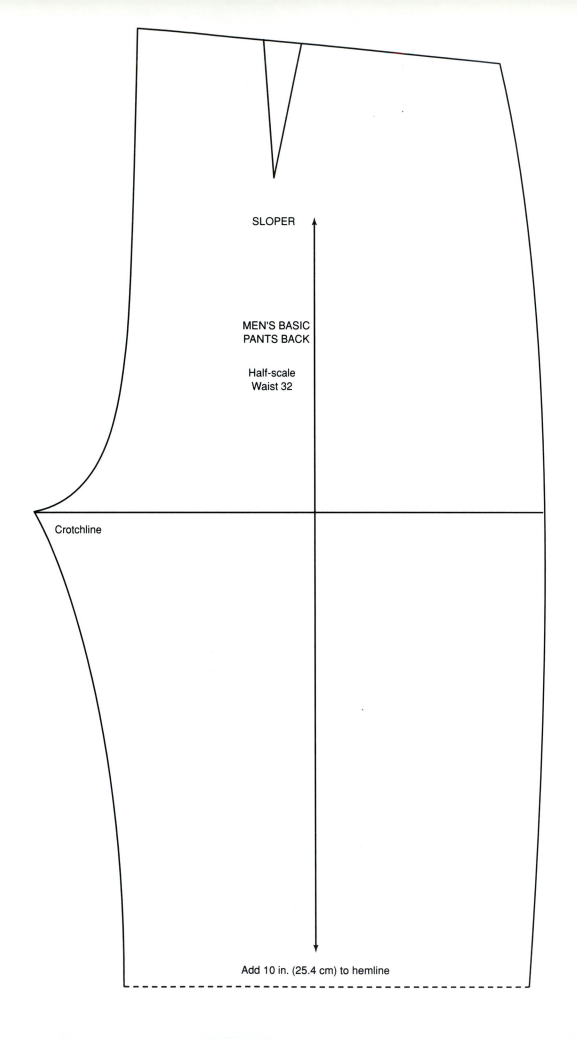

SLOPER

MEN'S BASIC
PANTS BACK

Half-scale
Waist 32

Crotchline

Add 10 in. (25.4 cm) to hemline

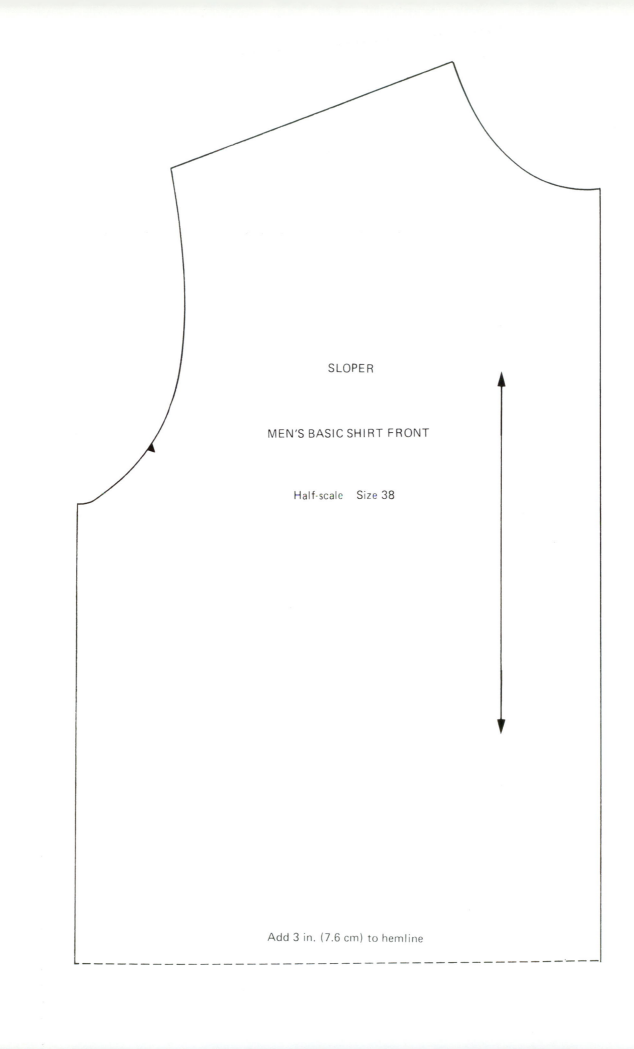

SLOPER

MEN'S BASIC SHIRT FRONT

Half-scale Size 38

Add 3 in. (7.6 cm) to hemline

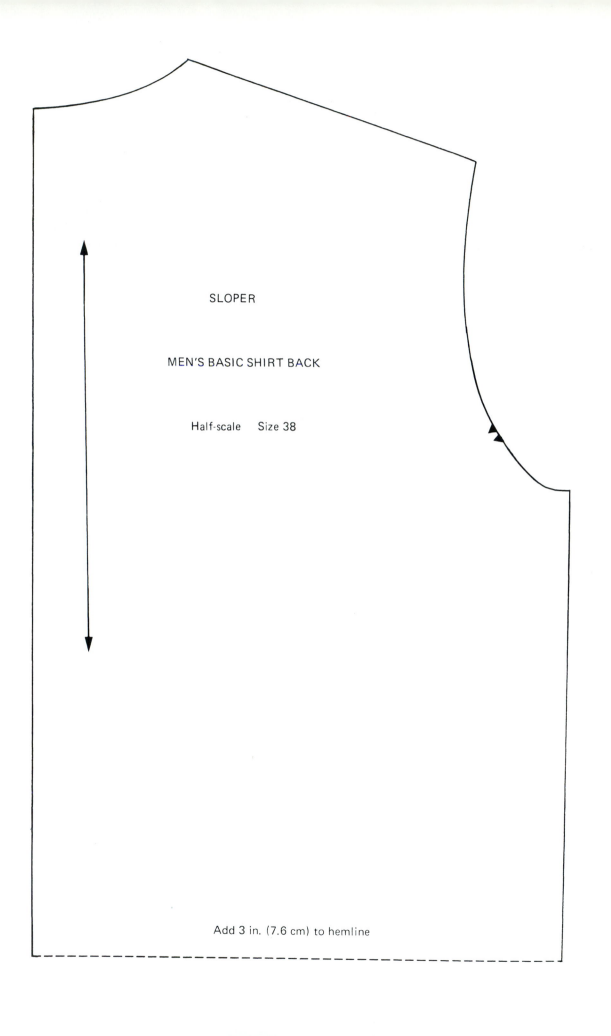

SLOPER

MEN'S BASIC SHIRT BACK

Half-scale Size 38

Add 3 in. (7.6 cm) to hemline

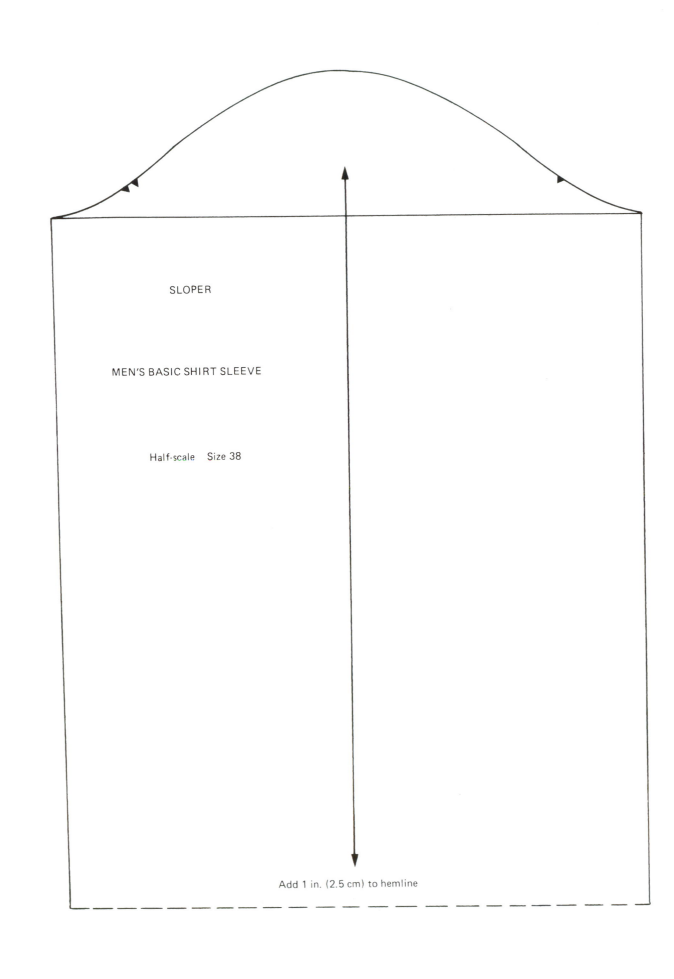

SLOPER

MEN'S BASIC SHIRT SLEEVE

Half-scale Size 38

Add 1 in. (2.5 cm) to hemline

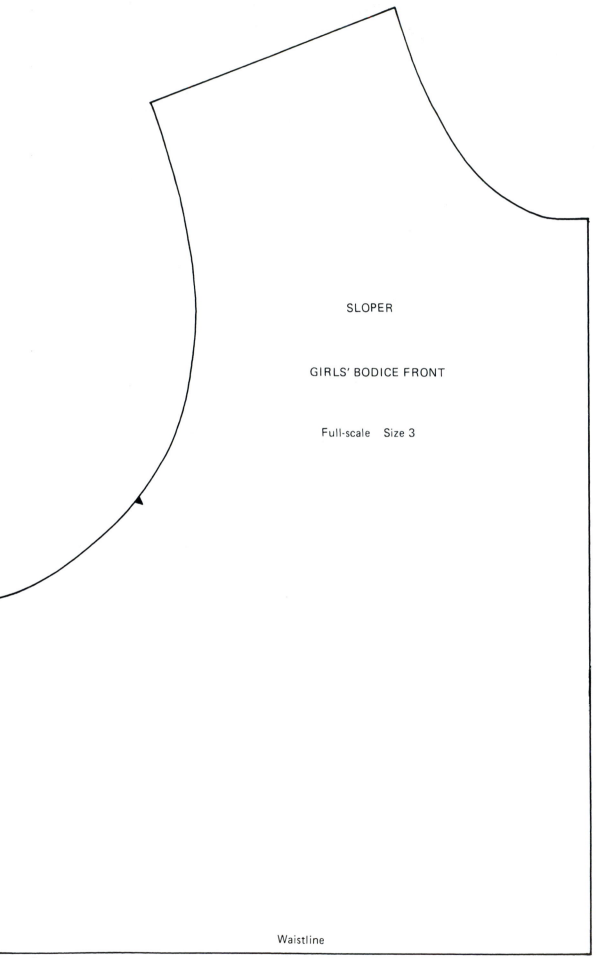

SLOPER

GIRLS' BODICE FRONT

Full-scale Size 3

Waistline

For a dress, add 9 to 12 in. (22.9 to 30.5 cm.) to hemline. Also add 2 in. (5.1 cm.) flare at sideseam hemline.

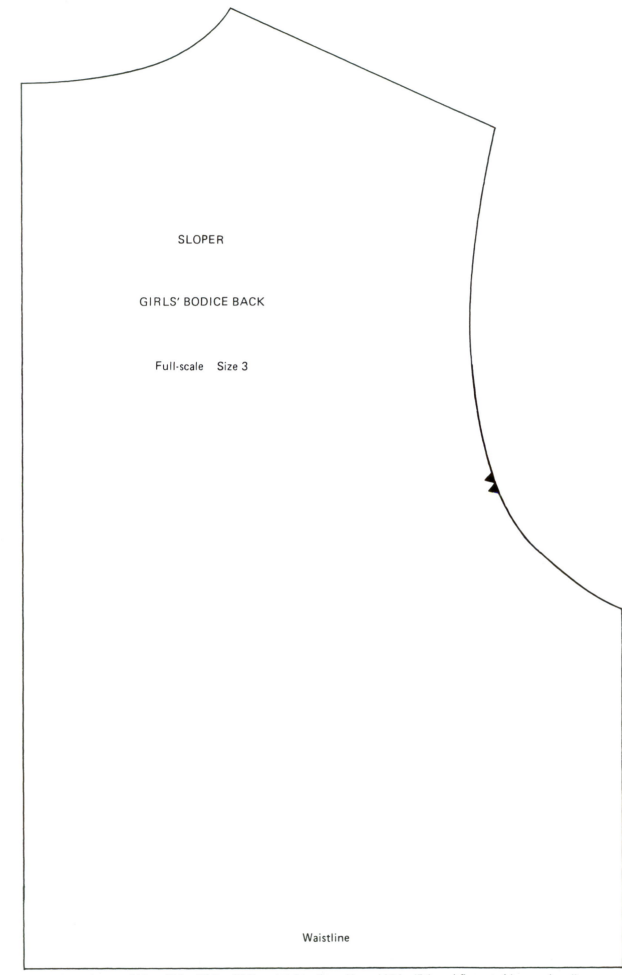

SLOPER

GIRLS' BODICE BACK

Full-scale Size 3

Waistline

For a dress, add 9 to 12 in. (22.9 to 30.5 cm.) to hemline. Also add 2 in. (5.1 cm.) flare at sideseam hemline.

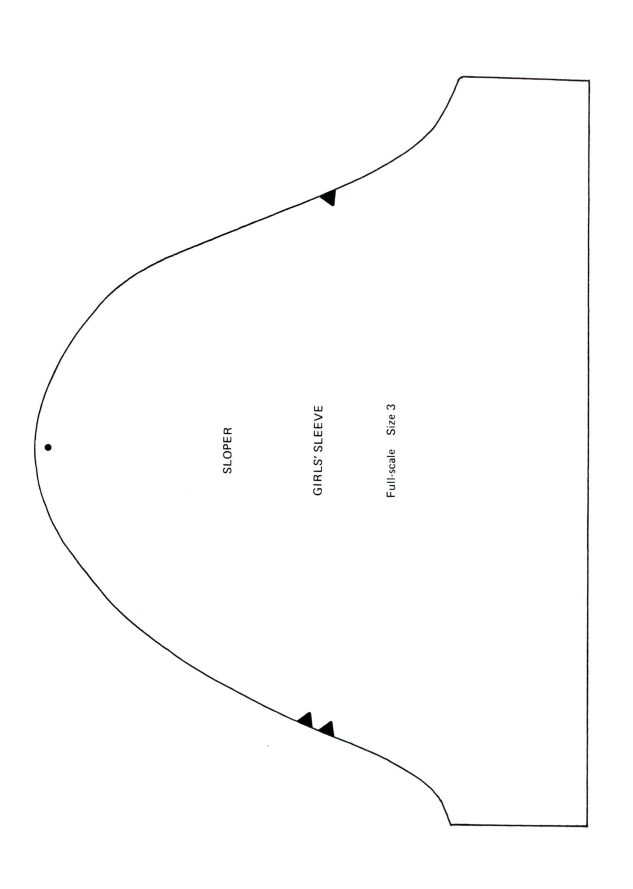

SLOPER

GIRLS' SLEEVE

Full-scale Size 3

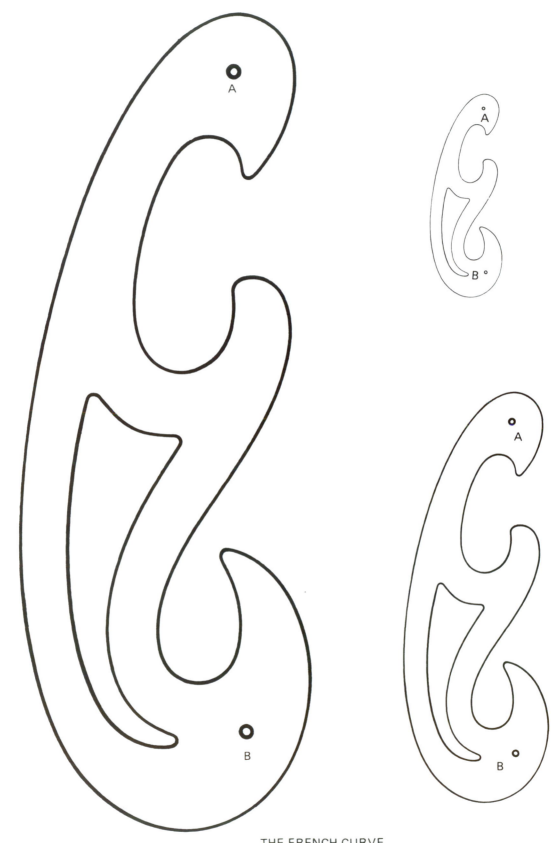

THE FRENCH CURVE
Full-scale, half-scale, and fourth-scale

B

Metric Conversion Table

1 inch, U.S. standard = 2.540005 centimeters

The centimeter equivalent to the inch measurement is given to the nearest tenth.

When using the metric system of measurement exclusively, the general practice is to measure to the nearest half centimeter for major measurements.

Inches	Fractions									Inches
	0	1/16	1/8	1/4	3/8	1/2	5/8	3/4	7/8	
0	0.0	0.2	0.3	0.6	1.0	1.3	1.6	1.9	2.2	0
1	2.5	2.7	2.9	3.2	3.5	3.8	4.1	4.4	4.8	1
2	5.1	5.2	5.4	5.7	6.0	6.4	6.7	7.0	7.3	2
3	7.6	7.8	7.9	8.3	8.6	8.9	9.2	9.5	9.8	3
4	10.2	10.3	10.5	10.8	11.1	11.4	11.7	12.1	12.4	4
5	12.7	12.9	13.0	13.3	13.7	14.0	14.3	14.6	14.9	5
6	15.2	15.4	15.6	15.9	16.2	16.5	16.8	17.1	17.5	6
7	17.8	17.9	18.1	18.4	18.7	19.1	19.4	19.7	20.0	7
8	20.3	20.5	20.6	21.0	21.3	21.6	21.9	22.2	22.5	8
9	22.9	23.0	23.2	23.5	23.8	24.1	24.4	24.8	25.1	9
10	25.4	25.6	25.7	26.0	26.4	26.7	27.0	27.3	27.6	10
11	27.9	28.1	28.3	28.6	28.9	29.2	29.5	29.8	30.2	11
12	30.5	30.6	30.8	31.1	31.4	31.8	32.1	32.4	32.7	12
13	33.0	33.2	33.3	33.7	34.0	34.3	34.6	34.9	35.2	13
14	35.6	35.7	35.9	36.2	36.5	36.8	37.1	37.5	37.8	14
15	38.1	38.3	38.4	38.7	39.1	39.4	39.7	40.0	40.3	15
16	40.6	40.8	41.0	41.3	41.6	41.9	42.2	42.5	42.9	16
17	43.2	43.3	43.5	43.8	44.1	44.4	44.8	45.1	45.4	17
18	45.7	45.9	46.0	46.4	46.7	47.0	47.3	47.6	47.9	18
19	48.3	48.4	48.6	48.9	49.2	49.5	49.8	50.2	50.5	19
20	50.5	51.0	51.1	51.4	51.7	52.1	52.4	52.7	53.0	20
21	53.3	53.5	53.7	54.0	54.3	54.6	54.9	55.2	55.6	21

Inches				Fractions						Inches
	0	$1/16$	$1/8$	$1/4$	$3/8$	$1/2$	$5/8$	$3/4$	$7/8$	
22	55.9	56.0	56.2	56.5	56.8	57.2	57.5	57.8	58.1	22
23	58.4	58.6	58.7	59.1	59.4	59.7	60.0	60.3	60.6	23
24	61.0	61.1	61.3	61.6	61.9	62.2	62.5	62.9	63.2	24
25	63.5	63.7	63.8	64.1	64.5	64.8	65.1	65.4	65.7	25
26	66.0	66.2	66.4	66.7	67.0	67.3	67.6	67.9	68.3	26
27	68.6	68.7	69.0	69.2	69.5	69.9	70.2	70.5	70.8	27
28	71.1	71.3	71.4	71.8	72.1	72.4	72.7	73.0	73.3	28
29	73.7	73.8	74.0	74.3	74.6	74.9	75.2	75.6	75.9	29
30	76.2	76.4	76.5	76.8	77.2	77.5	77.8	78.1	78.4	30
31	78.7	78.9	79.1	79.4	79.7	80.0	80.3	80.6	81.0	31
32	81.3	81.4	81.6	81.9	82.2	82.6	82.9	83.2	83.5	32
33	83.8	84.0	84.1	84.5	84.8	85.1	85.4	85.7	86.0	33
34	86.4	86.5	86.7	87.0	87.3	87.6	87.9	88.3	88.6	34
35	88.9	89.1	89.2	89.5	89.9	90.2	90.5	90.8	91.1	35
36	91.4	91.6	91.8	92.1	92.4	92.7	93.0	93.3	93.7	36
37	94.0	94.1	94.3	94.6	94.9	95.3	95.6	95.9	96.2	37
38	96.5	96.7	96.8	97.2	97.5	97.8	98.1	98.4	98.7	38
39	99.1	99.2	99.4	99.7	100.0	100.3	100.6	101.0	101.3	39
40	101.6	101.8	101.9	102.2	102.6	102.9	103.2	103.5	103.8	40
41	104.1	104.3	104.5	104.8	105.1	105.4	105.7	106.0	106.4	41
42	106.7	106.8	107.0	107.3	107.6	108.0	108.3	108.6	108.9	42
43	109.2	109.4	109.5	109.9	110.2	110.5	110.8	111.1	111.4	43
44	111.8	111.9	112.1	112.4	112.7	113.0	113.3	113.7	114.0	44
45	114.3	114.5	114.6	114.9	115.2	115.6	115.9	116.2	116.5	45
46	116.8	117.0	117.2	117.5	117.8	118.1	118.4	118.7	119.1	46
47	119.4	119.5	119.7	120.0	120.3	120.7	121.0	121.3	121.6	47
48	121.9	122.1	122.2	122.6	122.9	123.2	123.5	123.8	124.1	48
49	124.5	124.6	124.8	125.1	125.4	125.7	126.1	126.4	126.7	49
50	127.0	127.2	127.3	127.6	128.0	128.3	128.6	128.9	129.2	50
51	129.5	129.7	129.9	130.2	130.5	130.8	131.1	131.5	131.8	51
52	132.1	132.2	132.4	132.7	133.0	133.4	133.7	134.0	134.3	52
53	134.6	134.8	134.9	135.3	135.6	135.9	136.2	136.5	136.9	53
54	137.2	137.3	137.5	137.8	138.1	138.4	138.8	139.1	139.4	54
55	139.7	139.9	140.0	140.3	140.7	141.0	141.3	141.6	141.9	55
60	152.4	152.6	152.7	153.0	153.4	153.7	154.0	154.3	154.6	60

Standard Body Measurement Charts

IMPERIAL STANDARD BODY MEASUREMENT CHART

MISSES' BODY MEASUREMENTS IN INCHES

Size	EXTRA SMALL		SMALL		MEDIUM		LARGE		EXTRA LARGE		
Size	4	6	8	10	12	14	16	18	20	22	
Bust	31½	32½	34	35½	37	38½	40	41½	43	45	(")
Waist	22½	23½	24¾	26	27½	29	31	33	35	37	(")
Hip	32¼	34	35½	37	38½	40	41¾	43¼	45	47	(")
Back Waist Length	15¼	15½	15¾	16	16¼	16½	16¾	17	17	17	(")

GIRLS' BODY MEASUREMENTS

Size	4	5	6	7	8	10	12	14	
Height	41	44	47	50	52	56	58½	61	(")
Chest	23	24	25	26	27	28	30	32	(")
Waist	21½	22	22½	23	23½	24½	25½	26½	(")
Hip	23½	24½	25½	27	28	30	32	34	(")

MEN'S BODY MEASUREMENTS

Size	SMALL		MEDIUM		LARGE		EXTRA LARGE		XX-LARGE	KING SIZE		
Chest Size	34	36	38	40	42	44	46	48	50	52	54	
Chest	34	36	38	40	42	44	46	48	50	52	54	(")
Waist	28	30	32	34	36	38	40	42	44	46	48	(")
Hip	35	37	39	41	43	45	47	49	51	53	55	(")
Neck	14	14½	15	15½	16	16½	17	17½	18	18½	19	(")

BOYS' BODY MEASUREMENTS

Size	4	5	6	7	8	10	12	14	
Height	41	44	47	48	50	54	58	61	(")
Chest	23	24	25	26	27	28	30	32	(")
Waist	21½	22	22½	23	24	25	26	27	(")
Hip	23½	24½	25½	27	28	29½	31	32½	(")

TODDLERS' BODY MEASUREMENTS
Toddler's garments have a diaper allowance

Size	T-1	T-2	T-3	T-4	
Height	31	34	37	40	(")
Chest	20	21	22	23	(")
Waist	20	20½	21	21½	(")
Hip	20½	21½	22½	23½	(")

BABY

Size	Small	Medium	Large	Extra Large	
Month	0 - 3	3 - 6	6 - 12	12 - 18	
Height	24	26½	29	31½	(")
Weight	13	18	22	26	(lb)

Source: Kwik-Sew Pattern Company, Inc. 3000 Washington Avenue North, Minneapolis, Minnesota 55411.
This measurement chart differs from the chart used by some other pattern companies.

METRIC STANDARD BODY MEASUREMENT CHART

MISSES' BODY MEASUREMENTS IN CENTIMETERS

Size	EXTRA SMALL		SMALL		MEDIUM		LARGE		EXTRA LARGE		
Size	4	6	8	10	12	14	16	18	20	22	
Bust	80	83	86	90	94	98	102	106	110	114	(cm)
Waist	57	60	63	66	70	74	79	84	89	94	(cm)
Hip	82	86	90	94	98	102	106	110	115	120	(cm)
Back Waist Length	39	39.5	40	41	41.5	42	42.5	43	43	43	(cm)

GIRLS' BODY MEASUREMENTS

Size	4	5	6	7	8	10	12	14	
Height	104	112	119	127	132	142	149	155	(cm)
Chest	58	61	63	66	68	71	76	81	(cm)
Waist	54	56	57	58	59	62	64	67	(cm)
Hip	59	62	65	68	71	76	81	86	(cm)

MEN'S BODY MEASUREMENTS

Size	SMALL		MEDIUM		LARGE		EXTRA LARGE		XX-LARGE KING SIZE			
Chest Size	34	36	38	40	42	44	46	48	50	52	54	
Chest	86	91	96	101	106	111	116	122	127	132	137	(cm)
Waist	71	76	81	86	91	96	101	106	111	116	122	(cm)
Hip	89	94	99	104	109	114	119	124	129	134	139	(cm)
Neck	35	36	38	39	40	41	43	44	45	47	48	(cm)

BOYS' BODY MEASUREMENTS

Size	4	5	6	7	8	10	12	14	
Height	104	112	119	122	127	137	147	155	(cm)
Chest	58	61	63	66	68	71	76	81	(cm)
Waist	54	56	57	58	61	63	66	68	(cm)
Hip	59	62	65	68	71	75	78	82	(cm)

TODDLERS' BODY MEASUREMENTS
Toddler's garments have a diaper allowance

Size	T1	T2	T3	T4	
Height	79	86	94	102	(cm)
Chest	51	53	56	58	(cm)
Waist	51	52	53	54	(cm)
Hip	52	54	57	59	(cm)

BABY

Size	Small	Medium	Large	Extra Large	
Month	0 - 3	3 - 6	6 - 12	12 - 18	
Height	61	67	74	80	(cm)
Weight	6	8	10	12	(kg)

Other Resources
for Apparel Pattern Makers

COST SHEET

DESCRIPTION:				STYLE #		
				PRICE:		
SIZE RANGE:	FIBER CONTENT:			SEASON:		
CARE:	COLORS:			DESIGN #		

MATERIAL	YARDS	PRICE	AMOUNT	SKETCH		
BODY:						
INTERFACING						
LINING						
FREIGHT						
A. TOTAL FABRIC COST						
TRIMMINGS						
BUTTONS:						
ZIPPER:						
THREAD:						
PADS:						
BELT:						
ELASTIC:						
EMBROIDERY:						
PACKING				MATERIAL SWATCH		
LABELS:						
FREIGHT:						
B. TOTAL TRIM COST						
LABOR						
CUTTING:						
SEWING:						
PRESSING:						
BONUS/INSURANCE				REMARKS:		
GRADING & MARKING:						
TRUCKING						
C. TOTAL LABOR COST						
TOTAL COST						
(add A, B, & C)						

DESIGN INSPIRATION SHEET NAME _____

1.	Inspiration source – be specific
	Concept
	Color
	Fabric
2.	Target Customer
3.	What steps were taken to research the target customer?
4.	What store category would market this design and why? (Be specific)
5.	Price category (budget, better, moderate, designed)
	Retail price

SUPPLIERS OF COMPUTER SOFTWARE AND HARDWARE FOR THE APPAREL INDUSTRY

ANIMATED IMAGES INC.

62 Bayview St.
P.O. Box 1307
Camden, ME 04843
207-236-6403
Fax: 207-236-6419

StyleManager97, using client/server and web technology, now complemented by StyleQuery, TransferFile, and Concept-Manager, a set of software tools designed to support the entire process of product development for the apparel industry; APDNet provides a secure web-based environment for mills and apparel companies to communicate, event track and schedule fabric development from concept through creation

ASSYST INC.

5000 Aerial Center Pkwy., No. 200
Morrisville, NC 27560
919-467-2211
Fax: 919-467-2297
e-mail: info@assyst-intl.com
Internet URL: www.assyst-intl.com

AssyCAD, pattern design, grading and marking; AssyFORM, specification sheet and graphic information system; AssyNEST, automatic marking system; AssyCUT, cut path optimization and NC cutter data management; AssyCOST, cut order planning and costing system; Assy-GRAPH, graphic design system; SHAPE, electronic drafting system; TA-500, flat-bed plotter with pen and inkjet head, extremely fast and accurate; JP172NT high-speed inkjet plotter; AssyPLAN, sewing plan creation system

INVESTRONICA INC.

5875 Peachtree Industrial Blvd., Suite 350
Norcross, GA 30092
770-242-0798/800-468-7937
Fax: 770-242-1912

CAD/CAM/CIM products; Inves-Studio, fashion design; Invesmark NT, pattern design, grading and marker making; prod-uct manager; Invesdesigner, industrial pattern making system; Invesplot TRO1A and Ioline Summit; cutting systems, Invescut CV020, CV040 and CV070; matching system; Procon III, control production system; UPS, Invesmove

COMPUTER DESIGN, INC.

2880 E. Beltline N.E.
Grand Rapids, MI 49505
616-361-1139
Fax: 616-361-5679

U4ia Prints, artwork to production-ready drops and repeats; U4ia production, prepare flat/tonal print designs for separations; U4ia Premier, apply fabric/textures to photographs/line art; U4ia knits and wovens, create/visualize yarn-dyed fabrics (custom dobbies) and knitted fabric designs; U4ia 3D, visualization, pattern development for apparel/auto seating industries; virtual apparel environment, joins design with merchandising, advertising, marketing, sales, sourcing, and retailing

GERBER TECHNOLOGY INC.

24 Industrial Park Rd. W.
P.O. Box 769
Tolland, CT 06084
860-871-8082
Fax: 860-871-6007

AccuMark Silhouette™ pattern development system (backlit and opaque models); Artworks™ Design, merchandising and style development system; SP-150 and SP-200 plotters/pattern cutters; latest AccuMark™ 100/200/800 design, grading and marking systems on Windows; Ultra-Mark Analyzer™; UltraMark Optimizer™; MicroMark™ pattern grading and marking system; Product Data Management® (PDM™) information management system; AccuPlot™ 310 Plotter; AccuPlot™ 100 Plotter; AccuPlot™ 700-CXS plotter/pattern cutter; AccuJet™ 510 pen/ink jet plotter; GERBERplanner™ cut order planning system; FDS 2D/3D footwear grading/engineering system; sample maker; picture portfolio; W-6 Contractor Scheduler™; AccuMark™ made-to-measure system; GERBERcutter® S-3200 and S-7200; GGT-Niebuhr conveyorized spreading system; plaid matching system; POWER Processor™ cutting protocol system; InfoMARK 2000™ piece identification system; GERBERmover®

300/100 unit production system; IMPACT™ labor costing module; IMPACT™ production planning module; GERBERmover® and PDM™ interface

INFO DESIGN INC.

104 W. 40th St., 12th Floor
New York, NY 10018
212-921-2727
Fax: 212-768-4488
e-mail: infonyc@aol.com

Vision products include Meta Studio, Designer, CT Fast, CT Pro, engraving, knitting stylist, Jacquard, precision color, weaving; vision fashion studio, the new suite of Info Design NT modules: color reduction and cleaning, design and repeat, easy coloring, presentation and cataloguing, Easyweave

LECTRA SYSTEMS INC.

844 Livingston Court
Marietta, GA 30067
770-422-8050
Fax: 770-422-1503
Internet URL: www.lectra.com

Graphic Instinct sketching system; ProStyle artistic design; Freeline pattern drafting; Modaris pattern making; Diamino marker making; Graphic Spec technical drawing; graphic cost costing; Master File and Master Link data management tools; Dyna Plan and Opti Plan cut order planning; Progress II automated fabric spreading systems; Top Spin automated single-ply cutting system; vector automated cutting system; contour plotter/cutters; FlyPen plotters; Prime Jet plotters; PostPrint label system; Hewlett-Packard and OpenCAD workstations; StyleBinder organizational software; Focus Series laser cutters; style manager product development software for Windows

MODACAD

1954 Cotner Ave.
Los Angeles, CA 90025
310-312-9826
Fax: 310-444-9577

ModaDESIGN PRO integrated productivity tool, allows designers and manufacturers to automate sketching, draping, and textile design; ModaDESIGN PRO for home furnishings, interactive manufacturing system, simulates manufacturer's furni-

347

ture and other home furnishing items; ModaCATALOG interactive line development archiving, storyboarding and rep system for the apparel and textile industry; QUEST product data management solution, designed for apparel and textile industries, provides access to all phases of product development information; Moda-PLAN space management solution for retailers and store designers to create and view three-dimensional photo-realistic renderings of store layouts and planograms

MONARCH DESIGN SYSTEMS
74-10 88th St.
Glendale, NY 11385
718-894-8520
Fax: 718-416-0330

Software includes: Pointcarré Design Studio™, knit design and production, weave design and production, screen print separations, photo-realistic drape, relational image and databases; hardware includes:

Apple Macintosh, Power Macintosh, laptop Powerbooks, high-resolution scanners, high-quality printers, drawing tablets, storage devices; maintenance; supplies; leasing; service bureaus

PAD SYSTEM® TECHNOLOGIES
2100 St. Catherine W., Suite 720
Montréal
Québec, Canada H3H 2T3
514-939-4430
Fax: 514-937-0517

High End MAC OS and Windows CAD/CAM Software; PAD System® Sample; advanced 3-D pattern design, PAD System® Pattern; 2-D flexible pattern plan, PAD System® Digit; easy-to-use grading and pattern modification, PAD System® AutoMarker; unlimited background Automarker, PAD System® Marker; fast setting new marker, PAD System® Plot; unlimited background plot

SCANVEC GARMENT SYSTEMS LTD.
155 West St.
Wilmington, MA 01887
800-866-6227/508-694-9488
Fax: 508-694-9482

Windows-based software solutions for pattern design, grading, nesting, and marker making

[TC]² TEXTILE/CLOTHING TECHNOLOGY CORP.
211 Gregson Dr.
Cary, NC 27511-7909
919-380-2156
Fax: 919-380-2181

First public unveiling of [TC]² 3-D body scanning unit, one of the technology components that will make possible the concept of mass customization

Index